Making History Move

Making History Move

Five Principles of the Historical Film

KIM NELSON

Rutgers University Press
New Brunswick, Camden, and Newark, New Jersey
London and Oxford

Rutgers University Press is a department of Rutgers, The State University of New Jersey, one of the leading public research universities in the nation. By publishing worldwide, it furthers the University's mission of dedication to excellence in teaching, scholarship, research, and clinical care.

Library of Congress Cataloging-in-Publication Data

Names: Nelson, Kim (Documentary filmmaker), author.
Title: Making history move : constructing a historiophoty for the historical film / Kim Nelson.
Description: New Brunswick : Rutgers University Press, 2024. | Includes bibliographical references and index.
Identifiers: LCCN 2023031270 | ISBN 9781978829770 (paperback) | ISBN 9781978829787 (hardcover) | ISBN 9781978829794 (epub) | ISBN 9781978829800 (pdf)
Subjects: LCSH: Historical films—History and criticism. | History in motion pictures. | Visual perception in motion pictures. | LCGFT: Film criticism.
Classification: LCC PN1995.9.H5 N45 2024 | DDC 791.43/658—dc23/eng/20231001
LC record available at https://lccn.loc.gov/2023031270

A British Cataloging-in-Publication record for this book is available from the British Library.

Copyright © 2024 by Kim Nelson
All rights reserved
No part of this book may be reproduced or utilized in any form or by any means, electronic or mechanical, or by any information storage and retrieval system, without written permission from the publisher. Please contact Rutgers University Press, 106 Somerset Street, New Brunswick, NJ 08901. The only exception to this prohibition is "fair use" as defined by U.S. copyright law.

References to internet websites (URLs) were accurate at the time of writing. Neither the author nor Rutgers University Press is responsible for URLs that may have expired or changed since the manuscript was prepared.

♾ The paper used in this publication meets the requirements of the American National Standard for Information Sciences—Permanence of Paper for Printed Library Materials, ANSI Z39.48-1992.

rutgersuniversitypress.org

For Rob, Hagen, Ella, and Clio—muses all

Contents

	Introduction: Five Principles of Historiophoty	1
1	Narration	38
2	Evidence	71
3	Reflexivity	107
4	Foreignness	143
5	Plurality	167
	Acknowledgments	193
	Filmography	195
	References	201
	Index	213

Making History Move

Introduction

•••••••••••••••••••••

Five Principles of Historiophoty

What is historiophoty, and to what should it refer?

Lace and metal, towering powdered wigs defying gravity, and reams of molded fabric—all characterize the sumptuous imagery of history films. While written, oral, and theatrical histories paint pictures that hold up a candle to specific details, guiding the perceiver with lumina enough to lay out evidence and argument, in history films, the filmmaker's canvas is lit by stadium lights, manifesting a dizzying tableau of unaccounted detail from the shadows, unveiling specifics and spaces previously unfathomed, as they were undescribed. The splendor of seeing and hearing the alien—the evocation of vanished people, places, events, and times—is an intense attraction to experiencing history in moving images.

History has a special relationship to truth and identity; the moving image medium has great power to mesmerize and influence. Together, moving images and history merge into a substantial force, a *moving history* that makes a mass spectacle of memory (Nelson 2022). Moving histories enter a contract with their audience, different from films and series that craft fictional plots. Histories make truth claims that shoulder extra responsibilities that come along with what Hayden White described as "The Burden of History" (1966). *Historiophoty*, a term proposed by White in 1988, is the moving image answer to historiography, the collection of theories and methods that manage the burden and contract of history in the written word (White 1988). This book's unique and ambitious contribution to the scholarship of history in moving images establishes five principles of historiophoty to organize and systematize a framework of analysis and classification of these works. The principles draw from a wealth of cross-disciplinary scholarship within the intersecting fields of film and history to offer a detailed assessment

tool that contends with the processes and impacts of the most pervasive medium of history. Given the immense public impact of moving images as a platform of collective history and meaning production, structuring its analysis into a concrete theory and methodology of historiophoty is as critical as it is overdue. This introduction will lay a detailed groundwork for the methodology of this book by conceptualizing historiophoty, clarifying its core principles, and highlighting the works to which these criteria most readily and significantly apply—those about real people and events engaged in conflicts of broad sociopolitical significance.

Why Historiophoty?

This is a book-length argument for setting a foundation for the parameters of historiophoty, once and for all. Robert Rosenstone explains that understanding how history films "construct a historical world" and by which "rules, codes and strategies" are the most pressing issues for history in moving images (Rosenstone 1995a, 4). This is a call for historiophoty.

Recorded history, including filmic renditions, works upon the iterative and additive mechanics of human memory. History and memory share immense powers to adapt and alter traces from the past and remain convincing. History invokes the real, while film engages the emotions and senses in such a way that we recall history films almost like witnesses. What moving images bring to history are potent tools for learning. As Alison Landsberg explains, memories of our lived experience and moving images commingle, cobbling cyborg, pastiche identities (2004, 41). Further, Jeffrey Zacks, a professor of psychology and brain sciences, describes the biological effect of movies on us and the way they "hijack" our responses to the real world and "program our brains to have experiences. They create events in our heads" (2015, 276). When we read, we perceive our distance from the information, but as spectators of moving images, we use our innate senses to watch and listen, internalizing stories as pseudoexperiences. If, as John Durham Peters notes, "writing is the bias through which we read history" (2015, 279), we may surmise that filmmaking is the bias through which we *experience* it.

Setting Terminologies

I will occasionally use the word *film* as a simple, monosyllabic alternate reference for moving image media. In the same way that a train is a train, whether powered by steam, electricity, or diesel, the word *film* can withstand a shift in materiality. The term holds in describing the study and industry of moving pictures with sound, despite the transfiguration of film as an object, from celluloid to digital. Turning to the historical film, its generally agreed-upon boundaries include all works in moving images that engage the past, whether or not they deal with real people and events. The genre spans work from *Mad Men* (2007–2015) to *Shoah* (1985) to *Till* (2022). Because the latter two offer a realist interpretation

of actual people and events, they have specific responsibilities that differ from those about a past of imagined characters and conflicts. I will focus this book on the subset of moving images that Philip Rosen calls the historical film in "its purest form," the kind that audiovisually signals the past and "consists of a 'true story'" (Rosen 2001, 178). I call these works moving histories.

Histories are always palimpsests, inherently intertextual, distinguished from fiction as they always represent "a relationship of copresence between two or [more] texts" (Genette 1997, 1). Any history bases its status on its recourse to historical texts of one kind or another. Moving histories stake their claim to the real through reference to actual people and events, whether drawing from documentary footage, news reports, scholarly histories, novels, oral testimonies, or documents. I subscribe to Eleftheria Thanouli's, Alison Landsberg's, and Philip Rosen's approaches by considering moving histories across fiction and nonfiction traditions together (Thanouli 2019; Landsberg 2004, 2015; Rosen 2001). As Thanouli explains, "Any discussion of historiophoty is bound to be incomplete, unless it includes both fictions and documentaries, as two distinct genres sharing, nonetheless, the same underlying epistemological concerns" (2019, 237).

This rationale is supported in a roundabout way by the two most prominent historians to contribute to this area. Natalie Zemon Davis focuses on historical fiction films because she finds them *more problematic* for the methods and aims of history than documentaries, while Robert Rosenstone primarily writes about them because he finds them *less problematic* (Davis 1987, 478; Fauci and Rosenstone 1988, 3; Rosenstone 1989). Although it makes sense in many instances to tackle these distinct approaches separately, it is equally important to contemplate them alongside each other toward a more complete survey of historicization in mainstream moving images. After all, every moving history fits John Grierson's axiomatic description of documentary as a "creative treatment of actuality" (1933). As products of a popular medium, scripted and performance-based histories are genealogically linked to popular prose and the historical novel, while documentaries animate in the manner of a scrapbook or museum display, more in line with academic history in their focalization and direct indexical links to evidence.

The label "moving histories" incorporates several meanings of the verb *to move*, from the literal and material sense of images in motion to their poetic and emotional capabilities to move us, body and mind. Moving histories as a concept takes up the appeal by Alison Landsberg that "intellectuals and educators" respect the power of film to speak to history (2004, 154). This book investigates the implications of *moving history* as an artifact that

1. is physically composed of images in motion;
2. requires the theoretical parameters of history—designed for history in the written word—to move, shift, and adapt to encompass and benefit moving histories; and
3. possesses special powers to move audiences intellectually and emotionally.

Playing with the multiplicity of movement bound in historical movies, Vivian Sobchack writes that "historians are often moved by movies—even historically 'inaccurate' ones" (1997, 6). Describing the enchanting experience of watching historical epics as a child, Sobchack explains that she took the images to be real while understanding the stories were only stories—one way of stringing plot and meaning together among others, and yet, as histories, these spectacles offered "the most *compelling* accounts . . . in moving and showing human bodies disposed and active in space, they *moved* [her] in time" (15; italics in the original). And this is perhaps the most powerful aspect of movement in moving histories: their ability to sweep spectators up and transport them over years, centuries, or millennia.

Five Principles of Historiophoty

Robert Rosenstone and Natalie Zemon Davis are among the historians who have contributed the most to systemizing the key concerns of historiophoty. One of the most insightful and enduring appraisals of historians' responses to history on film is Robert Rosenstone's lead essay that prompted the *American Historical Review*'s (AHR) 1988 forum issue devoted to exploring "the problems and possibilities of portraying history on film" (Rosenstone 1988, iv; Rosenstone and Nelson 2023, 338). In this significant contribution, Rosenstone writes with trademark verve and eloquence about the threat and potential that moving images pose for history. He provides a practical and remarkably durable engagement with what historians find troubling about the distortions of history conveyed via documentary and feature films:

- forcing the past into a narrow, linear narrative with a singular point of view (1988, 1174)
- confusing memory with history (1174)
- conveying a paucity of historical information (1176)
- focusing on individual over collective struggles (1178)
- ignoring facts that contradict the overarching message, denying complexity (1180)
- making history conform to film's genre conventions and visuality (1180–1181)

Throughout the essay, Rosenstone considers the validity of these critiques and, in the process, provides a sturdy navigation of the relationship of the historical film to the concerns of historiography, mapping an outline for the concept of historiophoty that Hayden White would propose in his corresponding essay in the same issue.

In the preface to her book *Slaves on Screen: Film and Historical Vision*, Natalie Zemon Davis reveals that her interest in the intersections of film and

history has been long-standing, as she initially thought she would put her training as a historian to work in the arena of documentary film before becoming thoroughly enchanted by the archive (2000, ix). Davis, perhaps more than any other historian or philosopher, translates her concerns about history into a concrete, actionable context for filmmakers—while stopping short of attempting to rip the cameras from their shoulders. She is proactive, backing her ideas with creative and practical solutions based on her knowledge of historiography's best practices, combined with her experience taking part in a film production associated with her work. In part, the role of historiophoty is to do what Davis asserts is necessary: create a framework that encourages films to provide more "complex and dramatic indications of their truth status" (459).

Like Rosenstone and White, she is not a chauvinist about academic history's inborn superiority to popular history. Instead, Davis focuses on what film can do well and how it may incorporate the concerns and methods of history by adapting them to the language of this medium. She suggests several cinematic techniques that benefit the historical mission, including (a) "Brechtian distancing," giving Fellini's *And the Ship Sails On* (1983) as an example; (b) "multiple telling," citing *Rashomon* (1950) and *Last Year at Marienbad* (1961); and (c) the context of "historical knowledge," gesturing to *Citizen Kane* (1941; 1987, 478–479). In her book *Slaves on Screen*, Davis further develops parameters to demonstrate how film could do history better, which I will number for ease of reference:

1. "Seek evidence widely and deeply" with an open mind, "avoiding the impulse to remake the past in familiar terms"
2. Show the audience your sources and note when something is "ambiguous, uncertain or contradictory"
3. Qualify and highlight what is "speculation of [the] historian"
4. Understand, don't judge, as the Annales historians advise
5. Never intentionally falsify or omit (2000, 10–11)

These are insightful directives for moving histories. Rule 4 is a vital call to temper our appraisals of past actors to avoid an ignorant sense of temporal superiority whereby we judge others for their backward ways, as though we are the autonomous authors of our own progressive views rather than the product of our environments and the values to which we have been exposed, benefactors of the development of ideas over time. This is a particular issue for films that seek to set up mythic oppositions of good versus evil that may entertain while doing a disservice to any sense of responsible historiophoty. In addition, we must remember that we cannot know every aspect of the past that contributed to decisions made and actions taken. This tempers but does not preclude judgment. Rules 1 and 2 intersect and could be more clearly delineated. Ultimately, Davis set the stage for solid historiographic principles that are open to the

audiovisual interpretation of filmmakers. She is optimistic and realistic when it comes to the prospects of film for history, stating, "As long as we bear in mind the differences between film and professional prose, we can take film seriously as a source of valuable and even innovative historical vision" (2000, 15).

Building upon this foundation, the key principles to gauge historiophoty include

> Narration—analyzing the historical argument through content and form
> Evidence—linking historical claims to historical data
> Reflexivity—employing audiovisual aesthetics and narrative methods of speculation
> Foreignness—acknowledging difference
> Plurality—democratizing history

The five principles of historiophoty contribute a detailed method of analysis that synthesizes previous contributions into a comprehensive methodology. The goal of this system is to yield critical insights into this intricate and influential category of reality-based and reality-shaping screen narratives. As such, a unified and thorough approach to their appraisal is as complicated as it is imperative. This method provides a formal mode of analysis to unify the field of film and history around a theoretical approach germane to scholars of film and history and to the vast audience that consumes historical content in moving images. Each principle is the focus of a chapter that will be laid out at the end of the introduction.

Historiography, Historiology, Historiophoty

A key contribution of the methodology presented here includes isolating, refining, and concretizing historiophoty as a theoretical and methodological disciplinary practice by clearly delineating its meaning and setting it upon a solid foundation as an analytical tool. Defining and engaging historiophoty first requires attending to historiography. A term known to historians from their first year of university studies, historiography is often taken for granted as a generally understood concept by many historians who have written about film.

In *The Writing of History*, Michel de Certeau describes historiography as *history* plus *graphy* (writing), a combination he calls a paradox between two opposing terms that refer to the "real" mingled with "discourse," with the role of the historian being connecting these two disparate elements (1992, xxvii). In head-spinning fashion, historiography refers to history in writing as well as its theories, methods, and evolution over time. Earlier, in *Heterologies: Discourse on the Other*, de Certeau claims that historiography separates looser, older, popular modes of history—genres such as genealogy, regional or national myths, and oral traditions—from the methodologies of academic history (1986, 4).

History has always functioned to define genres of remembrance and patrol borders between history and legend. It follows that historiophoty, as it attends to history in audiovisual form, would do the same for film.

History, Memory, and the Indivisible Present in the Past

History films explore the lived human experience. They show us what we are capable of doing through what we have done, musing about how it all turned out. They offer time travel with the discombobulating problems of physics shunted aside. Historian David Lowenthal notes that our "attachment to the past is inescapable" and "renders the present recognizable. Its traces on the ground and in our minds let us make sense of current scenes. Without past experience, no sight or sound would mean anything; we perceive only what we are accustomed to. Features and patterns become such because we share their history" (1985, 86). His reflections on history mirror biological understandings of memory as no less than "the glue that holds our mental life together. Without its unifying power, both our conscious and unconscious life would be broken into as many fragments as there are seconds in the day. Our life would be empty and meaningless" (Kandel, Dudai, and Mayford 2014, 163).

History is collective memory built from the mechanics of personal memory. Films about the past speak to personal, communal, national, and global identities. They lean into the delights and mysteries of time travel while engaging in the serious business of reinterpreting the present through a reframing of the past. Curiosity and concern about the present propel the pursuit of history, filtering data from the past through the shared knowledge, beliefs, and values of a contemporary environment and culture.

History's power and allure lie in the attempt to discern our own future by recounting what happened to others, others whose futures we know. As Arthur Danto explains, the future of those chronicled in histories belongs in our past, and therefore "historical consciousness is a matter of structuring our present in terms of our future and their past" (1982, 17); crucially, then, the historian "has to know things his characters, who may be chroniclers to the same events, do not know: he knows how things came out" (27). Through this understanding, we grasp that history is not a failed empirical science. The historical method pairs evidence of an irreplicable string of events, often social phenomena, with retrospective inquiry and reasoned analysis. As philosopher and historian R. G. Collingwood suggests, "We do not move . . . to a past world; the movement in experience is always a movement within a present world of ideas" (1956, 154). The present is why the past matters. The future matters because it will become the present. Interpreting the past is the only way to understand our contemporary moment and conceive what the future present might be. All histories preserve and restore, read through the future of the past (Lowenthal 1985, xvi, 211).

Historiography Begets Historiophoty

Is the historiographical method the business of filmmakers and film scholars? Frank Ankersmit contends that it is the responsibility of historians to design their own methodology and practice and of philosophers of history to consider what is at stake, determining these roles as separate, composed of experts who should not "meddle" with one another (2012, 118). But ought theory and method not be more intertwined? Could they be in dialogue instead of speaking over and past each other? Each has much to offer the other. Some meddling and friction are necessary to break through methodological barriers and blind spots to spur creativity, scholarship, and praxis.

Other philosophers of history argue that a vigorous exchange between history and philosophy benefits both. Collingwood declares that this intermixing is so crucial that the disciplines of history and philosophy should be bound within the training of one person (1956, 7). I take Collingwood's view with the caveat that it need not be combined within one person but should be brought into dialogue by a collective, invested in various ways with the product of history via moving images.

Mia E. M. Treacey points out that film is often left out of the conversation in history (2016, 1). Likewise, while historians often pay scant attention to their practice as plied in moving images, dismissing it as mere entertainment, theories and methods of history are equally peripheral to many film practitioners. Rosenstone notes that since we cannot expect filmmakers to engage or propose theories about film, we cannot ask them to engage theories of history (2012, 23). And yet, these historians, professional and popular, are imbricated whether they acknowledge it or not. As Sobchack explains, "There is a dynamic, functional, and hardly clear-cut relation that exists between the mythological histories wrought by Hollywood cinema (and other visual arts) and the academic histories written by scholars. They co-exist, compete, and cooperate in a contingent, heteroglossic, and always shifting ratio—thus constituting the 'rationality' of contemporary historical consciousness" (1997, 4). Moving image media is too cogent and history too formative for either camp to ignore. This calls for historiophoty, as proposed by Hayden White (1988).

The status of the study of history in moving images often seems precarious, suspended between the disciplines of history and film. In 2001, Rosen argued that history in moving images had not been approached as a "subdiscipline" but only as a "topic," which had stunted the evolution of a "historiography *of* film" (xxii). Five years later, Rosenstone referred to the study of history and film as a "subfield" and elsewhere as a "field, (or subfield or sub-sub-field) in search of a methodology" (2006b, 159; 2006a, 165). In the intervening years, Rosenstone has noted a shift as the study has grown into a subfield, perhaps on its way to becoming a field, with the balance of scholarly attention shifting from historians to film theorists (2023). And yet, the search for a methodology seems to be ongoing. It is here that this book aims to contribute.

White's term has been slow to gain traction as a concept with a clear meaning. He proposed the term as a parallel to historiography, asking how we might compare "'historio*photy*' (the representation of history and our thought about it in visual images and filmic discourse) to the criteria of truth and accuracy presumed to govern the professional practice of 'historio*graphy*' (the representation of history in verbal image and written discourse)" (1988, 1193; italics in the original). In the interim, the word has garnered some attention, popping up sporadically in essays and books, but it has evaded a full and standardized definition. Its most frequent function is as a blanket term referring to films about the past or the study of them. But *historiophoty* is not merely a synonym for "history films," just as *historiography* relates to *history* but is not interchangeable with it.

The philosophy of history considers the question "What is history?" It simultaneously addresses *why* and *how*. A central concern of historiography is the methodology by which historians access the past. Leopold von Ranke established the historicist approach that values archival research and primary sources, a historical practice whose methods remain in use. Robert Berkhofer explains that historiography refers to (a) hermeneutics, the writing of history with a critical approach to sources; (b) histories of historical writing; and (c) theories of historical writing, pointing out that the third is often willfully ignored by academic history (1998, 227–228).

In his work of historiography, *That Noble Dream*, Peter Novick laments the confusing, multiple meanings of the term. In a footnote, he explains that the utilitarian word *historiology* had fallen from favor, replaced by the overladen term *historiography*, a word forced to supply too many meanings. *Historiology* signifies the science of history, its theories and its methods. Novick writes that in the same way that biology differs from biography and geology from geography, *historiology* is useful as a term, demarcated from *historiography* with a related but distinct focus (1988, 8). At times, it is more economical to refer to all aspects of historicizing subsumed within the word *historiography*, a catchall for the concerns and contexts of history as a discipline. In other instances, the term *historiology* is helpful for its precision and attention to the philosophies and practices that organize and direct this vital human impulse. Given this definition of *historiography*, *historiophoty* should attend to (a) theories, (b) methods, and (c) histories of the form. While a and b relate to historiology, all three comprise historiography. This book specifically attends to the ways historiophoty reflects historiology.

My goal is to contribute to the concept of historiophoty by translating ideas that inform, guide, inspire, and infuriate historians who work in words. To do this, I carve out the specific subset of historical films that function as audiovisual analogs to traditional history to propose five principles of historiophoty applied to a varied set of works. This book will not address the third branch of historiography by cataloging the history of the history film. That epic project, topic enough for a book-length study in its own right, has been undertaken to

great effect by Jonathan Stubbs in *Historical Film: A Critical Introduction*. Historiophoty includes the history of the reception of historical films, as authored by Treacey in *Reframing the Past: History, Film and Television*, which focuses on academic circles within the Anglosphere. Nor will I recommend an assortment of formal or aesthetic strategies for filmmakers, an overstep comparable to telling historians how to construct their sentences. I hope to infuse the concept of moving histories with the spirit of cross-disciplinary respect for the expertise of all those in its web: historians, philosophers, film theorists, filmmakers, and spectators. As vital as historiophoty was when White invoked it in the late twentieth century, it is more crucial now in our screen-saturated age, at a moment when our understanding of truth, representation, and the role of narrative in accessing the "real" is being reappraised in scholarship and popular culture. When history first emerged, it was oral and ephemeral—fleeting. Then history was written and static. Now it moves.

The Capture and Manipulation of History in Sound and Light

The popular history film has always been, and continues to be, a ubiquitous, powerful, and persuasive form of national identity formation and vehicle for propaganda, whether aimed at mythmaking, morale-building, or critique. For this reason, these films are significant as more than artifacts of popular culture. The lines between personal, poetic, and mythic histories have traditionally been drawn in different ways across cultures, forming a historiographical heritage that reveals history's many purposes and uses, from searches for origins and meaning to tools of political learning, entertainment, social cohesion, and control. The historical impulse begins everywhere in religion and folklore and evolves over time to make assertions about politics and morality. Histories have always embedded their authority somewhere, whether in the divine, the state, or institutions of social and public trust.

Moving histories deliver compelling and mesmerizing multisensory experiences with the capacity to reach broad and mixed audiences. Their power is expressed by Marc Ferro as he writes that "with the passage of time, our memory winds up by not distinguishing between, on the one hand, the imaginative memory of Eisenstein or Gance, and, on the other, history such as it really happened. Even though historians seek to make us understand and artists seek to make us participate" (1988, 73). This sense of participation leads to the curation of our very identities. As Rasmus Greiner points out, mainstream history films "determine which narratives enter popular historical consciousness" (2021, 192).

Historical aims, methods, and media have forked several times, from oral storytelling to the agricultural accounting practices of governments to histories of political manipulation to the entertainment of the novel and later to scholarly history. Moving pictures as a medium developed in the wake of the establishment of history departments at universities. They are a technological variant of our ancestral practices of the light-and-shadow play of history by the campfire.

Academic texts are a historiographical aberration—and an important one. A profound moment in the history of history was its canonization as a profession. Although history within the academy is the upstart and deviation, its methods and concern for proof have much to offer the moving history.

Although, in the interest of depth of thought, there is an important place for theorists to work unencumbered by the distractions of real-world practices, there is also great value in the exchange between theory and practice. Far from being an irrelevant distraction, theories may be fonts of creativity. Familiarity with contemporary thought about historical thinking contributes to the profundity and subtext of historical projects regardless of medium, pushing inquiry deeper than accuracy and period detail. While it is not reasonable to expect filmmakers, juggling the concerns of business and art, to be deeply versed in theoretical arguments associated with historical narratives, this does not mean that the craft could not benefit from theories that reflect upon the dynamics of historical truth.

Many critics of history decry its storytelling function as proof that history has more in common with fable than science. In this view, history is not empirical or provable but the layering of biased perspectives embedded within the power and hierarchies of documents and archives. As Janet Staiger explains, "Anything other than a virtual copy of the real event must emphasize certain aspects of the events and neglect others, and thus produce both drama and a point of view" (2000, 212). She further cautions that history's mission "to describe such unrepresentable events through a more traditional, linear narrative" cannot help but "produce a fetishism of the event" (211–112). Such appraisals raise doubts and look the limits of knowledge in the face but do not recommend the abdication of historical inquiry. Less charitable skeptics focus on history's reliance on the blunt tool of language that is further contaminated by narrative. In this pessimistic view, history cannot cover the scope of actuality because there is no singular way to understand and explain an event.

Collingwood attests that the futile drive toward an uncontestable, pure truth is a hangover from Plato and his substantialist argument that there are real, true things and that there is a "timeless truth," as opposed to the Sophist conception that truths are relative rather than eternal, an orientation that damns our quest to understand our changing world of perception as mere "pseudo knowledge" (1956, 22). Indeed, more recent, postmodern critiques of history seem to emerge from the same nihilistic frustration of the crushed utopian. Given the inaccessibility of a pure truth of social reality outside perception, a defeatist impulse arises that seems to suggest that without an empirical route to a testable and replicable historical truth, we should divest wholesale from historicizing—as if we could.

Hayden White burst onto the academic scene in the 1960s as a key critic of twentieth-century history. As a trained historian whose dissertation explored the papal schism of 1130, this was a call from inside the house. White posed a

challenge to history, whose tempered rejection ultimately strengthened the practice. It is fortuitous for the study of history films that he was drawn into contributing directly to the topic twice (1988; 1996), particularly in the first instance, proposing the term and concept of "historiophoty" to manage our engagements with historical truth in moving images.

Defining Historiophoty

In "Historiography and Historiophoty," White asks whether historiophoty can "adequately convey the complex, qualified and critical dimensions of historical thinking" and proceeds to impart his confidence that it can, in part due to the low bar he sees held up by scholarly history (1988, 1193). He argues that "imagistic evidence" should not be viewed as a mere supplement to written history or as something subordinate to be analyzed with tools devised to grapple with history in words but ought to be understood on its own terms (1988, 1193–1194; 1996). Although White proposed the concept, he did not dedicate much of his future scholarship to its development (2008, 83). When asked about historiophoty in a personal email correspondence sent months before his death, he cordially explained that the essay in which he proposed the term and broader project "stretches my knowledge of cinema to the limit," and he recommended Vivian Sobchack, Frederic Jameson, and Bill Nichols as better placed to consult on it (2017).

The first issue for historiophoty is to examine and defend the word itself. Its pronunciation can be tricky, as it is not instinctively clear upon which of its many syllables to place emphasis. How to approach this word with the tongue resulted in a humorous dustup printed in *Cinéaste* in 2007, when historian Louis Menashe invoked the term, calling it "unfelicitous" [sic] and unnecessary as an alternate term for *historiography* in a book review of Rosenstone's *History on Film / Film on History* and Denise Youngblood's *Russian War Films* (2007). In a subsequent response published in the journal, White notes that he found Menashe's review "informative and instructive, but [he] was disappointed (though not 'hurt') by [Menashe's] anti-intellectualist aside" in criticizing the term, further hazarding that Menashe "must have meant to say 'infelicitous'" before explaining precisely why it is a necessary term and *historiography* will not do in its place (2008). He writes that he "coined 'historiophoty' precisely because a filmic representation of the past or of history is not 'historiography' (or history-writing). And to call it such is to set up false expectations about what one is likely to find in a filmic as against a written 'history.' I suggested 'historiophoty' . . . the representation of history in light images in order to suggest the difference between a written and an imagistic presentation of the past or of history (which are not the same things at all)" (83).

Here, White shares the etymology of the term as coming from the "Greek phot(o)," meaning "light," and says that his "aim was to propose a way of getting film theory out of the bind of trying to treat photo-cinematic representations

of history as equivalents of written representations thereof" (2008, 83). Guy Westwell notes that although the word *historiophoty* is somewhat "unwieldy" and "difficult to say," it is nevertheless "*the* vital term because it insists that film is only one of any number of visual discourses that work *in concert* to shape historical consciousness" (2007, 578; italics in the original). With its necessity as a designation defended, White's neologism may be further credited as an elegant and evocative portmanteau that is perfectly felicitous when understood and pronounced correctly without a hard "o" in the middle. *Historiophoty* should be pronounced /hiˌstôrēˈäfəˈtē/ not /hiˌstôrēˈō fōˈtē/. Like Menashe, I thought the word sounded clunky until a historian suggested to me that it should sound like *historiography*.[1]

The term has been so underappreciated and underused that it is typically only encountered in print and is rarely uttered. This book seeks to change that, strengthening, delineating, and furthering a definition of *historiophoty* for moving histories that responds to historiography, as White urges, to deal with the "imagistic" as "a discourse in its own right" (1988, 1193). The assertion brings forth a series of further questions. How should historiophoty be construed? How might it apply to mass appeal and mainstream moving images? To whom should it matter? Which guiding theories and methods that have informed history are relevant? What are the advantages and disadvantages of history in moving images? All will be considered here.

It can be taken as a given that we are beyond any debate about whether moving image media is appropriate for history. More than a hundred years into histories concocted in audiovisuals, its suitability to the purpose is irrelevant. After all, any mode of narrative communication will become a vehicle for history. Histories will be made in moving images whether or not historians or others consider the medium ideal and fit for purpose. Recent work, such as film theorist Eleftheria Thanouli's *History and Film: A Tale of Two Disciplines* (2019), makes the case that when it comes to history in moving images, the time for lobbing shots from behind the disciplinary barricades of history or film has passed. She takes decisive steps toward building a historiophoty, applying Hayden White's detailed framework of historiographical analysis from *Metahistory* to the realist history film. Thanouli argues that historiography and historiophoty are more alike than different, defining the relationship between history and art by proposing a method that unites film and history's terms, concepts, and poetics through a philosophical perspective inflected by theories of history and film (ix, 71, 100, 236). I share Thanouli's admiration for White's contribution to historiography and her understanding that historical films form a genre of the real that cuts across and unites documentary and performance renditions.

[1] Thanks to Robert L. Nelson.

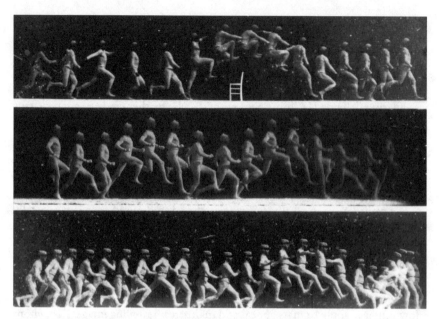

FIG. I.1 Any medium for storytelling will become a medium for history. Cinema pioneer Étienne-Jules Marey's studies of movement as captured by his chronophotographic camera in the 1880s. His invention contributed to the development of the technology of moving histories.

Historiophoty as Historiography of Affect

In *Visions of the Past*, Rosenstone calls for a set of "rules" to evaluate historical films, separate from those crafted for written history, an undertaking that he stipulates requires the expertise of those with knowledge of this complex medium (1995b, 15). When analyzing historical truth claims, we must always ask whose interests are served and remind ourselves how different the incentives are for academic historians versus screen-based historians. Whereas scholars aim to publish in esteemed presses to win the praise of specialist peers, most filmmakers need their work to achieve broad appeal. One emerges from a resolutely solitary practice, privileging new interpretations and popularity within small, rarefied circles of prestige and recognition; the other comprises creative authors, budgetary officers, casts, and crews tasked with animating the conflicts of another age.

Historiophoty concerns historicizing in moving images, and with it, the conduction and manipulation of human emotion. Carl Plantinga points out that a filmmaker's primary goal is to masterfully "elicit and manage spectator emotion" (2009, 130). Histories in moving images manifest what Greiner calls "histospheres," affective "model historical worlds" that audience members enter into so that they may "audiovisually perceive" and "physically and sensuously live" (2021, 49). Histospheres build upon "existing embodied memories

and conceptions of history . . . producing personal experiences with identity-forging potential" (152). Greiner's focus on cinematic histospheres excludes documentaries except in the case of "modal shifts" in the form of interstitial ruptures and interventions of documentary excerpts or acts inserted into scripted, performance-based works (170). As an example of the latter, he cites the killing of a rabbit in *The Rules of the Game* (1939). Although he proposes the histosphere specifically for "historical *fiction* films," stipulating that it cannot be "tacked onto" documentary (2021, 3; italics in the original), the concept describes the affective experience of the historical storyworld that also informs thinking through the effects of documentary renditions of the past.

Moving histories devise histospheres, a particular version of the historical storyworld that engages our bodies as affective units and our brains as prediction machines that operate by creating imagistic sensory models (Damasio 1994, 83–252; Zacks 2015, 27–69). In this space, films intermingle with our memories, becoming entangled with our very sense of self. They provide an experience, a cruise-control matrix, inspiring interior story models with concrete meaning and narrative perspectives. Thus, Plantinga describes films as delivering "an experience of social reality that is closer to conscious experience than perhaps any other art form" (2018, 186).

Entering the Histosphere

Moving histories tell by showing, while written histories show by telling. Monika Fludernik explains that mimesis creates an environment, whether historical or fantastical, a model storyworld built upon the foundation of the experiences of the audience (1996, 37). In nonvisual, oral, or print-based *telling* media, the art direction is contracted out to the minds and imaginations of individual audience members, whereas films usher audiences into virtual realms constructed by mortal world-building masters. Audiovisual communication engages an emotional register that is a superpower of moving image narratives. Filmmakers have refined the recipe for masterful manipulation of audience immersion and affect over the decades. When the evidence of history meets contemporary moving images, the data of the past is forced into a formula of preset genres, story structures, and run times. Conflict and drama must rise exponentially. Protagonists must be relatable and, in the case of performance films (see Figure I.2), played by bankable movie stars. Nevertheless, audiences think they are learning something about the past and the real when they watch history films—even those who tell themselves they are not—as will be explored further in chapter 2. How can we discern fact from fiction while watching a history with which we are unfamiliar? The first step is to differentiate films that revisit and make claims about actual events and people from those that merely use the past as a setting and environment.

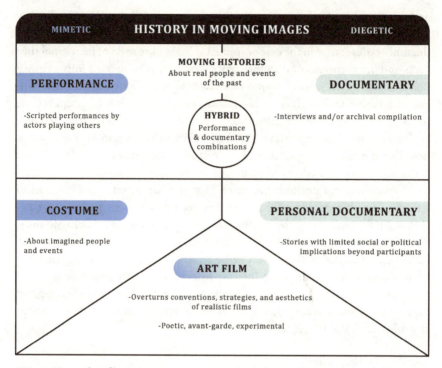

FIG. I.2 The modes of history in moving images. Moving histories occupy the top half.

Moving Histories

Essential to my project of establishing a framework for historiophoty is isolating the works to which it most readily applies, distinguishing moving histories from the dreamy subjectivity of the art film and mainstream fictional renderings set in the past as a backdrop for its aesthetic delights and exoticism. For a start, realism is a defining feature of moving histories; they are realist works that *historicize*, meaning they speak to historicity: real events and people from the past. Moving histories reenact and reanimate the actual past in a manner and with an intent separate from works about imagined characters and conflicts. Distinct from film history, moving histories are *not* works enacted in the present that become historical artifacts over time.

Realism has been described by many theorists as a form of embalming, an attempt to trap time. *Mummification* is a visual and cinematic word, conjuring an eerie and desiccated permanence where, otherwise, almost nothing would remain. John Durham Peters notes that when writing came along, interaction via speaking as a "technique" morphed into writing as a "technology," which is in essence a "taxidermy of words" that "mummifies language" in a manner distinct from the transitory nature of unrecorded speech (2015, 19, 262, 278, 309).

Taxidermy comes from the Greek *taxis*, meaning "to move," calling forth images of the archetypal yellow cabs of movies set in New York City. Since *derma* means "skin," *taxidermy* is literally the skin of past life made to move in the present. Moving skin is a strange linguistic origin for a practice that freezes something into an uncanny stasis, the opposite of movement in life or decay in death; it seems to speak more to the taxidermist's desire than its effect. As Philip Rosen proves, mummification is also an apt metaphor for the history film (2001).

Friedrich Nietzsche invoked mummification to describe and malign history (2019, 20). Nietzsche paints Clio, the muse of history, not as an idealized beauty in white robes, but as a mummy—like Norman Bates's mommy, pickled and confined to the cellar. While acknowledging that there is a purpose for history, Nietzsche attacks the "excess of history," claiming, "We moderns have nothing of our own ... filling ourselves to overflowing with foreign customs, arts, philosophies, religions, and sciences: we are wandering encyclopedias" (24, 45). He describes history as mummifying and thus stultifying.

Building on this theme, Rosen draws a connection between André Bazin's realist film theory as being "congruent with a historicizing cast of mind" and Bazin's claims of the importance of "embalming" to the visual arts (2001, 6). Bazin explains that photography not only represents objects in the context of their time and space, but because its verisimilitude cannot be outdone, it frees other arts from their obsessive quests for realism (2009, 3). Rosen references Bazin's concept of embalming in the context of cinema as "change mummified" in his excellent book of the same name, calling the phrase an oxymoron and also a "trope intertwining the time-filled with the timeless," as cinema captures a slice of time that is unraveled again through and over time (2001, 41). While photography seeks to halt and trap time, to guard a moment against its inevitable corrosion and dissolution, the time-based medium of moving images calls up the past to not only appear but dance. It layers the temporality of a scene depicted over that of its production and time running through the spectators' own fingers. Film breathes life into past events with fully formed evocations of movement, emotion, and light, making it a particularly potent and unique form of revivification.

Film theorist and cultural critic Siegfried Kracauer notes that in both cinematic and scholarly history, there is a "realistic tendency" composed of data and a "formative tendency" that explains that data (Kracauer and Kristeller 1995, 56). Both represent the real, shaping it through narrative. If we accept the parallels between film and history, it follows that film should have theories and best practices for historicizing, just as written history does. Eleftheria Thanouli defines realism as "a set of conventions that determines how and why a sign appears to be truthful and authentic" (2019, 55). Writing about literary narrative form, Northrup Frye explains that the "imitation of nature and fiction produces not truth or reality, but plausibility" (2020, 51). In comparing narrative conventions to visual art, Frye makes the crucial distinction that when the public

admires the likeness of a painting, it is actually for its "likeness to the pictorial conventions it is familiar with" rather than its mirroring of reality itself (132). Over a poorly lit dinner, we adjust to focus on our dining mate. We funnel out distracting sounds to focus on our conversation. Our sense of the reality of any event is channeled through our perceptions. Similarly, film realism seeks to represent real life within cinematic genres and aesthetics of realism, with the boredom and nebulousness of experience wrung out.

Historical works from *O.J.: Made in America* (2016) to *The Terror* (2018) to *Rome* (2005–2007) are eye-popping, polished, and artfully lit realities of Hollywood style or attention-grabbing, viewpoint-soaked montage. Cinema has always been a virtual reality headset inviting us into other people's dreams, summoning audience members into the interpretative worldview of others. Conversely, experimental art films may speak to history, but they resist or question realist conventions. They overturn rhetoric's cart, playing with truth as a notion, asking an audience to think differently about empirical ideals of seeing and knowing.

Antirealist and Avant-Garde Histories in Moving Images

David Bordwell points out that the plot of a classical narrative film "tends to move toward absolute certainty," whereas the art or experimental film projects "a relativistic notion of truth" that highlights the processes of manipulation of the story (1985, 212–213). As a result, as Plantinga describes, experimental films are "*style-centered*" and "replace epistemic concerns with aesthetic ones," and this "becomes the primary subject of the film" (2010, 176; emphasis in the original). These observations demarcate critical distinctions between the effects of history rendered through conventions of realism versus nonrealism. *Historicity* refers to actual events and people from the past as opposed to fiction. Rosen explains that "any *historicity* is realized as a combination of two moments," one being the time in which the history is made and the other being the past and the time represented (2001, 6; emphasis in the original). The distinction between realist moving histories, on the one hand, and experimental or avant-garde renditions, on the other, might be understood this way: realism focuses attention on the moment of historicity that concerns the past, while experimental works draw attention to the moment of historicization and the perspective and crafting of the past in the moment of production. Although those two moments are at play in any history, the hand of the artist is especially foregrounded in experimental works, drawing attention to the interpretive act and highlighting the contingency of any historical claim.

Thus, of the three major categories of film—documentary, fiction, and experimental or avant-garde—it is only the first two that function as popular and widely influential forms of history. As such, they are the focus of this study. The two mainstream film modes may employ reflexive aesthetic strategies of modest nonlinearity or the expressionistic use of audio and visuals, but they

adhere to general conventions of filmic reality, lest they be deemed experimental and consigned outside the boundaries of commercial broadcast, streaming, and distribution networks to art galleries and experimental film festivals. Jeffrey Skoller's *Shadows, Specters, Shards: Making History in Avant-Garde Film* (2005) illustrates how powerful and historiographically rich experimental films are for history. And yet, because they oppose the conventions of realist narrative, they submerge historicity under subjectivity, focusing attention on the artist's aesthetic by foregrounding the act of historicization and forwarding far more qualified and calibrated truth claims.

When it comes to depicting history, documentary and historical fiction offer two distinct rhetorics of the real that form divergent contracts with the world outside the screen. They differ in terms of narrative mode, spectatorial expectation, the performer's remit, the relationship to the real world, and the filmmaker's intention. Putting one's finger on the differences between fiction and documentary seems to become more elusive the more one thinks about it. Their distinctions are impossible to untangle and summarize with complete concision. *Fiction* becomes a particularly vexing word when pressed into the service of delineating works using fictional methods to portray nonfictional agents and events. For this reason, I distinguish the modes of moving history as documentary, performance, and hybrid. The next section details my rationale.

History as a Genre of Reenactment

Collingwood sees the difference between science and history as an investigation of the external versus the internal world. He provides the example that a scientist might ask why a "piece of litmus paper turn[s] pink," whereas the historian wonders why "Brutus stab[bed] Caesar," and thus, the goal of history is not to understand "the mere event but the thought expressed in it" (1956, 214). From here, he concludes that "all history, is the re-enactment of past thought in the historian's own mind" (215). Although we often associate cinematic reenactment with performance sequences inserted into documentaries, in this sense, a history movie performed by actors is one long documentary reenactment. But reenactment is also what interviewees do in a documentary as they think of and talk about the past. In fact, zooming out even further, all creators of moving histories are conductors of layers of reenactment that reverberate out from their own minds. As Collingwood explains, this is also the principal function of the historian, or in the case of moving histories, the filmmaker, who must "re-enact in his own mind the experience of the people whose actions he is narrating" (39).

Only a fictional truth can be considered absolute because it is so individual and ideological; its claims are so different, speaking to the truth of a specific feeling or a general pattern of human behavior. Fiction can, in this way, get at metaphysical truth, whereas historical truth seeks more specific knowledge about the world of perception. Staking claims about the thoughts and motivations of

a nonfictional character can only be provisional. Consider how uncertain and biased our understanding of our own motives is. From here, we seek to understand others. Historical truth is, therefore, always relative, complex, and contestable. It is conditional and carries broad collective concern as it addresses universal and shared realities.

Fiction motors reenactment. As White contends, "All narrative requires fictionalization" (1975, 352). He further asserts that "no other discipline is more informed by the illusion that 'facts' are found in research rather than constructed by modes of representation and techniques of discoursization than is history. No other discipline is more oblivious to the 'fictionality' of what it takes to be its 'data'" (1999, 322). Jacques Rancière crystallizes the nature of the entanglement of history with fiction in his elegant assertion, "The real must be fictionalized in order to be thought" (2013, 34). For these reasons, I suggest that the most productive way to distinguish these two core modes of history in moving images resides in the nature of the on-screen performance, given that there exists no area in which these two approaches do not overlap. It is, after all, the recognition of contemporary actors playing historical agents that functions as the most notable aspect of nondocumentary histories. Jean-Louis Comolli astutely identifies the remarkable incongruity of scripted performances of history that present in the portrayal of a historical agent "at least two bodies, that of the imagery and that of the actor who represents him . . . two bodies in competition, one body too much" (1978, 44).

Distinguishing the Modes of Moving Histories

Extrapolating historiophoty and its principles as an analytical tool requires clarification of what does and does not constitute historicity in moving images. Kracauer asserts that the historian "lacks the novelist or dramatist's freedom to alter or shape his material as he pleases" and "unlike the poet is under the obligation to build from given materials" (Kracauer and Kristeller 1995, 55, 82). To advance a fulsome historiophoty requires reckoning with the processes, functions, and effects of history in moving images. All literate media spectators quickly read a work's stylistic and aesthetic cues to intuit its mode as documentary or not, often interpreting paratextual clues before watching even a single frame. Documentaries operate within a nonfictional rhetoric, while history films and series with actors work within a fictional rhetoric, yet both investigate nonfictional topics. This muddles distinctions between fiction and nonfiction in ways that render them inadequate for the task of classifying moving image histories. Greiner reasons that "due to their referential relation to nonfilmic events from the past, historical films have always represented a combination of fictional and documentary modes of experience" (2021, 170). Nichols calls part 2 of his book *Representing Reality* "Documentary: A Fiction (Un)like Any Other" (1991, 105). Owing to its specific and distinct intersections with the real, historical fiction is

also a fiction unlike any other kind of fiction, to the point that the term *fiction* melts away as an unhelpful designation.

Terms traditionally used to describe nondocumentary, nonexperimental films—including *fiction*, *drama*, or *narrative*—are ineffectual as they offer little to no distinction from documentary. As Nichols explains, the separation "of documentary from fiction, like the division of historiography from fiction, rests on the degree to which the story fundamentally corresponds to actual situations, events and people versus the degree to which it is primarily a product of the filmmaker's invention. There is always some of each. The story a documentary tells stems from the historical world but it is still told from the filmmaker's perspective and in the filmmaker's voice. This is a matter of degree, not a black-and-white division" (Nichols 2017, 12).

Therefore, the most reliable difference between documentary and nondocumentary histories is the intention of the former to represent and speak to the real world through characters performing *in their own identities*. Mainstream documentaries express drama through narrative, and all narratives, fictional or not, rely on processes of fictionalization. One does not refer to nondocumentaries as drama or narrative without offending documentarians or as fiction without offending philosophical and theoretical understandings of the historical method.

Performance as Marker of Mode

Documentaries contain performances. The mere presence of a camera transforms the human behavior before it into a self-conscious act. As Errol Morris remarks, "Interviews are performances. Making [*Wormwood*], I thought quite often about the relationship between a performance and an interview, and a performance by an actor on set where admittedly there's a script that they're following. It's trying to create an element of spontaneity. I sometimes try to distinguish it from, say, taxidermy, where everything is dead—it's stuffed, it's mounted on a wall, versus something that has some kind of life to it" (Seitz 2017).

Nonetheless, it is in the character of performance that we find the most consequential distinction between the two core modes of moving history, a point brilliantly articulated by Thomas Waugh, who explains that "documentary performers 'act' in much the same way as their dramatic counterparts except that they are cast for their social representativity as well as for their cinematic qualities, and they are composites of their own social roles and the dramatic requirements of the film" (1990, 67). Performance in moving histories is either predominantly "presentational," speaking in one's own identity to an audience about a shared world and reality (as in the case of documentary), or "representational," in which people take on other identities (Weimann 2000, 11–17). From my own experience on sets directing documentary and performance works, this is the crucial distinction. In one form, you feel the weight of asking people to present themselves as themselves, releases are signed, and you coax a narrative in collaboration with performers whose

participation is always contingent, subject to their ongoing calibration between the demands of being interesting for the camera and maintaining their identity and the real relationships that they will return to as soon as the recording stops. In the other, actors operate as mediums who enact text from the page through speech and gesture. They are tools with consciousnesses that the director relies upon to conduct emotion and to interpret, channel, and manifest meaning.

In terms of historical films, documentaries offer a narrative address that leans *diegetic*, bringing the author into communion with the audience and enacting a world shared by the maker, performer, and spectator alike. Each character is a social actor, whom Waugh eloquently describes as "acting to play oneself" (1990). While documentaries include performances, they showcase autobiographical expressions of the self, regardless of their level of deception or theatricality. Documentaries present a particular category of performance that aligns with and magnifies our performances of ourselves in our own lives, staged in high school hallways, restaurants, supermarkets, and online. Meanwhile, performance works offer *mimesis*, subsuming the identities of the author, spectator, and historical agent alike into the actor as an avatar, enticing us into a liminal screen-reality world.

The pact of documentary performers is that they present themselves, regardless of the access and transparency with which they reveal their inner truth(s), motivations, and thoughts, as opposed to the performance actor's task to represent someone else (including the winking autofiction of the metaperformers' caricature in which they purport to play themselves, but if you get the joke, not really). For Waugh, representational performance means "acting naturally" versus presentational performance, which he describes as "performing an awareness of the camera" (1990, 68). He describes "not looking at the camera" as a vérité "code" that "preserve[s] the representational illusion" (72). An actor, professional or otherwise, who looks at the lens, makes eye contact with the audience. Although separated in time, like light from space, such an act acknowledges and brings the selfhood of the spectator to the fore. In presentational performances, this counts as connection; in representational works, it marks a profound rupture of the conceit of the enclosed screen world.

While representation versus presentation is one aspect that divides performance, another is scripting. A performance that originates in a script is most often deemed representational, conjuring actors acting as others. The oxymoron "scripted reality" describes a subset of the reality television genre that instantly reveals its reality as fiction and fraud. And yet, the distinction of scripting brings with it its own complications. There are approaches to representational performance that rely on improvisation rather than scripts. In many ways, such improvisation techniques are not so much unscripted as charting an alternate scripting method that springs from a planned outline and recruits performers to write the script through an oral, collaborative, spontaneous, and generative rehearsal process. On the other hand, many documentaries involve scripts. Although the border between documentary and its faux derivatives of mockumentary and reality

TV is theoretically maintained by the contract that only a documentary's voice-over narration or the on-screen director's behavior will be preordained and prescripted, this line may blur in ways imperceivable to the audience.

In moving histories, the past is either mimetic, an imitation performed, as in *Free State of Jones* (2016) and *Harriet* (2019), or diegetic, collaged, and told, as in *Let It Fall: Los Angeles 1982–1992* (2017) and *MLK/FBI* (2020), while other works merge these strategies in more equal measure, as in *Rise of Empires: Ottoman* (2020) and *Wormwood* (2017). Thus, the two core modes of moving history are *documentary* and *performance*, and there is a submode—the *hybrid* that combines the two.

History Rendered by Mimesis or Diegesis

The labels of fiction and nonfiction are not without utility in distinguishing methods of moving histories. They capture an aspect of the distinction between the form and function of the two fundamental modes of presenting history in moving images. Yet the difference is more precisely reflected by the terms *mimesis* and *diegesis*. Performance-based moving histories address the past mimetically through people, landscapes, sets, and props that, whether sentient or not, are cast in the part of a person or object of another era, bringing the spectator into the shared, fictionalized time of a historical world. As mimesis, they present "the world in the present tense, the dramatic feature plunges you into the midst of history, attempting to destroy the distance between you and the past and to obliterate—at least while you are watching—your ability to think about what you are seeing" (Rosenstone 2012, 18). Conversely, documentaries express diegesis, probing the past as passed, in retrospect. In their most common form, historical documentaries intertwine blocks of indexical images with interview sequences that narrate, constructing a story through presentational language. Even a compilation documentary that eschews interviews functions in the same way as an arrangement of presentational imagery that, despite capturing a profilmic present tense, is arranged through editing and reads as speaking to the past in the past tense. Documentaries employing reenactment, whether through animation or performances by actors, mix in mimetic strategies in a similar fashion as André Gaudreault demonstrates that "poets" do, slipping into mimesis whenever they impersonate characters and taking on and performing in the voice of another, rather than referring to characters in the third person (2009, 8–12).

Plato describes the distinction between mimesis and diegesis in a way that applies directly to performance and documentary film when he declares that the poet who communicates "by means of voice and gesture, is telling his story by way of dramatic representation; whereas, if he makes no such attempt to suppress his own personality, the events are set forth in simple narrative [*haplē diēgēsis*]" (1945, 81). A mimetic purist, Aristotle emphasizes that poets should be "mimics" who "say as little as possible in [their] own voice[s]" (2018, 49). Francis Cornford, the translator of the Oxford edition of Plato's *Republic*, further

articulates this distinction in his introduction to the ninth chapter when he explains that in Plato's time, a "Greek schoolboy was not allowed to repeat Homer or Aeschylus in a perfunctory gabble, but [was] expected to throw himself into the story and deliver the speeches in the tones and gestures of an actor" (1945, 80). Since the 1980s, excited teenagers have performed mimesis on the documentary material of their own lives when they drop the phrase "and they were like," signaling a shift in recounting events from a third-person, past-tense, presentational summary to a theatrical amateur impression of another through the performance of a first-person, present-tense, representational reenactment.

Unlike performance films, evolving in a direct line from staged drama, the documentary is a more specifically cinematic form with looser classical antecedents. Its constituent parts were unassembled until the emergence of projection technologies produced magic lantern shows in the fifteenth century that would later combine with lectures and travelogues (Gunning 2008, 10). The author of a performance film speaks through actors in a way familiar to the audience of Sophocles and Aeschylus, whereas the documentarian has less in common with the lecturer or oral storyteller of that age. With recording technology came the ability for the poet or filmmaker to structure an argument in the past tense, not as a second source paraphrase, but by expressing a narrative through quoting, decoupage style, using the audiovisual archive and interview subjects speaking for themselves as themselves. The historical practice of the *xiuhpohualli* ("yearly account") of the Mexica peoples from before European colonization exemplifies a precursor to the third method, the hybrid mode of moving history, in which histories were told from multiple points of view, mixing mimesis and diegesis, presentational and representation performance, past and present tense. In this tradition, skilled historians relayed

> the people's history at public gatherings in the courtyards located between palaces and temples . . . ; in moments of high drama different speakers stepped forward to cover the same time period again, until all perspectives taken together yielded an understanding of the whole series of events . . . generally recounted stories that would be of interest to the group—the rise of chiefs and later their deaths (timely or untimely), the wars they fought and the reasons for them, remarkable natural phenomena, and major celebrations or horrifying executions. . . . Political schisms were illustrated via colorful dialogue between leaders of different schools of thought. The speakers would sometimes even slip into the present tense as they delivered such leaders' lines, as if they were in a play. (Townsend 2019, 4–5)

Despite the accuracy of these Greek terms in distinguishing these two central modes of moving histories, and as a way to disentangle the overlap of hybrid methods in between, the widespread use of the term *diegetic* to reference aspects of a film that are part of the storyworld of the characters may complicate their use to categorize these modes.

Isolating the Historical Storyworld

The logic of fiction and nonfiction further bears on representational and presential approaches to the past as they create distinct models or storyworlds within the mind of the spectator. The theory of possible worlds developed in the 1970s elucidates the workings of narrative by referring to the world created by the text within the minds of its readers (Ryan 2010). The concept offers a useful frame to understand moving histories' modes and effects, which aligns with neuroscience and cognitive theory. A storyworld lives as a model within the minds of its creators and receivers. Jeffrey Zacks explains, "Whether we experience events in real life, watch them in a movie, or hear about them in a story, we build perceptual and memory representations in the same format. It does not take extra work to put together experiences from a film with experiences from our lives to draw inferences. On the contrary, what takes extra work is to keep these different event representations separate" (2015, 110).

Lubomír Doležel uses the possible worlds theory to class storyworlds as nonfictional or fictional. Through this scaffolding, he argues that we may "reassert the status of historiography" as a form of learning or "noesis" whose "possible worlds are models of the actual past. Fiction making is an activity of poiesis: fictional worlds are imaginary possible alternatives to the actual world" (2010, viii). He asserts that part of the nature of storyworlds is that many aspects of the narrative reality are left uncharted and unexplained. These discontinuities reveal the divergence of fiction and nonfiction approaches to narrative as fictional gaps are "ontic" and part of "the act of world making" in contrast to historical gaps, which are "epistemic" and "determined by the limits of human knowledge" (38). He rejects fiction as a route to historical learning as it sidesteps "truth valuation" owing to the

> specific illocutionary character of fictional texts. Fictional texts are performative: they call possible worlds into fictional existence.
>
> Historical texts are means of *noesis*, of knowledge acquisition; they construct historical worlds as models of the actual world. Therefore they are constrained by the requirement of truth valuation. Historical text is not performative; it does not create a world that did not exist before the act of representation. Rather, it is constative, a description of a world that preexisted the act of representation. (42)

Doležel rejects mimesis as a method of historical inquiry, alleging that we cannot learn anything from a history that spackles what is unknown about the past with fictional speculation and "invention" (2010, 51). He labels those who fall for the "bait" of historical fiction as "naïve" and alleges that historical and fictional storyworlds "are clearly distinguished and do not allow fusions" (124).

And yet, such fusions are a dominant source of historical contact. A recent public survey by the American Historical Association found that performance-based histories in moving images are a leading source of "historical information,"

second only to documentaries and ahead of all other forms, including history conveyed through museums, lectures, books, or the internet (Burkholder and Schaffer 2021, 18). When it comes to mass and public history, moving histories reign supreme. As such, we cannot discount them.

If the presentation of the historical past in mimetic reenactment informs a spectator's sense of history, its appropriateness for that purpose becomes moot. Therefore, contra Doležel's extrapolation, possible world theory clarifies how performance-based history functions as a form that operates within and between the mechanics of historical and fictional narratives. Performance histories occupy a broad spectrum between the historical-leaning model of a film like *Oppenheimer* (2023), which evokes real people and events through mimetic and fictive techniques. Conversely, abjectly fictional works draw upon incremental historical data and markers in creating pure fiction and fantasy, as in *Lord of the Rings: The Fellowship of the Ring* (2001). Historical fictions set in a real historical environment about fictional people and situations, such as *1917* (2019), lie between the two. Through this lens, historiophoty emerges as a system of methods and theories concerned with the expression of a historical storyworld, whether it proceeds by mimesis or diegesis.

Documentary Method

In Robert Burgoyne's analysis of *They Shall Not Grow Old* (2018), he invites his readers to consider Peter Jackson's film "as a work of *quotation*, rather than of restoration ... [wherein] intertextuality and interdiscursivity become valid, even necessary frames for reading the film" (2023). This concept of quotation elucidates the documentary method in incredibly insightful ways. Documentaries, like academic histories, proceed by *collage* and *quotation*, arranging primary and secondary materials into a narrative structure supporting a historical argument.

These works of quotation take several key forms, whether they are

1. made entirely from archival resources like *Senna* (2010), composed of archival television footage depicting the Brazilian Formula One driver Ayrton Senna who died in a race at age thirty-four; or
2. interweaving and quoting from contemporary interviews and archival audiovisuals, as in *Mary Two-Axe Earley: I Am Indian Again* (2021), a short film that traces a woman's fight on behalf of Indigenous women in Canada to keep their "Indian status" after marrying non-Indigenous men; or
3. works that combine archival elements with contemporary interviews and performed or animated reenactments, as in Errol Morris's *The Thin Blue Line* (1988) or *Wormwood*.

Performance histories eschew quotation, comprising performed reenactment, an intertext of paraphrase, fictive speculation, and allusion.

Moving History as Genre of Empiricism

Due to the crossover concern with representing historical reality between documentary and performance films, the scholarship of documentary theorists is relevant to both modes. Bill Nichols's contributions to discerning the taxonomies, ethics, and historiographical implications of the documentary illuminate our understanding of the functions and implications of all works that fall into the multimodal genre of reenactment that is the moving history. For example, he writes that any "code of documentary ethics needs to focus on protecting the well-being of two groups: (1) film subjects (whom I have also termed social actors since they act out social aspects of their lives before the camera but are usually not trained as actors) and (2) actual viewers or audience members"; he pairs this with a compelling plea to documentarians to "do nothing that would violate the humanity of your subject and nothing that would compromise the trust of your audience" (2016, 157–158). This spirit should extend to all works of history in moving images, an ethics that should apply to subjects living or dead. Nichols's code informs all five principles outlined in this book.

Nichols's designation of documentary modes—"expository," "poetic," "observational," "participatory," "performative," and "reflexive"—further helps us understand history in moving images as a genre of the real (2017, 149–171). While the poetic mode describes experimental works, all other modes delineate varieties of cinema realism. The observational mode in documentary represents the nonhistorical impulse of capturing the contemporary, profilmic world in the present tense with the promise of little intervention. This style, associated with the Maysles, Frederick Wiseman, and Allan King, eschews reenactment and speaks to the present as proximally as possible. As a documentary approach, therefore, it applies a historicizing function in the arrangement of the edit, but it seeks to address contemporary issues in the act of unfolding rather than from the position of the backward gaze of history. From another vantage point, it is close kin to the representational reenactment of performance films (and documentary reenactment sequences) that call for performances in front of a camera that actors pretend is not there. The observational mode is, therefore, not an approach to history in documentary, but it comprises and describes all performance histories.

Nichols's poetic mode denotes an experimental and art film approach outside the scope of popular moving histories. This is distinct from the inclusion of poetic techniques and interventions in an interstitial manner as a common way to express doubt and historiographical complexity in moving histories, as will be explored in chapter 3. The poetic mode may alternately be called the art, avant-garde, or experimental film. The form resists the traditions and aesthetics of realism, emphasizing subjectivity and contingency as a central focus and concern. It foregrounds "visual and acoustic rhythms, patterns and . . . overall form" (2017, 150). In so doing, this approach avoids the objective truth claims

that are the point and peril of moving histories. They tend to be more lyric, curious, and speculative rather than assertive about what happened, how it happened, and why. Moving histories are works that proceed through documentary or performance-based realism or hybridize these modes to reenact actuality.

Differentiating Historical Performance Films

For a film to be considered historical, it must be set in a specific time and place that accords with the actual world. Even with wholly imaged characters and events, a film like *Gosford Park* (2001) is historical, set within an actual social and material past. Conversely, a series such as *Game of Thrones* (2011–2019) operates within a pastiche of ancient and medieval cultures, materials, and environments, recycling and mashing up historical occurrences crossed with ancient and modern mythologies, making it a fantasy series despite its historical trappings and fascination.

Performance films set in the past that are not about real people or events intersect historiophoty in specific ways, focusing on social and political mores and presenting a tapestry of material objects from a particular time. They populate a historical stage with fictional characters and events that accord with the setting. Many align with what Margrethe Bruun Vaage calls fictional works about "types," imagined emblems that stand in for real people, locations, and situations with "a clear desire to invoke a politically reflective attitude in its spectators" (2017a, 262–263). She addresses historical films, ranging from costume films and historical fiction to what I brand moving histories. Vaage classifies works about real people and events of the past as "tokens," explaining that these films about actuality offer a "double invitation" in which audiences (a) anticipate learning something about history and (b) engage these works by checking them against what they already know about the given history to discern their veracity (258–260).

Many costume or historical fictions about "types," such as *Mudbound* (2017), share the "burden" and earnestness of moving histories, unlike those films placed in the past primarily for its pageantry, costumes, and audiovisual exoticism, like *Atomic Blonde* (2017). Yet despite the occasional intersections of real historical characters and events as supporting cast members, cameo references, or episodic plot points, these kinds of "social reality" films keep judgments of historical agents and actions peripheral to a concentration on social analysis.

A significant appeal of all works about the past is how they speak to contemporary concerns on some level, engaging Burgoyne's concept of "dual focus," in which the past speaks to the present (2008, 10–11). But dual focus and double invitation have separate valences in moving histories that proceed by way of "tokens," which foreground indexicality over metaphor, engaging historicity by constructing arguments about social realities that rest upon real identities, and events. This creates a different pact with those depicted, along with distinct resonances for those who watch.

Vaage explains that the spectator of a social realist work anticipates that "types" will "be true in the sense of being representational or typical of the (real) group that she perceives the work to make claims about. The spectator expects a certain accuracy and authenticity in the type [of] representations" (263). While movies and shows set in the past about imagined people and events are part of the constellation of historical films favored by audiences who crave cinematic time travel, they create a different contract with those seeing them than moving histories do.

Isolating Moving Histories as a Category of the History Film

The five principles of historiophoty require disentangling the threads that tie disparate treatments of the past together, separating moving images about real people and events—the real past—from works merely set in a previous time. Series like *Downton Abbey* (2010–2015), *Halt and Catch Fire* (2014–2017), and *Hell on Wheels* (2011–2016) are not moving histories, despite their narrative and aesthetic powers of time travel and vibrant social commentaries and the intersections of real people or situations in their plotlines, because they are not principally about actual people and events.

Performance works about actuality are retrospective and historical by default, as realist films shape scripts around the beginnings, middles, and ends of unified events, and the time involved in production and postproduction inevitably pushes a story event even further into the past. Documentaries are always, by definition, about real people and events set in our world. Whether a documentary is a moving history depends on whether it

1. focuses predominantly on events that took place before the production phase of the film and
2. represents topics of social or political significance that extend beyond its dramatis personae.

In the digital age, the release of documentaries about current events may have a much faster turnaround than in the analog days of *Harlan County, USA* (1976) and *Kanesatake: 270 Years of Resistance* (1993). For example, *The Square* (2013), about the protests of the Egyptian Revolution of 2011 instigated to ouster President Hosni Mubarak, features a new ending that was updated between screenings at Sundance in January 2013 and TIFF in September of that same year (Anderson 2013). Although all three of these examples are films of great historical significance, as observational renderings of contemporary events, they belong to the observational mode of documentaries about recent phenomena. These works only became historical, like other films on contemporary topics, as they aged. Another variation on the contemporary documentary uses vérité and observational approaches to capture current events, documenting people

dealing with fallout from the past. A documentary like *Prey* (2019) has broad sociocultural resonances, following men who are middle aged and older reeling in the aftermath of sexual abuse by a Catholic priest shunted between Ontario parishes from the 1950s to the 1990s. Films like this are concerned with history but center on the rippling conflicts and resonances at the time of production, melding the historical and contemporary issue documentary.

On the other hand, moving history documentaries adjacent to personal history documentaries are not motivated by understanding an era or sociopolitical phenomenon. Here, the character is not the portal to a culture but the object of inquiry. For example, *Stories We Tell* focuses on the private concerns of the creator and main character, Sarah Polley, and her family. The film is highly influential due to its formal properties and metahistorical approach as a meditation on memory and meaning. The narrative does not concentrate on public aspects of Polley's fame and is only peripherally about her mother as an emblem of the family pressures facing ambitious women in the late 1970s and early 1980s. Had it focused on aspects of the story that have greater sociocultural resonance, it would be a microhistorical moving history documentary. Instead, it offers a detailed portrait of a family drama, and the documentary triumphs as a personal history. Conversely, a film like *What Happened, Miss Simone?* (2015) is a moving history, as it concerns the life of entertainer and public figure Nina Simone, resonating historically for her place in time and the social and political intersections of her life and career. Like academic works of microhistory, such as Carlo Ginzburg's *The Cheese and the Worms* (1976) and Davis's *The Return of Martin Guerre* (1983), the point of these histories is to spotlight the documented events impacting a limited community as a method to uncover the ideas, beliefs, and social mores of a larger culture. Another film of this type is *The Last Duel* (2021), based on the documentary evidence of a dispute between a knight and a squire that led to a trial and, as the title implies, the last government-sanctioned duel in France in 1386.

Within the performance genre, films *set in the past* may be personal histories based on a true story about real people and events of resonance to individuals within the film but of limited political relevance beyond, such as *The Souvenir* (2019) and *Into the Wild* (2007). These works are more accurately described as biographical or autobiographical, though an argument could be made that they are a branch of moving histories. Other films and series are historical fictions, set in a realistic past, primarily about imagined characters and events. Examples of this form include *Raise the Red Lantern* (1991), *Mad Men*, and ᐊᑕᓈᕐᔪᐊᑦ [*Atanarjuat: The Fast Runner*] (2001). These works address the social realist resonances of Vaage's concept of type described previously. They may evoke a realistic past that revolves around historically significant events and imagined characters like *1917* and *Babylon Berlin* (2017–).

The form a work takes, whether it is discrete or serialized, is also relevant to these classifications. Historical performance series, as opposed to short or

feature-length treatments of real people and events, necessitate such a quantity of fictionalized story events and speculation that the storyworld shifts from a historical realm of fictive crafting to a predominantly fictional realm. Series about historical figures, like *Narcos* (2015–2017) and *Vikings* (2013–2020), require such an abundance of fictive imagination, and in the case of *Vikings*, in the face of such a dearth of evidence, they are bound to be far more fictional than historical—even as audiences may draw much of their understanding of a given history from their renditions. This category includes counterfactuals such as *Inglorious Basterds* (2009) and *The Man in the High Castle* (2015–2019).

Moving histories are about real people and events of sociopolitical relevance, like *Selma* (2014) and *How to Survive a Plague* (2012). Being classed as a moving history does not guarantee accuracy to the evidence of the past. They may take sweeping liberties with character and plot, such as *Braveheart* (1995) or *The Great Escape* (1963).

Moving histories depict

- real people,
- real events,
- material and sociopolitical culture,
- events that reverberate beyond the characters in the film, and
- scenes that rely on evidentiary links.

Figure I.3 categorizes films and series within a full range of realist history, distinguishing historical fictions and personal or current-event documentaries from moving histories.

The Five Principles in Five Chapters

With a fuller understanding of what historiophoty is and what kinds of works are most pertinent to it, I will lay out the structure of the book and each principle. Chapter 1, "Narration," delves into the perspective expressed by history as it goes mainstream through moving images. As theories of history emerge from the other side of postmodernism, we must make peace with narrative and accept that it is not intrinsically good or bad but how we make sense of our lives. What Collingwood writes about history is equally applicable to narrative: the gulf between "principle" and "practice" is not a failing of the discipline but an inescapable reality of existence (1956, 247). As Edward Branigan explains, "Narrative is a way of organizing spatial and temporal data into a cause–effect chain of events with a beginning, middle, and end that embodies a judgment about the nature of the events as well as demonstrates how it is possible to know, and hence to narrate, those events" (1992, 3). This chapter draws upon narratology, historiography, and film theory to propose a poetics of moving history and consider how it can be used to shake loose the narrative perspectives and arguments

32 • Making History Move

Documentary	Contemporary, ongoing events	Retrospective, past events	Sociopolitical relevance	Conflict within limited group
Let It Fall: Los Angeles 1982-1992		●	●	
They Shall Not Grow Old		●	●	
Stories We Tell		●		●
Kanehsatake: 270 Years of Resistance	●		●	
Citizenfour	●		●	
Prey	●		●	
Mary Two-Axe Earley: I Am Indian Again		●	●	

Hybrid	Contemporary, ongoing events	Retrospective, past events	Sociopolitical relevance	Conflict within limited group
Rise of Empires: Ottoman		●	●	
American Animals		●		●
Wormwood		●	●	

○ **Moving History:** Must check both boxes as a historical project, presenting a retrospective point of view and exploring events of broad sociopolitical relevance

○ **Personal History:** Explores a story of significance to a small community or individual

○ **Current Event:** Depicts the unfolding of events in progress

	Main Characters		Story Events in Plot	
Performance	Most/all fictional	Most/all historical agents or composites	Most/all fictional	Most/all historical
Free State of Jones		●		●
Atanarjuat	●		●	
Downton Abbey	●		●	
Da 5 Bloods	●		●	
Once Upon a Time...in Hollywood	●		●	
Judah and the Black Messiah		●		●
Babylon Berlin	●		●	
A Royal Affair		●		●
Deadwood		●	●	
Mad Men	●		●	
Vikings	●		●	

○ **Moving History:** Predominantly non-fictional characters and events.

○ **Historical Fiction:** Historical verisimilitude in art direction, mise-en-scène, and social mores rather than specifics of historical agents and events.

FIG. I.3 Distinguishing moving histories from other historical films in the documentary, performance, and hybrid modes.

that motivate and anchor films about documented events. It also summarizes the plots of the works that will be referenced throughout the book: *Free State of Jones*, *Let It Fall: Los Angeles 1982–1992*, and *Rise of Empires: Ottoman*. Narration will be explored through these titles as case studies of performance, documentary, and hybrid moving histories.

John Durham Peters identifies history as separate from fiction for its use of "corroborating sources" (2015, 353). Evidence attends to how moving histories

account for their sources. Chapter 2, "Evidence," considers the evidentiary proofs of scholarly history to reappraise how they have been translated for histories in moving images. This principle queries how audiences discern fact from fiction, especially while watching a history of a past with which they are unfamiliar. Mainstream moving histories value engagement over accuracy, but they are not always at odds. As Donald L. Miller, a prolific and award-winning historian with experience as a consultant on multiple history film projects based on his own books—including *The Pacific* (2010) and *Masters of the Air* (2024–)—notes, filmmakers tend to make up stories and subplots in histories as a recourse when they have not done their research (2019). Natalie Zemon Davis agrees that this often leads to sloppy storytelling that is far less intriguing than what the record suggests (Davis 2000, 126–131).

Chapter 3, "Reflexivity," explores the ways that moving histories infuse the present into the past to invoke a critical awareness of the distance between representation and reality. While the principle of narration concerns the shaping of historical reflection through structure and the signaling of authorship through the choice of narrative techniques, this principle looks to the philosophy of history to consider ways that historiological theories can be interpreted into plots, casting, mise-en-scène, and the audiovisual language of moving images in moments of rupture.

Chapter 4, "Foreignness," concerns rendering the past in ways that capture the ideas and customs of times that are alien to us. It highlights the impulse of moving histories to cast the past in our own image and the peril of stripping out the strange and alien as it withholds diachronic knowledge of ourselves as a species and flattens much of the richness of this medium as a portal. This principle highlights Davis's directive to "let the past be the past" (2000, 136). When filmmakers elide the foreignness of a given time and place, it becomes more challenging to see our own world clearly and to consider the beliefs and customs that we as audience members participate in that are as fluid and transitory as those of the past.

The final chapter, "Plurality," emphasizes undoing the prejudices and inequities of yesterday and today that are baked into the archives, dictating who populates the stories remembered. In *Beyond the Great Story: History as Text and Discourse*, Robert Berkhofer makes a radical appeal for history that is plural, multicultural, antitotalizing, reflexive, experimental, and local (1998). He seeks correctives to the mythic and modernist impulse to identify with a hero and an individual worldview, advocating that a fuller picture of the mechanisms and meanings of change at the heart of history requires "plural and multiculturalist viewpoints" (190). Seeing the past through the eyes of those with different experiences and levels of historical agency is to take advantage of one of the great powers of stories and histories to broaden our understanding of others and see outside ourselves. As Davis reasons, a film can present "more than one story at once" (1987, 478). Julie Nash, director of *Daughters of the Dust* (1991), points to the lure of the hero as spectators subsume themselves into the role of the

protagonist in films, giving filmmakers an incentive to tell stories about people with agency and power (Rhines 1996, 96). This blurring of myth and history only reinforces prejudices built into the archive and does damage to our sense of historical reality and contemporary belonging.

Together, these principles answer Hayden White's plea to contend with historiophoty. They shape a methodology designed to orient and undergird future theoretical analysis of history in moving images by providing insights into the role and practices of this complex form. I have endeavored to provide a comprehensive approach to historiophoty and these principles. This also means that each chapter provides a survey of the topic of each principle. My goal is to create an overarching schema useful to this field that can be expanded by others, just as my work builds upon the contributions of many scholars across the disciplines of film, history, philosophy, and beyond.

Criteria for the Selection of Moving Histories for In-Depth Analysis

In preparation for the chapters to come, I will extrapolate the framework for my choice of each of the three moving history case studies analyzed through each principle in the book. Responding to current interests in the field, I initially considered a global set of source texts but realized that this approach would be too broad and the project would be diffused by mixing international cinemas and historical traditions. Next, I looked for English-language films or series that represent each of the core modes of moving histories, intersecting several principles in illustrative ways. I sought out works released after 2015 that are accessible both in terms of their target audience and availability. Working within this context, I landed on a wide-release, theatrical Hollywood feature film, a major television network–funded documentary, and a streamer-produced hybrid series, all of which were available on *Netflix* in Canada and the United States at the time of my research and initial writing.

Of the five principles, a primary concern for selection was the fifth, the plurality of representation of characters and their interests. The selected texts include two U.S. productions and one U.S.-Turkish series. The sheer amount of work created in the United States for mass audiences worldwide and the cultural and ethnic diversity of its citizenry made it a very fertile source from which to draw. Another goal was to select one or two female filmmakers, but at this point in history, the number of such filmmakers making moving histories remains confoundingly rare, leading to a very small sample size.

In selecting core texts, my primary concern was to isolate works that accord humanity and sympathy across a diverse group of people through the expression of the work's narration, its argument, and its perspective(s). Key criteria included the following questions:

SELECTION CRITERIA FOR CASE STUDY TEXTS

REPRESENTATION OF DIVERSITY IN:	PERFORMANCE Free State of Jones	HYBRID Rise of Empires: Ottoman	DOCUMENTARY Let it Fall: Los Angeles 1982-1992
Age	●	●	●
Class	●	●	●
Ethnicity	●	●	●
Nationality		●	
Physical Ability			
Race	●	●	●
Religion		●	
Sex/Gender	●	●	●
Sexuality			●

FIG. I.4 The range of characters (re)presented and humanized in the case study moving histories in this book.

- Is the work liberal in its concerns, extending curiosity and compassion to a variety of groups of people?
- Does the text observe Davis's fourth injunction, channeling the Annales historiographical approach, to seek understanding rather than judgment?
- Is the exploration more than a pure act of presentist litigation, meting out praise and shame along contemporary political lines and values? Does it, instead, seek to illuminate fundamental aspects of human behavior within a historical context, furnishing a fuller comprehension of history to teach us meaningfully about ourselves?
- Are primary and secondary characters defined as whole human beings outside of their character function in relation to the protagonist?

All works chosen excel for the range of characters accorded agency and sympathy. While *Free State of Jones* caricatures members of the Confederate elite, it presents a wide scope of interest, from poor Southerners forced in various ways to support and participate in the Civil War to the plight of the enslaved and formerly enslaved to women and children. Another key strength of the film is its novel and concerted approach to evidence and citation, which will be explained in detail as part of the principle of evidence in chapter 2. This aspect of the film's paratextual package was a crucial reason that I chose it for in-depth consideration. After all, evidence is the essence of what separates history from fiction, art, and propaganda. Furthermore, "history is not the past as such, but the past for which we possess historical evidence" (Collingwood 1956, 202).

I selected *Let It Fall: Los Angeles 1982–1992* (2017) for the plurality of voices included, the care and complexity of its arguments, and the even-handedness of John Ridley's direction. The pool of options in selecting a hybrid moving history was limited. *Rise of Empires: Ottoman* season 1 was selected for the range

of characters it portrays, spanning class, sex, nationality, ethnicity, and religion, and its extraordinary management of empathy across two empires at war. This book references each of these works in the context of every principle and chapter as a case study for each mode. It is not necessary to view all or any of these texts to grasp the analysis, as each will be described in detail to situate the reader so they can apprehend how the five principles apply to any moving history as an integrated system of analysis.

The Historical Legitimacy of Moving Histories

Historian Eric Foner asks a crucial question for historiophoty in an interview he conducted with director John Sayles. In a revealing exchange between the acclaimed historian and venerable director, Sayles stresses the "struggle" that erupts when filmmakers want to depict an authentic history but funders compel them to alter the facts to make it more exciting (Foner and Sayles 1996, 15). Sayles then equivocates and adds that filmmakers are more concerned with the "spirit" than the facts. Foner objects to this and asks why, when filmmakers intentionally change the known facts, they do not "present it as a historical fiction" (16). This is a crucial question for the historical ethics of historiophoty. What Foner describes is the antithesis of history and the essence of fiction. We may critique histories for blinkered arguments and faulty research and arguments, but willfully changing the data surely ejects a work from its status as history.

Sayles counters that there is power in history. While demanding changes to history to make it more marketable, producers also insist on the "based on a true story stamp" because "it brings legitimacy to the audience" (Foner and Sayles 1996, 15–17). Legitimacy on these terms is an abuse of history's power. These films trade on the value of entertainment bound up with the impression that they are presenting a depiction of the real. The exchange highlights the greatest chasm between the pressures set upon historical truth in academic history versus commercial cinema. As Hayden White stresses, the meaning of a story or history is constructed and expressed through its plot, and further, in an echo of Aristotle in *Poetics*, White underlines that what separates history from the novel is that the historian is not free to "invent the events" (White 1990, 173; Aristotle 1997, 81).

Moving histories make many historians nervous. Historian Pierre Sorlin points to the issue of history films as a genre and medium caught between two worlds, "defined by a discipline that is completely outside cinema" that furnishes "no special term to describe them" (1980, 20). With striking visual aplomb, historian Mark Carnes writes that history, the way film tells it, "fills irritating gaps" and "polishes dulling ambiguities and complexities" until a film "gleams" and "sears the imagination" (1996, 9). He speaks to the looseness with which films often depict historical events, not letting the facts get in the way of a good story and their profound sensuous impact. Warning of the business and capitalist influences exerted by the film industry on history, Janet Staiger explains

it is ultimately a benefit to the enterprise that those with diverse skill sets and interests are making histories (2000). Beyond this, she advises film studies to take an interdisciplinary approach and look to academic history because to do otherwise would be "to work with blinders on" (127). This book contributes to the work of others in history and film studies who have torn off those blinders and worked across disciplinary boundaries by synthesizing their work into a historiophoty. What history should see in film is a mass platform and potential partner in the historicizing mission. What film should see in history is a wealth of thought about methods and meanings that could inspire new audiovisual approaches and techniques, thereby enriching cinematic renditions of the past.

Writing offers a depth of analysis unparalleled by other media. Meanwhile, moving image media provides new outlets, insights, and audiences. The five principles of historiophoty crystallize the subfield of moving history by surveying, engaging, and incorporating theories and philosophies of history as part of its mission. Such an exchange requires openness. The faithful guardian of history, like the mother of King Solomon's baby, is less interested in ownership than what serves and nurtures history's purpose. Although academic history's prized goals of quantity and quality of data, the uncovering of new records, and offering novel analyses and interpretations do not play to film's strengths or concerns, the values that guide historiography compose a heritage and an ontology of the act of historicizing that belongs to the process rather than a single medium or professional class. Recording is essential to our modern understanding of history as newspapers, books, school curricula, museums, websites, and moving image media recount and renegotiate the past. If we accept that every communicative medium will be used to address the past and that film is an active medium for history, then a more comprehensive understanding of historiophoty is necessary. Speaking to the interdisciplinary tug-of-war at hand, Rosen states that "formations of historicity are not limited to the products of an elite occupational caste called historians" (2001, 46).

Despite these sentiments, it is likely that filmmakers would most vigorously resist the notion that theories of moving history are relevant to their efforts. However, to set about historicizing in such a popular, compelling, and ubiquitous medium as moving images, one that already assembles a large cast and crew of artists and technicians, and to only draw on historians' expertise for their imprimatur rather than looking in a more profound way to their theories and methods is to arbitrarily shut down a rich and evolving source of artistic frisson and inspiration. Just as a film's attention to artful shadows does not mean the gaffer or cinematographer alone controls the light, attention to historical evidence and methodologies does not mean abandoning history films to academic auditors. The filmmaker's ability to interpret recorded historical events remains vast. Appropriating and considering the theories and philosophies of history for moving image media, far from foreclosing artistic possibilities, should instead be seen as a fertile source of new ideas, approaches, and resonances.

1
Narration

● ●

How is the meaning of a moving history shaped, communicated, and interpreted?

The first principle for assessing moving histories is narration. The most complex of the five, it articulates the authorial perspective of history through formal modes, genres, and aesthetics, expressing ideology and meaning. Narration comprises a taxonomy of formal and artistic characteristics across moving histories' documentary and performance modes. This chapter interrogates moving histories as a form of rhetoric and lays out a detailed poetics of narration through an understanding of moving histories as an influential form of fact-based (or fact-adjacent) storytelling.

The first concern of the principle of narration is whether we can reliably understand the past via narrative. Offering a pessimistic view of history as a form of knowledge, philosopher Alex Rosenberg scoffs at the desire to know another's motivations and points to this very intention as proof of history's inefficacy and hopelessness as a form of knowledge or way to navigate the present or future. In his book *How History Gets Things Wrong: The Neuroscience of Our Addiction to Stories*, he argues that "natural selection contrived to make our early ancestors (and thus now us) from mind-readers into hyperactive agency detectors as a quick and dirty solution to the design problem they faced in trying to survive on the African savanna. It worked well enough right through the end of the Pleistocene and into the Holocene. But, as a predictive tool, it became blunter and blunter as human culture and its institutions developed, with its usefulness pretty well plateauing out sometime after agriculture and writing arose" (2018, 215).

But how does he suppose people orient themselves or think on the scale of the sociopolitical? His book suggests they ought not bother. He lionizes science,

denies narratives within it, and advocates wiping from the shelves of history any work not crafted in the image of Jared Diamond's indisputably excellent *Guns, Germs, and Steel*, suggesting that history ought to be understood as a genre of literary fiction (1999, 219–224).

Speaking to earlier critiques of narrative that found their way into science, Peter Novick recounts nineteenth-century efforts to avoid bias as scholars attempted to proceed with experiments via observation only, without a hypothesis that preconceives and thus distorts and narrativizes findings. In response, he quotes Charles Darwin's private writings about the idea of scientific experiments undertaken without the influence of a hypothesis. Darwin wrote that this would result in experiments in which geologists look at pebbles and limit themselves to describing the colors (Novick 1988, 36). Although narrative frameworks and a priori hypotheses influence findings, they are as necessary for historical inquiry as they are for empirical experiments. To find answers, we must ask questions. To ask questions, we must have a point of view from which to orient ourselves. This is just as well since we cannot free ourselves from viewpoints, and those who claim that they have only signal their dubiousness as sources of opinion or information. Through the attempt to understand the intentions and actions of historical agents, we seek to learn from the past and interpret patterns in the present, knowing they will never offer an exact match. Historical interpretations, considered together, teach us about ourselves as a species, what motivates us, and where dangers lie. The maker of a moving history expresses a point of view by climbing inside each character to interpret a person's goals and values through words and acts. The enterprise requires flexibility and critical thought from makers, actors, interviewees, and spectators. We must read the characterization of agents as tentative and speculative.

Living through the reverberations of postmodernism is to experience history as meaning both nothing and everything simultaneously. It is no more than the taped-together shards of narrative built by privilege, commandeered as a tool of power, and no less than a vital explanation for every material and social circumstance in the present, a scorecard that binds all outcomes. The premise of this book is to demonstrate that, contra these polar ideas, history is essential because, as R. G. Collingwood writes, "its teachings are useful for human life; simply because the rhythm of its changes is likely to repeat itself; the history of notable events is worth remembering in order to serve the basis for prognostic judgments, not demonstrable but probable, laying down not what will happen but what is likely to happen, indicating the points of danger in rhythms now going on" (1956, 23). Or as Northrup Frye eloquently states, "The preoccupation of the humanities with the past is sometimes made a reproach against them by those who forget that we face the past: it may be shadowy, but it is all that is there" (2020, 345).

A wise generation, like a wise person, learns from the mistakes of others. History offers a macro psychological study of human impulses, actions, and

reactions, a catalog of past conflicts and their results. It teaches us about the disasters and triumphs we are capable of so that we may learn from them, reform, course correct, and progress. Deconstructing the formal and narrative components of moving histories, the subset of realist historical films about actual people and events, allows us to step away from the lure of their convincing constructions and consider how this art-entwined amusement historicizes. Moving histories constitute a profound and impactful offshoot of historiography, bringing history's lessons to the many, including those who do not identify as historians in any way, neither professional nor amateur nor hobbyist. As Tzvetan Todorov explains, "The narratives that all society seems to need in order to live depend today, not on literature, but on cinema: filmmakers tell us stories whereas writers play with words" (1990, 38). Moving histories are the material apotheosis of the historical impulse to enchant, transport, challenge, and inform. It is their role in informing that inspires much of the interdisciplinary dialogue within the subfield of history in the moving image.

Although moving histories lack the strengths of academic studies to equivocate, introspect, and present sweeping canvases of humanity, they interact in ways innate, sensual, and convincing. They matter as a critical source of mass history (Landsberg 2004, 1–2, 9–11). In mesmerizing detail, they map the trajectory of a thin slice of the past from a set position. Resonant and mobile monuments to memory and identity, they incant and manifest a tight tableau, offering a small cast of characters as archetypes, offering faces to read, music to absorb, and images to enter. The narrative aspect of mainstream moving images is central to their popularity and powers of persuasion. As Edward Branigan explains, "Film *narrative* is a way of understanding data under the illusion of *occurrence*; that is, it is a way of perceiving by a spectator which organizes data as it were witnessed unfolding in a temporal, spatial, causal frame" (1992, 115; emphasis in the original). Consider the power that the sensation of witnessing the past has on us. Films are convincing because, as David Bordwell describes, they invite audiences to "make assumptions, draw inferences . . . [and] frame and test hypotheses about prior and upcoming events," constructing "meaning . . . toward unity," in the case of histories, about the real (1985, 34). Moving histories bring the past into play with audiences in both senses of the word.

The author of a moving history articulates perspective through their choice of a rhetorical model, whether mimetic (performance-based), diegetic (documentary), or a combination of the two. Its argument is expressed through its poetics, explored in this chapter through case study analysis from each of the three main tendencies: *Let It Fall: Los Angeles 1982–1992* (2017) as a sample of diegetic documentary history, *Free State of Jones* (2016) as a mimetic performance history, and the first season of *Rise of Empires: Ottoman* (2020) as a hybrid of the mimetic and diegetic approach.

Moving Histories as Rhetoric

Narratives compress or exclude the mundane and expand and draw out details to reveal and revel in what is exciting. For fiction and history, this molding of time is more than the mere manipulation of emotional tension and pacing. It focuses attention on what is meaningful and away from what is not. On top of this, Paul Ricœur describes the concept of narrative as no less than an arrangement of time necessary for human understanding to make sense of existence (2009, 65–71). And further, by isolating and knowing the ending to a historical narrative before undertaking to recount it, the conclusion embeds into the interpretation throughout. Thus, we "learn to read time backward" (Ricœur 1980, 181–183).

What separates the historical genre from *poiesis* or imaginative fiction is not whether the narrative embeds universal themes and meanings; most fictions and nonfictions do that. Instead, histories promise universals articulated through the real, lived experiences of others rather than through freeform crafting by an author. The best fictions consider profound truths, then layer in detail; history starts with the details and searches for the deeper truths they might convey. For Collingwood, history studies actions and events alongside theories about the thoughts and motivations of agents. He describes this as the "outside" and "inside" of history. In his view, for "history, the object to be discovered is not the mere event, but the thought expressed in it" (1956, 214). Therefore, fiction is a kind of truth from the inside out, while history searches for truth from the outside in.

Rhetoric proffers evidence and proof to induce the audience toward a judgment (Aristotle 2018, 5–14, 60). This aligns with the role of history. Dominick LaCapra's advice for dealing with the "strange" project that is history is to explore it as a kind of rhetoric, as a part of a language that engages literary criticism and philosophy (1996, 10, 15, 17). Frye defines rhetoric as always entwining two impulses, "ornamental speech and persuasive speech. These two things seem psychologically opposed to each other, as the desire to ornament is essentially disinterested, and the desire to persuade essentially the reverse. . . . Persuasive rhetoric is applied literature, or the use of literary art to reinforce the power of argument. Ornamental rhetorical acts on its hearers statically, leading them to admire its own beauty or wit; persuasive rhetoric tries to lead them kinetically toward a course of action. One articulates emotion; the other manipulates it" (245).

Consider Frye's description of rhetoric in the context of moving histories like *The Last Duel* (2021), *The Act of Killing* (2012), and *Wormwood* (2017). Then ask yourself, is the narrative captivating, the message cogent, persuasive, and clear? Aristotle claimed that the success of any rhetoric depends on (a) the esteem and trustworthiness of the author, (b) the quality of the evidence presented, and (c) the emotional impact of the argument (2018, 60, 120). Although

moving histories may have credibility issues on the first two counts, the medium is unparalleled in the third.

Mainstream and popular films practice rhetoric through images, music, plot, and dialogue. Music and the narrative arrangement of history function in similar ways in documentary and performance films, as music prompts affect and whispers meaning while plot builds a case. A history documentary channels the voice of its author, whether from center stage or the wings. Documentary reenactments notwithstanding, its imagery is indexical with dialogue spoken by a person whose identity stretches across both sides of the screen. Although subtext may come in the form of imagery selected, the ordering of scenes, or prevaricating speech, documentary language often propels more explicit meanings. Meanwhile, a performance author is a grand puppet master, working through the representational imagery of people, landscapes, costumes, sets, and props that are cast, crafted, co-opted, rented, or bought to play a part. Skillfully delivered performance dialogue, laden with buried and implicit meanings, expresses a historical argument like waves lapping onto a beach.

Poetics of Moving History Narration

The principle of narration deconstructs the formal and aesthetic choices made in the creation of a moving history to isolate and understand how the author crafts meaning. The first and most profound narrative choice for the author of a moving history is the rhetorical mode, whether documentary, performance film, or hybrid. History is, by definition, a nonfiction topic. It may be addressed within the mode and rhetoric of fiction in the performance model or the rhetoric of nonfiction in the documentary model, or it may liberally mix them. While the introduction differentiates the documentary from the performance film, this principle and chapter drill into the implications of those modal choices on the meaning of a moving history.

Mode

All language, all narrative, all history swims in fiction. The residue of our mental processing, fiction is the analog noise embedded as ideas pass from one mind to another. It is the mark of human perspective and meaning-making. As Michael Renov points out, "Truth and fiction have been ironically but definitively aligned. Truth, it has been supposed, depends on fiction, finding its shape and substance through the agency of human invention" (1993, 10). Applying the label "nonfiction" to moving histories obfuscates the complexities of truth as presented in documentaries. Meanwhile, using the term *fiction* for performance films erases the distinction between works about real people experiencing documented events versus those about imagined characters and stories. Moving histories belong to a nonfiction genre that may operate through mimesis, which is considered a vehicle of fiction.

We understand that histories and nonfiction topics include creative speculation alongside the purported facts, just as fiction is inspired in some measure by reality. Real events motivate the best fiction. Further, Renov explains that "all discursive forms—documentary included—are, if not fictional, at least fixed *fictive*, this by virtue of their tropic character" (1993, 7). As Carl Plantinga notes, although documentaries are not "taken as *the truth*," they "assert and imply truths" about "the actual world" (2018, 57; italics in the original). Tellingly, Plantinga's description of documentary applies equally to moving history performance films. The broad labels of nonfiction and fiction associated with truth-telling versus lying, or creative fabrication, blur what separates the two main tendencies of moving histories. In the case of films about the past, the difference lies in (a) how the author is situated in the work, (b) the tense, and (c) the character of the performance. Moving histories dispense the notion of documentary as nonfiction and performance films as fiction. These two core strains are dual flavors of nonfiction storytelling that proceed by present-tense imitation of others in *mimesis* or past-tense telling "as oneself" in *diegesis* (Waugh 1990).

The Author's Position and Truth Status

Is documentary the moving image equivalent of academic history? Eleftheria Thanouli asserts that it is, due to the documentary's "respect for the truth" and aims of objectivity (2019, 173). This is undoubtedly correct as a general assertion. The storyworld of the documentary cleaves much closer to that of the academic history as described by Lubomír Doležel and noted in the introduction. For example, gaps in the nonfictional storyworld are often due to gaps in the record. The compact of documentaries is that they will reflect the actual world and past events and not make things up. But the intention of documentaries to be objective and truthful is not assured. Documentaries may be as biased, drama-focused, and deluded as any other kind of film. More reliably, the similarity between documentary and scholarly history relates to signaling the author's position in relation to the work and its indexicality. According to Gérard Genette, in historical prose, "fictionality is defined as much (or more) by the fictional character of the narration as by the fictional character of the story" (1991, 71). He describes the relationship between author and narrator in "fictional" or "factual" narratives this way: in history, the author *is* the narrator, not a character. Whereas in fiction, the author *is not* the narrator or a character, and the narrator *may or may not* be a character. Therein lies the most profound and undeniable difference between history and fiction: in history, the historian's knowledge is "relative, indirect and partial" versus the "elastic omniscience" of the author of fiction (66–67, 73, 82).

One guarantee that accompanies any "nonfiction," including documentary and historical narrative as opposed to pure fiction, is that the author is not all-seeing or all-knowing. Historians' claims are contingent, contestable, and verifiable. Historians and filmmakers speak from their own identities; often, the

perspectives they promote in their narratives reflect upon them as well as the pasts they recount. Some historians choose to highlight themselves and their positions, furnishing their work with alternate interpretations and even contradictory data. In contrast, others provide a less troubled, more self-assured narrative that eludes invitations into the inner workings of the argument. The author of nonfiction may attempt to read the minds and motivations of the people recounted, but only the creator and commander of the imagined has the power to do it.

All moving histories transmit a perspective, and as such, they are narrated. Robert Burgoyne illuminates this point when he explains that films without a personified narrator, which is almost always the case for performance histories, "seem to present a direct and unmediated recording of events, free of a narrator's colorations and inflections" (1990, 5). This style of film bypasses cognitive tools of critical reception with profound implications. Burgoyne warns that whether perceivable or not, all stories—be they written, filmed, fictional, or historical—are "told," but because this "impersonal narrator" evades our grasp as a source of the film's construction and point of view, many literary and film theorists have argued that stories without a designated narrator reveal events rather than telling them (4). Florian Mundhenke extricates the modes of documentary and fiction in terms of contextual, textual, and paratextual clues. He explains that within the text itself, the distinction

> between the two modes can be seen in two points. First, there is the role of the enunciator (the instance presenting the diegetic reality). In fiction, there is an invisible enunciator. The presence of the enunciator is effaced in such a way that the spectator believes that the world and its events exist by themselves (through continuity editing, non-involved cinematography etc.). With the documentary film there is a real-presupposed enunciator, directly referring to the audience. That can be the director . . . or experts commenting on the events. . . . Second, there is a process of fictivization at work in fictional films. The recipient watches and thus actively constructs and experiences while building a "closed illusion"—also accepting and compensating inconsistencies. . . . In the documentary film there happens, in contrast, a blocking of fictivization. The recipient watches the events as part of a shared reality and accepts the events as they are, since they have happened in real life. (2021, 292–293)

Ironically, mimetic renditions of the past may seem more convincing, even as spectators understand that they are entering a parallel universe of fictive crafting. As Mieke Bal explains, when the narrator is external to the narrative, it "can then appear objective, because the events are not presented from the point of view of the characters. The focalizer's bias is, then, not absent, since there is no such thing as 'objectivity,' but it remains implicit" (1997, 149). She adds that this is "the most important, most penetrating, and most subtle means of

manipulation. Analyses of newspaper reports which aim at revealing the hidden ideology embedded in such reports should involve focalization in their investigation, and not restrict themselves to so-called content analysis, i.e. the semantic analysis of content" (171). This presents a historiographical challenge, especially if we further consider André Gaudreault's point that within the visual language of film, the authorial perspective is advanced *with every change in the moving image*, whether this happens within a shot or between them (2009, 35). Gaudreault asserts that mimetic performance works communicate through showing and the "monstration" of the screen image as the "self-effacement of the author" (55). Consider the implications for moving histories as we are apt to be more skeptical about the verbal testimony of others than we are about what is displayed before our eyes (Bordwell 1985, 18).

Because documentary spectators anticipate an argument, Plantinga notes that they process them in a more intentional way (2018, 57). The performance universe envelops us into a dreamscape conducted by its author while the documentary presents our own world back to us, which we may claim prior knowledge of and investment in. Despite the critical stance that documentary spectators may bring to a portrait of reality within a sphere they share with the filmmakers and their subjects, Robert Rosenstone warns that its audience often has a false sense that they are getting the full story. Documentaries also involve images, emotion, and linear causal storytelling. They may allow misremembrances or an unrepresentative set of interviewees to stand without context, comment, or challenge (1988, 1179–1185; 1989).

Of course, many, if not most, filmmakers skip the consideration of whether to cast a given work as a documentary or performance project due to various factors, including their ingrained preferences, budget model, body of previous work, and established networks. Moving histories may also avoid binaries of documentary versus performance models as they incorporate mode shifting. Performance histories might opt to include interstitial documentary elements, such as interviews in the participatory style of *Reds* (1981) or archival footage, as seen in *Detroit* (2017). Similarly, a documentary may incorporate reenactments in poetic or observational performance styles, like the impressionistic interjections into *The Fog of War: Eleven Lessons from the Life of Robert S. McNamara* (2003) or the illustrative reenactments of *The Thin Blue Line* (1988) that seek to evoke a mood or recall events lost to time.

Method

Performance histories weave together observational reenactments through representational and mimetic performances. A documentary's approach, perspective, and prefacing of the authorial voice may take many forms, as elucidated by Bill Nichols in *Representing Reality* (1991) and further refined in his *Introduction to Documentary* (2017). Whether visible or invisible, verbal or mute, the documentary maker is accountable for the authorial perspective, inferred and

MODE	Documentary, Performance, Hybrid
METHOD	Expository/ Participatory/ Reflexive/ Performative/ Observational (Classical)
STORY AND PLOT	Causal-chronological, Beginning/ Middle/ End Arrangement, Structure, and Presentation
EMPLOTMENT	Romance/ Comedy/ Tragedy/ Satire
IDEOLOGY	Liberal/ Conservative/ Anarchic/ Radical
SUBTYPE AND GENRE	Topical/ Biographical/ War/ Epic/ Metahistorical + Genre
THEME	Value-laden meaning of the work
CHARACTER	Interpretation of the agents of history, their actions, and intentions - Heroic/ Human/ Pathetic
VISUALS	Composition, mise-en-scène, lighting
MUSIC	Evocation of meaning

FIG. 1.1 The poetics of narration in moving histories.

ever-present, in one or more of the following operations: dictating or signing off on the structure of the plot, appearing as an on-screen or off-screen persona or interviewer, or voicing a verbal narration.

The remainder of this chapter recommends a poetics of narration for the moving history, introduced and applied to an example from each mode of moving history. The participatory documentary *Let It Fall: Los Angeles 1982–1992* chronicles a decade of civic and social dysfunction that led to extreme violence in the streets of South Central LA in 1992.[1] *Free State of Jones* is a performance film spiced with occasional expository moments and reflexive documentary elements through titles and archival imagery. It depicts a mixed-race community, including army deserters and the formerly enslaved, led by Newton Knight in resisting the Confederate army in Jones County, Mississippi. Season 1 of *Rise of Empires: Ottoman* is a hybrid moving history, fusing observational representative performances, participatory presentational interviews, expository graphics, and voice-over narration to tell the story of the Ottomans toppling what remained of the Roman Empire in 1453. The six-part Turkish American production was filmed in Turkey, featuring an all-Turkish cast performing in English. With the first two elements of narrative poetics, mode and method, described in the introduction and previously in this chapter, we will turn to the oldest tool for systematic narrative consideration, classic poetics.

1 The region of the city called South Central Los Angeles in the 1980s and 1990s is now called South Los Angeles. When writing about this area in reference to *Let It Fall: Los Angeles 1982–1992* in this book, I will use the designation South Central, as it offers more specificity to the time and place in the film.

Classic Poetics

The principle of narration draws five elements of analysis from Aristotle's six criteria in *Poetics*: *logos* (story), *muthos* (plot), *dianoia* (character/thought/decision-making), *opsis* (visuals), *melopoiia* (melody/music), and *lexis* (speech/dialogue; 1997, 70).[2] Written in 335 BCE, Aristotle's book is foundational as the first known philosophical tract of dramatic and literary theory. As historian and narratologist Genevieve Liveley details, the ancients, and Aristotle in particular, engage ideas such as affect and persuasion in a manner that remarkably and "consistently evince a cognitively inflected approach to narrative poetics and a marked concern with the ways and means through which authors and audiences co-produce and co-process stories" (2019, 236–252). Aristotle's *Poetics* endures as a testament to dramatic storytelling that applies almost seamlessly to modern-day moving images. It is astonishing when one considers how different the stagings of Aeschylus and Sophocles are from the works of contemporary filmmaking. Yet for screenwriting in particular, *Poetics* is built into the bedrock of popular filmmaking thanks to its popularity among American filmmakers, as espoused in many screenwriting books and by writer-directors such as Gary Ross and Aaron Sorkin (Tierno 2002; Price 2020; Sorkin, n.d.; Ross 2018). Because only Aristotle's treatise on the epic and tragedy are known to us, the terms *poiesis* and *tragedy* stand in throughout this chapter to reference his commentary on dramatic arts and storytelling.

The next section explores *logos* and *muthos*, the stories and plots of the works analyzed throughout the book. It is a useful starting point, as the scope of a moving history's events and their arrangement is critical to the consideration of all the other elements of the principle of narration (and all the other principles that follow). From there, the chapter will shift to exploring narration theories from historiography and film studies relevant to historiophoty and will conclude by returning to the remaining elements of Aristotle's original schema.

Story and Plot

In history, data, whether oral or recorded, inspire the story (*logos*). The beginning, middle, and end of a narrative—whether ordered by the filmmaker or spectator—compose the story. Plot (*muthos*) is the most legitimate and powerful way to craft meaning without intentionally altering evidence. Due to the impact of structure on interpretation, the plotting of a film reinforces and unveils much of the author's opinion about the historical agents and events. Plot breathes perspective into story, a perspective that can be legibly read by critics.

The first step for the author of a moving history is to select a true story of consequence from the past. *Free State of Jones* is about a multiracial, class-based resistance to the Confederacy organized in the South during and through the

2 All Greek words and translations are taken from George Whalley's translation of *Poetics* (Aristotle 1997).

aftermath of the U.S. Civil War. *Let It Fall: Los Angeles 1982–1992* concerns events that precipitated the street violence in South Central LA in April and May of 1992. Season 1 of *Rise of Empires: Ottoman* explores the fall of the Eastern Roman Empire to the Ottomans in 1453. Each story spawns a plot that reinforces an argument about what the story or events signify. Plots express, suppress, and order events, in turn articulating meaning (Plantinga 2010, 3).

The main plot of *Free State of Jones* is chronological. It begins with the Battle of Corinth in Mississippi in October 1862 and follows protagonist Newton Knight as he deserts the Confederate army, hides out in the swamps, links up with a small group of men who have escaped bondage, and builds a resistance movement of poor White farmers that claws three counties from Confederate control in the midst of the Civil War. The main plot ends in 1876 with Newton and his partner, the formerly enslaved Rachel, walking arm in arm from a government building. Rachel's white dress casts the building behind her as a metaphorical wedding chapel. The happy couple is oblivious to the judgmental gaze of two doddering White men who look on askance. An intersecting subplot focuses on Newton and Rachel's great-grandson Davis Knight, whom the state of Mississippi tried and convicted in 1948 for miscegenation. It was a judgment later reversed by the Supreme Court of Mississippi in 1949, as a title near the close of the film explains. A core aspect of the plot in the Reconstruction era revolves around Moses. A composite or character "type" (Vaage 2017a), Moses flees slavery and befriends Newton in the swamps. He comes into his own after the war as he endures the jostling and denial of rights for Black men between the federal government and local authorities. Moses gains then loses a farm and becomes deeply involved in emancipation politics, registering other freedmen to vote. These actions lead to his lynching by a small group of White men. The film ends with two archival stills of Newton Knight, to whom Matthew McConaughey, who plays him in the movie, bears an uncanny resemblance. In the second still, Knight, an elderly man, sits beside a boy who may be a son from his union with Rachel.

Let It Fall: Los Angeles 1982–1992 explores a decade of mounting tension that led to violence in the streets of South Central Los Angeles between April 29 and May 4, 1992, that erupted in the wake of the not-guilty verdict for the four police officers charged with assault and excessive force in the beating of Rodney King in 1991. The plot argues that this cataclysm was ten years in the making. Director John Ridley establishes a dual foundation for the upheaval: the growing frustration and outrage over the extreme and violent policing of Black people in South Central LA under the arrogant, dogmatic, and bigoted leadership of police chief Daryl Gates, alongside the Los Angeles Police Department's (LAPD) transition from the chokehold to the use of batons to subdue arrestees. The core events of the film span James Mincey Jr.'s death in a police chokehold after an altercation, the murder of bystander Karen Toshima in gang cross fire on a crowded street, the destruction of Black homes in ensuing police raids, the murder of teenager Latisha Harlins by shopkeeper Soon Ja Du, the Rodney

King beating in 1991, and the trial of the "LA 4," convicted in the beating of truck driver Reginald Denny.

The documentary details tension mounting in the South Central Los Angeles community when, in response to a jury finding of second-degree murder in the shooting of Harlins at close range over a misunderstanding concerning a jug of orange juice, White judge Joyce Karlin sentences Du to time served, five years' probation, and community service. The next sequence follows the trial of the police officers most responsible for the savagery and gratuitous violence in their arrest of Rodney King, an event captured on video that galvanized many through its airing on news broadcasts. This section flows into the resulting eruption of frustration and destruction in the streets in response to their acquittal. Here, the documentary reveals interviewees introduced throughout the film as having an array of connections to the six days of unrest. They include perpetrators of the vicious attack on truck driver Reginald Denny to those who risked their lives to save people, including one of Denny's rescuers, and family members of teenager Edward Song, slain as he tried to protect Korean American–owned businesses from looting and destruction. Song was killed by Korean American rooftop snipers armed with the same goal. One of the police officer interviewees turns out to be the LAPD lieutenant responsible for calling units off the streets, an act others described as an accelerant of the mayhem, as well as another officer who, at significant risk to her safety, defied those orders to rescue a woman. The denouement catalogs the trial of the "LA 4," the men caught on video beating Reginald Denny and leaving him for dead. It closes with the resignation of LAPD police chief Daryl Gates and the levying of civil penalties on the officers who had escaped criminal convictions in the brutal Rodney King beating. The last image presents a tally of the results of the street violence typically referred to, with freighted language by various sources, as either the LA riots or the LA uprising. In black text over a white screen, the documentary's conclusion reinforces its point of view. It calls this cataclysm an uprising, understood as a predictable and inevitable response to a decade of continued, multifront state violence, reminding us that at the end of the chaos in May 1992, it was those same Black communities who lost most:

The uprising resulted in

862 destroyed buildings
$1 billion in damage
8,000 arrests
2,000 injuries
More than 50 deaths

[a crossfade to]

The majority of those killed were black (Ridley 2017)

Rise of Empires: Ottoman recounts the conquest of Constantinople by the Ottomans in a battle that lasted from April 6 to May 29, 1453. The series combines performance scenes depicting events from the life of Sultan Mehmed II as a child and in adulthood leading up to and through the siege. The stages of the offensive alternate between the point of view of the Ottomans and Byzantines. Maps and CGI (computer-generated imagery) constructions offer aerial views of the battle, the city of Constantinople, and its surroundings circa 1453. The film merges artfully shot interviews with scholars and popular history writers from the United States, United Kingdom, and Turkey. The series pulls these elements together with commanding explanatory narration by British actor Charles Dance, no doubt cast to bring the zest and imprimatur of his *Game of Thrones* (2011–2019) character Tywin Lannister to the proceedings. He intones in a manner as fit for an expository documentary as for a superhero television series or a video game trailer. The first episode opens with Mehmed II amid a frenetic battle scene that cuts to the stillness of the sanguine emperor Constantine XI in his court. Interviewees explain the strategic importance of the city while performance sequences set the plot into motion from the moment Mehmed II received word of the death of his father, Murad II, in 1451, making Mehmed sultan. The series covers the preparations for the siege by the Ottoman army of eighty thousand against seven thousand defenders led by Genoese mercenary captain Giovanni Giustiniani Longo. The episodes follow a chronological trajectory of the offensive and the defensive tactics of the siege. Short, interspersed sequences portray Mehmed as a child by his father's side in an earlier attempt to conquer Constantinople and Mehmed II as a boy at court during his initial sultanship from age twelve to fourteen, before his father's reemergence from early retirement. The show depicts Mehmed II throughout as possessing an almost single-minded obsession with conquering Constantinople. This, paired with his obstinate nature, puts him in continual conflict from childhood with adviser and grand vizier Çandarli Halil Pasha, whom Mehmed will execute by the series' end. The final scene of the last episode shows Mehmed II happily ensconced on the throne where we had previously seen Constantine XI sit and worry. With the story and plot for these prototypes of each mode explained, the chapter will turn to the historiographical aspects of crafting narration.

White's Intervention

Many historians consider Hayden White one of the most important historical philosophers of the twentieth century, crediting him as being central to both the cultural and linguistic turns in historiography in the 1970s. His work has implications across history, linguistics, rhetoric, and film theory. Eminent historian Dirk Moses describes White as "the most influential critic of the discipline of history over the past forty years, a thinker whose dissections of its conceits,

as elegant as they are erudite, have forced historians to reflect critically on what they do" (2005, 339).

A trained historian, White's initial work focused on twelfth-century Italian history. He published his first work of theory, "The Burden of History," in 1966 in the journal *History and Theory*. Like Nino Rota's "Godfather Theme," tucked into the score of *Fortunella* (1958) and a trill on the track "L'Illusionista" in Fellini's *8½* (1963), Hayden White's "The Burden of History" forwards the seeds of what would be fully explored seven years later in his book *Metahistory: The Historical Imagination in Nineteenth-Century Europe* (1975 [1973]). Professor of literature Suzanne Gearhart describes White's position in *Metahistory* as a "radical" one in which he argues that history is "ultimately determined by formal and rhetorical structures," urging historians to accept the similarities of history to fiction while insisting that there is a boundary between the two (1984, 7). Essential reading for graduate students in history for decades, *Metahistory* has much to offer historiophoty.

White proposed a detailed literary analysis to understand the construction of history, which included four aspects—"modes of emplotment," "ideology," "modes of argument," and "tropes of poetic configuration"—in his paradigm-shifting contribution to historiography *Metahistory*. His conceptions of modes of argument and tropes are densely theoretical and esoteric to the concerns of the five principles of filmic analysis; however, the first two elements of his criteria effectively illuminate the interpretive function of narration in moving histories, as will be detailed in the next two sections. A robust acknowledgment of the value of White's deconstruction of the historical narrative for moving images comes in the form of Vivian Sobchack's delightful essay on the historical feature film. In "The Insistent Fringe: Moving Images and Historical Consciousness," Sobchack pushes back on Roland Barthes's dismissive assessment of viewers of sword and sandal flicks as naive to probe the history film as the "dominant model of popular historical consciousness" (1997, 12). She describes her own adeptness in interpreting and parsing historical epics as a childhood fan and claims that White's complex ideas have a strong purchase on the average spectator while simultaneously implicating the historians in their cinema seats. She claims that "filmgoers have become unprecedentedly savvy about (mis)-representation and have learned the lessons of Hayden White's *Metahistory* even if they've never read it. That is, filmgoers know that histories are rhetorically constructed narratives, that 'events' and 'facts' are open to various uses and multiple interpretations. And, as filmgoers have not been able to escape the lessons of historiography, so, on their side (and try as they might), historians have not been able to escape the lessons of the movies and television" (5).

In one stroke, she defends the average audience member's critical thinking abilities to contextualize a film's historical rhetoric and argument alongside an inverse claim stipulating that the power of moving histories holds historians more firmly in their sway than they might care to admit. For those interested in

a penetrating analysis of the implications of *Metahistory* for film, Thanouli puts forward the most complex and meticulous application of White's full schema to historiophoty in her book *History and Film: A Tale of Two Disciplines* (2019). Informed by Thanouli's intervention, the principle of narration draws specifically from White's analysis of modes of emplotment and ideology, as both illuminate the narrative poetics of moving histories in ways that are accessible and revealing.

Modes of Emplotment

White's proposal of modes of emplotment governs the shape and structure of a history and, therefore, its meaning. White isolates four modes, drawing on Northrup Frye's classifications with narratological origins reaching back to Aristotle's *Poetics*. Frye's modes of emplotment include romance, tragedy, comedy, and irony, which White refers to faithfully, except as he swaps in satire for irony (Frye 2020; White 1975, 8–11). These categories are distinct from film genres, as romance and comedy mean very different things in scholarly literary criticism. This, along with White's proposal of the political ideologies of anarchism, radicalism, conservatism, and liberalism, help determine the orientation of a moving history (1975, 426–427). A historian's selection of events and portrayal of characters and a work's tone and valence, when considered through the choice of an ending, dictates emplotment and meaning.

Narratives describe characters, actions, and events in an array that withholds and divulges information. History is the evidence of experience pressed into a narrative mold. Due to the commercial pressures on mainstream cinema, this mold adheres to the literary science of poetic catharsis and the realpolitik of consumer tastes and markets. In Aristotle's work on rhetoric, he emphasized the power of "astonishment," constructed from the improbable and exaggerated as a means to persuade (2018, 49). This pressure to astonish and entertain has implications for moving histories. They convey meaning through an approach to character via a metaphorical low-angle, high-angle, or eye-level shot, in a narrative built toward salvation, ruin, or the dead end of stasis, all of which implicate a particular mode of emplotment.

Frye explains that a critical difference between narrative structures rests upon whether the characters are superior, inferior, or on the same level as the audience (2020, 33). Because characterization is intricately tied to the mode of emplotment, the rendering of the protagonist is crucial to narration. When a protagonist is superior to humanity but not the environment, a story operates in "*high mimetic* mode," traditionally in the form of an epic or tragedy; if the hero is the audience's equal, it takes on the "*low mimetic* mode" of comedy or realist fiction, while main characters who are inferior to us in capabilities and intellect inhabit the "*ironic* mode" (Frye 2020, 34; emphasis in the original). Characters must rise to the level of conflict. High-mimetic narratives prod protagonists to bring superhuman capabilities to their tasks, such as in *Braveheart*

(1995). Resonant and relatable tales of all-too-human heroes saddled with navigating great conflict include *12 Years a Slave* (2013) and *Wormwood* (2017), while inferior protagonists who are comic, pathetic, and irredeemable villains or rogues populate *The Death of Stalin* (2017) and *The Act of Killing*. Moving histories serve historiophoty best in the second two categories, revealing human actions in ways that help us understand ourselves and our failings. *Let It Fall: Los Angeles 1982–1992* is low mimetic, reveling in the realism of human motivations and actions. *Free State of Jones* blurs the line between high- and low-mimetic categories, with Newton Knight operating as a slightly superior human. *Rise of Empires: Ottoman* jumbles characterizations that live together in the tenor of a medieval fantasy genre. It leans toward the high mimetic with mythic superheroes in its renditions of Sultan Mehmed II and Giustiniani, the mercenary leader of the defense of Constantinople, with ironic characterizations of Constantinople's traitors, grand duke Loukas Notaras and the governor of neighboring Galata, while their scheming Ottoman counterpart, grand vizier Çandarli Halil Pasha, is molded as a low-mimetic man of pride and principle.

There are two other characteristics of the mode of emplotment. One enmeshes protagonists with their surrounding society; the other isolates them. The former is associated with romance or comedy, and the latter with tragedy or irony (Frye 2020, 33). Kenneth Burke explains that these two main categories rest upon "Aristophanic assumptions, which equate tragedy with war and comedy peace" (1984, v). White characterizes romance as the "hero's transcendence" and "triumph of good over evil" (1975, 8–9). Frye describes romance as an "adventure" plot that focuses on the conflict between the protagonist and antagonist (186). Ironic emplotment is rare in historical films and rarer still in moving histories based on real people and events. Opposing romance, it casts characters as vulnerable and weak, depicting an "unidealized existence" that leans toward the comedic and absurd (223–224). Comedy is romance-lite, built around pedestrian people and conflicts that feature a happy ending—which White warns is "temporary" (Frye 2020, 167; White 1975, 9). Frye defines tragedy as centering "sacrifice" (214). For White, tragedy dramatizes "the fall of the protagonist" in a manner that offers the silver lining of learning for both the characters who survive the final reckoning and the audience (1975, 9).

Beyond the scale of characterization, ranging from quasi-mythic to human to petty, the crucial determinant of the mode of emplotment is a resolution that leaves the protagonist in triumph, tragedy, or adrift in an open ending. Any kind of emplotment may structure any history. *Braveheart* is a tragedy, though it would have been a romance had it ended at the close of the Battle of Stirling Bridge in 1297 or had it been scripted from the perspective of the English. Thus, the choice of romantic, comic, tragic, or satiric plots offers revealing insights into the authorial point of view. To understand how these modes of emplotment function within moving histories, we must refine the idea of what constitutes superior humans and conflicts in the contemporary age. Burke explains

how these styles of emplotment shifted from their fundamental models in the nineteenth century, noting that "comedy deals with *man in society*, tragedy with the *cosmic man*. (This emphasis, after the organized documentation, that followed Darwin, eventually led to Hardy's kind of tragedy, *man in nature*. In classic tragedy the motivating forces are superhuman, in romantic-naturalist tragedy they are *inhuman*.) Comedy is essentially *humane*, leading in periods comparative stability to the comedy of manners, the dramatization of quirks and foibles" (1984, 42; emphasis in the original). Heroes of romantic and tragic histories are mortals who must rise to meet extreme conflict. For that, they are accorded great respect, be they royalty or peasants, patricians or proles.

As noted, satiric and comedic moving histories are rare and tend toward costume and historical fiction films. Examples of costume satires include *Monty Python and the Holy Grail* (1975), *Monty Python's Life of Brian* (1979), and the tragi-satire *Life Is Beautiful* (1997). Costume comedies are legion, including *A Room with a View* (1985), *Driving Miss Daisy* (1989), *Downton Abbey* (2010–2015), and *Mad Men* (2007–2015). The concerns, petty conflicts, and lower stakes of comedic history plots rarely rise to a filmmaker's attention for adaptation of the real in moving histories. The average person's challenges do not demand the specific "token" characterizations of history, and so these characters are often approached as amalgams or "types" (Vaage 2017a, 262–263). Satires, on the other hand, typically mock and critique power. They are an effective instrument for political commentary but strike a tone rare in mainstream moving histories. Exceptions include the satiric skewering of *The Death of Stalin* or comedic histories like *Green Book* (2018) and the HBO series *Gentleman Jack* (2019–2022). Why are so few moving histories cast in the comic mode? Burke asserts that "history of the past is worthless except as a documented way of talking about the future" (1984, 159). History is a serious business and often a search for meaning and origins. There are no doubt many reasons that it is in the nature of moving histories to lean toward high stakes and protagonists battling more powerful antagonists, including their resonance to threats present and future.

Literary terms for the modes of emplotment do not travel easily from historiography to historiophoty due to the contagion of names borrowed for film genres. *Dunkirk* (2017) is a romance but decidedly not about falling in love, losing love, and getting it back, just as *Green Book* is a historical comedy with few laughs. With these terms in mind, *Free State of Jones* is a romance film with a subdued happy ending, and *Let It Fall: Los Angeles 1982–1992* is a tragedy. *Rise of Empires: Ottoman* achieves the rare feat of balancing sympathy for both sides, proving that even in popular media, audiences can handle the complexity of extending humanity to two opposing groups in a historical conflict.

Figure 1.2 charts the level of conflict and the ending of each work toward analyzing its mode of emplotment. Spectators may root for Mehmed II and the Ottomans or Constantine XI, Giustiniani, and the Byzantines. The series

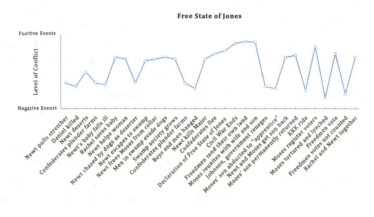
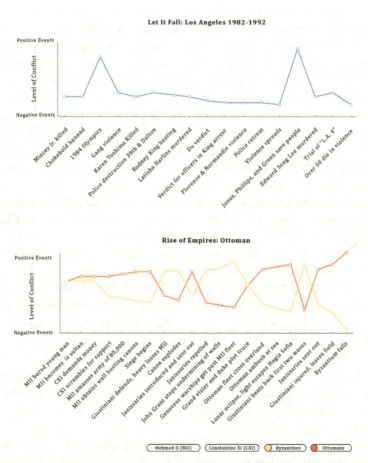

FIG. 1.2 Emplotment of *Free State of Jones* (romance), *Let It Fall: Los Angeles 1982–1992* (tragedy), and *Rise of Empires: Ottoman* (Ottoman romance/ Byzantine tragedy).

lodges Mehmed II into the role of the protagonist, beginning and ending the series with him, devoting more screen time to his story, replete with flashbacks to his youth. Yet simultaneously, it accords respect across both sides of Constantinople's walls. The depiction offers presentational and representational performances that express compassion toward the goals of each civilization. A clash of East against West, religions, and a multicultural versus monocultural society, the show offers a singular kind of moving history, one that is both romance and tragedy, depending on which side the spectator identifies. The plot plays out like a sports match that swings in each team's favor at various points, generating much suspense. While the narrative of *Free State of Jones* bends upward and *Let It Fall: Los Angeles 1982–1992* arcs down, owing to its multifaceted positionality, the plot of *Rise of Empires: Ottoman* forms the coarse shape of an alligator, its jaws wide open.

Ideology

The other category that White proposes that is critical to deconstructing a moving history's narration of past events attends to its political ideology. In his formulation, he draws from Nietzsche's explanation of the varieties of historical impulses and political ideologies that orient a historian's perspective. Conservative and anarchic histories are *antiquarian*, built upon "conservatism and reverence," depicting the past for its own sake (2019, 17). *Monumental* histories catalog "action and struggle," while a *critical* history "judges and condemns" the actions of the past so that we may alter systems and activities in the present to serve radical or liberal worldviews (12–17). Moving histories are less prone to motivation by more extreme ideologies such as anarchism, with its fundamentalism and longing for an idealized past, or radicalism, with its rush to dismantle corrupt systems toward a better future. Documentaries reflect radicalism when they articulate the need for swift and immediate action, painting establishment structures as obstacles, such as in the climate change documentary *This Changes Everything* (2018). Whereas a film like *The New World* (2005) romanticizes anarchism and human relationships tied to nature. Most film histories tend toward liberalism with the modulated progressive leanings one would expect from those with artistic temperaments who work successfully in a medium dependent on deep connections to private or public institutional funding, distribution, and support. Conservative films are often overtly patriotic, such as *Saving Private Ryan* (1998) and *Pearl Harbor* (2001), promoting old hierarchies and conservative, traditional values of strength, courage, and wholesomeness. Again, as with the confusion inherent in the overlap between terms in White's theory of emplotment that are more commonly used to describe film genres, conservatism as an ideology should not be confused with its vagaries as a political practice.

Let It Fall: Los Angeles 1982–1992 levels its core critique at the excesses and prejudices of the legal infrastructure of Los Angeles as a microcosm of the country. It argues for liberal reform rather than a wholesale dismantling of

government structures—courts, prisons, and policing—toward anarchic or radical aims. The documentary features police officers voicing a range of perspectives, from the prejudiced to the well-meaning and from the fallible to the heroic. Similarly, *Free State of Jones* illustrates a liberal ideology that critiques systematic oppression. Both films take aim at organs of state power that dehumanize and oppress by pillaging resources through race and class-based hierarchies. Gender-based oppression is a secondary motivating concern of *Free State of Jones*. A conservative ideology drives *Rise of Empires: Ottoman* through its medieval fantasy genre conventions and lack of a contemporary critique of butchery, mayhem, and warfare. The series skips the mass murder, rape, and enslavement of the inhabitants of Constantinople in the days and weeks following the battle. This is in keeping with its romance arc and the conservative ideology that applauds courage and might for their own sake.

Subtype and Genre

In *The Hollywood Historical Film*, Burgoyne proffers five "subtypes" of the historical film: epic, war, biographical, topical, costume, and metahistorical (2008, 3, 22–49). There is a noted crossover between subtypes and film genres in the first three. The costume subtype describes works about the past that are not moving histories. A moving history might operate within the logic of one subtype that doubles as its genre or may pair a subtype with another genre. For example, the biographical film *The Assassination of Jesse James by the Coward Robert Ford* (2007) operates as a biographical western, *The Act of Killing* is a biographical war documentary, and *Zodiac* (2007) is a topical film, mystery, and thriller. The costume designation indicates an approach to history via "types" (Vaage 2017a), which emphasizes the social and material aspects of the past outside the purview of moving histories. His fifth subtype, the metahistorical, is characterized by "embedded or explicit critiques of the way history is conventionally represented through form or content," citing *JFK* (1991) and *Flags of Our Fathers* (2006) as examples (Burgoyne 2008, 46, 5). *Free State of Jones* combines the categories of biographical, topical, and war. *Let It Fall: Los Angeles 1982–1992* is a topical documentary. *Rise of Empires: Ottoman* is a biographical war series operating within the genre conventions of medieval fantasy.

The choice of a subtype and genre has an outsized impact on the interpretation and meaning of a moving history. For this reason, one may criticize a moving history on the grounds of its interpretation and the author's choice of genre for its lack of appropriateness to the data points of the narrative. A strong example of this is Rosenstone's first foray into writing about history in moving images in an article about *Reds* (1981), the blockbuster film about John Reed that was, in part, based on Rosenstone's research and on which he was a historical consultant (1982, 306–307). At times complimentary, Rosenstone also enumerates various historical inaccuracies in the film. Yet in his view, director Warren Beatty's most egregious blunder was the decision to make Louise Brant

the de facto protagonist and to tell the story in the romance genre rather than as a drama centered on Reed and the political events in which he participated (306). With the aspects of narration from historiography and cinema studies explained, we will slip back several millennia to return to the Greeks and Aristotle's parameters for analyzing *poiesis*.

Theme

Theme (*dianoia*) relays the author's perspective through the characters' reasoning. It also informs and organizes the plot, providing a key, value-laden insight into the point of view of the narration. Theme encapsulates the historical argument that the author channels through characters and their actions and outcomes. A narrative's theme guides the writing process. An author reinforces or sets back the value of the theme in each scene until it is clarified and affirmed in the end. Theme is extracted from cues within the work and sometimes through the paratextual signaling of ancillary websites, taglines, and the metaphoric imagery of promotional materials and trailers. Spectators may interpret different themes from the same material based on what they are looking for in the text, how it relates to their experience, the clarity or ambivalence of a theme, and the existence of multiple or competing themes. Therefore, spectators, including this author, can only isolate the theme of a moving history speculatively and tentatively.

Free State of Jones advances the theme that the righteous ultimately succeed. Newton Knight opposes the Confederacy. Seeing past class, gender, age, and race-based bigotries, he ascribes humanity and dignity to everyone resisting the South from within, partnering with other struggling farmers and the formerly enslaved to oppose slavery and the war. For example, in one scene, Knight rides out to help a mother and her small girls defend their homestead from Confederate-sanctioned marauding. Scenes depicting the savage murder of Moses during the Reconstruction period offer the most dramatic threat to the theme. Strong themes never dictate a straight trajectory for the plot. Like the protagonist, they are constantly challenged. Although oppressive racism and the class violence of the Confederacy and its aftermath continually beat the characters down, the film ends on the dual track of Knight's grandson's vindication after being sentenced for miscegenation in 1948 and Newton and the formerly enslaved Rachel walking as partners, arm in arm. The tempered happy ending suggests that progress requires courage and vigilance and that the righteous will out. Change is slow and continually unfolding but arcs toward justice.

The title of *Let It Fall: Los Angeles 1982–1992* emanates from a phrase uttered by interviewee Gary Williams, one of the four men charged in the beating of truck driver Reginald Denny, and it articulates the theme of the documentary. Referencing the extreme policing of the Black community, Williams says, "It's just one story that adds to the next one, to the next, and it's a domino effect. That domino tip, it's gonna make the rest of them fall." A silent, rapid-fire, four-second

FIG. 1.3 Interviewee Gary Williams inspires the title of the documentary *Let It Fall: Los Angeles 1982–1992*.

montage of events previously shown in the film follows this scene. It includes an archival image of police training by using chokeholds on one another, James Mincey Jr. (who died in a police chokehold) in his casket, a close-up of Mincey's girlfriend from her interview footage, two shots of the destruction to Black homes in police raids in the thirty-ninth and Dalton neighborhood, archival imagery of police with assault rifles, and a shot of LAPD police chief Daryl Gates at a press conference. Next, the film cuts back to Williams, who says, "If you don't stand for something, you'll fall for anything. And we just can't keep falling for police brutality" (Ridley 2017). Then the screen goes black. This sequence occurs thirty-nine minutes into the film. The quote also appears near the beginning of the documentary's official trailer. It encapsulates the theme of the film, which lays out the argument that the violent response to the verdicts in the criminal case against the four officers most involved in beating Rodney King was a reaction a decade in the making, expressing the theme that sustained state prejudice and violence leads inexorably to revolt, or more simply, violence begets violence.

Rise of Empires: Ottoman portrays the battle for Constantinople with a generosity of spirit toward both sides. Emperor Constantine XI is serene and noble, while the mercenary soldier Giustiniani shoulders the responsibility of defending the city and what remains of the Roman Empire. Ultimately, the wily and driven Mehmed II outmatches Giustiniani. It may seem inevitable since the series depicts Mehmed throughout as possessing a single-minded fixation on the conquest of Constantinople from childhood. Voice-over narrator Charles Dance mellifluously utters the tagline for the series at the end of the opening credits of each episode, "for one empire to rise, another must fall," but

this statement is not a theme due to its lack of an ascribed value judgment. The last episode ends with Mehmed II on the throne of Constantinople. He tips his head toward the camera with relish, smiles, and says, "And so, we begin." The theme dramatized by this treatment of this history is that to the most determined, talented, and passionate go the spoils (Şahin 2020).

Isolating the theme signals the narrative point of view. A slightly altered version of *Free State of Jones* might dramatize the theme that social and material inequality breeds instability. A different version of *Let It Fall: Los Angeles 1982–1992* could explore that very same theme. An alternate focus for *Rise of Empires: Ottoman* might illustrate the theme that plural societies are stronger. Whereas a radically different theme for the conservative *Rise of Empires: Ottoman* would be the more liberal and progressive idea that war is an abomination, which would have led to ending the series on a different aspect of the fall of Constantinople.

Character

Given that a core facet of *dianoia* (thought) is the expression of characters through their behavior and acts, their depiction is foundational to *poiesis* as an art form of "*mimesis* of an action" (Aristotle 1997, 67). In mainstream moving images, *lexis* or dialogue is another critical quality of character expression. In narrative, as in life, actions rather than words expose a person's true nature. Characters function as vehicles of meaning and animators of plot. Investigating the past through its human representatives is key to the argument and meaning of a moving history. To whom does John Ridley choose to speak about the six days of unrest in *Let It Fall: Los Angeles 1982–1992*? Which experts will Errol Morris summon to uncover the operations and conspiracies of the MKUltra program in *Wormwood*? What motivations do filmmakers and interviewees assign to the ambitious and autocratic Mehmed II in *Rise of Empires: Ottoman*? Academic historians may avoid decisively diagnosing their subjects' inner aims, wants, and fears, preferring to let the arrangement of documented utterances, writings, and events shape inferences. Rarely is such luxury taken in mainstream moving histories.

There has been a long-standing debate in screenwriting about whether the crux of a filmic narrative rests upon the crafting of character or plot. Aristotle asserted "the Primacy of Plot over Character" in a subheading in *Poetics* (1997, 73), but many writers have since suggested that character is supreme. Screenwriting guru Robert McKee settles this dispute in a draw, writing that they are "interlocked. The event structure of a story is created out of the choices that characters make under pressure and the actions they choose to take, while characters are the creatures who are revealed and changed by how they choose to act under pressure . . . if you change the event design [plot], you have also changed character" (1997, 106). The score seems settled. Characters and plot

reinforce each other as spectators enter the events of the past through actors and interviewees.

The casting of presentational and representational performers is simultaneously very different and very similar. In documentaries, characters are often unknown, yet they must be as captivating and charismatic as professionals. Character and casting determine whether the work strives for a more complicated or constrained point of view. *Wormwood* focuses much of its attention on Eric Olson, whose scientist father died under suspicious circumstances in 1953, while *Let It Fall: Los Angeles 1982–1992* orchestrates a more expansive survey of multiple perspectives. Writer and director Gary Ross voices his sociopolitical intentions to contribute to ongoing conversations about class and race through characterizations of the courage and nobility of Knight, Rachel, and Moses. The characterization of men like Major Amos McLemore and Lieutenant Barbour displays and dramatizes the greed, bigotry, and inhumanity of the Confederacy. Consistent with current forms of high-mimetic narrative, in *Free State of Jones*, the good are better and stronger than us, more conscientious and courageous. The bad are worse, motivated by malevolence and pure self-interest. The goal of characterization in the film is to craft a strong argument around clear moral lines.

Films gauge the worth of a character by their courage and commitment, what they are willing to sacrifice and for what purpose. The most profound stake a character can face is death. It is that level of threat that the protagonists in each of the case study works must confront. In *Free State of Jones*, Newton, Rachel, and Moses risk their lives for righteousness as all three put themselves in mortal danger to resist injustice. Moses sustains those risks on behalf of Black men's suffrage. In the sequence chronicling the civil unrest in *Let It Fall: Los Angeles 1982–1992*, civilian Bobby Green and police officers Donald Jones and Lisa Phillips rescue others while putting their own lives in peril. In *Rise of Empires: Ottoman*, Mehmed II, Giustiniani, and Constantine XI face death by leading their respective sides in battle: Mehmed and Giustiniani throughout the siege, and Constantine when the Ottomans finally breach the walls.

Audiences interpret words spoken in moving histories through the filter of a given character's reliability, established by their actions and the values that underpin them. In all moving histories, save compilation forms of historical documentary, characters speak explicitly to events and the historical argument of a work. Contemporary interviewees generate material for documentarians to draw from and place into dialogue with reenacted or archival imagery and footage that sculpts an overarching argument. In documentaries, editing collages and structures character expression into meaning while this crafting takes place primarily in the writing and acting stages of performance works.

Free State of Jones opens by highlighting the class-based bigotry of war as a ragtag phalanx of weary and wretched men trudge into gunfire. This is

reinforced by direct and evocative dialogue in the first few scenes, as Newton Knight discusses the sudden enactment of the "New Conscription Act" with his friend Jasper Collins, a law that releases from service any man managing estates with more than twenty slaves. Near the battle site, Knight and Collins watch the wealthy men, relieved in every way, load onto a cart for their escape from the clutches of death. Continuing the conversation by firelight in the next scene, Knight, Collins, and others discuss "fighting for cotton," which pressed war onto the shoulders of subsistence farmers to fight for a crop they do not possess, built around a system of bondage in which they do not profit or participate. A teenage boy emerges from the forest, a relative of Knight's, who explains that the Confederates stole his family's farm animals and conscripted him. The boy is confused, untrained, and scared. Knight offers to fight beside him the next day. His actions prove the conviction of his words. In his first moments of battle, the boy is shot. Knight runs to the field hospital with the child in his arms, telling him he loves him and repeating, "You're not dying," as the boy turns pale, complains of thirst, and dies. In the next scene, Knight prepares to return his body to his family. Knight's friend Will Sumall offers the platitude, "He died with honor." His assessment juxtaposes jingoistic propaganda with the reality of the utter pathos of the previous scene. Knight responds, "No, he just died" (Free State of Jones, n.d.).

Late in the second act, Knight publicly declares in Ellisville, Mississippi, that the surrounding county is now the Free State of Jones, laying out four tenets to guide the newly independent jurisdiction and swearing allegiance to the Union cause. Ross wrote the four values expressed by Knight in the film based on his research into the aims of the movement (Ross 2022). Knight speaks in the patriarchal vernacular of the times and undergirds the core class and race-based themes of the film in a manner resonant to Knight's contemporaries in 1864 and the audience of 2016. The stated core "principles" that animate Knight's rebellion and the movie are

1. "No man oughta stay poor so another man can get rich."
2. "No man oughta tell another man what he's gotta live for or what he's gotta die for."
3. "What you put in the ground is yours to tend and harvest and ain't no man oughta be able to take that away from you."
4. "Every man is a man. If you walk on two legs, you're a man. It's as simple as that." (Ross 2016)

In *Let It Fall: Los Angeles 1982–1992*, interviewees form a diverse cast of characters who tell the story of Los Angeles in the lead-up to April 1992 from many perspectives. They include family members who lost loved ones to street violence, either at the hands of the LAPD or gang members and vigilantes. Other key interviewees include police officers involved with incidents in the plot

and members of the South Central community who either participated in the violence or saved victims from it. An archival cast appears through interview clips of Rodney King, Reginald Denny, police chief Daryl Gates, and mayor Tom Bradley. In director John Ridley's hands, each character is humanized, forming a spectrum from the courageous to the grieving, flawed, ignorant, and sinister.

Interviewees underline the central argument and theme just past the halfway point of the film. In the wake of the so-called Rodney King verdict (which was actually the verdict rendered upon his attackers), the court acquits all four officers of assault and the use of excessive force. The sequence begins with archival footage of the freshly exonerated LAPD officer Laurence Powell grinning at a press conference after the ruling. This scene cuts to two intersecting interviews with South Central residents who took very different actions later that day. Donald Jones went into the melee to save Soi Chai Soi, while Henry Watson was one of the four men charged in the beating of Reginald Denny.

> WATSON: It's going down. Trust me. We ain't gonna keep sitting back and accepting this.
> JONES: If you're going to shoot Latasha Harlins in the back of the head for some orange juice and get probation, you are going to beat Rodney King fifty-seven times with a stick and then somehow want to justify that, you're going to take a battering ram and decide that that's the way you need to get into homes in the Black community and what you're telling me is you have no respect for us.
> WATSON: Everyone needs to feel the same pain ... in their schools, in their churches. Do you understand what I'm saying? The same anguish, the same heartache. They need to feel the same thing. (Ridley 2017)

In this sequence, Watson and Jones express their reaction to the verdict, offering a tableau of emotions existing within the Black community of Los Angeles at the time. Each voice the film's point of view, one as id, the other as superego.

Rise of Empires: Ottoman approaches characters in a more stock manner, keeping within the genre conventions of fantasy and works that depict histories with a tenuous historical record. Given this, it is notable that the series treats people on both sides with dignity. Unlike comparable works, such as *Game of Thrones*, *Gladiator* (2000), and *300* (2006), there is no arch King Joffrey, conniving Commodus, or animatronic Xerxes I. The antagonists are of a second order, motivated by the all-too-human drives of greed and survival rather than a bloodlust for mayhem and destruction for its own sake. The worst of its antagonists is the governor of Constantinople's neighboring city, Galata, who, in a cruelly ahistorical subplot, betrays Constantinople to the Ottomans. Less devious but also scheming is the grand vizier to the sultan, Çandarli Halil Pasha,

FIG. 1.4 Cem Yiğit Üzümoğlu as Sultan Mehmed II in *Rise of Empires: Ottoman*.

and Loukas Notaras, grand duke and chief minister to the emperor, who conspire together to end the battle. Loukas is sniveling, and the Galatian governor is treacherous. The series portrays both historical figures as slightly buffoonish characters.

Although oriented around Mehmed's point of view, the series depicts Constantine XI as serious, valiant, and ethereal, an Eastern Roman stoic who seems to have stepped out from a Byzantine fresco, while Mehmed II and Giustiniani are passionate men of action. Three female characters appear as secondary characters. They include Serbian princess and political schemer Mara Branković a mother figure to Mehmed and a former member of his father's harem. Therma Sphrantzes, a noble Byzantine, serves as a love interest for occasional melodramatic and frothy scenes with Giustiniani. The composite character, Ana, is of Turkish origin and enslaved by the Byzantines. Her dubious storyline sees her escape the city walls to meet and chat with Mehmed II at his camp before returning to the city. Interspliced presentational documentary performances voice Turkish and Western points of view. Most notably, American author and history podcaster Lars Brownworth conveys melancholy about the fall of Constantinople; meanwhile, Celâl Şengör, a Turkish geology professor at Istanbul Technical University, is at times giddy about the Ottomans' success. The full slate of ten interviewees provides a range of analytical and reasonably neutral perspectives, emphasizing the even-handedness of sympathy in this medieval war series that swaps dragons for authors and professors.

Casting Charles Dance from the HBO juggernaut *Game of Thrones* makes for commanding, direct, and intense voice-over narration that underlines plot developments and emphasizes stakes with a flourish. The mood shifts throughout the series, reflecting the differences between dramatic performance scenes

and authoritative documentary interviews. Scripted scenes focus predominantly on "great men" strategizing, battle scenes, and Mehmed's childhood flashbacks. The interviewees' commentary constantly places those sequences into context as actual historical events being staged, dramatized, and creatively reenacted. The interviews tether the series to the evidence of the past. Although performance scenes compose most of the series, short expert interviews regularly punctuate the action. Sequences devoid of such interjections signal scenes freely improvised and likely rife with artistic liberties.

Visuals

Aristotle called visuals (*opsis*) the least important aspect of poetics while simultaneously referring to the poet as the art director of the scenes within each audience member's mind, describing the poet's role as the "image-maker" who, "like a painter," is "engaged in representation" (2013, 50). Although Aristotle loses interest in visuals and music and ceases to refer to these facets of *poiesis* halfway through *Poetics*, the moving image medium brings these features of narration to the foreground. Unlike Archaic theater, in film, the visual is a core conveyor of meaning, communing with our innate reading of facial and bodily expressions and spatial and symbolic imagery, evoking intense, visceral reactions of fear, disgust, anguish, elation, and desire. Imagery is central to the medium's immediacy and resonance for spectators, just as it is the cause of alarm for many historians, as Rosenstone has written about in such a compelling way (1988). Moving histories merge the impact of traditional visual arts, such as painting and drawing, with our deep sensitively to interpersonal exchange, an evolved response that cannot account for screen representations that look out at us but do not see us and are not, in fact, there. Rather than telling a story captured in a moment on a wall or canvas, moving histories link images through time in a way that mimics life propelled by narrative drive.

Moving histories made of archival footage assembled from observational raw materials, such as *A Night at the Garden* (2017), quote history by structuring actions into a succinct argument. Director Marshall Curry initially intended to make a traditional participatory documentary of a pro-Nazi rally at Madison Square Garden in 1939 that would include interviews with historians interwoven with archival imagery of the events. He later chose to focus on the visual testimony of the raw materials as the most compelling way to express his goal of highlighting persistent threats to the United States from the time of the thirty-second presidency reawakened in the age of the forty-fifth. He explains his decision to edit the raw footage together as a more potent way to communicate his argument, which "is less an indictment of bad things that Americans have done in the past than it is a cautionary tale about the bad things that we might do in the future. When the protester is being beaten up there's a little boy in the crowd who I zoomed on in the edit. You can see him rub his hands together, doing an excited little dance, unable to contain the giddy excitement that comes from

FIG. 1.5 A young boy at the center of the frame rubs his hands in glee as he watches American Nazis beat a Jewish protester in *A Night at the Garden*.

being part of a mob" ("A Night at the Garden," n.d.). In the end, Curry felt that layering interviewee dialogue would only dilute the power of the images.

Free State of Jones includes liberal use of screen titles that signal the film's intention to balance entertainment with historical accuracy. Characterized by lingering shots of the natural world, particularly the dramatic beauty of the swampland of Mississippi, the lighting in the movie is natural. It features moody interiors dappled in firelight and exterior sequences of high-key sunlit farmsteads and streets. Other outdoor settings express the lurking threats of man and nature in scenes shot under the canopy of the marshes, including in the darkness of dusk and nighttime. The film is shot predominantly in close-up and medium shots with some long shots but very few extreme long shots. The compositions keep the audience tightly engaged with the interpersonal dynamics of the story.

Ross intended for the film to be a rejoinder to *The Birth of a Nation* (1915), addressing a similar timespan while reorienting character sympathies and the visual canvas. In D. W. Griffith's hands, the stately home signifies wealth, patriarchal family roles, Whiteness, and safety. He depicts nature as the canvas of the untamed and uncivilized, libidinous predation, Blackness, and danger. The foyer before a grand staircase that serves as the site of familial wholesomeness for Griffith is the setting for cruelty and criminality for Ross. This is the space where plantation owner James Eakins stalks the enslaved Rachel.

Conversely, Newton Knight's hearth is meager, and the bulk of the action takes place outdoors. In *Free State of Jones*, most homes we see belong to poor farmers. Structures that offer simple shelter, these houses are subject to continual plunder from the Confederate war machine. The untouched nature of the Mississippi swamps is a place to reset and begin the postcolonial dismantling of immoral hierarchies. When we are in the house of the rich, we see Rachel peeking in on reading lessons for the little girls in the family. She tries and fails to evade the grasp of their father, the lecherous patriarch. The film's opening visually establishes a robust antiwar message as a motley group of Confederate soldiers, fear etched across their faces, tread over dead bodies on a ridge into Yankee cannon and gunfire. The next scene evokes a similar pathos as Knight sprints, pulling an injured man on a stretcher to a hospital tent that seems more like a medieval torture center, its wooden floors stained red, blood-dyed hospital linens flapping in the wind.

Let It Fall: Los Angeles 1982–1992 is characterized by the interplay of the pixelated video of archival footage amassed from local news reports and amateur video of the 1980s and early 1990s with intimate, low-key, close-up interview shots. Archival news report interviews are cropped into close-ups to match. The visual framing of interviewees reinforces Ridley's approach to the material, conferring respect to all. He films each person in a similar manner that avoids determining protagonists and antagonists. Ridley also resists the temptation to contradict interviewees through visual montage and editing structure, trusting his audience to draw out biases or contradictions in their testimony through the course of the documentary. The film repeats several visceral images and clips as motifs, including the video of the Rodney King beating, a still image of James Mincey Jr. in his casket, footage of the destruction of Black homes by the police, and a self-portrait of Karen Toshima, the victim of a gang shooting.

Rise of Empires: Ottoman features performance scenes interspersed with interviews and voice-over narration. The visuals in the film draw heavily on other popular entertainments. The vibrant opening scene of the series is reminiscent of *Gladiator*, with grainy, quick, disorienting shots of battle featuring Mehmed II in close combat, mud flying. The lighting in the series is dramatic, rich, and moody, a medieval world painted in shadow with slices of light filtering through windows, past the warm glow of candles and torches. Many of the scenes take place in dim, romantic interiors. The series stages outdoor combat sequences primarily at night. The visuals are consistent with other fantasy series like *Game of Thrones* and include the video game aesthetics of CGI animations, such as a scene in which a hooded Giustiniani lurks in the shadows, having dispatched the treacherous governor of Galata, visually evoking the *Assassin's Creed* (2007–) franchise. Interviews splice the performance sequences in the series, shot with intimate, low-key lighting in a cool color palette in multiple shot sizes and angles. The artfully captured interviews frequently mix two kinds of medium shots with two versions of close-ups at more extreme angles, including

profile and high-angle shots. The documentary interviews form tableaux that intercut stable, balanced, and conventional compositions of the experts with asymmetrical arrangements that place more negative space behind interviewees, lending an air of vulnerability and frisson. The use of experts alongside maps and CGI models of Constantinople and its surroundings in the fifteenth century conveys the intention of the makers to tie the creative liberties of the performance sequences to the accepted facts of the history. This approach serves the twin goals of signposting a sincere appreciation for sources of evidence and a desire to convey some accurate historical knowledge.

Music

Music (*melopoiia*) is a crucial and complex component of our sensual experience of filmic narratives, drawing from our experiential, intuitive, and inborn response to music and nonverbal noise, set apart from our rational linguistic assessments of the literal and figurative meaning of words. With its emotional precision, music is a subtler yet more keenly calibrated conduit of affect than dialogue, a divining rod for the author's narrative interpretation of theme and emplotment. Music reveals a film's intentions to balance emotion and introspection through compositions that manipulate spectator affect with either a heavy hand or light ambivalence, as signified by the Philip Glass-style score that has become a trademark of the introspective and speculative Errol Morris film. Music accompanies and intersects costume and set decoration to either sink strong anchors of narrative meaning through contemporary instrumentation and style or to further evoke the world within the frame with instrumentation and period compositions in ways the audience often absorbs unconsciously. Music is another locus of the temporal layering of history, mixing diegetic period instrumentation and melodies with contemporary songs.

A score by Nicholas Britell delivers most of the music in *Free State of Jones*. The only exception is diegetic fiddling by a background player in the swamps during a pig roast scene. The film opens with a mournful string piece entitled "Battle of Corinth." It plays as the film transitions from imagery of the dead on the battlefield to Knight pulling an injured man on a stretcher. The *Free State of Jones* theme, a string and piano composition that evokes a restrained and delicate optimism, plays late in the film over an archival montage representing the end of the war and the enactment of the Thirteenth Amendment banning slavery. This song plays into the next scene as Moses's wife and son, free from bondage, run side by side through a field toward the camera and into Moses's arms. In the next shot, Moses works his own land. The music and scene fade to black and silence as we hear the voice-over of a man, incredulous, saying, "But we won." The line functions as an audio prelap, guiding us to the next scene. The black screen cuts to an image of Moses and five Black men talking to Knight about the rolling back of the promised reparations of forty acres and a mule. The scene ends with one of the men saying in bewilderment, "I don't understand. We free,

or we ain't free?" Moses responds, "You understand. We're free, and we ain't free" (Ross 2016).

In the film's last act, Moses walks home alone after a day of promise and exuberance, registering formerly enslaved men to vote. He ambles along a road bordered by farm fields as the composition "Voter Suppression," featuring simple rising strings, induces suspense and dread. Moses breaks into a run as he realizes a small group of White men are stalking him.

Conversely, many dramatic scenes, from soldiers marching into bullets to Newton Knight's discovery of Moses's gruesome torture and murder, are starkly silent and unaccompanied by music. The score avoids imposing the exhilaration, triumph, and patriotism of many war films, operating in a restrained, meditative register that asks the audience to consider the broader themes of tribalism, greed, and racism. The musical choices throughout the film reinforce an intention to prompt sober reflection rather than manipulate prescribed emotions.

Mark Isham's string-based score in *Let It Fall: Los Angeles 1982–1992* is spare and evocative, save for two popular songs accompanying archival montages introducing the Los Angeles of the 1980s. "All Night Long" by Lionel Ritchie plays over a vibrant montage showcasing the rise of the city's excitement and international prestige as host of the Olympics of 1984, while Ice-T's "OG Original Gangster" punctuates a sequence depicting the rise of gang violence in the city and the resulting response of the LAPD. In a common documentary technique, the film opens with a montage of descriptions from interviewees speaking about the core topic of the film: the chaos that erupted in South Central LA on the day of the verdict. At other points in the documentary, spare music accompanies commentary, as subtle strings play over archival images of police training on one another with the chokehold technique as retired lieutenant Tom Elfmont explains the procedure. Minimalist notes from a piano dust Latesha Combs' description of witnessing the murder of Latisha Harlins by shopkeeper Soon Ja Du as a child. More urgent and fully orchestrated music accompanies the sequence depicting Du's light sentencing, which evokes a sense of alertness and awakening to a situation rather than steering the audience into an overdetermined sense of foreboding. Subtle strings animate interviews and archival footage that display the details of the attack on Rodney King and how each of the four accused officers positioned themselves in their defense. The documentary also employs silence effectively. The grainy, wide-lens security camera footage of Du shooting Harlins in the head at close range is jarringly mute.

Music in *Rise of Empires: Ottoman* is true to the adventure and fantasy genre, and the video game aesthetics reinforced by many of the visuals. The soundtrack mixes striking electronic music over the opening and closing credits and at integral moments of drama, such as in a sequence in episode 4 that accompanies the Ottomans bringing their fleet overland and into the Golden Horn. Spare and archaic organ pieces accompany scenes of the brooding Constantine XI

on his throne. Simple string music emphasizes scenes of mild intrigue, such as a romantic scene between Giustiniani and Therma and a sequence in which Mehmed learns as a child of the death of his mother, a woman he barely knew and could scarcely remember. At other points, traditional Turkish music and intense drumming accompany scenes in the Ottoman camp as they prepare for battle. The choice immerses spectators in the environment of the historical world, emphasizing the exoticism and affect of the time and place. In the sixth episode, as the Ottomans prepare for their final assault, musicians play traditional Anatolian instruments of the period, including a period-appropriate woodwind instrument called the zurna, which has an arresting sound. Music in the series goes uncredited but reflects the varied impulses of the show to capture the aesthetics and excitement of medieval video games, war, and fantasy films. At other points, an understated score characterizes a competing interest in subtlety and historical accuracy that matches the tone of many of the interviewss but few of the performance scenes.

From Form to Content

Grasping the narrative point of view of the author through a work's engagement with narrative poetics and form is critical to reading and assessing a moving history. Given that what defines history is its link to evidence, the next principle and chapter turn to this vital distinguishing element that serves as the dividing line between history and fiction.

2
Evidence

●●●●●●●●●●●●●●●●●●●●●

What is evidence's relationship to moving histories, and how is it acknowledged?

Evidence separates history from fiction. The processes and ideals of history are deeply entwined with evidence, and it is in this principle that the exchange between historiography and historiophoty is most significant. Each bit of evidence is a tether to historical data embedded within a history. This series of tethers distinguishes moving histories from other film genres. This principle responds to Natalie Zemon Davis's injunctions for history films regarding the responsibility of history to evidence. It is of prime importance to moving histories for two reasons: (a) films that purport to be about the past, as opposed to merely being set in it, make a contract with the audience tied to evidence, and (b) when filmmakers change or elide the details about and complicated motivations for documented actions and events, they frequently trade rich and insightful details of actual human behavior for more generic stories that refer instead to other fictions. Methodologies regarding the mining, interpretation, and citation of data as evidence compose a core concern of historiography, governing the theories and practices of the academic form of history. The question of how this translates to moving histories is a chief concern of the genre. This chapter engages several critical junctures in which academic historians engaged moving history, the evidentiary practices of historiography that are useful to historiophoty, and examples of moving histories that directly address evidentiary claims.

What Is Evidence?

Siegfried Kracauer describes the distinction between history and fiction as one reaching back to antiquity. He argues that historians do not have the freedom of poets and playwrights, obliged as they are to work from a given set of materials (Kracauer and Kristeller 1995, 55, 82). Those materials encompass evidence, constituted from "objects, documents, official statements, etc., that are used to prove something is true or not true" (Cambridge Dictionary 2021). Here, no doubt, Kracauer refers to Aristotle and his claim that "the poet's job is not relating what actually happened, but rather the kind of thing that would happen—that is to say, what is possible in terms of probability and necessity.... For this reason poetry is more philosophical and more serious than history; poetry utters universal truths, history particular statements" (Aristotle 2013, 28). As argued in the introduction, this is a simplistic view of history, suitably archaic and lacking the benefit of an accumulation of analysis in the theoretical wing of historiography since the establishment of history as a field within the academy. Aristotle mischaracterizes the relationship of *poiesis* and history to universals and particulars as each involves both, history drawing universals from particulars and *poiesis* drawing particulars from universals. Each is intimately concerned with the possible and probable based on past occurrences. While the poet or author of fiction may start with a message and fill in the details, the historian must begin with the details and craft an argument by weaving it into a structure. Due to the intrinsic difference between the route to universals and particulars and their relative claims to truth, historians of any media have a duty to show their proofs—whether or not they oblige—while the poets and fiction makers do not.

Our imaginations are central to the creation and reception of thought, including history. Like a story to a plot, Ludmilla Jordanova explains that a narrative point of view or argument transforms sources and data into evidence (2019, 91). The general contract of history suggests that creative additions will take the form of connections between the data points of evidence rather than overriding or altering the data itself. Bill Nichols provides an expansive definition of evidence that refers to documentary but applies to all moving histories as works about the real. He explains that evidence "refers back to a fact, or situation—something two or more people agree upon, something verifiable and concrete—but facts and events only acquire the distinctive status of evidence within a discursive or interpretive frame. Evidence, then, is part of discourse, be it rational-philosophic, poetic-narrative, or rhetorical, charged with a double existence: it is both part of the discursive chain and gives the vivid impression of also being external to it. In other words, facts become evidence when they are taken up in a discourse; and that discourse gains the force to compel belief through capacity to refer evidence to a domain outside itself" (2008, 33).

The makers of popular history often claim expansive creative license. Oliver Stone expresses the opinion of many filmmakers who historicize when he

cautions that audiences should not base their "views on one movie, one historian, one dramatist, one ideology, or one perception, no matter how seductive or convincing the messenger. Life is far too ambiguous" (Stone 2000, 45). However sound and reasonable, this plea does not give cover for the violation of the evidentiary contract of history and clashes with the reality of moving histories' intense capacity to persuade. Studies show just how difficult it is for viewers to distinguish between accurate and inaccurate depictions of the past in popular films, even when primed in advance with precise, written renditions of a history and cautioned to monitor a film for creative license taken (Umanath, Butler, and Marsh 2012). The sensory and emotive power of moving histories obliterates many other forms of knowledge.

Moving history forms a genre in several senses of the term, from its "*blueprint*," the template that precedes production, to its "*label*," part of its distribution and marketing, to its "*contract*" with the spectator that dictates and manages expectations (Altman 1999, 14). Like a comedy, romance, or thriller, a moving history has particular preproduction and production requirements and appeals to specific audiences with preset interests. Historical data brings prescribed characters, events, and a range of potential meanings. Evidence imposes creative limitations and spans what Paul Ricœur calls the "Threefold Frame," beginning with (a) documentary proof, which proceeds via (b) "causal or teleological explanation" and (c) through "emplotment" (2004, 250). In responsible moving histories, the work is crafted in that order rather than by starting with the plot or argument first. As Davis asserts in *Slaves on Screen*, history is not "wish fulfillment," as she laments that in some instances "fabrication, perhaps intended to increase suspense or character development in the film seems arbitrary and unnecessary" (2000, 79). Of course, history involves selection and, therefore, omission. Some events will be included while others are excised; this shapes meaning. At issue is the intention behind what is left in and what is filtered out. Is it what is deemed inconsequential that is pushed aside, or what challenges the argument, creating complexity? A core principle of academic history dictates that such decisions be addressed by the historian in the text or paratext. This chapter explores how documentary, performance, and hybrid histories adopt and adapt history's evidentiary practices.

The (Con)Fusion of Evidence and Imagination in History

In his contribution to Vivian Sobchack's edited volume on the historical film, Hayden White claims that "the event" separates history and fiction as he reflects upon the elision of the meaning of the event in modernist and postmodernist art and literature (1996, 17–18). He warns that

> the dissolution of the event as a basic unit of temporal occurrence and building block of history undermines the very concept of factuality and threatens therewith the distinction between realistic and merely imaginary discourse.

> This dissolution undermines a founding presupposition of Western realism: the *opposition* between fact and fiction. Modernism resolves the problems posed by traditional realism, namely, how to represent reality realistically, by simply abandoning the ground on which realism is construed as an opposition between fact and fiction. The denial of the reality of the event undermines the very notion of "fact" informing traditional realism. Therewith, the taboo against mixing fact with fiction, except in manifestly "imaginative" discourse, is abolished. And, as current critical opinion suggests, the very notion of "fiction" is set aside in the conceptualization of "literature" as a mode of writing which abandons both the referential and poetic functions of language use. (18; emphasis in the original)

Although White does not condone the wholesale erasure of this boundary, he points out that "facts are a *function* of the meaning assigned to events, not some primitive data that determines what meanings an event can have" (1996, 21; emphasis in the original). Or, as Suzanne Gearhart points out, although some scholars see a distinction between facts and narrative, others insist that facts "must already be narrated to achieve their historical status" (1984, 290). The boundary between fiction and nonfiction is porous, like a walled enclosure punctured by multiple open gates. White further explains that it is as impossible to imagine history without fictionalization as it is to "conceive a serious fiction that did not in some way or at some level make claims about the nature and meaning of history" (1996, 21). While avoiding cross-contamination of history and fiction is unattainable and even undesirable, upholding the general distinction between the two is imperative.

A year after White's essay, Eric Hobsbawm advocates for common-sense divisions between history and fiction as he writes that historians "have a responsibility to historical facts in general, and for criticizing the politico-ideological abuse of history in particular" (1997, 6). He further warns of the "rise of 'postmodernist' intellectual fashions in Western universities, particularly in departments of literature and anthropology, which imply that all 'facts' claiming objective existence are simply intellectual constructions—in short, that there is no clear difference between fact and fiction" (6). Clarifying the stakes, he continues, "Either Elvis Presley is dead or he isn't. The question can be answered unambiguously on the basis of evidence, insofar as reliable evidence is available. . . . Either the present Turkish government, which denies the attempted genocide of the Armenians in 1915, is right or it is not" (6). When we decide Elvis lives on in a bunker, we delude ourselves; when we deny the victims of genocide, we do real, factual harm. As brilliant and elucidating as White's historiographical interventions are as a form of soul-searching and a reality-check on the formal and metaphysical aspects of history, there is a strong need to maintain a critical appraisal of sources and to adhere to historiographical methods for all works that purport to present history while resisting the evaporation of all but the faintest lines between history and fiction.

Hobsbawm pauses to raise particular alarm over the incursions and threats historical fiction poses in "fudging the border between historical fact and fiction" (1997, 6). In this, he singles out performance histories and mimetic reenactments of the past for specific concern. As it happens, one of the central injunctions of screenwriting is that a writer creates a world within a universe of laws, many based on genre guidelines. An author may adapt genre rules in a given work, but this must be established near the outset to set audience expectations and parameters for conflict—for example, whether a zombie can or cannot run. Once the author decides on an outbreak of slow, bedraggled, and clumsy zombies, they cannot suddenly break into an elegant sprint for the film's climax. To break those rules brings forth a complaint lodged all the way back in *Poetics* and Aristotle's critique of the concept of deus ex machina, when at the end of a play, a god swoops in to save not only the protagonist but playwrights who have written themselves into a corner (1997, 117). Every mainstream film genre comes with an inheritance of practical and formal frameworks with attendant audience understandings. This is how the audience broaches the story and takes part in it. Bestselling screenwriting expert Robert McKee puts forward several rules for the craft of screenwriting, one being the "principle of creative limitation," which "calls for freedom within a circle of obstacles," encouraging writers to embrace a set of barriers that strengthen and inspire storytelling (1997, 90). Moving histories encompass a genre with creative limitations marked by evidence.

The History of History's Appraisal of the Historical Film

Considering that the first films about history were produced for Edison in 1895, it is remarkable how long it took for historians and critics to pay attention to moving images as a medium for public history (Stubbs 2013, 62). As cataloged by Anthony Aldgate, curators and historians awoke, en masse, to the popularity of history in the movies and on television beginning in the 1960s (1979, 8–10). Surges in historian interest in history in moving images often follow the release of a series or film of national significance that becomes a historical event in its own right. A key early moment for history and film occurred in the U.K. in response to the BBC's twenty-six-part series *The Great War* (1964). One example of a critical response to the series was a thoughtful and captivating paper presented at the Institute of Historical Research the following year by Christopher Roads, deputy director and keeper of the Department of Records at the Imperial War Museum (IWM). The paper was reprinted in the *Journal of the Society of Archivists* as "Film as Historical Evidence" one year later. It offers a nuanced appraisal of the challenges and benefits of film to historiography and addresses historiophoty *avant la lettre* by considering the implications of moving image histories as a direct form of historical discourse.

First, Roads evaluates film as a form of documentation, comparing it unfavorably to still photography, given the unwieldiness and expense of the technology, particularly on the battlefield, which was a central setting for the archival materials of the IWM (1966, 183). Next, he classifies the utility of film for history, from best to worst, based on its level of intervention—from raw, unedited documentary footage to the edited documentary to the performance history. In effect, he catalogs film along an incremental spectrum from a primary to a secondary material and from its usefulness to historians as a source of historical evidence to a medium of direct access for popular consumption (184). While showing a clear preference for the uses of film to historiography, he acknowledges "no technical reason why such publication itself should not take the form of cinefilm" (190).

His assessment of the relationship of moving images to history reads as complex, fair, and enduring. It prompts even the twenty-first-century reader to ponder moving images as a testament to the past and how the level of authorial intervention impacts a work's value as evidence and its reach. In the case of historiophoty, the issue of intervention is insistent and complex, given that narrative meaning will be imposed—if not by the author, then by the audience. If, for example, the short documentary *A Night at the Garden* (2017), comprising edited archival footage of a pro-Nazi rally in New York City in 1939, was not structured into a narrative through editing but instead made available in its entirety, it would not necessarily make for a better history. *A Night at the Garden* cuts the raw footage capturing a sprawling evening of twenty thousand American Nazi supporters assembled in Madison Square Garden to seven minutes. The edit focuses on the scale of the event; the size of the crowd; the introductory remarks; visuals of young, uniformed boys on stage; and the violent response to a Jewish protester who manages to grab the microphone for a few moments. Immediately and aggressively tackled by the American Nazis, he is roughly handed over to the New York City police. An unstructured assembly of the event would provide more information about the evening's program. However, its diluted argument would still fall short of being the unadulterated truth. The result would be a less-shaped and modified record and one of interest to far fewer people, locking its lessons into obscurity. After all, history will be edited and narrativized by someone—if not the filmmaker, then the audience member.

In another light, we can surmise that spectators edit a long and uncut film by turning it off or walking away. White explains that any "*historical work* represents an attempt to mediate among... the *historical field*, the unprocessed *historical record, other historical accounts*, and an *audience*" (1975, 5; emphasis in the original). The interpretation or narration of evidence, the forming of data into narrative meaning and a plot may be proposed by those who have spent months or years on a project—studying it in physical or digital archives and libraries, investigating through reading, watching, and listening—or it can be left to audiences to draw their own conclusions based on their prior interests, values, and

associations. If historians were to abandon narrative as a contaminant art form, it would not disappear; it would only be outsourced, left to others: to filmmakers and producers, social media influencers and algorithms, grade school textbooks, journalists, and politicians—often those with less imperative to be guided by sources over other concerns. The disavowal of narrative grants not an adulterated true history but merely, as White points out, an "unprocessed" one (5). Ricœur echoes this, explaining that attempts to substitute raw data or charts in the place of narrative only leave interpretation undone and unfinished (2009, 66). As a testament to our reliance on narrative to process facts, Frederic Jameson astutely points out the irony that "the disappearance of master narratives has itself been couched in narrative form" (2005, x). As Jameson reveals, the deniers of history and narrative provide the opposing argument themselves.

Quibbling over Factuality

Although historians frequently ignore moving histories as a sideshow and distraction, those who have paid attention have at times been criticized as artistic neophytes playing the hall monitor. The phenomena may be best exemplified in an energetic book review by film theorist Robert Sklar with an argument energetically summed up in its title "Historical Films: Scofflaws and the Historian-Cop" (1997). Sklar pushes back against the impulse to rate historical films for accuracy, critiquing historians for a singular interest in "plot paraphrase," suggesting the focus should instead be on understanding how people in the past saw themselves (348). He further reminds historians that history is conveyed beyond the areas of their concern through "narrative and dialogue—or costumes and décor—but also through . . . cinematography, editing, music, sound and performance" (348). For his part, historian Pierre Sorlin concurs and cites "colours, shapes, movements, etc.," in describing histories in moving images (1980, 103).

The audiovisual elements of light, composition, casting, sound recording, and score are just some of the aspects crucial to the meaning conveyed in moving image reenactment, and historians do well to acknowledge them. And yet, why would we expect or ask them to judge aesthetic and formal properties beyond their expertise? Historians often focus on character, art direction, and plot because this is where their knowledge lies. While many resent the reaction of historians and critics to the liberties taken by moving histories that change or omit crucial data from the historical record for creative or pragmatic purposes, it is a worthy discourse and part of the full life span of the moving history as its impact ripples out far beyond its exhibition. The dialogue that follows in the wake of a moving history is a critical aspect of the genre because histories implicate people in ways that fiction may not. Creative distortions in moving histories misrepresent real people and events, but perhaps more importantly, they compromise what audiences might learn from the past. While no moving history will ever satisfy every perspective or capture truth in its entirety, discussing

the argument and view of the world put forward, and pointing out errors and flaws, is part of this genre's distinct status, importance, and active reception process.

One of the most instructive approaches to moving histories to date was, like Roads's paper, a critical response to the success of the BBC's *The Great War* series. It consisted of an interdisciplinary conference *Film and the Historian*, in 1968, followed by the volume *The Historian and Film*, edited by Paul Smith in 1976. The conference got off to a dramatic, and perhaps inauspicious, start with a lurid introductory speech by historian A. J. P. Taylor who railed against the "monstrous" deployment of "historical material in order to create effects" and the use of historians as consultants for prestige only. His homily eventually reached a fever pitch, calling on historians to be "the masters and film makers, and the technicians will do what we want" (Chapman 2001, 138). As a well-known historian in Britain in his day and as a regular presenter on the BBC, Taylor undoubtedly felt well placed as an authority on history in moving images. No matter that his shows were no more than filmed monologues from a sound stage. His stern, self-serious, direct-address deliveries to the camera were no more than recorded lectures, nothing like historical documentaries or moving histories that we would recognize today. Taylor would not be among the contributors to the edited volume that emerged from the conference.

The publication, appearing eight years after the conference, remains a rich reflection of issues concerning moving histories, in part because of the cross section of the authors involved. The most enduring are the last essays of the book, "History on the Public Screen I" by historian Donald Watt, a historian with experience consulting on televised history productions, and "History on the Public Screen II" written by historian-turned-BBC producer Jerry Kuehl. Each offers clear insights into perennial frictions between the imperatives of historians versus producers in making and marketing historical knowledge.

The View from Inside

As a historian turned producer, Kuehl's essay lays out what moving histories do to history with precision. He addresses historians' complaints about the surface treatment of audiovisual history with a valuable comparison of words spoken on-screen to words on the page that remains edifying. He notes that trained BBC newsreaders speak quickly and clearly at 160 words per minute. Therefore, in fifty minutes, the length of the average BBC documentary, they would only be able to speak the equivalent of about fifteen pages (1976, 177). Cautioning that any professional documentary producer would ensure that verbal commentary accounts for less than a quarter of screen time, he explains that the news reader's pace of 1,000 to 1,500 words uttered in a fifty-minute show would quickly turn a documentary into "an illustrated radio programme" (177). And thus, he wagers a history documentary has the same word count as a one-page news article or a fifteen-minute lecture, as in the attempt to "say more [the]

audience will understand less. They will, in time, simply switch off—figuratively and literally" (177).

Kuehl's detailed mathematical breakdown provides specific context for an issue Rosenstone raises and White tackles in the *American Historical Review*'s forum issue about history on film. White addresses historians' complaints about the "low information load" of many moving histories, which, he argues, muddles "the question of scale and level of generalization at which the historical account ought 'properly' to operate with that of the amount of evidence needed to support the generalizations and the level of interpretation on which the account is cast. Are short books about long periods of history in themselves non-historical or anti-historical in nature" (1988, 1194–1195)? Moving histories are shorter on information than most scholarly historical communications, with attendant advantages of reach and disadvantages of lower levels of detail and context.

Kuehl provides a comprehensive log of historians' legitimate harangues about moving histories, including that they do not allow "time for reflection" and are best suited to "telling stories and anecdotes" and communicating "atmosphere and mood" (1976, 178). Regarding the benefits of televised history, he extols the diversity of spectators drawn into broadcast histories versus university lectures. He further notes that specific feedback from the *World at War* (1974–1975) series demonstrates the value of reaching audiences who do not have a history degree. According to Kuehl, after the series, audience feedback indicated that general British audiences learned what historians had long known about the Second World War:

- The Luftwaffe defeat in the UK was due to logistical issues for the Germans, not because they were beaten by the RAF.
- Most German troops fought on the Eastern Front.
- Hitler was a social reformer who destroyed the Prussian aristocracy (1976, 180).

Proving the immediate power of moving history and its long-term effects is the fact that these three points about World War II remain breaking news to non-history majors today—if they come across that information at all. No doubt, this is partially due to competing misinformation from other films. For example, Hollywood and Western European movies and series overemphasize their individual nations' roles in World War II, focusing on the perils and heroism of the Western Front.

Cowriting with others in the pages of *Cinéaste*, Kuehl later elaborates his position that the most important purpose of history in any medium is to demystify and elucidate the horrors of war (Rosenthal et al. 1978, 15). This is undoubtedly one of the most vital public goods of moving histories: their mass appeal combined with antiwar narratives serve as a visceral reminder of the total devastation and immorality of armed aggression and intraspecies mass murder.

Yet his steely defense of history in moving images extends to documentary only (1999, 119, 122). This is curious as it is often performance histories like *Letters from Iwo Jima* (2006), *Saving Private Ryan* (1998), *Sarraounia* (1986), *Come and See* (1985), and *All Quiet on the Western Front* (1930) that remind the largest audiences of war's violent cruelty. This message seems especially valuable for those separated by an ocean or who are more than a generation removed from it. In response to his singular defense of documentaries for history, we can use Kuehl's arguments against him. As the audiovisual evidence of the feature-length documentary moves to the interpretations and impressions of the performance history, the number of spectators increases again. Accordingly, with that gain in audience size, Kuehl's assessment of fifteen minutes' worth of information shrinks further, perhaps to bullet points.

The Travails of the Historical Consultant

Watt's essay describes the "curses" of history films, explaining that producers, "sophisticated" and "highly educated" as they may be, often undertake historical research themselves and underestimate the intelligence of the audience. At the same time, he notes that budgetary realities often encourage international partnerships, which in turn create audiences without shared knowledge. Watt explains that these international coproductions also impose unrealistic time constraints on the research and production schedule, cycling through low-paid researchers rather than hiring experts for the long-term who bring expertise to the job (1976, 172). Drawing on lessons that seem hard-earned from tumultuous and stinging collaborations on film productions, he lists the following advice for any "historian rash enough" to agree to be a historical consultant:

- Demand "the right to vet" the content in time for changes to be made to avoid "distortions."
- Know the shooting script and producer's disposition in advance.
- Be alert for inaccuracies introduced via moderator or narrator ad-libbing.
- Avoid "realist re-enactments."
- Know that the producer has the final say. (174–175)

Adding to his final point, Watt cannily advises keeping a log of conversations with the producer (1976, 174–175). A paper trail like this could potentially be useful for historians wishing to disengage from a project that has abandoned the facts in pursuit of entertainment. Watt is self-aware enough to see the other side as well and, serving as a retrospective parry to A. J. P. Taylor, he cautions that the "historian as amateur producer is no more satisfactory than the producer as amateur historian," as there is a "home movie" aesthetic in historian-led productions (175). Watt's philippic paints a vivid picture with enduringly wise counsel for those who take on a role as the guardian of evidence in a moving history.

Contemporary dispatches demonstrate the ongoing demands of the position. Liam Brockey, a historian of Jesuits in Asia in the sixteenth and seventeenth centuries, was a historical consultant on Martin Scorsese's *Silence* (2016). He describes his experience as resoundingly positive and rewarding while reinforcing some of Watt's points. The film adapts a historical novel rather than drawing primarily from scholarly texts. Brockey's expertise was called upon most often for his advice on period details, costumes, and props. These aspects were not what he felt equipped to comment on as they related to areas that extended well beyond the historical record. Reflecting upon the kinds of questions he was asked, such as the color of Jesuit underwear in the seventeenth century, he wryly notes that "sometimes you reach the frontier of knowledge" (2017). Meanwhile, his repeated entreaties to correct mistakes in the novel that served as the source material for the film were frequently overruled. For example, the novel and film depict a historical figure who, in fact, had died before the action of the story. He likened this to making a historical film in which George Washington and Abraham Lincoln attend the same ball. Brockey was sent fifty-seven sample images to help choose one table while his concerns about the faulty inclusion of a person from another era were brushed aside (2017).

A Historiographical Approach to Historiophoty

Another perspective to flag is that of John E. O'Connor, one of the first American historians to draw attention to history in moving images. Like Roads, his initial interest was the various uses of film as an aid to historiography in the service of traditional historical research and teaching rather than the viability of moving images as a medium for history. Over time, his work grew to encompass historiophoty, and he contributed a great deal to the topic. He cowrote a teaching guide published by the American Historical Association (AHA) and directed a large, multimedia, multiyear project, *Image as Artifact*, supported by the AHA and the National Endowment of the Humanities, which addresses media literacy for historians and history students. His stated goal for the project was to enhance (a) "a critical methodology for historical analysis of moving image documents," (b) "visual literacy," and (c) "the contributions which traditional historical methodology have to offer the practice of film and television study" (1990a, ix). It is work that remains vital.

O'Connor was another contributor to the influential AHR forum issue on film. In words as apt now as then, O'Connor writes that film represents "one of the most direct means for demonstrating the relevance of history to contemporary life," and visual literacy is, therefore, "an essential tool for citizenship in contemporary America" (1988, 1208). Acknowledging the power of moving images, he recommends ways that historians should engage the medium. In many respects, his contribution to the forum is an abstract of his larger *Image as Artifact* project, which appeared in 1990 in a package including a comprehensive

teaching guide, a video companion produced on VHS and Laserdisc, and the edited volume *Image as Artifact: Historians and the Moving Image Media*. The audiovisual contribution was, and remains, particularly pathbreaking, though it showcases some of the home movie aesthetics that Watt warns about. In it, historians Natalie Zemon Davis and Daniel Walkowitz contribute a historian's version of a "director's commentary," narrating scenes from films based on their research. Another section on video literacy breaks down how documentary interviews are set up, filmed, and assembled for non-filmmakers to emphasize how context is lost and rearranged through framing and editing (O'Connor 1990b).

The edited volume, *Image as Artifact*, praises moving image works that were once contemporary depictions that have become historical documents over time above those that are about the past and that historicize. Nonetheless, O'Connor's methodology also informs the analysis of moving histories. His erudite proposal suggests the following approach to evaluate the history film:

> **"STAGE ONE"**
> "Content (what does the film say?)"
> "Production (how may forces at work in producing the film influenced what it says?)"
> "Reception (what did it mean for the people who saw it at the time?)" (1990a, 284–285)
>
> **"STAGE TWO"**
> Distinguishes "frameworks" that include the following questions and concerns:
> What is the "historical interpretation"?
> Reception context: What "social and cultural values" did the film intend to spark in viewers, and how were "camera and editing techniques used to elicit a certain response?"
> Creation context: What is the political framework in which the film was financed and made? How does the work fit within the genre to which it belongs? (296–301)

The five principles of historiophoty draw from several of these concerns. The principle of narration considers what O'Connor dubs "content," "reception context," and "frameworks," while his invocation of "reception" and "production" inform the principle of plurality. O'Connor's project endures for its instructiveness and relevance.

History's Methods and Goals

Evidence stakes a claim to truth that allows others to weigh the merits of an argument. Ludmilla Jordanova cautions that truth brings with it "connotations of completeness," and objectivity misleads if it is interpreted as meaning that knowledge could exist free of bias (2019, 89). She further advises that "passions and values should also be constantly subjected to scrutiny; they need to be tempered by evidence ... attention should therefore be directed to the definition, selection, and interpretation of evidence. It is pointless to hold up an ideal—unbiased history—which is simply unobtainable" (3). Additionally, we must acknowledge that truth is bound in trust (Maza 2017, 98). History's methodologies are, therefore, practices and rituals of trust. Evidentiary proof can be mimicked, used, or abused to cobble a pathway to support almost any belief. As Errol Morris extols, "I have always bristled at the idea that style guarantees truth" because "truth is a *quest*! It's a *pursuit*!" (Seitz 2017). No methodology relieves us of the need for diligence or the mental labor of the critical reception of history. Knowledge of the human past is an ongoing collective project of critical curiosity and inquiry.

The historian's method proceeds by (a) research, (b) citation, and (c) discussion of evidence. Can these practices translate to moving histories, and if so, how? The interplay of evidence in moving histories is one of the most precise dividing lines between performance, hybrid, and documentary modes of moving history. History documentaries present evidence within a body of work, through compilations that sculpt archival material, or by telling the past through expert and witness testimony, or they may mix these approaches. Their credit sequences include bibliographical details on sources, from interviewees to archives. On the other hand, performance histories paraphrase evidence through scripted action and dialogue. Its sources typically take the form of historical consultants referenced in the credits. The responsibility for gathering and presenting the evidence varies widely, as a compilation filmmaker works with collaborators from the past, sometimes performers, photographers, cinematographers, and participants long dead. In contrast, interview-based documentaries are collaborations with others in the present that speak about the past. Performance-based histories are partnerships made in the present that look backward by presenting the past in the active present tense.

The research process is crucial to works set in the real world of the past. Key concerns include the following questions: Who undertakes the research? How experienced and resourced are they? How expert are they in the history at hand? How much time are they allotted to do the work? To what extent did they seek evidence to support an a priori point of view? Did they look for disconfirming data? And when found, did they reveal it? For the audience, the answers to these concerns are often opaque. Credits traditionally reference researchers,

but it is impossible to discern a hired, dedicated consultant from someone consulted in an email exchange.

Filmmakers helm teams. They seek out the best contributors to performances, cinematography, art direction, and editing. The value of what historians bring may be overlooked because, as Maza points out, the historian's methods are considered widely accessible (2–4). Given that accessibility, for almost a century, research has been considered the gathering expertise available to any screenwriter with a library card (Smyth 2006, 112–113). Evidentiary practices are only as good as their practitioners.

Evidence within the Text

There is always an interplay between evidence shaping the narrative and the narrative shaping the evidence. Lines blur for even the most cautious historians. It follows that moving histories thrive in the intersection of a two-way interaction between historians and filmmakers. Sorlin advises historians to "take an interest in the audiovisual world if they are not to become schizophrenics, rejected by society as the representatives of an outmoded erudition" (1980, 5). Similarly, filmmakers do well to look to historians—with collaborative temperaments—who may bestow more creative grist in the form of context, customs, worldviews, and zeitgeist for the cinematic historical storyworld than filmmakers realize. Having considered the relationship and implications of evidence for moving histories, the remainder of the chapter explores its deployment in their texts and paratexts.

The Palette of Documentary Evidence

In the first paragraph of the preface to *Representing Reality*, Bill Nichols asserts the connection "between documentary and the historical world as the most distinctive feature of this tradition," describing the mode as one that "proposes perspectives on and interpretation of historic issues, processes and events" (1991, ix). Analogous to academic history in its focalization and aura of authenticity, they are also very unalike, as documentaries often deploy and interweave evidence directly, more museum display than written discourse. Sarah Maza describes documentaries as "the popular form that lays the greatest claim to 'truth' . . . with its seductive shuffling of images, documents, and landscapes set to 'authentic' or melodramatic soundtracks—pipes, fiddles, soaring strings" (128). A documentary is a careful balance. As Rosenstone so eloquently and evocatively describes them, their mandate "to sacrifice complexity to action, one that virtually every documentarist would accept, underlines a convention of the genre: the documentary bows to a double tyranny—which is to say, an ideology—of the necessary image and perpetual movement. And woe to those aspects of history that can neither be illustrated nor quickly summarized" (1988,

1180). Evidence in moving history documentaries proceeds through (a) archival arrangement, as in the compilation film, or (b) expert or witness interviews that rely on imprimatur or memory, often accompanied by visuals of reenactment or archival imagery—the evidence of the past in documentary moves and speaks. The question for archival material and interviews in documentary is, what is their deployment meant to prove, and how are these sources contextualized?

Diegetic Evidence

Let It Fall: Los Angeles 1982–1992 (2017) mixes the evidence of archival footage with witness and participant testimony about the events in the documentary. The archival evidence is extensive and, at times, augments or contradicts verbal testimony. The value of the evidence presented is enhanced by the wide range of interviewees selected, engaging a solid methodology of objectivity. The documentary is further strengthened by the complexity it brings to the characterization of those involved, avoiding the lure of mythical storytelling that pits heroes against villains. It combines evidentiary strategies through archival material that depicts the beating of Rodney King, Latisha Harlins's last moments as captured in security footage, and helicopter shots of Reginald Deny as he's pulled from his truck, contextualized by interviewees related to the events from multiple and often divergent perspectives. The unreliability of memory, malleable and prone to revision, is checked by the range of views included. In addition, the film interweaves personal recollections with news and camcorder footage of the events. Archival photographs and videos establish the contours of what happened, while individual testimony explores the range of human emotions, perspectives, and impacts that emanated from them.

Another approach to documentary evidence is taken in the compilation film. *They Shall Not Grow Old* (2018) is one example, displaying World War I film footage modernized through restoration, colorization, and motion-smoothing. Viewers focus on the imagery, movement, and faces of soldiers with little distraction aside from veteran interviews and sync speech reenacted to give voice to soldiers silenced in the footage. Much of the critical attention to the documentary remarked upon the digital enhancement of the material with astonished admiration or apprehension, and sometimes both. To appraise the validity or sacrilege of the film, one must consider the intentions of this laborious restoration that rebuilds and transforms diegetic, presentational material into a mimetic frame with color, soundscape, and motion alterations. The documentary's message is not to explain the geopolitics of the First World War or to document particular situations or battles but to revive moments and places to match much more closely what it would have looked and sounded like for those there and to enable audiences to relate to the soldiers as human beings and victims of imperial squabbles and circumstance. It is easier to mourn real people in the heightened realism of naturalistic sound, color, and motion than

glitchy apparitions. Looking upon the faces of men resting before an onslaught, in which audio commentary informs us that almost no one will survive, the film pays homage and laments the senseless sacrifice of these men who had the terrible misfortune to be born at a time and place that saw them shipped to those fields.

A purer, less adulterated compilation documentary, like *A Night at the Garden*, detailed previously, is far more straightforward in its use of evidence. It is all evidence. Director and editor Marshall Curry alters the data through the structuring of the edit. Its short length and simplicity reflect its goal, showing the audience a shocking event buried and hidden from historical consciousness. The environment of its reception supplies the context: this happened in the United States and may happen again or may be happening now.

Mimetic Documentary Evidence

A striking and innovative approach to documentary evidence appears in Joshua Oppenheimer's *The Act of Killing* (2012), featuring performative reenactments of mass murders by a perpetrator. The groundbreaking film features a technique called "archeological performance," a theory and practice conceived and developed by director Joshua Oppenheimer and collaborator Michael Uwemedimo as part of an earlier film, in which they ask interviewees to not only talk about the past but act it out. They describe archeological performance as a method that intertwines "a buried historical event, and its restaging with historical actors ... a process of simultaneous *historical excavation* (working down through the strata) and *histrionic reconstruction* (adding layers of stylized performance and recounting)" (2007, 181; emphasis in the original). As deployed in *The Act of Killing*, the technique mimes and reenacts to create an audiovisual performance for the camera from the historicizing processes of memory. In one such scene, the main character Anwar Congo role-plays on a rooftop to show how he strangled hundreds of people with wire. In the scene, he plays both himself and his victims. The performance reveals the past couched in layers of time and marked by the present. Congo demonstrates the murders he perpetrated in the 1960s, decades later, as an old and broken man. It transforms and fuses mimesis and diegesis, reenacting and telling as he shows and plays himself. Congo's enthusiastic acting out of his role and the actions of those he murdered is bookended by self-pitying complaints about the nightmares these actions have plagued him with over the years. The point of the film and its evidence is to present a psychological study of the perpetrator of a genocide.

Evidence Performed

Performance works deliver the historical world fully rendered with its ties to evidence severed and withheld from view. The audiovisuals of the past are presented through contemporary interpretations of action, speech, light, sound,

texture, and physical space. Every character and scrap of material in a performance history plays a part as someone or something else. Evidence only enters the mimetic frame as a moment of rupture, like the insertion of archival imagery, an indexical tractor beam that exposes the environment as a set, and characters as actors. Footage may be spliced directly into the main action, as in *Detroit* (2017), which intercuts chaotic representative performances of street scenes with archival presentational shots of the same events. Alternatively, films may insert archival material directly into an enacted mise-en-scène as a slice of authenticity. This is another tactic employed in *Detroit*, when the actors as characters watch archival news reports on a television that is part of the set. A layering of mimetic present-as-past with the diegetic past itself, the technique intermingles presentation and representation strategies. In the case of *Detroit*, these archival insertions provide direct evidence. The events are not in dispute. They have become entwined with the identity and history of the city, understood as a flashpoint for civil rights across the country. The incorporation of these documentary clips delivers a reflexive jolt to remind the audience: this happened.

Other evidentiary interjections may take the form of text, titles, or archival images cut into a sequence, as in *Free State of Jones* (2016). These choices may signal the deep historiographical intentions of the filmmaker or seek to acknowledge the profound impact of actual events and policies by showing audiences the faces of the actual people effected. Archival imagery serves all these purposes in *Free State of Jones*. One montage includes an image of the Thirteenth Amendment to the U.S. Constitution outlawing slavery, followed by photographs of soldiers at the end of the Civil War. Inserting titles or interstitial archival imagery is a reflexive practice with roots in the silent era (Smyth 2006, 36). Judicial and limited use of titles is critical as paratextual disruptions snap the metaphorical world of the performance history into a diegetic frame. For this reason, the place for evidence is typically not within the main text of the performance history.

Hybrid Evidence: Dual and Dueling Mediation

Hybrid films blend documentary forms of evidence with performance-based, present-tense reenactments in more equal measure. In the case of *Rise of Empires: Ottoman* (2020), some scenes are reinforced by interviews. The shift from richly rendered performance sequences to the commentary of interviewees reminds the audience of the skeletal sources for the vivid scenes depicted. In contrast, other scenes do not intersect with expert commentary, indicating that they offer pure creative inventions. Lower-third titles under the interviewees distinguish popular authors of this history from historians but do not define the academics' areas of expertise, some of whom have more tenuous claims to knowledge relevant to the history. The season heavily features Celâl Şengör, a geology professor

and expert in tectonics who appears in every episode. He is not called upon to speak to the geological implications of the siege; his inclusion is undoubtedly due to his charisma on camera and his enthusiastic zeal for the Ottomans.

Archival imagery is mostly inaccessible to a series like *Rise of Empires: Ottoman*, set as it is in the fifteenth century. One rare moment of documentary evidence occurs when historian Marios Philippides, professor emeritus at the University of Massachusetts Amherst and leading expert on this history, holds two Byzantine coins in his palm. He compares the heavy silver coin of Constantine XI's predecessor John VII Palaiologos to Constantine's thin copper to demonstrate that money was the core issue for the Byzantines. Philippides explains that "Constantinople was broke" (Şahin 2020). Audiences unfamiliar with the details of the fall of Constantinople take away from the series a deeper understanding of the details of the event and the motivations and sympathies on each side, while acknowledging that the primary mission of the series is to transport and entertain.

Errol Morris's *Wormwood* (2017) exemplifies another approach to hybrid histories. The series explores the death of CIA (Central Intelligence Agency) scientist Frank Olson in December 1953 and his son Eric's decades-long struggle to expose the death as something other than the suicide it was initially ruled. What is certain is that Frank Olson fell to his death from the thirteenth floor of the Hotel Statler in New York City. The series turns on the mystery of whether he jumped or was pushed after being given LSD (lysergic acid diethylamide) without his knowledge or consent by CIA colleagues nine days prior. With a four-hour runtime over six episodes, the series combines generic archival imagery to evoke the era with photos and footage specific to the Olson family and the political actors involved. Interviews with key witnesses and participants include Olson family lawyer David Rudovsky and journalist Seymour Hersh, among others. The heart of the series revolves around interviews with Eric Olson, whom Morris compares to Hamlet in a montage of shots of Laurence Olivier in that role in the film from 1948. The series crosses genres as a political thriller, a searing portrait of a dysfunctional family, and a moving history that catalogs the impact of a secretive government program with broad geopolitical implications. Artfully shot interviews from multiple vantage points, including two setups that bring Morris into the frame, are intermixed with interstitial cinematic reenactments. Performance sequences envision the Olson family home around the time of Frank's death, the evening he was given the LSD, and the hotel room and hallway on the evening he fell. *Wormwood* evolves a style introduced in *The Thin Blue Line* (1988) to a deep aesthetic richness. The series incorporates a new approach to the interview techniques that Morris has been developing over his career, combined with artful sequences with creatively rendered split screens and beautifully shot performance tableaux with prominent actors. In keeping with his philosophies about documentary and truth, Morris uses the performance scenes in a different manner from *Rise of Empires: Ottoman*. Rather than

functioning as the spine of the story, *Wormwood*'s reenactments adapt metahistorical experiments from *The Thin Blue Line* that use performance scenes as a sandbox for interpretation, exploring mood and considering a range of possible truths to surmise the most likely scenario rather than forwarding a confident sense of objective reality.

Paratextual Citation

Evidence takes various forms within the texts of moving histories. On one extreme, evidence makes up their entirety, as in compilation documentaries like *A Night at the Garden* and *Senna* (2010). On the other, evidence functions in preproduction as a mere springboard for the creative interpretation of performance-rendered histories that do not often gesture to evidence beyond art direction, as with *Vikings* (2013–2020) and *The Favourite* (2018), much like any historical fiction.

The gold standard of accountability in academic history is footnoting. Does it have a place in moving histories? In the AHR forum on the history film, historian David Herlihy indicts history films, in part because "footnotes cannot be filmed" (1988, 1188). Meanwhile, historians predisposed to viewing moving images as a medium for history often suggest they can be footnoted. In her 1987 essay, "Any Resemblance to Persons Living or Dead," Natalie Zemon Davis suggests footnotes as a method for film, although by 2000, in *Slaves on Screen*, she refrains from recommending specific historiographical techniques (1987, 478; 2000, 131). For his part, White sees no reason that films cannot defend their ideas or predicate via footnote (1988, 1196). He is theoretically correct that footnotes are possible, and since the 1990s and the advent of nonlinear digital editing, it has only become easier and less expensive to create and include them. Whether it works as an artistic or narrative device is another question. Films could footnote, but should they?

In their chapters in *Film and the Historian*, both Kuehl and Watt point out that reading allows for slowing down, revisiting, or rereading material, permitting an article or manuscript to pack in more detail without losing or alienating the reader. But a film, like a lecture, is a time-based medium, and its pace, under ideal conditions, is set by the artist or speaker. With writing, readers control when and whether they read citations. On-screen, in-frame footnotes distract from the immersive quality of moving images in an irritating and ineffective way. Footnotes could be a version of the subtitle that the home viewer could toggle on or off. But would any filmmaker want that as an option?

In-Text Citation

The documentary *The Agony and the Ecstasy of Phil Spector* (2008) gives a sense of the effect of real-time footnotes. The film presents quotes from articles about Spector and his work as a running lower-third text dialogue displayed

intermittently throughout the film. The effect adds a layer of distraction and strangeness appropriate to an already kitschy aesthetic that fits the film's specific subject but simultaneously demonstrates the unsuitability of the insertion of footnotes directly into more mainstream moving histories. Filmmaker fears that footnotes would violate the form, annoying and repelling most viewers, is well-founded and irreproachable. They would instantly turn any multimillion-dollar spectacle into an art film.

However, footnoting or historian commentary could be part of an "extras" menu as an engaging (and production-intensive) way to contextualize and link to sources. In fact, this technique works well, as showcased to great effect in the two short sequences that feature historian commentary in O'Connor's *Image as Artifact* video companion featuring Davis and Walkowitz (O'Connor 1990b). Incorporating a historian's commentary as an optional extra with moving histories would be a valuable development for the genre with great appeal for audiences, and it would be a benefit to historiophoty. Although only a segment of the audience may be interested, it would be a valuable exercise that opens the kinds of dialogue that moving histories ought to spur.

Credits

History's relationship to truth and trust relies on openness about research and evidence. Including source material in credits, as Davis recommends, is a sensible nod to the gravity and special status of the moving history (2000, 132; 1987, 476). Just as credits include legal information such as music rights and permissions, it follows that they could list sources as a form of bibliography or endnotes. Pertinent information includes who undertook the research, in what stages of production, and what sources informed the construction of the script, including essays, books, interviews, and consultants. Such a practice would not impact productions in an onerous way in terms of their budgets or labor. It would reframe the conversation about historical truth in moving images in constructive ways and give the audience an entry point to explore the evidence that shaped the narrative—should they elect to watch the credits.

By convention, moving histories come with mini bibliographies tucked into the credits through listings of researchers, consultants, and archives that contributed material if the work presents that material directly within the text. The credits of *The Fog of War: Eleven Lessons from the Life of Robert S. McNamara* (2003) list an archival research supervisor and six research assistants. Morris goes further in *Wormwood*, adding incentives for spectators to watch the credits, displaying the performance of a maid vacuuming the hallways of the Hotel Statler throughout the credit sequence, suggesting that there is something to stick around and see, but not something so exciting or distracting that it induces viewers to skip the reading part.

The last credit block in *Free State of Jones* includes a disclaimer in all caps that reads, "While this picture is based upon historical events, some names have

FIG. 2.1 Archival credits for *Wormwood*.

been changed, and certain characters, events, incidents, dialogue are fictionalized for the purposes of dramatization" (Ross 2016). A card dedicated to "Historical Consultants" appears after one for background players and before the credits for crew members. It lists eleven names along with their academic credentials and university affiliations.

Extratextual Citation

Given the *burden* that is history, evidence is consequential and not ancillary or optional but intrinsic to it. Providing evidence for the narrative argument and arrangement of any historical explanation is a critical methodology and necessary to history as "a way of providing perspectives on the present that contribute to the solutions of problems particular to our own time" (White 1966, 125). If not embedded within or appended to the narrative, how might citations be alternately attended to and addressed, in what forms, and to what effect?

Companion Works

Oliver Stone's *JFK* (1991) proves the power of moving histories as it made history several times over with its metahistorical and counterhistory aesthetics that altered the way performance histories were made while also prompting the U.S. government to disclose documents relating to the Warren Commission on the assassination of President Kennedy (Selk 2017; National Archives 2022). With only a handful of exceptions, Stone has concentrated primarily on historical topics in his films, working mainly in the performance mode and alternating between historical fictions and moving histories. He has made a string of biographical films in both performance and documentary modes and has been outspoken about the role of history films in culture while being fastidious about documenting his sources.

Stone's commitment to historiographical methods is unprecedented among mainstream filmmakers, as he has compiled and published massive bibliographical

compendiums to back up his narratives. In the case of *JFK*, he published an annotated screenplay alongside four hundred pages of essays, including presidential memos about the Vietnam War, the transcript of Jim Garrison's closing statement from the trial depicted in the film, and the full text of the Senate resolution from 1992 reopening the files relating to the assassination. The final section of the book catalogs government action undertaken in direct response to the movie (Stone and Sklar 1992, 531–571).

Many have criticized Stone's tactics, especially those employed in *JFK*, for confusing the boundaries of performance and documentary history while dealing in conspiracy theories. Stone again sought to engage the historical record to preempt his critics in his subsequent moving history, *Nixon* (1995). This time, he published an annotated script with a "swarm of footnotes" and an accompanying CD-ROM with over seventy thousand documents (Stubbs 2013, 185). The annotated screenplay is a comprehensive and elegant method of translating citation methods to moving histories, creating a space where the filmmakers might meet historians halfway on shared territory. And yet, while Stone takes citations seriously, and his care and effort are impressive and laudable, the sheer scale of these annotations and references may diminish their effect if the intention is to detail sources for the audience. How many have the interest or patience to access and wade through these mountainous references? These intimidating volumes of information may themselves be the message that Stone wishes to send.

A scientific study on the immediate audience effects of *JFK* concludes that the filmmaker and audience share the responsibility of sorting out fact from fiction. Investigations into the influence of the movie on spectators found that "emotions, beliefs, and behavioral intentions can be significantly influenced by a movie such as *JFK* [and this] should strongly underscore concern that the media, even the cinema where fiction and fact may be unabashedly indistinguishable, is a powerful tool both for education and for misinformation. Although Hitler's propaganda filmmakers demonstrated this point some years ago, the message remains vital in our information- and media-rich democratic society. Clearly, even when the filmmaker aims to educate, the responsibility for attaining perspective, balance, and verity has to lie not only with the media-maker but also with the media-consumer" (Butler, Koopman, and Zimbardo 1995, 255).

These findings raise further questions. Do audiences feel any such responsibility to seek balance and perspective? Even if spectators search for more information, how equipped are most to assess the quality of information? Consider historians themselves. A specialist in some aspect of the Boer War may be well equipped to decipher what is legitimate in the argument and depiction of *Breaker Morant* (1980), but how prepared is this person to contextualize *Free State of Jones*, *Rise of Empires: Ottoman*, or *Let It Fall: Los Angeles 1982–1992*? What is the filmmaker's responsibility, and does it extend beyond the film? What is the appropriate venue for citations and further context?

Digital Paratext

Digital media expands the options for citation exponentially. Websites offer a platform for filmmakers to connect directly with audiences and an opportunity to lay out source material. Although spectators interested to know more about a given history might go directly to Google and Wikipedia for information, transmedia outreach possibilities allow new ways for productions to attract, engage, and interact with audiences in an accessible manner. Transmedia extensions through websites, podcasts, and social media tie-ins enable a space to provide evidence and context that does not interrupt the flow of the core audiovisual narrative. The next section surveys moving history companion content in the form of websites and documentary supplements created by members of a film's production team to consider how these digital extensions serve as resources.

Companion Websites

The documentary *Let It Fall: Los Angeles 1982–1992*, created under the aegis of Lincoln Square Productions for ABC News, does not maintain a website. *They Shall Not Grow Old*'s website is limited, featuring a trailer hosted through YouTube with links to Facebook and Twitter. The two other documentaries referenced in this chapter support websites that function in dialogue with the films and as bibliographical extensions.

The Act of Killing's home page offers pop-up information on how to purchase the documentary upfront. The site has pages dedicated to press package materials, a trailer, stills, news, and awards alongside links to social media. A "background" page addresses the historiographical approach of the filmmakers and the historical context. The page features two tabs that are also files available as downloadable PDFs. "Production Notes" details the "archeological performance" process undertaken by the filmmakers. The second tab, entitled "Historical Context," offers a six-hundred-word summary of the history of the Indonesian genocide of 1965 to 1966, an analysis credited to historian John Roosa, a specialist in the history ("Act of Killing," n.d.).

A Night at the Garden's website is an expertly compiled historical resource featuring the Vimeo-hosted short in its entirety with reviews, a synopsis, a director Q&A, a miniarchive of media related to the 1939 rally, and film credits. The Q&A page contains pertinent historical context and details about director Curry's process. He describes his initial intention to make a much longer documentary featuring interviews with historians mixed with the archival footage before ultimately deciding "there was a real power in just watching it unfold without explanation . . . keep[ing] it pure and cinematic and unmediated"; Curry explains his stated goal, which is for the film to function more as a "cautionary tale" than an "indictment" of the past ("Night at the Garden," n.d.). His claim that it is more powerful for audience members to draw connections

FIG. 2.2 Historical context available on *The Act of Killing*'s website.

between threats past and present themselves, rather than via expert testimony, is convincing and insightful. Curry's answers range from discussing the context of the event in 1939 to reflecting upon why this is a forgotten history. He suggests that many aspects of what happened are "eerily contemporary" without being more specific ("Night at the Garden," n.d.). The creation and release of this film in an era of Trump rallies presented in news footage that habitually showed protesters roughed up as they were removed makes the meaning of the documentary to the present implicit. The connection feels more potent as an unprompted association made visually by spectators rather than if the patterns were spelled out by the filmmaker.

The Q&A section includes clickable links to *New York Times* articles about the rally and its aftermath, published within days and weeks of the event. The site's media section is a well-curated collection of primary and secondary reference material about the film and the history it details. Another link includes a television commercial for the documentary that aired on MSNBC and CNN with the note that it was rejected as "unsuitable for air" by Fox News. Visitors to the site may also access WNYC archives of the rally that include speech transcripts, an image of antifascist flyers handed out to the crowd, and a range of articles and other media released in the wake of Curry's film.

Both documentaries' websites provide valuable information about formal and aesthetic choices and broader context about the events the films depict. Each does so in a replicable format that suits web-based media and is highly accessible to many. These sites are the product of filmmakers with keen historiological commitments that extend beyond supporting the success of their films. They provide entry into an understanding of their processes and aims, offering a deeper grasp of the history. *The Act of Killing* achieves this through detailed

FIG. 2.3 Archival material on *A Night at the Garden*'s website features an article about the rally published the following day.

written analysis, *A Night at the Garden* through a tailored and intuitive multimedia archive.

The stolid commitment to external context and citation evinced on companion websites by the documentaries in this chapter does not extend to the hybrid histories. Only *Rise of Empires: Ottoman* maintains a website, but it is exclusively geared toward promoting and marketing the series. The home page features a pop-up to the trailer hosted on Vimeo, footage from the series, and a box to enter an email address to "request an episode." The website also includes pages "about the series," for the "trailer," and "about STX television." The "about the series" tab features artwork in the form of four promotional posters (*Rise of Empires*: *Ottoman*, n.d.).

Detroit once housed a website. Accessible for several years after its premiere, the *Detroit* site's prime purpose was to function as a virtual marketplace. *Detroit*'s home page included several hyperlinked sections: "Film," "1967," "True Stories," and "Tickets." On the "Film" page, visitors could click on three featured images from the movie to open them as full-screen images. The "1967" page functioned in the same way with four archival photographs. The "True Stories" page hosted six images linked to short videos hosted on YouTube, most under one minute. Two videos featured interviews with actors from the

film talking about the production process and their opinions about the history, intercut with clips from the film. The third video was the longest at ninety seconds, featuring clips of Black police officers, their names and titles displayed, addressing the sociocultural milieu of Detroit in 1967 as one of high tension. The other half of the videos were short, approximately forty-second vox populi interviews. The final page, "Tickets," linked to information about where to see the film and functioned as the website's focal point. The short videos featuring movie clips and interviews with witnesses to the events in 1967, and those involved in the 2017 film, were reworked into short, informative video documentaries packaged with the digital purchase of the film. Despite the low cost to maintain websites, the limited run of companion websites like this highlights the temporal nature of much web-based paratext. Even movies like *Detroit*, with more financial resources than *The Act of Killing* or *A Night at the Garden*, may opt for a limited-time-only web presence.

In stark contrast to *Detroit*, *Free State of Jones* hosts a website with detailed and accessible methodological attention to historical detail that adeptly addresses citations in the language of historiophoty. Designed at Gary Ross's behest by the "For Good Measure" web design company and paid for by the film's production company STX, the *Free State of Jones* website provides a template for what academic rigor and accessibility look like in hyperlinks (Free State of Jones, n.d.; Ross 2018). A *New York Times* piece published days before the film's theatrical premiere, "A Confederate Dissident, in a Film with Footnotes," explains that thanks to its "elaborate website," it is the first Hollywood drama to come with an extensive index of citations (Schuessler 2016). The website presents an intuitive and audiovisual interpretation of academic footnotes initiated by a filmmaker with a clear interest and acumen in research and audience engagement. It aesthetically and intellectually exploits the possibilities of the web to guide people through historical context, providing insightful background information on filmic choices, presenting evidence, and flagging departures from the record.

The landing page features an action shot from the film with Matthew McConaughey as Newton Knight in the trenches of the Civil War. From here, the site prompts the viewer to scroll down to a "foreword" by Ross wherein he explains the goal of the site, stating,

> We felt it was important in an historical movie, especially a movie about such a crucial time in history, for the audience to know what was true and what was fictionalized, even if it was based on underlying source material.
>
> In this site you will be able to navigate through the entire movie, click on the areas that interest you, and see a brief explanation of the historical facts that informed the screenplay. If you are more curious about that part of the movie, we have footnoted the paragraph to see sources on which it is based. But footnotes themselves can be misleading, so if you want to see the entire primary source, you

FIG. 2.4 The *Free State of Jones* website lays out the film's structure in sections with screenshots, summaries, and responsive, clickable footnotes.

can click again and be transported to the original document. We hope this is helpful, maybe even fun. Some things need to be invented in a movie, but most things in Jones were not. I think it's only right that you are able to tell which was which. (Gary Ross, director, Free State of Jones, n.d.)

From there, the site invites the visitor to enter. The next page breaks the 140-minute film into thirty-five sections. Each of the thirty-five parts includes an image and an explanatory paragraph with clickable footnotes that lead to direct citations from sources. These, in turn, are also clickable, taking the reader a layer deeper to an extended excerpt or directly to the specific reference itself.

Composite Characters and Creative Reinterpretations

Another notable aspect of the site is how it handles parts of the film that deviate from the historical record, as if in direct response to Davis's provisos for history films, asking that works signal when evidence is "ambiguous or uncertain or contradictory" and to "not knowingly falsify events, or suppress evidence" (Davis 2000, 10–12). The website accords with her first plea and openly admits to its violation of the second. It functions to satisfy the demands of historical accountability without puncturing the core text's immersion and temporal transport. Section 23, entitled "Retaliation and the Church Ambush," outlines creative liberties taken, explaining that "the action has been moved from a creek to a church for cinematic purposes," and includes two clickable footnotes to citations about the actual event. However, the description does not inform readers that the ambush victim, Colonel Elias Hood, is a fictionalized

composite character. Likely inspired by the historical figure Major Amos McLemore, Hood oversees the rounding up of deserters from the Confederate Army before Knight kills him (History vs. Hollywood, n.d.). Whereas McLemore is believed to have been shot by Knight while he met with other Confederate soldiers in another man's home, in the film, Knight strangles Hood with Hood's belt in a church that the website acknowledges stands in for a historical creekside battle (Bynum 2016, 105). Although the site does not contextualize this character amalgam, it explains others.

Daniel, depicted on the opening image of the site and the poster and publicity stills for the film, functions in the plot as the catalyst for Knight's actions. Section "06. On Daniel" explains the "whole-cloth creation" of the character of Knight's nephew to illustrate the effects of the "Twenty Negro Law" that released wealthy enslavers from battle, shifting the burden to the poor (Free State of Jones, n.d.). The film forgoes the historical understanding of Knight's desertion—namely, the home front threat of a man named Bill Morgan, who had supplanted Knight in the family household (Bynum 2016, 100). Instead, the film trades an intriguing and high stakes historical catalyst that sheds light upon the complex realities of the U.S. Civil War for one based on pure principle, following the impetus of so many historical fictionalizations to idealize human motivation and incentives (Davis 2000, 85), as will be explored further through the principle of foreignness. This creative reimagining in the film has Knight desert the battlefield to bury his young nephew in an impulse owing more to Sophocles's *Antigone* than the established record of Newton Knight. On the site, Ross explains, "Daniel was, therefore, a fictional invention to explore these issues: the outrage of conscription, the class division inherent in it, and the human cost of the war even to boys in their mid-teens. . . . I wanted to put a face on that. Daniel seemed the best way to do it" (Free State of Jones, n.d.).

The section entitled "12. On Moses" highlights the Moses character as "a fictional invention, but one based on research and ample precedent," citing "numerous examples of cooperation and alliance between maroons (escaped slaves living autonomously in the wilderness) and white deserters who resisted the Confederacy" (Free State of Jones, n.d.). Ross further notes that "it would be irresponsible to simply tell a story of white yeoman resistance to the Confederacy without depicting African American resistance as well. The extent to which African Americans were agents in their own emancipation has been too often understated in both historical texts and films" (Free State of Jones, n.d.). Ross emphasizes the dignity with which Mahershala Ali portrays Moses in his character's description as "a former slave who refuses to accept the subjugation of chattel slavery. At no time in the film is he subordinated to the slavocracy," which is part of an explanation that includes links to two books as sources (Free State of Jones, n.d.).

FIG. 2.5 Composite characters contextualized in *Free State of Jones*.

In highlighting deviations from historical evidence, the website invites the reader to consider how much latitude moving histories take in detaching from facts and constructing myths and metaphors. In *Writing History in Film*, William Guynn explains that "facts serve as fixed anchors of discourse" and that they ensure that we are not "cast adrift in the arbitrariness of fiction" (2006, 44). Evidence is the dividing line of history. While Rosenstone allows for "symbolic" or metaphorical "invention," he distinguishes between "true invention" as exemplified in *Glory* (1989), in which details are imagined, and characters composited in a way that is faithful to "the historical discourse" and "false invention," such as in *Mississippi Burning*, that distorts history and sidelines Black people in favor of highly fictionalized White saviors (1995b, 72–73; 2012, 73). But on Guynn's side of the ledger, detaching from truth and facts makes for a competition of metaphors that become almost impossible for spectators to arbitrate. Although such symbolism may be inextricably part of our language, metaphor is best invoked as syntax rather than semantics, forming imagery or motifs rather than expressed through plot and deployed to alter known characters and events.

Filmmakers create composite characters for two core reasons, either for narrative expediency or to make up for exclusions in the archival record. Both motivations fuel the creation of fictional characters depicted alongside historical agents in *Free State of Jones*. Moses is important, an amalgamation to make up for prejudices and failures of the historical record. But why was Hood not McLemore? Would creative invention not best be relegated to the necessary connective tissue of evidence to fill out characters ignored by history rather than being a part of an intentional alteration of known data? As Davis suggests,

there is a difference between addressing unknowns about the past versus forming "approximate truths," exploring "thought experiments," omitting relevant information, or intentionally subverting known information (2000, 127). At the same time, approximations like these will be part of every moving history narrative. Ross is exemplary in his historiographical care and transparency about alterations, even as some of his decisions might be respectfully challenged. The template set by the *Free State of Jones* website allows a place to highlight cinematic revisioning and invention for contemplation by the audience. Its director commentary extends beyond footnoting, as though acknowledging Jordanova's point that since sources alone cannot create a complete picture, an openness about the author's selection criteria is required (2019, 96).

Companion Documentaries

Digital distribution has led to the packaging of companion documentaries delivered as *extras* with many moving histories, as is the case for the documentary *They Shall Not Grow Old* and the performance histories *Detroit*, *The Last Duel*, and *Free State of Jones*. These companions contextualize the films, each employing various methods toward assorted results.

Purchase of a digital download or DVD of *Detroit* comes with six documentary extras or special features ranging from 1 to 3.5 minutes in length. The videos package several interviews previously available on the film's website. The short documentaries intercut scenes from the movie with archival footage and abbreviated interview clips. Interviewees include director Kathryn Bigelow, key cast members, and writer Mark Boal, alongside those who experienced the events firsthand at the Hotel Algiers, including Melvin Dismukes and Julie Hysell, both of whom feature as central characters in the film. Ike McKinnon, a police officer at the time of the film, who served as Detroit's police chief from 1993 to 1998, also appears. The video "The Truth of Detroit" includes journalist David Zemon explaining that in 1967, Detroit was 40 percent Black and was policed by a force that was 95 percent White. A video entitled "The Invasion of Detroit" includes full-screen titles detailing the military and police presence on the streets including "8,000 national guards 4,700 combat troops and 360 state police" resulting in "43 killed 1,189 injured 7,231 arrested" (Bigelow 2017). A final video, "Algee Smith and Larry Reed: GROW," depicts Reed, a founding member of the Motown group the Dramatics and a focal character of the film who survived the incident at the Hotel Algiers, performing a song for the movie with Smith, the actor who played him. The content is short, sacrificing context for economy in communicating key aspects of the filmmaking team's intentions, concerns, and point of view while moving audiences through the emotions of frustration, lamentation, and anger to cautious hope.

An uncredited eighteen-minute documentary, *The History of Jones County* (2016), accompanies a *Free State of Jones* download or DVD. The documentary features interviews with contemporary residents of Jones County that include

Knight's descendants, historians, descendants who are also historians, and Victoria Bynum, the historian whose book serves as a key source for the feature film. Rather than focusing on the filmmakers' intentions, the interview-based documentary explores the history that the film is about, focusing on the environment in which Knight acted and the residual effects on the community.

Methodological Context

The thirty-minute documentary companion, *The Making of They Shall Not Grow Old* (2018), features director Peter Jackson directly addressing viewers, acting as a guide through a detailed summary of the methods and motives that guided the making of *They Shall Not Grow Old*. Aside from brief on-screen appearances, most of the documentary (about the documentary) is built around Jackson's voice-over, providing context about his intentions, choices, and the mechanics of the production process. It includes scenes in the editing suites, descriptions of the technical properties of the original footage, details about the context of filming in the war, breakdowns of the many methods used to update the footage, and the rationale for the aesthetic and structural choices made in the film.

For example, as part of the colorization process, Jackson traveled to Belgium and France to photograph the color of the landscapes and grass to ensure chromatic fidelity. Like *A Night at the Garden*, Jackson discusses his decision to bypass interviewing historians and limit voice-over to interviews with World War I veterans shot decades after the war. The raw materials of the documentary comprised one hundred hours of archival visuals and six hundred hours of veteran interviews. Jackson details several challenges presented by the footage and the filmmaker's chosen work-arounds. Because the material did not include depictions of intense fighting or hand-to-hand combat, the production team chose to depict the faces of soldiers previously shown in the film to create a sense of camaraderie and familiarity for audiences when cutting those images with veteran commentary about the experience of losing friends. Jackson describes his use of external source material to inform the narrative, mentioning the critical distance required to filter the nationalism inherent in contemporary soldier and home front magazines and newspapers.

In addition, he explains the process of audio reenactment, employing forensic lip readers to fill the void of the silent footage. The production researched the regiments depicted and matched them with actors from the same regions to perform dialogue reenactments to accompany the visuals. Jackson's interview closes by explaining exclusions from the film and the rationale. Citing the vital contributions of women and colonial soldiers from across the globe, his grandfather among the latter group, he notes that he opted to focus on British soldiers as an archetype. He further reveals his personal impetus for doing the film in tribute to his grandfather, who survived the war only to be plagued by illness from injuries he had sustained and die at age fifty. In closing, he describes the

film as one made by "a non-historian for non-historians," hoping that it will lead audiences to ask their relatives if a family member was involved in the war to learn more about it. The documentary functions as a comprehensive afterword that supplies a range of relevant historiographical, narratological, and methodological context.

Pure Extra

Supplemental documentaries do not always have explicit historiographical intentions. *The Making of The Last Duel* (2021) is a fast-moving confection of quick and jarring edits of behind-the-scenes footage match cut with shots from the final film and occasional black-and-white images interlaced as pseudo freeze-frames. It bypasses consideration of the historical context. There is no reference to the past beyond the costumes and mise-en-scènes on display. Directed and shot by Ridley Scott's granddaughter, Cuba Scott, the companion documentary captures and capitalizes on the frenzy of production in various locations. It also includes snippets of the elder Scott's filmmaking method, peeking into his production notebooks replete with extensive storyboarding.

Nonetheless, a few captured moments of Ridley Scott at work do reveal aspects of his philosophy on filmmaking with some real insights into historiophoty. In one scene, he stands in the video village, a tent filled with monitors, watching a battle scene. He exits, complaining, "It doesn't tell the story! It's just fighting!" His outburst offers keen introspection into the deeper motives behind his distinctive brand of battle filming and choreography. In this way, the documentary underlines two central aspects of performance histories: (a) they must shape history into a continual stream of motivated meaning and narrative propulsion, an acknowledgment that transposes and reinforces Rosenstone's comment about the necessity of perpetual movement in documentary to the performance history, and (b) they reveal the massive undertaking of productions set in the past and the epic scale of funding and effort they require.

Moving Histories' Purpose: Discussion and Dialogue

Ultimately, evidentiary proof does not guarantee the quality of evidence, and its methods can link to any manner of myth, conspiracy, or politicized agenda. Therefore, the necessary corollary of citation is discussion and the weighing of evidence by an audience. Because moving histories speak to our shared reality, we have a stake in their depictions as they breathe meaning into our customs, laws, cultures, and sense of identity, heritage, and inherited values. Moving histories stoke ideas not fully processed by mere watching. And yet, where does the dialogue and discussion of a moving history take place? This is perhaps the aspect of history's method, vital as it is, that is least tangible in popular modes of history.

Stella Bruzzi describes moving image works set in the past, from history documentaries through to those about fictional events and characters, as "approximations" that are "both figurative and imaginary structures, the stagings of evidence and fact, re-enactments of the pooled resources of filmmakers, spectators, historians other collators of evidence" (2020, 5). Further, she suggests that an approximation "comes into being as its multiple elements connect and collide," as they depend on "active interactions with facts and history and the equally active engagement of a receptive audience" (3). These collisions occur within the body of each spectator whose impressions may surface to be expressed and exchanged with others in face-to-face encounters or online in the scattershot silos of social media, in film and television reviews, apps, websites, blogs, podcasts, or film and history scholarship. When historian Donald Watt cataloged his list of the "curses" of "History on the Public Screen," he noted the absence of any serious and well-informed criticism (1976, 173). Key illustrations of engaging, accessible, and generative online criticism and dialogue about moving histories include analyses offered by websites like History vs. Hollywood and the thoughtfully researched, fun, and captivating video essays made by Nick Hodges for his *History Buffs* YouTube channel. Audience appraisals of moving histories and their claims are highlights of the form.

Out of respect for the ambitious intentions and herculean efforts of moving history makers, discussion of moving histories should veer less often into accounting, recrimination, and watching for anachronistic slipups toward discussions of what the film aims to say: its themes, moral judgments, and interpretation of historical evidence. Here, Carl Plantinga's tenets of ethical criticism are instructive for historiophoty, particularly in the reception process and ensuing dialogue about the merits of evidence, truth, and meaning of a given work. Plantinga advocates for "openminded" approaches that discuss, appreciate, and devote serious analysis to "mainstream work," allowing a space for "expansive" considerations "rather than homing in on one element," not only focusing on critique but commending and acknowledging when there are triumphs of "immersion and absorption," an approach that values the artistry of orchestrating emotional impact (2018, 250). Just as interpretations of the past in moving histories should not sort historical agents into binaries of good and evil, our response to those interpretations ought to strive for nuance. Weighing and challenging the choices made in translating historical data into a moving history is an integral part of the creative life span of each work.

A recent dustup around the former president of the American Historical Association demonstrates this point. In his President's Letter of August 2022, James H. Sweet diagnosed the effects of a culture drowned in "an overabundance of history, not as method or analysis, but as anachronistic data points for the articulation of competing politics" (2022). In the essay, he brings moving histories into the discussion by citing *The Woman King* (2022) as an example of

this kind of history, pointing to significant and distorting departures from historical data in the film. His comments brought on an onslaught of criticism that revealed both the effects of contemporary digital culture and proved his point about the depth of personal and political resonance in history. Although some responses, like that of historian Malcolm Foley, were open and considered in questioning and addressing Sweet's argument, many more were not (Foley and Satia 2022; Frum 2022).

The crucial endpoint for evidence in moving histories takes shape in the dialogue that emerges in the dissemination process. Although Sweet equivocates, writing that Hollywood is no more obligated to attend to history's methodologies than institutions of journalism or tourism, he stipulates that "bad history yields bad politics" (2022). This suggests that a methodology of some sort is in order, so why not history's methodologies adapted to purpose? Herein lies the argument of this book. History is essential to our politics and understandings, past, present, and future. Therefore, public historians who speak to the crowd, whether via the page or any kind of screen, are very much obligated to attend to history's methodologies, transposed to serve their specific environment. If specialists build tools designed for a particular job, why would those pursuing that effort in a different venue ignore those tools?

One thing we can say about every work in this chapter is that it was a project made by people who care about history. Although this does not mean that their work should not be criticized or critiqued; after all, even the most altruistic or civic-minded intentions do not guard against misinterpretations or even bad histories. Still, many moving histories deserve to be met with an acknowledgment of the sincerity with which they were made. Because the audience for moving histories is so broad and the internet so compartmentalized and diffuse, their widespread impact will remain difficult to quantify and extrapolate. Nonetheless, even if it is barely perceptible in the immediate wake of the release of a moving history, many succeed in nudging the culture toward new considerations, interpretations, and internalizations of the past. Whether they inspire praise or critique, moving histories can equip and orient us to consider and strive for different futures.

In a section dubbed "Prologue" on the *Free State of Jones* website, Ross provides an enlightening look into the considerations of a filmmaker who endeavors to meet the twin pressures of respecting the responsibilities of history and achieving popular resonance. When we gain awareness of the perspective and goals of the filmmaker, we gain a broader understanding of the evidence and its selection, interpretation, and deployment. Ross's reflections are revealing and thus will be quoted at some length here. Reflecting on the process and impact of history in moving images, he writes that

> historical films are an odd hybrid. They have constraints of traditional nonfiction writing and the dramatic demands of popular filmmaking. It's no wonder that they

occasionally wind up in the middle of an argument: How much creative license is legitimate? How much responsibility to history does the filmmaker have?

In the modern world, where we get so much of our information from popular culture, the filmmaker is under even more pressure. Today, people read less and watch more, and whether we like it or not, academic history is often overwhelmed by popular history. *Les Mis* actually *becomes* the French Revolution, *Homeland* is somehow the "real" war on terror, and Lincoln is inevitably remembered as he was in *Lincoln*.

On the other hand, it is, of course, impossible to craft a narrative film that adheres to every minute detail or factual incident of a historical subject. As filmmakers, we have to imagine the private moments, make sense of the character arcs and motivations, let the audience peek behind the sweep of history to glimpse the personal details that often don't exist in the public record. (Free State of Jones, n.d.)

Some scholars couch efforts to recount the real in terms of inevitable failure, but this is a matter of expectation. If one has an unrealistic goal, such as knowing an absolute truth that remains constant over time, yes, one will fail. In a mood of moderating expectations, Bruzzi evocatively describes history in moving images as "stagings of evidence" that do not constitute "failure" but instead offer a "constructive opening up of a film or performance to multiple perspectives and interpretations, which in turn are the embodiment of the inherent fracturedness of reality and the performative instability of 'realness'" (2020, 7). If histories always fail at absolute truth, then it makes sense to toss out the idea of absolute truth as an irrelevant fantasy to move on to the consideration of their aspirations, best practices, meanings, and effects.

Show Your Work

Understandably, many filmmakers may prefer not to take the defensive stance that citations imply. It might expose filmmakers to criticism and give spectators more avenues for complaint, especially if they disagree with the underlying argument or deem the citations inadequate. With accounting for historical truth, there is the risk of more attention, criticism, and pushback. Critique may be welcomed in the process of developing a work, but it is less enjoyable for the exhausted author of a finished piece. Although it is part of the environment of historiography and expected in the academic sphere, it is far more combustible in the mainstream film ecosystem.

Nonetheless, for those with the courage and passion to take on the burden of history with integrity and commitment, it is surely worth it. Just as with complex math problems, historians of any medium have a responsibility to show their work and the route they took to their conclusions, their historical sum. It becomes more important as we leave the analog age for the digital. Now,

the already substantial power of narration and structuring may be buttressed by indetectable CGI, deepfakes, and the invisible, synthetic hand of artificial intelligence (AI). In this view, the evidentiary framework established around *Free State of Jones* by its writer and director, Gary Ross, already an impressive achievement, becomes a *necessary template* for moving histories and the work of people like Nick Hodges and his *History Buffs* project even more imperative.

One practical outcome of decades of scholarship across the disciplines of film and history accumulated into our internet era is that filmmakers can more easily and effectively include source material as part of the package of historical films and series. The exemplary transmedia paratexts detailed in this chapter by filmmakers who were clearly involved and invested in their creations—including the websites of Curry, Oppenheimer, and especially Ross, along with Jackson's companion documentary—address a point made by Jordanova when she writes that audiences and auditors ought to be met with "transparency" and given "access to the resources authors use" (2019, 129). But she has a tricky and uncomfortable qualification about popular histories, stating, "There is no reason why the general public, which is not after all composed of scholars, would want the apparatus made visible" (97). Although evidence is undeniably a part of the burden of history, ultimately, the interplay of evidence with moving histories will only matter to filmmakers if it matters to audiences; this book argues it should.

The next chapter turns to the aesthetic mechanism in which another aspect of the apparatus is revealed, the medium itself, as part of the principle of reflexivity.

3

Reflexivity

●●●●●●●●●●●●●●●●●●●●●●

What is the role and range of reflexivity in moving histories?

The combination of arresting visuals, quick editing, and the narrative structuring of meaning in moving histories creates an experience that undeniably privileges affective engagement over critical distance. Despite intuitively understanding that moving histories cook up narratives with mixed fidelity to the imperatives of historical evidence and entertainment, spectators internalize what they watch as a form of knowledge about the past.

Reflexivity functions as a breaker switch to audience experience, shifting from past to present, screen world to real world, absorption to alienation, and affect to reflective thought. As Alison Landsberg evocatively describes, it results in experiences that "disorient the viewer, 'forcibly' pushing him or her out of the narrative and back into his or her own body" (2015, 27). As audiences enfold themselves in audiovisual time travel, they may forget the vehicle and their role as voyeurs. With a clap, reflexivity transports spectators, at the speed of light, from the historical world of the mise-en-scène back into their lives in the ever-unfurling present. Reflexivity in moving histories offers mini bursts of self-awareness, awakening spectators briefly before they roll over and reenter the dream. The principle of reflexivity explores the "rupture" techniques that Landsberg calls for and cites as tools to acknowledge our distance from that past, a stance "crucial to the historian's critical disposition" (26–27).

Reflexivity plants a flag for circumspection, creating a "moment" in which an audience member "is made suspicious of the 'facts' of a story or the ulterior motives of a narrator, he or she immediately becomes hermeneutically alert" (Bruner 1991, 10). The last chapter examined evidence, including how

transmedia constellations, companion documentaries, and websites create an external web of references that contextualize a moving history. The principle of reflexivity deals not with those ancillary epitexts but with the core text itself. As historian Robert Berkhofer describes it, reflexivity means including a countertext within the work itself (1998, 244). Paul Ricœur recommends this historiographical method of foregrounding self-reflexivity and point of view directly into a text as "the historian's actual reflection on the moment of representation" (2004, 223). Such interjections operate as a dramatic gear shift between perspectives and time periods that draw attention to the medium.

It is a surprisingly old impulse integral to creative work, as Robert Stam reveals in *Reflexivity in Film and Literature: From Don Quixote to Jean-Luc Godard*. He explains that "all art has thrived on the tension between reflexivity and illusionism, between *trompe-l'oeil* [illusionism] and *clin d'oeil* [reflexivity]" (1985, 2; emphasis in the original). According to Stam, realism functions "as a body of stylistic devices, a set of conventions that, at a given moment in history, manages to generate a strong feeling of authenticity" (15). Reflexivity takes two forms, interstitial or total (Limoges 2021, 187). Total reflexivity is primarily the purview of avant-garde and art film. With the noted exception of satirical emplotments, the reflexive asserts itself in moving histories through interstitial incursions of the aesthetics of avant-garde cinema or boundary crossings between performance and documentary modes.

Reflexivity is native to documentary. Documentaries are often less linear, causal, and cohesive than performance histories, presenting a structure and logic through collage and pastiche patterns, jumping between characters, back and forth through time, and mixing modalities between interviews and archival material or reenactment. Although this chapter will explore all modes of moving history, performance histories will receive special attention as the *trompe-l'oeil* mode par excellence and the one most challenged and altered by reflexive interruptions.

As explored in the principle of narration, moving images build authority and believability atop our evolved tendency to believe what we see, which reads as objective. It naturally follows that we are more likely to perceive what we are told as subjective, an expression of another person's perspective and opinion. In moving histories, reflexivity gives audiences pause to consider the mediating factors of the apparatus and its poetics, which pass through human judgment and interpretation over an allotted and extended period of time.

The Overpowering Image

A great deal of the intensity of moving histories is bound in their visuals. This seems obvious. What is surprising and less intuitive is how central images are to prose history. Drawing on Augustine's meditations on time, Paul Ricœur asks,

"What is it to remember? It is to have an image of the past . . . this image is an impression left by events, an impression that remains in the mind" (2009, 10). Similarly, Frank Ankersmit proclaims that the goal of historical writing is to create images (1983, 98). While David Lowenthal describes the work of the historian as a complex process of translating images into words and back into images (1985, 217). In his characteristically evocative style, Robert Rosenstone warns about the effect of the supplied visuals of the "spectacle" of film that destroy "critical distance" as "huge images on the screen and the wraparound sounds overwhelm us, swamp our senses, and destroy attempts to remain aloof, distanced, critical. In the movie theater, we are, for a time, prisoners to history" (1988, 1177). Due to the convincing directness, specificity, and fullness of the image in moving histories, the alienation effect of reflexivity is all the more disruptive, striking, and necessary. The ability of moving images to materialize our dreams, memories, and thoughts as sound, light, and movement is formidable, transmitting the theater of the human mind into a shareable display. Filmmakers project pictures suffused with meaning into other people's consciousnesses.

Memory and the Production Practices of Our Own Private Screening Room

The foundation of history sits atop memory. Both memory and history function by reanimating archival traces of the past in the present. Although memory seems like a video called up and projected in the mind, it is instead more malleable, like theater, ordered up and staged each time anew from a personal screenplay. Contemporary neuroscience posits that the brain stores sound and images separately with information archived moment by moment, and as "we remember a past event, the brain pulls out the script and puts on a little performance . . . part of the brain stores the script, while others are responsible for the stage, setting and props" (Carroll 2019, 324).

Most crucial to this process is that each time we replay a memory, we reinterpret it afresh at that moment and then store a revised version—without notations about changes from one draft edition to the next. What we remember is not the original experience but the last time we remembered it (Montague 2018, 48). In building and rebuilding a memory, the materials are a jumble of "stories told to us, ideas and facts layered onto experiences and photographs," all assembled seamlessly at the time of remembering (68). Therefore, what we think of as revisiting our experience in the elementary schoolyard may be a trip back in time of only a week or two to the last time we thought of it. From an interpretation that may have been faulty to begin with, we further encode the noise or bias of our perspective, values, and attention each time we subsequently recall it. Ricœur warns that as a result of the interdependence of identity, memory, and history, identity exerts pressure on memory and distorts it (2004, 80–81). As we make meaning from the past, we bend evidence to affirm an a priori understanding of ourselves and how the world works. No less than the interpretation of our reality and our personal identity is at stake.

We narrativize ourselves and navigate our lives in terms of actions and reactions, causes and effects. These processes inform the meaning we extract from experience. The role of reflexivity is to remind us of the instability of these narratives. Its goal is to illuminate our tunnels to the past, not to undermine them. Like the historian or filmmaker, we press our memories into a sensible, linear account that we retrospectively draw meaning from in the present. Since a memory seems accurate, whether mounted from an original or "remolded" script, people are equally convinced of the precision of their memories, no matter how much they have been altered over time or in response to photographs, media imagery, or other people's input (Carroll 2019, 324).

The relationship between the mechanics of memory and moving histories is deep and multidirectional. The core responsibility of reflexivity is to serve as a caution. The jolt of the reflexive signposts the mediating function of memory as the way we make sense of everything. Despite acknowledging history's precariousness due to its foundation in the mechanics of human memory, Ricœur defends history as our best option to organize knowledge owing to the lack of a better alternative (2004, 47, 136, 168–170). He suggests that as we approach "mnemonic phenomena," we focus on its strengths, especially given that we "have no other resource, concerning our reference to the past, except memory itself" (21). To those demoralized by the limitations of memory or who hold postmodernist commitments in response, Christopher Nolan's *Memento* (2000) serves as a paean and corrective.

As will be explored as part of the principle of plurality, we relate one-to-one to characters and struggle to grasp and be moved by collective concerns. For this reason, moving histories typically explore collective struggles and conceptual arguments through individual conflicts. In his book *On Collective Memory*, Maurice Halbwachs defines *collective memory* by isolating a range of *collectives* of memory, including within the family, religion, and social class. He underlines the influence that sociocultural pressure exerts on our expression of personal memory, explaining that the imperatives of personal memory "obligate people not just to reproduce in thought previous events of their lives, but also to touch them up, to shorten them, or to complete them, so that however convinced we are that our memories are exact, we give them a prestige that reality did not possess" (Halbwachs 1992, 51). This description is indistinguishable from that of the historicizing process. The narrative demands on history in any media are set by no less than the demands of our consciousness. Halbwachs remarks on the imprint of the present on the past, noting that the past does not "recur"; it is "not preserved" but "reconstructed" (39–40).

One of the differences between history and memory is that with the former, we can filter, question, and acknowledge the complications of remembering, its layers of interpretation, its writings and rewriting, and its reboots and remakes through collective gatekeeping. Our individual memories are closed to debate unless we offer them up to external scrutiny by electing to compare our memories with

others who shared an experience or through consulting photographic or other evidence of an event. Another benefit of the collective process of history lies in the role of reflexivity and its ability to moderate while flexing a critical impulse.

The synergy between remembering and rendering the past in moving images, and the primacy of visuals to memory, is underscored by *mnemotechnics* and the "mind palace," a memory technique invented by the Greeks, championed by Cicero, and handed down through the ages. The method depends on visualizing in relationship to architectural space, a rhetorical technique to remember long speeches with detailed accuracy.

Several classic texts trace its origins to Simonides of Ceos, 556–468 BCE, a famous lyric poet from Greece and the first known paid, professional lyricist (Yates 1972, xi, 29–30; Cicero 1988, 351–354). The most fanciful version includes mythic overtones, in which Simonides attends a banquet with the plan to recite a poem dedicated to twin "demigods" Castor and Pollux. When Castor and Pollux arrive unexpectedly (in Cicero's version, it is just two unidentified men), Simonides leaves the hall to meet them. Next, the hall collapses, killing everyone inside. As the only survivor in the aftermath, Simonides is asked to recount who was in the room. Standing in the ruined hall, he goes through the space, remembering the guests table by table, in his mind, and through this process, discovering the mind palace technique (Yates 1972, 2; Cicero 1988, 351–354).

Mnemotechnics instructs in the art of memory and rhetorical persuasion, explaining that striking, emotional imagery—visuals that are shocking rather than banal, whether stunning or grotesque, comic or jarring—enhances memory (Cicero 1968, xxii; Yates 1972, 2). It remains a thriving and widely practiced method of memorization. Its contemporary relevance pops up in books on memorization practices, and it achieved meme status after Sherlock Holmes (Benedict Cumberbatch) evoked his mind palace in the hit BBC series *Sherlock* (2010–2017).

In emphasizing the impact of the visual and spatial on our memory, this ancient practice speaks to the power of moving image media thousands of years before its invention. Unlike the ephemeral mechanics of memory, photographic moving images bring colossal amounts of detail, spirited upon emotion and affect, overwriting other understandings of the past. Could anything be more profoundly impactful to our sense of individual and collective memory than the rendering of the past in moving images? Moving histories represent a collective, mass exercise of mnemotechnics on public memory with intense powers of persuasion, a power that reflexivity serves to puncture. Reflexivity interjects to moderate the intense influence of the medium, reminding spectators that the persuasiveness of the narrative is illusory.

Reflexivity and Questioning Authority

The *clin d'oeil* of reflexive disruption is intrinsic to many art forms as they emerge, as the artifice of a medium is more obvious to everyone before conventions set

in. Evident in early recorded history, philosophy of history, novels, and films, reflexivity surfaces in works from Herodotus's *Histories* to Voltaire's *Philosophy of History*, in early novels such as Miguel de Cervantes's *Don Quixote* and Henry Fielding's *Tom Jones*, and films such as R. W. Paul's *The Countryman and the Cinematograph* (1901) and Edwin S. Porter's remake *Uncle Josh at the Moving Picture Show* (1902).

As implausible as it may sound, historical skepticism originates as part of the historiographical method rather than emerging as a modern concern and intervention. Herodotus speaks in the first person, habitually referencing himself and introducing his authorial perspective into the text. He tells tales, many of which we know are fantastical, expressing doubt about the provenance of several. For example, in book three, he prefaces an account, writing "another story current, but not, I think, a convincing one" (1996, 204). Voltaire questions his historical data two millennia later in his *Philosophy of History*, drawing attention to a lack of diversity in the sources of history and asking, "Is all that the monks have written to be believed? They were almost the only people who knew how to read and write, when Charlemagne did not know how to sign his name" (1966, 243). Although self-reflexivity in contemporary media reads as resolutely post-Enlightenment or postmodern in tone, it seems to arise naturally in any new media as creators and authors explore its contours before codifying genres and conventions.

In the early days of the emergence of the novel, Miguel de Cervantes engaged a satirical tone, directly addressing the viewer, breaking the illusion of the narrative, and reminding readers of the book in their hands. Similarly, in film, Paul, as imitated by Porter, plays upon the artifice of cinema through the "frame within a frame" technique. Paul depicts a man reacting to movies on a screen next to him, ignorant to the fact that its projections are not real. He rollicks in delight watching the moving image of an attractive woman, and flails in fear at the sight of an oncoming train. Once a medium becomes established, reflexivity takes on a different valence, reframing perspectives, breaking conventions, blurring boundaries, and overturning set standards and expectations.

What changed with the mass media of the 1900s was not so much history's form but its variety, volume, and accessibility. Within this context, reflexivity took on relevance as an expression of skepticism and reserve. Robert Stam notes that left-leaning film theories inspired by Louis Althusser proselytized reflexivity as no less than a "political obligation," gaining widespread traction in movements like the French New Wave as part of the cultural transition from the 1950s to the 1960s (1985, 13). It achieved currency again in the mid-1990s within an aesthetic movement that Eleftheria Thanouli dubs "post-classical" (2009).

The Reflexive Spirit
Thanouli explains that the postclassical model marries traditional and art film sensibilities, combining classical "character-centred causality" with a heightened awareness of the role of mediation, displaying a "baroque fascination with

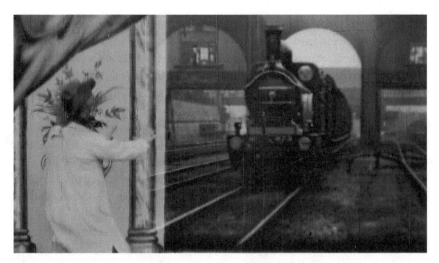

FIG. 3.1 The frame within a frame as a *clin d'oeil* nod to the artifice of film in R. W. Paul's *The Countryman and the Cinematograph*.

excessive reflexivity, multi-layering and fragmentation . . . invit[ing] several levels of perception" (2009, 23, 36). She explores turn-of-the-century works, including *Chunking Express* (1994), *Trainspotting* (1996), and *Run Lola Run* (1998), that employ interstitial reflexivity through art film flourishes that break with classical conventions and highlight hypermediacy. Thanouli's analysis calls attention to classical and postclassical cinema as two central approaches to mainstream moving images. Each engages history with distinct ramifications for truth and historical thinking. The postclassical responds to the postmodern critique, while the classical reads as an objective window into the past. Reflexivity counters the natural "metalanguage" of classical narration, which, according to the historical poetics of David Bordwell, gives the impression of truth as it "reveals all," reading as "transparent" (1985, 18). Alun Munslow describes this phenomenon as "zero focalization," in which the historian as the channeling perspective disappears and "the past explains itself" (2010, 159).

Interstitial reflexivity punctures the veneer of objectivity without resorting to a total subjectivity, striking a reflexive tone that expresses a metamodern sensibility, a concept that has gained traction over the last several decades as a successor to the postmodern. Metamodernism manifests through a mix of realism and abstraction, alongside irreverent reappropriations of classical forms, spiked with pop culture references that display multicultural and global influences, exemplifying a respect for classic, utilitarian, and realistic forms approached with circumspection, remixing, and playfulness (Okediji 1999). As articulated by Timotheus Vermeulen and Robin van den Akker, metamodernism seizes on postmodernism's destructive fixation on history and rehabilitates the historical impulse (2015, 55). Ultimately, postmodernism and poststructuralism do not dispense with

history, or even grand narratives, as counter-narratives come to dominate. They do away with the consolidation of coherent methods. Exemplifying the ways that postclassical cinema expresses the metamodern zeitgeist, Thanouli writes that postclassical cinema "does not renounce the importance of the 'real'; what it renounces is the unproblematic and seamless manner that classical Hollywood had used to approach it" (52). Metamodernism promotes a "reconstructive" attitude in place of the "postmodern deconstructive," an attitude expressed through the reflexive impulse (Bentley 2018, 723). Metamodernism calls for a détente between alienation and affect, allowing them to coexist in a dance in which they call attention to each other. The interstitial reflexive interruption breaks the spell of a narrative flow, softening the work's grip on the presentation of a historical truth, shifting attention from content to form and back again.

Reflexivity checks the narrative drive in history that services our inborne desire to make sense of things, as "contingent and discontinuous facts of the past become intelligible only when woven together as stories"; until we make sense of it, the past, just like the present, is "chaotic and episodic, a hodgepodge" (Lowenthal 1985, 218, 220). Metamodern, postclassical, or reflexive approaches to the past moderate judgment, insert epistemic humility, and evoke doubt while satisfying our natural compulsion to draw conclusions, learn, feel, and understand. Ricœur's thinking marks a profound shift from postmodern deconstruction to metamodern reconstruction through his lifelong project to probe narrative. In *Time and Narrative*, he agrees that narrative is how we make sense of the swirling confusion of experience while highlighting the tendency toward overdetermination in linear structures that make the accidental look inevitable (2009, x, 41). Although Ricœur requests that his analysis of the "narrative character of history" (91) not be interpreted as a justification of "narrative history," he also explains that narrative is no less than how time is made human (52).

Reflexivity's Theatrical Antecedent

In evocative imagery, Jay Ruby calls reflexivity "seeing backstage" (1977, 3). Since Bertholt Brecht, scholars, artists, and critics associated the reflexive impulse with his concept of epic theater and its goal of alienation, or *Verfremdung*, that appeals to the audience's intellect over their emotions, rebuffing Aristotelian narrative in pursuit of raising the spectator's political consciousness (Brecht 2003, 23, 81). Brecht clarifies that he does not disavow emotional response. He praises the ability of art through the ages to allow audiences to "share the emotions" of those "of a bygone period, different social classes, etc.," toward "partaking interests which really are universally human" (146). Instead, he seeks a dialectical rail switch that moves audiences between enmeshment in the emotional thrall of a narrative to occupying a state of suspension outside it.

In 1934, Walter Benjamin referenced the significance of Brecht's project in a talk at the Institute for the Study of Fascism. Published later as "The Author as Producer," the essay explores the aesthetic options and political limits of

revolutionary ideas in media and art. Benjamin heralds the "principle of interruption," which emerges from Dadaism to reveal the frame of an artwork, prompting reflection on the mode of production alongside the delivery of content (2005, 768). He offers Brecht's *epic theater* as a prime example of such a vehicle of "astonishment," describing its "procedure of montage . . . [that] disrupts the context in which it is inserted" and "counteracts illusion," in a manner that eschews naturalism and engenders awareness of the artistic practice, swapping reflection for emotional reaction, turning audience members into "collaborators" (777–779).

Natalie Zemon Davis also draws on Brecht, considering reflexivity crucial to responsible history, urging filmic renditions to signal that there are multiple ways to interpret the same history through cinematic language and toward "Brechtian distancing" (1987, 479). For Davis, the most intractable problem for history in moving images is how they convey the uncertainty and fluidity of history, "the 'perhapses,' the 'may-have-beens'" (2000, 133–135; 1983, viii). Reflexivity is one crucial and compelling method to convey this uncertainty.

Rosenstone lays out the challenge of performance histories and reenactments that present the past through a direct view rather than a backward glance, recruiting audiences as onlookers and quasi-participants, weakening the natural and experiential separation between the contemporary and historical, which severely tamps our critical filter (2012, 18). Reflexivity in moving histories attends to this. It is Brecht walking through the soundstage door to interrupt Aristotle's march toward catharsis. Jarring breaks in narrative conventions prompt us to see the fabrication baked in layers into moving histories, to wrestle with the incongruity between a movie, a series, a documentary and the lived past that cinema realism and continuity editing have taught us to ignore.

Cataloging Reflexivity in Moving Histories

Historiography developed several methods of contextualization. They include first-person introspection sewn directly into the text or expressed in the paratext of footnotes, prefaces, and conclusions or afterwords. No one can entirely escape, account for, or even grasp all the biases that guide one's own explanations and perceptions of reality. But this does not mean it is not worth the effort. As a result, it has become a hallmark of history to openly acknowledge the three key factors that moderate a history: the layering of human perspectives, the channeling effect of the specific medium, and the influence of time.

In *Beyond the Great Story: History as Text and Discourse*, Robert Berkhofer engages postmodern concerns toward reflexive responses by brokering peace between postmodern deconstruction and historical construction. Berkhofer explains that reflexivity's role is to demystify, exposing the "social realities that produce texts," including embedded inequalities and hierarchies accounting for culture and history as a perennial "site of social struggle" (1998, 4–5, 6, 71). Historical realism functions as the dominant system of history. It takes different forms depending on the conventions of a given media. Nonetheless, all histories

produce a "mimetic 'gap'" between the interpretation of the past and the past itself (58). In response, Berkhofer advocates drawing explicit attention to the poetics and rhetoric incumbent in representation, alongside exploring the "dilemmas" of the historicizing process (282).

The Functions of Reflexivity

There are many ways to examine and understand reflexivity in moving images. In *Writing History in Film*, William Guynn summarizes reflexive techniques, ranging from (a) *"voix d'addresse,"* the evocation of voice-over for distancing, to the use of (b) *"secondary screens,"* the "frame within a frame" technique, to (c) *"diegetization of the apparatus,"* which he describes as "foregrounding the technical effects," to (d) quotation from other texts via archival photos and film (2006, 79–80; emphasis in the original). Jay Ruby categorizes reflexivity in terms of the aspect of production emphasized, whether the "Producer," "Process," "Product," or "Reader/Viewer" (2000, 154).

The principle of reflexivity considers

1. which aspect of interpretation is highlighted, whether
 a. the human perspective,
 b. hypermediacy and the foregrounding of aspects of mediation, or
 c. the role of time, and
2. whether the reflexive element operates through and within the story-world or outside of it as part of the nondiegetic frame.

1. Perspective

Human consciousness molds historical texts at many junctures: (a) through witnessing at the time of the event, (b) as the event is recorded, (c) when it is organized and stored through archival practices or passed along in oral traditions, interpreted and arranged in transmission through a narrative or argument, (d) in the reception process within the receiver's mind, and (e) and in dialogue with others afterward. In the case of moving histories, these perspectives include all those who witnessed, recorded, altered, and contributed to the historical source material; those involved in the production, postproduction, and distribution processes; and the audience. When reflexivity invokes perspective, it references the process of interpretation of at least one of these moments of human judgment.

2. Medium

John Durham Peters explains that "revealing means a shift in form—in medium" (2015, 110). Reflexivity brings attention to the medium that shapes meaning, privileging certain aspects of history over others. Every reflexive act that catches the viewer's attention, whether through parody, anachronism, voice-over, or

METHODS OF REFLEXIVITY	PERSPECTIVE	MEDIUM	TIME
DIEGETIC			
Frame within a Frame	Detroit	Detroit	Detroit
Art Direction	The Passion of Joan of Arc	The Passion of Joan of Arc	Walker
Casting	Da 5 Bloods	Da 5 Bloods	Da 5 Bloods
Performance	The Big Short	The Big Short	Spartacus
Language	Deadwood	Deadwood	The Witch
NON-DIEGETIC			
Mode Switching	Rise of Empires	Rise of Empires	Rise of Empires
Screen within a Screen	Wormwood	Wormwood	Wormwood
Cinematography	Ida	Ida	The Passion of Joan of Arc
Emplotment	The Death of Stalin	TheDeath of Stalin	The Death of Stalin
Plural Viewpoints	The Last Duel	The Last Duel	Free State of Jones
Paratextual Portals	Reds	Argo	Satyricon
Voiceover	Rise of Empires	Rise of Empires	Rise of Empires
Noncontinuity Editing	Good Morning, Vietnam	A Royal Affair	Wormwood
Archival Material	Detroit	Detroit	Detroit
Titles	Free State of Jones	Free State of Jones	Free State of Jones
Music	Marie Antoinette	Marie Antoinette	Marie Antoinette

FIG. 3.2 Reflexive techniques with examples from moving histories and historical fictions.

another strategy, draws attention away from the narrative to the form and its conventions.

3. Time

Narratives stretch, slice, and erase time. For moving histories, this manipulation of time takes place in writing and performance, but most profoundly through editing. As a time-based medium, moving images construct an art form with a deep and complex relationship to time. Editing takes the raw materials of scenes captured by microphones and cameras and arranges them over time. The ordering of the story that takes place in the edit is a critical aspect of cinema realism and a rich site of potential reflexivity. Moving images plot temporality along what Christian Metz called "the axis of sequences," the linear ordering of shots from beginning to end or through the layering of time within the frame along the "axis of simultaneity," which he describes as "reciprocal relations between visual facts and verbal facts in a single shot or a single sequence" (1974, 173–174). Organizing along the *axis of sequences* is the central purpose of the edit, structuring shots and scenes to create meaning through linear cause and effect.

Moving histories jump time and tenses with every reflexive act. For example, inserting an archival image into a performance film shifts the spectator from immersion in present-tense action to imagery framed and read as past tense. This happens at multiple junctures in the movie *Detroit* (2017), in instances referenced as part of the principle of evidence in the previous chapter. One instance of the insertion of archival imagery along the axis of sequences occurs

when a shot cuts from a representational, performed scene of street violence to archival presentational imagery of the event. The collision takes place along the axis of simultaneity in several other sequences in which a television screen beams archival news imagery into a representation scene. As it does, the impression changes from immersion to retrospection, either in a consecutive manner or through a simultaneous layering effect. In noncompilation documentaries, the effect is reversed as archival imagery cuts into an interview sequence that references the past in past tense to archival imagery that exhibits the past as present and yet is often marked with indelible signs of pastness through pixilation or other audiovisual artifacts.

Reflexive Techniques

The shifting of spectator attention from inside the storyworld to its external framework may take many forms and serve a range of effects. Figure 3.2 lays out fundamental reflexive techniques with an example of a work that incorporates each one. More detailed explanations will follow. Although each reflexive strategy evokes all three aspects of interpretation—authorial perspective, medium, and time—in many cases, a technique more strongly evokes one or two elements over another. As the goal is to interrogate reflexive techniques, this chapter and the chart also draw on historical fiction, and sometimes genres outside history, to analyze how these choices read through the prism of historiophoty and may function within a moving history.

Diegetic Reflexivity

Diegetic reflexivity refers to profilmic ruptures of cinema realism manifested within the mise-en-scène of the historical storyworld.

Frame within a Frame

This *mise en abyme* or image within an image form of estrangement shifts attention to the medium and the artist's perspective, ranging from metaphorical framing of one storyworld within another to visual or architectural framing within the mise-en-scène to the framing of moving images on a screen placed within the mise-en-scène.

Frame within a Frame: Story within a Story and Performance within a Performance

This rendition of the frame within a frame technique nests a story within a story and a performance within a performance. Shakespeare's *Hamlet* is a famous version with its play within a play. *Ararat* (2002) exemplifies the technique employed in moving images for historiographical effect. Atom Egoyan's feature film explores the Armenian genocide of 1915 in a film about the making of a performance-based film about that history. This technique offers a twin mirroring effect that probes, deconstructs, and dramatizes the process of

historicization, addressing the authorial and performers' perspectives, questioning our access to truth, the demands of the medium, and the role of time. In addition, the characters within the storyworld mimic the audience's experience of interpretation and response. The narrative-based form of this technique, the story within a story, functions along the axis of sequence.

Frame within a Frame: Visual Obstruction

Other versions operate within the axis of simultaneity, collaging imagery within a shot, creating a frame through a visual obstruction that masks the camera and audience's field of vision. Achieved as architectural or natural objects in the scene interrupt the audience's view, it creates a border around the action within the frame, drawing awareness to the outer frame of the image in the audience's own space. The effect of framing scenes visually by impeding the view of the camera ranges in subtly. It may or may not trigger reflexive introspection for spectators. Subtle variations function as a form of visual poetics, as in Yasujirō Ozu's *Floating Weeds* (1959), in which several scenes are bordered by partially opened sliding doors. Although audience members might interpret this choice as a reminder of their role in eavesdropping on this family drama, the aesthetics also make sense metaphorically within the film's logic as a visual evocation of secrecy within families.

An obscured visual perspective frequently evokes a point of view (POV) shot in which we see what a character sees, established by obstructed sightlines. POV expressed in this way diminishes the reflexive function, reading as cinema realism that depicts a character's experience anchored within the illusion of the story. Like Ozu's sliding doors framing a scene, when an obstructed shot is motivated within the story, as in *The Pianist* (2002) when Władysław Szpilman (Adrian Brody) watches the Warsaw uprising through the broken glass of his hiding spot, the audience makes sense of the composition within the narrative of the film and may or may not reflect on the way it evokes their own positionality.

The obstructed POV shot becomes more reflexive and disruptive when emphasized through repetition. A famous example is Alfred Hitchcock's *Rear Window* (1954), which shows much of the conflict and action from the main character L. B. Jeffries's (James Stewart) viewpoint across his back alley. The vending machine view of his neighbors' apartments invokes the flat compositions of cinema and television. From his immobilized perch, Jeffries is simultaneously protagonist and spectator, the central agent of the film and an emblem of the audience member, a position continually reinforced visually and echoed in dialogue. If the story had him watching real events of historical importance, then the technique would have been a metaphor for more than spectatorship. It would expand to comment upon the fragmentary nature of evidence and the role of witnessing and interpretation as part of the cycle of historiographical perspective, from authorship to audience.

FIG. 3.3 The frame within a frame as Władysław Szpilman's POV in *The Pianist*.

Frame within a Frame: The Layered Mediation of a Screen within Screen

The third variation of this technique encases an artifact of mediated history within a shot. The depiction of characters at the cinema is a recurring scene in movies and the most common example of this technique. The motif takes on a specific meaning in moving histories. Several scenes in *Detroit* depict characters watching television. A critical scene that precipitates the police violence that will impact the film's protagonists shows them reacting to televised footage of unrest unfolding in nearby streets. The televised shots are contemporary to the storyworld but appear antiquated and grainy, in black and white, evoking the distance between the performance scenes and the real events they portray. The actors appear as actors and as agents of historical perspective. The fifty years between 1967 and 2017 are made visible within the film frame.

Art Direction

Describing "diegetization of the apparatus," Guynn refers to the choice to emphasize cinematic stylization within the mise-en-scène over a realist aesthetic. As an example, he cites Roberto Rosellini's *Rise of Louis XIV* (1966) for its intentional composition of flat frames and artificial lighting to create a "deliberately artificial character . . . that foregrounds the mimetic act" (2006, 77, 95). *The Passion of Joan of Arc* (1928) also exhibits reflexivity in its spare interiors that eschew realism for an expressionist starkness in set dressing, announcing the events as artistic renderings in every shot.

Another reflexive approach to mise-en-scène intentionally expresses anachronism through sets, costumes, and props. Examples of films set in the past that embed the present through art department anachronism include contemporary props in *Walker* (1987), modern costume flourishes in *A Knight's Tale* (2001), and the full spectrum of art direction from props to costumes and sets in the

FIG. 3.4 The frame within a frame layering time and mediation in *Detroit*.

postclassical film *Titus* (1999). Elements of art direction intentionally and flamboyantly mismatched with the era of the plot serve to spotlight the actor as an actor and the role of the crew members involved with the anachronism. Such incongruities highlight the temporal swathe separating events from the out-of-sync object and emphasize the theatricality and artificiality of the medium.

Casting

Casting in moving histories is malleable within certain boundaries of age, appearance, and race. However, casting estranges when it crosses set conventions of moving histories. Although a character's age may be interpreted broadly in either direction, as when Matthew McConaughey at twenty-eight played Roger Sherman Baldwin at forty-eight in *Amistad* (1997), portrayals across race and gender categories draw more attention to the actor as an actor. Despite being practiced more regularly in fictional genres, including historical fiction, casting across race in mainstream moving histories has always been somewhat rare, typically featuring White movie stars as people of other backgrounds, including John Wayne as Genghis Khan in *The Conqueror* (1956) and Angelina Jolie as Mariane Pearl, the wife of the murdered journalist Daniel Pearl in *A Mighty Heart* (2007). Although it was not the intention at the time, Wayne as Khan now reads as an absurd and satirical reflexive disruption of the real. Casting White historical figures as actors of other races, as in moving histories like *Anne Boleyn* (2021) starring Jodie Turner-Smith in the eponymous role, may have been spurred by the massive success of the Broadway musical *Hamilton* (2015) combined with a nonreflexive move to color-blind casting, in which casting agents and filmmakers pledge to ignore an actor's race in casting decisions in favor of seeking the best performer for each role. In the case of the

moving history, whether the intention was reflexive or not, such casting brings contemporary racial politics into the historical argument in ways that the earlier casting of Wayne and Jolie did not intend. Casting historical figures in performance reenactments has also become political and polarizing in ways separate from reflexivity, as exemplified by the selection of Adele James, a biracial Black British actor, for the lead role of *Queen Cleopatra* (2023). Although the tussle over Cleopatra VII's genealogy has been ongoing for decades, the importance of moving histories beyond entertainment and leisure is emphasized by the Egyptian government's heritage ministry entering into the fracas to condemn the show (Khorshid 2023; Yee 2023).

Casting across gender, though relatively popular in theater, remains uncommon in mainstream moving images, as when the White female actress Linda Hunt played Billy Kwan, a Chinese Australian male with dwarfism, in the conventionally realistic moving history *The Year of Living Dangerously* (1982). Though much discussed in the press at the time of its release, it was not a disruptive gesture within the storyworld of the film, although it may have functioned that way for some viewers. Similarly, the casting of transgender characters is a topic of interest in the press but not as a response to decisions made for reflexive purposes. Casting one gender for another continues to bring a sense of hypermediacy and estrangement in the rare cases that it is the goal, as when Cate Blanchett played Bob Dylan in a chapter of Todd Haynes's Dylan biopic, *I'm Not There* (2007).

One of the most compelling and original examples of reflexivity in casting occurs in Spike Lee's historical fiction *Da 5 Bloods* (2020). In Lee's film, four veterans return to Vietnam many years later to reclaim the body of a fallen comrade and a buried treasure. Lee had the same actors play the surviving soldiers in the present day and in flashbacks set during the war, striking against the convention of hiring younger actors to play characters at a younger age. In scenes set in the 1970s, only Norman (Chadwick Boseman), a soldier who died in combat, is played by an actor who appears young enough to have been part of the U.S. fighting forces in that war. The survivors to the modern day are portrayed in the war with no attempt to make the actors Clarke Peters, Delroy Lindo, Norm Lewis, and Isiah Whitlock Jr., all men in their late sixties, appear younger.

The choice offers an arresting audiovisual evocation of our access to the past and the fact that memories do not allow us to revisit but only to rethink in the present. The flashback scenes evoke a powerful portrait of the mechanics of personal memory, loss, and survival with resonances and implications for collective history. The sequences serve as a lyric meditation on history as echo, an ongoing reconstruction always grounded in and altered by the present. Ironically, this resonant decision was partly due to budget constrictions. Lee has explained that he had hoped to de-age his actors, as Martin Scorsese did in *The Irishman* (2019), another Netflix film in which older actors play themselves as younger men. As Lee only had a quarter of the production funds of Scorsese, the option

was foreclosed (Lively 2020). However, by not de-aging the actors, *Da 5 Bloods* avoids the uncanny valley of discernible deep fake visuals of *The Irishman*, instead striking an affective, cinepoetic metaphor for memory and the historical process. In response to a digital effects roadblock, Lee breaks a core film convention with great reflexive, historiophotic, and philosophical force, creating an ode to historical access, aging, and remembrance.

Layering Celebrity

Acting decisions offer another channel of reflexivity that highlights the influence of human perspective and form. While operating within the conventions of classical film, the presence of an actor in the place of a historical figure in performance histories already offers a primary element of rupture. In his famous essay "Historical Fiction: A Body Too Much," Jean-Louis Comolli marvels at how we watch a film about actual events in the past, and despite the incongruity of knowing that we watch an actor, we still also "believe" that the actor is the person represented (1978). Comolli posits that audiences act as "accomplices" in the special "game" that is history in the moving image (46). Writing about the biopic, Alison Landsberg explains that when a known actor plays a real person from the past, it disrupts our "immersive engagement" and "enables the distance necessary to produce historical knowledge" (2015, 43). Through this analysis, we can understand that all performance histories and reenactments come with some level of reflexive undertow, the strength of which varies depending on the tenor of the performance, the fame of the actor, and the person portrayed.

The reflexive effect of the "body too much" is most potent in the case of bona fide movie stars cast to play famous historical figures. Like sliding open a handheld fan, these performances communicate transtextually, imbuing a historical figure with undertones of an actor's past roles and public persona. The reflexive disjuncture between the performed and the real is most potent in the case of famous historical agents whose appearance is documented and known to many, especially for the frequently photographed. To a lesser degree, the effect translates to those captured in realistic artistic renditions of their day, such as the much-memorialized Julius Caesar, in his case, owing to the combination of his fame and power and the popularity of realism in Roman portraiture of his era. Spectators may hold two images in their minds: their memory of depictions of the actual historical figure and the incoming imagery of their impersonation. They may disconnect at any moment from the historical storyworld to consider the actor's other roles, personal life, or perceived discrepancies between the actor and the person played. When the historical figure is not well known or not realistically memorialized, the actor's image overwrites the blank mask of the real person.

Audience expectations encourage the casting of celebrities in period dramas who, in turn, function as living, breathing palimpsests. These performers trail impressions from previous roles and, in many cases, imprints of their

headline-grabbing personal lives that cling to them like a shadow. *Reds's* (1981) John Reed is shot through associations from *Bonnie and Clyde* (1967) to *McCabe & Mrs. Miller* (1971) to *Shampoo* (1975) with shades of Beatty's well-known off-screen persona. It is impossible not to read John Reed's actions peripherally through the context of Beatty's past in ways that create a discernible signal noise.

Cast no doubt for his name recognition, talent, and arresting physical resemblance to Newton Knight, Matthew McConaughey as Knight brings to the screen what we know of him from his past roles—from *Dazed and Confused* (1993) to *How to Lose a Guy in 10 Days* (2003) to *Magic Mike* (2012) to *Dallas Buyers Club* (2013) to *True Detective* (2014), along with appearing in Lincoln Town Car television advertisements (Walker 2014) and a well-publicized personality. McConaughey imbues Knight with extreme gravitas, and Knight is all the more impressive read through the prism of McConaughey's on- and off-screen personalities. He overcomes not only racism, class bigotry, and the violence of the Civil War but also a personal propensity for being a jocular, easygoing, beach-loving Gen-Xer.

The audience's awareness of the actor acting is less alienating in portrayals of historical figures less known, like Newton Knight, or those whose adventures preceded realist depiction, such as Aztec emperor Itzcoatl or Viking king Ragnar Lothbrok. For this reason, performance renditions of less well-known figures such as Fred Hampton (Daniel Kaluuya) and Bill O'Neal (LaKeith Stanfield) in *Judas and the Black Messiah* (2021) create a distinct experience from watching David Oyelowo as Martin Luther King Jr. in *Selma* (2014). As a result of the wealth of photographs and film footage of King, along with the inedibility of his message and his immense and enduring sociopolitical currency, audiences are acutely aware that they are watching Oyelowo as King, placing a reflexive mist over the entire work. And yet, in the case of *Judas and the Black Messiah*, Kaluuya and Stanfield arouse a heavy measure of actor-inflected reflexivity via their portrayals in the immensely successful *Get Out* (2017). Although not competing against well-known depictions of the historical agents they play, the actors inject a multilayered reference to slavery and a flash forward to modern-day bigotry into *Judas and the Black Messiah* through the themes and plot of Jordan Peele's *Get Out*.

The Reflexivity of a Dissonant Chorus

A cast that performs in competing tones creates an intentional or unintentional form of reflexivity that draws attention to perspective and medium. Featuring a cast of Turkish nationals unknown to English-speaking audiences, *Rise of Empires: Ottoman* (2020) does not reverberate with references to the actors' filmographies or competing real-world personas, but the three leads lend reflexivity as they perform in slightly different tonal registers. Birkan Sokullu, as the mercenary Giustiniani, plays the romantic hero of a transnational myth, interpreted as an action star. Tommaso Basili, as Constantine XI, personifies the

Shakespeare-descended idiom "heavy is the head that wears the crown," appearing weighed down emotionally and physically. Basili plays the last emperor of Constantinople as burdened, contemplative, and still, a man who has walked out of the flattened perspective of a Byzantine fresco, while Cem Yiğit Üzümoğlu, in the lead role of Mehmed II, embodies the video game aesthetics that animate the series. He does not seek to portray much of the historical Mehmed II, the driven, brilliant strategist and ruthless conqueror. Instead, he embodies the boyish, contemporary, adventure-seeking exuberance of a video game–playing teen. The portrayal of Serbian king Đurađ Branković also ruptures the historical world through the actor's clunky delivery, reminding the audience of the performance aspect of the scene through his unconvincing efforts. Poorly executed performances or accents are often reliable albeit inadvertent vehicles for focusing attention on the apparatus and its human conduits.

In addition, kitsch or "scenery-chewing" performances of history's villains played against the straight renditions of a good guy lead—such as in Joaquin Phoenix's churlish Commodus in *Gladiator* (2000), Laurence Olivier's portrayal of a lecherous Roman patrician as a seedy British aristocrat in *Spartacus* (1960), Linus Roache as the deliciously camp King Ecbert in *Vikings* (2013–2020), and John Roukin playing a flamboyantly mincing British lieutenant as John Simcoe in *Turn: Washington's Spies* (2014–2017)—all function as reflexive reminders of perspective and medium. Other performance-based alienation techniques include hybrid and documentary reenactments in which the indexical imagery of a historical agent competes directly with a representational performance within the same text. For example, *Wormwood* (2017) repeatedly invites audiences to compare archival photos and footage of Frank Olson with Peter Sarsgaard, the actor who plays Olson in the many reenactment sequences of the series.

Breaking the fourth wall is an archetypical *clin d'oeil* form of parody or satire built into the script, functioning as another moment of reflexivity through performance when characters address the audience directly or puncture the division between the set and storyworld. *Tom Jones* (1963) and *The Big Short* (2015) include performer-focused reflexivity as characters directly address the viewer, drawing attention to the conventions of the moving image medium while shifting focus to the actor underneath the character. The *archeological performance* of *The Act of Killing* (2012), described in the previous chapter, is another example of a reflexive performance technique in which the audience considers the past in complete cognizance of the layers of human perspective, medium, and time.

Language

Most often in moving histories, characters speak plainly in an unadorned manner contemporary to the production and intended audience, stamping the present into every utterance. Language is one of the only conventions of historical realism that becomes a site of rupture as the result of an earnest effort to be

more accurate to the historical context. Mel Gibson shot *The Passion of the Christ* (2004) and *Apocalypto* (2006) in foreign languages as part of a commitment to historical verisimilitude and dialogue. Robert Eggers's *The VVitch: A New England Folktale* (2015) features period English based on primary source material from the era (NPR 2016). These rare historical movies that do not bow to the rule of automatic translation emphasize the distance of time between the historical era and the moment of reception.

Another way language functions as a reflexive tool is when moving histories mix language or diction from unrelated times or places. The practice was a staple of Roman epics of the 1950s and 1960s, imprinting the politics of the American Revolution on films like *Spartacus* and *Ben-Hur* (1959), creating a "layered record," as described by Robert Burgoyne, that references other historical events and periods, drawing in often unrelated narrative associations and visual resonances (2008, 77). In these Roman epics, accents point to politics and class, allying democracy and Christianity with an American accent versus empire and pagan decadence signaled by the British. Alternatively, moving histories may exhibit reflexive dialogue through poetic and elevated language. The historical fiction *Deadwood* (2004–2006/2019) effectively illustrates the technique. In the series, the historical saloon owner Al Swearengen, played with relish and aplomb by Ian McShane, epitomizes the delights of unrealistic speech as an alienation effect, collaging periods and styles by featuring a resolutely theatrical, Shakespearean cadence and flourish (Benz 2007).

Nondiegetic Reflexivity

Elements of screenwriting, cinematography, and editing dictate reflexivity expressed outside the storyworld and offer even more possibilities for narrative subversion. These alienation tactics disrupt the flow of the story and the conventions of realism, drawing attention to production and postproduction elements of the medium.

Mode Switching

Crossing boundaries between modes is inherently reflexive. Mode switching spans minor incursions, such as mixing performance histories with the hallmarks of documentary, including titles, archival material, and interviews to hybrid works that more evenly combine the two. Mode switching through combinations of presentational interviews, representational reenactments, and archival imagery characterizes reflexive techniques intrinsic to documentaries. When such shifts align with audience expectations, as in documentary, they are less likely to elicit a Brechtian response in the viewer.

The fault line between documentary and performance sequences marks a critical locus of reflexivity in hybrid works, whether the spine is performance-based,

as in *Rise of Empires: Ottoman*, or documentary-focused, like *Wormwood*. Yet one of the most captivating and innovative hybrid films from the perspective of historiophoty and metahistorical reflexivity is Bart Layton's *American Animals* (2018), a true crime, personal history feature rather than a moving history. The movie examines and enacts a failed heist of rare books from the Transylvania University Library in Lexington, Kentucky, by a group of teenagers in 2004. In the process, the film offers an intriguing model of a postclassical and metamodern approach to truth for moving histories, forming a multimodal dialectic between the immersive performance mode and the plural perspectives reflected in documentary interviews with the inept burglars and their demoralized parents.

One performance sequence that typifies its highly reflexive collision of modes and worlds shows actor Evan Peters, as teen thief-in-training Warren Lipka, pulling up to a convenience store with actor Barry Keoghan playing Lipka's hapless collaborator, Spencer Reinhard. The two characters have just had a fraught conversation about their planned robbery. The real Lipka and Reinhard feature as the main characters in documentary interview sequences interspersed throughout the movie and are the main characters portrayed in performance scenes that encompass the majority of the screen time. As actor Keoghan (as Reinhard) enters the shop, the camera pans back to actor Peters (as Lipka), waiting in the car, sitting next to the real Warren Lipka, who has materialized in the passenger seat, crossing over from the interview scenes into the glossy performance world to discuss the film in progress. Within the performance scene, Lipka is visually doubled along the axis of simultaneity, as though Peters has ejected the spirit of Lipka in corporeal form. The "body too much" made visible, Peters now inhabits his own body alone (Comolli 1978). Peters turns to the man he is playing and speaks.

Performance scene:

PETERS (ACTOR PLAYING LIPKA, SPEAKING AS PETERS): So this is how you remember it?
LIPKA: Not exactly. But if this is how Spencer remembers it, then let's go with it.

Next, the film cuts to the store's interior, where Keoghan (as Reinhard) waits in line behind another man. Keoghan looks back to the car and we see his POV: Peters (as Lipka) sits alone, staring ahead through the dashboard window, waiting. The scene cuts to a short documentary interview with Lipka speaking directly to the camera about planning the heist.

Documentary Interview scene:

FIG. 3.5 A screenshot from *American Animals* in which Evan Peters, playing Warren Lipka, asks the real Lipka (in the passenger seat) about the accuracy of the scene he is playing in the film. Lipka does not look too sure.

> LIPKA: It's twelve million dollars. Could we get it? You know, like, what would it take? It would take extraordinary effort to get it. Not ordinary effort.
>
> *Performance scene:*
> *Keoghan (as Reinhard) waits in the shop as the man in front of him completes his purchase, turns, and crosses the frame to leave. For less than a second, we glimpse his face. It is the real Reinhard, another doubling that punctures the veneer of the performance storyworld.* (Layton 2018)

The film is not a moving history because it does not depict an incident of sociopolitical importance beyond the community involved or elucidate the sociopolitical mores of an unknown culture as microhistory. Nonetheless, Bart Layton's film is a brilliant metahistorical meditation on the concerns of historiophoty. It reflexively draws attention to the role of the multilayered perspectives of historical agents, performers, and the filmmaker. As it breaks cinematic conventions, it exposes the function of the medium in the negotiation of truth, simultaneously exploring the canvas of truth as a zone rather than a target.

Screen within a Screen

The nondiegetic variation of the frame with a frame composites images in postproduction rather than through literal or metaphorical profilmic layering. Created in editing, the technique collages imagery and time within the frame along the axis of simultaneity. The technique also appears in the epilogue section on *Argo* (2012), described later in this chapter. *Wormwood* repeatedly creates split screens with cut-and-paste visuals of archival imagery with text, newspaper articles, and clip art. The effect emphasizes hypermediacy and the intrusion and

FIG. 3.6 Black and white and falling out of the 4:3 frame in *Ida*.

influence of the filmmaker. For example, episode 2 of the series features a screen collage presenting Sidney Gottlieb, the former CIA head in charge of the MK-Ultra program, who is alleged to have administered LSD to Frank Olson without his consent. The frame is a space where the archive and the presentational and representational historical agent collide. It displays a document signed by Gottlieb over an archival photograph of him next to a still of actor Tim Blake Nelson, who plays him in the reenactments in the series. This spatial montage is part of a linear montage sequence of other key characters with signed documents and images arranged in a similar fashion. The technique presents documents referenced in voice-over from an interview with Eric Olson, speaking to the series' access to evidence and methods of narrativization while drawing us out of the interviews and reenactments to behold the mediation of the apparatus.

Cinematography

Moving images may highlight their intervention by flattening space or designing shots that draw attention to themselves as constructions. Illustrations of reflexive cinematography across genres include the attention-grabbing evocations of depth of space as in *Citizen Kane* (1941), stylized framing in *Ida* (2013), convention-breaking shot sizes as in *The Passion of Joan of Arc*, extreme lighting as showcased in the excessive use of silhouette shots in *The Northman* (2022), choosing a black and white color palette as in *Schindler's List* (1993), movement

choices such as the locked and unmoving camera of *What Time Is It There?* (2001), and the excessive camera motion of *The Celebration* (1998).

Emplotment

Irony, satire, and parody propel distancing through tone. White calls this aspect of history its mode of emplotment, which is "essentially dialectical" in that "the author signals in advance a real or feigned disbelief in the truth" (White 1975, 37). Satirical history is more common in fiction, such as films like *Monty Python and the Holy Grail* (1975), *Monty Python's Life of Brian* (1979), or *The Norsemen* (2016–2020), than in histories about real events like *The Death of Stalin* (2017), perhaps because it is difficult to laugh at the conflicts that rise to the level of memorialization and remembering through history. Satire functions as a steady hum, alerting audiences to the fabrication of history at the foundational level of narrative and plot, funneling all aspects of the history through what Limoges (2021) calls total reflexivity, indulged from beginning to end rather than in intermittent flashes. The difference between satire in moving histories versus historical fiction is that the former summons alertness on the part of the viewer to remain critical about events as represented or presented as opposed to relaxing into the fun of the shared joke of abject fiction. In a fascinating way, satirical historical fictions like the Norwegian comedy series *The Norsemen* (not to be confused with Robert Eggers's ultraserious *The Northman*) skewer the project of history while moving histories like *The Death of Stalin* mount a more oblique challenge to historicity, reappraising the seriousness we accord to the agents of history and, by extension, to ourselves.

Plural Viewpoints

Though a historical fiction, Akira Kurosawa's masterpiece *Rashomon* (1950) charts a template for historiophoty as a monument to the cinematic exploration of human perspective and the complexity of truth. *The Last Duel* (2021) translates this model into a moving history. Ridley Scott's feature adapts a history book of the same name by Eric Jager, recounting the conflict between a knight and squire that escalated into the last public duel-to-the-death in Paris on December 29, 1386. As the book and movie recount, the battle was precipitated by a long-standing rivalry between the two men, culminating in an accusation of rape by knight Jean de Carrouges against Jacques Le Gris—a crime perpetrated against Carrouges's property: his wife, Marguerite. The film grants a section to each of the three main characters and their points of view. They begin with a numbered title card with the phrase "The truth according to. . . ." The complainant's perspective, Carrouges's (Matt Damon), leads the narrative. The perspective of the accused, Le Gris (Adam Driver), follows. Finally, we see the version of events according to Marguerite (Jodie Comer). Like *Rashomon* before it, *The Last Duel* illuminates our relationship to reality and "what happened" through access expressed through competing subjectivities.

Documentaries that offer plural viewpoints often provide a network of subjectivities and an inherently reflexive approach to objectivity. *Let It Fall: Los Angeles 1982–1992* (2017) does this, engaging reflexivity by incorporating a range of testimonies that include contradictions. The film trusts its audience to filter competing impressions to enter a realm of truth. LAPD officer Robert Simpach's point of view challenges comments from other retired LAPD members as he voices a conservative, casually unapologetic, and bigoted worldview that excuses excessive force by police officers, including the savage beating of Rodney King. While the inclusion of the perspective of a member of the "LA 4," the unrepentant Henry "Kiki" Watson, convicted in the brutal attack of Reginald Deny, offers a radical rhetoric from the other side of the spectrum. Like Simpach, he sanctions violence against groups, tout court, based on race. The other interviewees express perspectives that fall within the wide gulf that separates these two. By including more marginal perspectives, from Simpach to Watson, both of whom read as extremes, the film creates a mosaic of impressions of the events that remind the viewer that they are receiving impressions of reality to consider rather than a single impression of reality itself.

Paratextual Portals to the Past: Prologues and Epilogues

Prologues and epilogues are a long-held tradition of the history genre. They function as a threshold between present and past. Jonathan Stubbs explains that this structural framing highlights the "position" of the historical film in relation to the past and serves a "memorializ[ing]" function (2013, 28). In cataloging audiovisual tools that engage the responsibility of history, Davis explicitly mentions the value of prologues and epilogues, citing the turning pages at the beginning of Carl Dreyer's *The Passion of Joan of Arc* as one example, defending it from those who might call it "cliché" (1987, 477). This section offers a detailed dive into this aspect of reflexivity in response to Davis's particular attention to it as a method of historiophoty.

The opening credit sequence of *Marie Antoinette* (2006) reflexively frames the film around the fusion of Kirsten Dunst with the representation of Marie Antoinette. Antoinette lounges in profile, surrounded by towering architectural cakes, attended by a maid. A discordant "post-punk" score with the song "Natural's Not in It" (1979) by *Gang of Four* grounds the visuals in the modern world. In the final frames of the shot, Dunst as Antoinette turns and looks into the camera and smiles. The spectator sees Dunst looking into the lens, acknowledging the medium and the audience. With insouciance, the look establishes the film's goal as portraying Antoinette, like the actress before the camera, as a young woman with an inner life, aiming to blow apart the two-hundred-year-old "let them eat cake" smear that engulfs her memory. The shared look recruits the audience into the frame, a reflexive centering of hypermediacy and time travel that promises a new interpretation of the queen as a human being rather than as a political symbol canonized through the slander of her enemies.

FIG. 3.7 A glance across two hundred years in *Marie Antoinette*.

Mode Shifting Portals

A key appeal of the framing function of the prologue or epilogue is that it may function as a reflexive method for moving histories to incorporate postclassical and reflexive critical distance without piercing a classical approach to the core narrative. *Argo* provides a version of the prologue as a historical pretext to spectatorship. The film chronicles the CIA's efforts to liberate six U.S. embassy members in Tehran who evade becoming hostages of the Iranian revolution by holing up in the Canadian embassy and escape by posing as members of a Canadian documentary film crew. Following the opening titles, the film sets forth via a two-minute sequence that places the Iran hostage crisis in the historical context of American meddling in Iranian national affairs. A montage of animation stills seems to nod to the graphic novel and film *Persepolis* (2007), which dramatized the Iranian revolution from the perspective of author Marjane Satrapi as a young girl. The section crossfades into archival stills and moving images as female voice-over narration describes the CIA-backed undermining of Iranian democracy led by premier Mohammad Mosaddeq in favor of the installation of Mohammad Pahlavi as the shah in 1953. The film portrays the 1979 Iranian hostage crisis and the American diplomats as the victims they were, but this prologue deftly contextualizes their experience within a broader political framework, depicting Iran as a victim of self-interested and short-sighted American petrol-capitalist intervention with British assistance. The approach communicates this critical context more effectively and efficiently than any tools that the performance storyworld might offer. This historical backdrop would otherwise only be accessible through expository dialogue, which would likely be forgettable and ineffective, or by way of flashback scenes that would divert much time, attention, and narrative flow from the historical storyworld at its center.

Stella Bruzzi meticulously describes *Argo*'s documentary opening, arguing that its archival imagery operates as "a marker for the credibility of what follows, however far the subsequent narrative deviates from the facts" (2020, 30–31). However, the film's prologue provides little cover for its falsifications, including its fabricated, action movie, *The Great Escape*-like finale at the airport with its unintentional *Austin Powers*-esque élan. Although *Argo* is uneven in addressing history in its core text, the documentary introduction delivers crucial geopolitical foregrounding to the film's main plot that guards against reading the film simply as a good versus bad "axis of evil" worldview.

Bookended by indexicality, *Argo* ends with an archival epilogue as a gateway out of the representative world of the past. A spatial montage sequence combines end credits with a collage of each main character. Every title card pairs a still of the performer next to an image of the person portrayed. Though film critics and theorists often argue that these archival insertions falsely overpromise authenticity and a filmmaker's sober commitment to accuracy, they also jar spectators by stressing the gulf between the real people and their impersonators. Indexical imagery epilogues may posit a commitment to some level of accuracy, but more profoundly, they acknowledge the insurmountable distance between the real and its interpretation—its layers of mediation, biological and material.

Reds (1981) exhibits another use of the documentary prologue. Its documentary opening features former friends, acquaintances, and contemporaries of John Reed reminiscing about him, one at a time, in front of a black background. Through this opening, director Warren Beatty engages historiophoty by including the plural perspectives of testimonies contradicting one another and, in the process, emphasizing historicization as an act that enmeshes memory and history. It reminds the audience that they are entering the unsteady and contingency-laden world of the historical.

Combinations of documentary and performance footage resonate, Bruzzi writes, because "their juxtaposition within one narrative functions as a metaphor for the inherent fracturedness of history" (2020, 37). Near the end of this introductory sequence, a performance scene with Warren Beatty as Reed cuts in. Reed races after a horse-drawn wagon down a dirt road as it kicks up plumes of dirt and dust, splicing color, action, youth, celebrity, landscape, and performance into the midst of a slow and still, almost monochrome documentary sequence of talking heads. The performance world enters the frame, underscoring our travel as audience members, through time and worlds, from diegesis and presenting oneself to mimesis and the performance of another. The interviewees talk about someone that Beatty is only pretending to be. As a result, the film launches with a cinematic commitment to historical truth designed to reference the multileveled construction at work in moving histories.

Time Shifting

Rather than jumping modes, prologues and epilogues may merely jump time as an entry into or departure from a historical storyworld. According to Elena Theodorakopoulos, prologues serve as a tradition of the Roman and biblical epic, as both historiographic framing and warm-up acts to the excitement of the coming sensorial spectacle that express the "appearance of historiophoty" (2010, 124). One of the most famous prologues of a "sword and sandal" epic is the title sequence of Stanley Kubrick's *Spartacus*.

Saul and Elaine Bass created a slow-rolling montage of high contrast, close-up images depicting plaster casts of statuary that signal our access to the ancient Roman past in the contemporary age. Their intention was to speak to the "duality of Roman rule—the oppressiveness and brutality, as well as the sophistication that made possible so many contributions to Western civilization" (Bass and Kirkham 2011, 193). The camera lingers on tight shots of hands and then lips, evoking the plight of the film's protagonists, their physical labors and obscurity. It then focuses on Roman inscriptions and, finally, statuary of the faces of the powerful shot straight on and in profile. The prologue ends on the face of a Roman emperor, reminiscent of Constantine,[3] personifying the imperial rule that would emerge decades after Spartacus's defeat. The face cracks and then breaks apart using a technique Elaine Bass borrowed from the Japanese Bunraku Theater, here conveying decadence and decay (194). The opening tableau sets the film into motion with sculptures serving as a synecdochic representation of the contagion, corruption, and ethical bankruptcy of the powerful who rot institutions from the inside.

Burgoyne explains that this opening creates a "museum-memory of ancient Rome" (2008, 79–80). The prologue entices the audience into the world of the film over the familiar bridge of relics on display. These figures of absolute sovereignty have long since lost their ability to incant reverence, fear, or menace. The prologue reminds the audience of our access and distance to the history the film recounts and reminds us that our links to the past are often etched by the mighty and the brutal, those with the resources to leave traces. The rest disappears.

Theodorakopoulos explores *Satyricon*'s (1969) epilogue, explaining that it encourages spectators to reframe the film and consider the fragmentary sources of history (2010, 124–125). The film ends midsentence, faithfully following its source material authored by Petronius in the first century CE. The main character, Encolpius, appears in the last live-action shot of the film in a flat frame square to the camera. The shot cuts from a tight close-up to a wider close-up of his face, the blue background behind him split between the sky and sparkling sea. The shot freezes and then cross-dissolves into a mirror copy of the final

[3] The emperor also appears as plaster statuary in *Rise of Empires: Ottoman* and is pictured in figure 4.1.

frame as a fresco image. The camera shakily pans out to a larger fresco, including the other characters from the film, and then further still to show the fresco sitting atop the crumbled remains of a building overlooking the water. Exiting through these liminal, fused visuals of fictional characters painted onto ruins, Fellini deposits the audience back into their own time with a metaphorical and visual evocation of the archive and processes of mediation, speaking to the instability and impermanence of our entry to the past.

Voice-Over

Voice-over narration is inherently reflexive. Whether in a presentational documentary or representational performance, it breaks the seal of an enclosed narrative. Even at its least distracting, voice-over interrupts the flow and diverts attention from absorption into the historical storyworld. It simultaneously gestures to the role of perspective, separating and exposing the strata of narrative time, from production and the recording of scenes to postproduction and the performance of voice-over to reception when the voice-over reaches its intended addressee.

Third Person, Expository, and Objective Voice-Over

Third-person voice-over narration conjures the expository documentary, primarily associated with political propaganda and nature documentaries, from Walter Huston in Frank Capra's *Why We Fight* (1942) to David Attenborough in *Planet Earth* (2006). This disembodied narration, when a voice is not connected to a person revealed on-screen, suggests an immaterial objectivity associated with omniscience. Further, owing to connotations of ponderous political propaganda and science films of the 1940s through to the 1960s, this voice-over style established a template that most documentaries now avoid.

On the other hand, expository, third-person narration in performance histories tends to be all-knowing but often satirical, drawing humor from the shades of arrogance, overconfidence, and sobriety lent from its reputation earned in documentary. An aesthetic with direct roots in parody and reflexivity of the early novel, this technique transfers the tone and narrative structure of the picaresque novel in moving image adaptations in films like *Barry Lyndon* (1975) and *Tom Jones*. This narration style demystifies as it "tells the truth" with *clin d'oeil* ambiance.

First Person, Subjective

First-person narration emanates off-screen, traditionally attached to the perspective of an on-screen character. It communicates the character's inner world in a contemplative and self-reflective register as in *The Thin Red Line* (1998) and *Apocalypse Now* (1979). This address bypasses the unwritten law that performance films render a character's needs, desires, and fears through visuals and actions. Instead, it invites audiences into an intimate relationship with the

protagonist, spurring empathy or tension, especially as they see gaps open up between a character's intentions, behaviors, and outcomes. Unlike third-person commentary, dramatic irony often charges this mode of narration, as audiences often know more than the source of these first-person reflections. Further, this subjective perspective typically reads as biased. It does not convey the same "truth value" as a third-person "impersonal" voice-over, instead offering a range of reliability, from high in *JFK* (1991) to negotiated in *Rashomon* to outright deceptive in *The Usual Suspects* (1995; Burgoyne 2008, 131–132).

Documentaries employ personal voice-over narration when a host or director who appears in the film records introspective voice-over narration to draw the audience deeper into the work, as modeled by Nick Broomfield and Michael Moore and evocatively exemplified by Werner Herzog in *Grizzly Man* (2005). First-person narration may also feature the voice-over of a character, host, or director who does not materialize in the frame, as in Chris Marker's *San Soleil* (1983) and Vikram Jayanti's *The Agony and the Ecstasy of Phil Spector* (2008). Despite their invisibility, the *I* pronoun discloses a resolutely first-person and subjective point of view. This choice opposes the expectations of expository documentary voice-over, conveying skepticism, potentially engaging contradiction, and always stipulating that our access to truth is blinkered.

Noncontinuity Editing

Gaps, breaks, repetition, freeze-frames, abstract imagery, ironic and disjunctive pairings of sound and imagery, and nonlinear story structures disrupt causal meaning-making, diverting attention to the mediation, perspective, and role of time in moving histories.

Freeze and Repeat

According to director Peter Jackson, his documentary *They Shall Not Grow Old* (2018) features repetition and freeze-frames to coax audiences into identifying with the characters (*The Making of They Shall Not Grow Old* 2018). The effect subtly disrupts the realism achieved by coloring and adjusting the antiquated footage to adhere more closely to contemporary cinema and our nonmediated audiovisual perception. Repetition also reveals inconsistencies when reenactments present possible alternate realities. Errol Morris does this in *Wormwood* as the series plays and replays interpretations of Frank Olson's death as murder, accident, or suicide in a manner reminiscent of the reenactments of competing testimonies rendered in his earlier film, *The Thin Blue Line* (1988).

Let It Fall: Los Angeles 1982–1992 features arresting, fast-paced montages of archival material and a repetition of imagery that startles the spectator through the recurring shots of police training videos of the chokehold technique, a photograph of James Mincey Jr. in his casket, and the destruction of Black homes at Thirty-Ninth and Dalton. These disruptions of interview sequences draw attention to the mediation of history while emphasizing the film's argument.

With possible reference and reverence to Errol Morris, a repeated scene in *American Animals* showcases the metahistorical possibilities of looping scenes in a sequence layering performance reenactment and interviewee voice-over that describes and shows the two main characters participating in a street corner meet-up to arrange the sale of the stolen books. In the performance world, actor Barry Keoghan as Spencer Reinhard watches from across the street as Evan Peters playing Warren Lipka waits on a corner of Central Park on a wet and cloudy afternoon. The action first plays out as a reenactment narrated via audio from an interview with Reinhard in which Peters (Lipka) meets a dark-haired, middle-aged man with a ponytail and blue scarf. The scarf changes to purple midscene as Reinhard alters his description of the man. Buoyant after the meeting, Peters (Lipka) crosses the street toward Keoghan (Reinhard). The frame freezes.

Next, Lipka appears in an on-camera interview describing the person he met as a well-dressed, white-haired man in his fifties. The interview cuts back to the freeze-frame of Peters (Lipka) crossing the street after the meet-up. The shot springs to motion in reverse, returning Peters to the corner. The scene then plays through a second time with an older man, this time narrated via a voice-over from an interview with Lipka. Although Reinhard and Lipka do not necessarily supply paradoxical descriptions of the man, they pick out different aspects of his appearance to describe what the film visualizes through different choices in casting and costume. The contact may have looked like a combination of the two descriptions: a well-dressed, white-haired man with a ponytail wearing a blue or purple scarf. Yet the sequence inventively demonstrates the exigencies of memory while exposing the faulty specificity of performance reenactment that etches concrete images and sounds to spackle over the gaps that characterize historical traces and descriptions.

Nonlinearity

The use of flashbacks is a common continuity editing technique that simulates the lived experience of remembering. Their level of reflexivity depends on context, including the length and audiovisual realism of the flashback. Flashforwards are less common and more inherently alienating. Unlike the flashback, they do not mirror realistic human experience. Instead, they draw attention to the medium's power to propel us forward into the unknown future of the storyworld's present.

Reflexive plot structures feature in the variations of repeated scenes in *The Last Duel*. Similarly, *Free State of Jones* (2016) communicates a historiophotic self-awareness through its time-jumping plot structure and liberal use of archival images and explanatory titles. Employing recurring flash-forwards, the film skips from the main plot set in the Civil War and Reconstruction era to a subplot about Knight's great-grandson's miscegenation trial eighty-five years later. Through this structure, the audience considers the impact of enduring prejudice

and racism in the twentieth century. The technique encourages the audience to extrapolate further by flashing forward again to consider these issues in their own time.

Flashbacks such as those in *Rise of Empires: Ottoman* build a portrait of Mehmed II from childhood. However, as a standard convention of any genre, they do not shift the spectator from absorption to alienation. Documentary flashbacks populate *Let It Fall: Los Angeles 1982–1992* in the form of archival news reports and security and trial footage. They offer a limited distancing effect, as they follow the accepted convention of documentaries to jump back and forth in time. After all, as the inverse of realism, reflexivity does not emerge from breaks in verisimilitude with reality but from conventional expectations. Exceptions are retrospective inserts that draw attention not because they are from the past but owing to another facet of reflexivity. For example, a variety of store security footage of the murder of Latisha Harlins evokes the mediating factor of recorded video of the time and context through its abstraction with its pixilated, blurry visuals and eerie silence.

Audiovisual Expressionism and Experimental Flourishes

Experimental imagery inserted into moving histories breaks the spell of realism, forward momentum, and the convincing nature of linear causality, bringing hypermediacy into the frame. Art films are a fertile source of inspiration that moving histories draw on to conceive inventive and experimental sounds and images that speak to metahistorical concerns in myriad forms.

Documentaries often deploy stylized audiovisuals toward reflexive aims with reenactments designed to emphasize their speculative and provisional nature or interstitial sequences that offer an introspective pause in the narrative. Reenactments and mood cleansers that break conventions of classical realism span the stagey and theatrical as modeled in *The Thin Blue Line* to meditative, experimental approaches, exemplified by the out-of-focus shots of contemporary city life that appear between archival images and interviews in *The Fog of War: Eleven Lessons from the Life of Robert S. McNamara* (2003).

The performance history *A Royal Affair* (2012) dramatizes the doomed romance between Caroline Mathilde, queen of Denmark and Norway from 1766 to 1772 (Alicia Vikander), and Johann Friedrich Struensee, a doctor, philosopher, politician, and commoner (Mads Mikkelsen). It adheres to the conventions of performance-based realism throughout, except during a collision of frames, as a Struensee sits in a chair under great duress, awaiting his fate. A jump cut punctures the moment, cutting directly from a medium shot to a medium close-up, expressing the tension and danger he experiences but also calling the apparatus and medium to the audience's attention. The scene's emotion crashes into a jarring continuity rupture as the audience is dramatically pushed back into their own environment, reminded of their helplessness to intervene in a destiny long since set and played out.

Alternatively, the disjuncture may be a tonal mismatch of sound and imagery as a form of interstitial satire or irony. A montage sequence in *Good Morning, Vietnam* (1987) exemplifies this through the ironic message of its noncontinuity editing, pairing scenes of violence perpetrated by American and Vietnamese forces on Vietnamese civilians to the uplifting tune "What a Wonderful World" as performed by Louis Armstrong. The effect is contemplative, transforming the song into something explicitly melancholy and sarcastic, inserting an audiovisual commentary in an affective critique of the war and its U.S. involvement.

The film *12 Years a Slave* (2013) provides another example of audiovisual expressionism, exhibiting the poetic sensibilities of director Steve McQueen and his background as a visual artist in a sequence that arranges disorienting visuals toward empathic immersion and introspection while reminding the audience of the craft and art of the film. The scene dramatizes protagonist Solomon Northrup's (Chiwetel Ejiofor) attempts to get a letter to friends in the North through a White drifter named Armsby (Garret Dillahunt). Before receiving the letter, Armsby betrays the plan to the sadistic plantation owner Edwin Epps (Michael Fassbender). Epps confronts Northrup at night. As Epps moves away with his lantern, the screen goes dark. Northrup is left reeling and alone, vaguely outlined in moonlight. This shot holds for over ten seconds, with the sound of Northrup's distressed breathing as the most discernible feature of the shot. In the following image, a close-up of Northrup's face is half obscured by the letter he holds out of focus before him as it is licked by flames. This shot lasts fifteen seconds. The first three seconds pass in abject silence before string music begins. The subsequent visual offers a close-up of the letter burning in the dirt for ten seconds, followed by a fifteen-second close-up of Northrup's face, faintly illuminated by the dying light of the flames consuming the paper. The final clip in the sequence lasts seventeen seconds as the dancing embers of the page turn to ash and the light goes out. The sequence elevates art film sensibilities through its expressionistic, affective imagery, paced to slow down the causal chain of narrative actions and reactions. It draws attention to its own artistry while placing the audience into a contemplative state of mind as Northrup's hope for freedom burns with the letter.

Archival Material

Oliver Stone famously popularized visualizing the past in chaotic montages that intercut archival footage with reenacted performance imagery made to match in *JFK*. This new template for moving histories merges documentary, art film, and MTV aesthetics, ladled atop a linear performance-based framework. Debate endures over whether the insertion of archival images into performance works emphasizes reflexivity by breaking the hermetic seal of the historical storyworld or asserts a domineering and often disingenuous claim to authenticity. Almost thirty years after Stone's *JFK* premiered, film critic Anthony Lane bemoans the

ubiquity of archival material in performance histories in his review of *Detroit*, explaining that audiences

> can't always tell where archive footage of the urban turmoil ends and the scripted semi-fictions begin, so restive and so probing is the camera. The victims' names are real; those of the three policemen are made up.... Later, a street scene is interrupted by a black-and-white photograph from the period, showing the same place—a curious device, as though Bigelow, concerned by any charge of fabrication, were nudging us and saying, "No, look, it's all true." This habit has grown chronic among filmmakers, the usual trick being to wait till the end of the movie and then to wheel on the real: the genuine military hero of "Hacksaw Ridge," say, or the actual Indian mother and her long-lost son from "Lion." When was it decreed that movies must, if possible, flash their credentials of authenticity? (Lane 2017)

One person's badge of authority is another's reminder of the distance between the fabrication and fictionalization of moving histories and the past. The *New Yorker* critic uses the verb interrupt to describe a black-and-white photograph intersecting a scene. Is this an assertive claim to accuracy or a leap into the chasm between the world displayed in the main text and its source material, drawing attention to the discordance between presented and represented reality? Although the indexical and performance mélange may mislead in *JFK*, in *Detroit*, the result is an alienating effect, creating a disjunction between the detailed precision of performance recreations and their grainy referents. The effect of the rupture depends on the discrepancy between the two modes, whether emphasized and therefore more reflexive, as in *Detroit*, or blended to disappear and evade our grasp, as in films like *JFK* and *Stories We Tell* (2012).

Titles

As noted in the previous chapter, the insertion of titles into performance histories employs a rupture practice with roots extending back to the silent era. Titles often pin the narrative to the original event through dates and place names, signifying a determined attention to historical detail. Despite their ubiquity in performance histories, titles also serve as disruptions to the narrative of the performance world and the conventions of cinema realism, a reminder of the special status of the historical genre and its relationship to reality. Although their ubiquity in the genre diminishes the alienation effect, stamping text onto what would otherwise play as a realistic world relativizes the proceedings. Like archival imagery, titles simultaneously communicate a commitment to a set of established facts of history on the filmmaker's part while also drawing attention to the constructed nature of their work. Although contemporary audiences may more readily equate the technique as a documentary gesture, either way, titles shift attention from image to text, from a world experienced to one told.

Free State of Jones liberally deploys titles interlaced with archival stills. In one example, Newton Knight sits against a tree in the swamp, carving a wooden star, in a sequence of images silent except for the music of Nicholas Britell's "The Free State of Jones" theme. A Black teenager runs over and speaks to him with great solemnity. The massive full-screen title "APRIL 1865" appears over the shot. The scene then cuts to a montage of archival photographs from the time that includes a parade of soldiers with the American flag cheering Union soldiers, Abraham Lincoln giving his second inaugural address on March 4, 1865, and a posed portrait of Lincoln, ending on a close-up shot of the Thirteenth Amendment that bans slavery and "involuntary servitude, except as a punishment for crime" (Ross 2016).

Titles are more extensive in the third act of the film, detailing the gains and losses of Reconstruction from the perspective of the formerly enslaved and their supporters. Another montage chronicles the backsliding of Reconstruction as landowners fight to maintain slavery systems through an apprenticeship scheme. Titles not only locate time and place in *Free State of Jones* but describe events of historical importance to the narrative. One montage begins with Knight sitting on the front porch of his humble and dilapidated homestead. An intertitle fades onto the image: "In response to local laws like apprenticeship, Congress puts the South under martial law." This scene cuts to a photograph of soldiers in profile with the following title superimposed on top: "Additional troops are sent, and former Confederates are stripped of their power." The next photograph shows ten Black men with five Black children posing in the street of a town with the title "Freedmen are granted political participation for the first time." The final still image depicts soldiers on a road scattered with canons with the title "This begins the period known as Military Reconstruction." The words "Union League Demonstration Ellisville, Mississippi" overlay the beginning of the performance scene that follows in which a group of Black men march through the street chanting for the Union League (Ross 2016). Moses (Mahershala Ali) leads the protesters. This scene flows into a sequence centering on Moses's work registering eligible Black voters. The film shows the ways that the law, in theory more than practice, extended voting rights to all adult males.

Music

Robert Stam points to film scores as one of the least true-to-life aspects of cinema realism. Although music should be a site of rupture, he explains that "all music which is not immediately anchored in the image . . . is by definition anti-illusionistic. The musical scores of Hollywood dramatic films lubricate the spectator's psyche and oil the wheels of narrative continuity. At the same time, they direct our emotional responses in the manner of traffic cops; they regulate our sympathies, extract our tears, excite our glands, relax our pulses, and trigger our fears, always in strict conjunction with the image" (Stam 1985, 263).

Rather than functioning to pull us out of the narrative reflexively, nondiegetic music works on us like the soundtrack piped through a grocery store or

coffee shop that imperceptibly alters our mood, for good or ill. Musical accompaniments to moving images provide precision-guided emotional manipulation, playing on audiences instantaneously, seamlessly, and often with more impact and specificity than any word or image could hope to achieve.

Music becomes a reflexive tool only in the case of obtrusive, obviously anachronistic film scores that pair popular music of a different era that competes for attention with the visuals, evoking a wink through sound as part of the *clin d'oeil* effect. Examples include the historical fiction A Knight's Tale, set in the1300s to a soundtrack that includes music by David Bowie, Heart, and Bachman Turner Overdrive, and the moving history *Marie Antoinette* with its punk and new wave infused soundtrack featuring the Cure, New Order, and Siouxsie and the Banshees. The combination of contemporary popular music with moving histories set in previous eras distracts from the power of music to effect seamless emotional contagion. This choice may make protagonists seem more contemporary and relatable while drawing attention to the distance of time, location, and cultural context of the history and its mediation.

Signposting Temporal Transport

Reflexivity functions as an arcing flare that draws attention to the complexities of addressing historical truth. It extends an aesthetic acknowledgment of the burden of history, functioning as the hypnotist's snap back to the reality of the spectators' time and place, issuing a reminder of the distance of the material world from the remembered world framed by the screen. Moving histories like *Free State of Jones, Wormwood, Let It Fall: Los Angeles 1982–1992*, and *The Act of Killing* constitute a metamodern approach to historiophoty, mixing elements of reflexivity with reconstructive strategies that express a complicated but legible relationship to the reality of the past.

The next chapter explores a different kind of distance: the temporal, cultural, and political inlet separating one time from another. Foreignness not only invites more accurate and stimulating time travel to an exotic past; it inspires introspection. Moving histories that transmit lost values and rituals, old concerns and prejudices, show us how we have changed over years and generations—and more importantly how we have not. By recognizing lost laws, beliefs, customs, and ways, we may reframe our contemporary values as foreign and in flux, part of the past of a future that will one day seem strange, whether quaint or retrograde. The expression of foreignness and its value to moving histories is the focus of the fourth principle of historiophoty.

4
Foreignness

How do moving histories capture the material and social reality of their time and place?

Foreignness concerns the accuracy, complexity, and richness of detail with which a moving history depicts its historical agents' physical and psychological reality, creating critical context for the audience's affective and cognitive participation. This principle draws on Natalie Zemon Davis's call to override "the impulse to remake the past in familiar terms" and "understand" rather than "judge" (2000, 10–11). Attention to foreignness makes for more responsible history and more engaging works that deliver on the sensual allure of time travel, undoubtedly one of the most potent delights of history in moving images. Davis's second point urges against presentism and uncomplicated, binary assessments of the past. It reminds us to temper judgment through the consideration of context. In the process, we engage history as history rather than as an origin myth or contemporary political playground. The detailed rendering of a society's material and conceptual atmosphere is especially important for moving histories that reach audiences with little prior knowledge of a given time and place. It also heightens the experience of watching for everyone, perhaps most concretely for those who know an era well and relish experiencing a skillful artist's treatment of it. Making the past too much like the present results from a failure of diligence, historical curiosity, and imagination.

What is foreign in the past depends on two aspects of atmosphere: first, nature and its intersections with human invention through technology; and second, culture and the ways that ideas, laws, customs, and beliefs shape human experience and behavior. These are, after all, the two most profound aspects

separating us from other animals—the complexity of our technologies and their transformative impact on nature and our ability to share and rally around abstract ideas and translate that into collective action.

Foreignness operates

1. as a marker of fidelity to the accuracy of a historical rendering, its specificity and detail as an expression of evidence. This includes attention to differences within the culture depicted and between that culture as a whole to that of the moving history's makers and spectators;
2. as an alienation effect that reminds the audience of their distance from the past conveyed within the historical storyworld; and
3. aesthetically and artistically as a form of enchantment that exploits the medium's unique abilities to convey the sensual and material look, sound, and atmosphere of another time and place.

In short, foreignness is an essential principle of historiophoty for its impact on viewers as a tool of (a) learning, (b) political messaging, and (c) enthrallment. Critical to the ethics of historicization and the compact of history is that histories draw meaning from the past grounded in historiographical context and methodologies rather than through the laws and practices of fiction.

History seeks to uncover human incentives. By exposing what is foreign in the past, we understand ourselves diachronically and synchronically: who we are as a species, where our cultures and customs come from, how we respond to circumstances, and what has or has not changed over time. Foreignness fosters a sense of our progress over time while reminding us of what is universal and what is in stasis. The foreign may be material and sensual, like the moonlight streaming through the cypress branches onto the makeshift rebel village in the swamps of *Free State of Jones* (2016), or value-based, as with Alice Olson's obedient and complacent response to the CIA's explanation of her husband's death in *Wormwood* (2017). It reminds us of the distance of the past, even though it need not be the 1860s and wartime for people to live rough in nature or the 1950s for them to acquiesce in the face of authority. People who coexist in the same moment, even those sharing the same country or the same street, may also live separated in this way, as if in time. To see the past as different allows us to grasp more clearly what remains the same. Rather than diminishing our recognition of the universality of human emotion and impulse, the specificity of foreignness heightens that revelation. Foreignness relies on accuracy and complexity: accuracy in evoking the look and feel of the past within its conventions and institutions and complexity in depicting the remote ideas and rituals that motivate actions.

Engagements across Time

David Lowenthal catalogs the range of history's appeals that "dominate time travel literature: explaining the past, searching for a golden age, enjoying the exotic, reaping the rewards of temporal displacement, and for knowledge, and refashioning life by changing the past" (1985, 22). While the search for a "golden age" marks history as naive, and the impulse to alter the past to create an alternate reality in the present represents charged ahistorical and politicized aims, the other attributes Lowenthal lists, running from benign "enjoyment" to useful "knowledge," are heightened by moving histories that render the physical and psychological otherness of the past. Calling attention to what is foreign with accuracy may disavow the nostalgic quest to revisit a simpler time or a golden age. It guards against the search for parallel, fictional origins to explain a parallel and partisan present.

Many credit L. P. Hartley with originating the metaphor of the past as foreign. The first line of his novella *The Go-Between* proclaims, "The past is a foreign country: they do things differently there" (2000, 5). The sentence introduces the main character, Leo Colston, and his discovery of childhood mementos, including his diary, as a man in his sixties. The diary, a tactile and visual object, serves as a catalyst in this case, sparking the childhood memories that inspire the first-person narration of the novel. Colston approaches his diary like a history text, trepidatious about reexperiencing and reconsidering the events it documents. The past that Colston refers to is a personal history, yet the opening passage underscores that understanding the past requires distance, knowing the outcome, and a change in perspective. All are necessary to read deeper meanings and to draw alternate lessons from the interpretations and intentions of the transcribers of history. The past must become foreign to be legible as history. Colston, in 1950, acts as a historian, weighing and reconsidering the testimony in his own teenage diary through the remove of time. He is separated from the author of this primary source by fifty years. The second half of the sentence contextualizes the first, explaining that the past seems foreign because people did things differently. They did things differently because circumstances differed, and the concepts and ideas through which they processed those circumstances were different as well.

The concept of the past as a foreign country appears even earlier, in 1874, with Friedrich Nietzsche's *Use and Abuse of History*, as he repeatedly describes the past as "foreign" (2019, 21, 29, 33, 51). Centuries before this, while cautioning against too much immersion in history books, Descartes describes the effect of reading classical history and literature, noting that "conversing with those of other ages is about the same thing as traveling. It is good to know something of the customs of various peoples, so as to judge our own more soundly" (1998, 4). The sentiment expresses an Enlightenment-era relationship to history with continued salience. Descartes includes with this description the rationale for why it matters. In judging the beliefs and actions of the past as strange, we may practice humility and avoid clinging to our contemporary

values and beliefs as though we have somehow reached a stable apotheosis. Brecht forwards the same historiographical rationale for heeding attention to what is alien in the past, writing, "We must drop our habit of taking the different social structures of past periods, then stripping them of everything that makes them different; so they all look more or less like our own, which acquires from this process a certain air of having been there all along, in other words of permanence pure and simple. Instead, we must leave before our eyes so that our own period can be seen as impermanent too" (2003, 190). In a similar vein, Davis claims that audiences will be more likely to see the "possible parallels" for themselves "if the strangeness in history is sustained along with the familiar" (2000, 131). Therefore, rather than serving as a distraction, foreignness reveals. It is through the immersion into specifics that universals surface.

In her book, *European Cinema and Intertextuality: History, Memory and Politics*, Eva Mazierska begins by discussing the past as a foreign country, noting that the idea has become so ubiquitous that it reaches the point of becoming a cliché, albeit a useful one that functions as a "methodological directive" (2014, 1). She cites Eric Hobsbawm's argument in *On History*, stipulating that all elements of the past need to be presented within their sociocultural context, in contrast to postmodern approaches advocated by Jacques Derrida and Michel Foucault that promote an unbounded intermixing of historical and contemporary points of view (1–2). For historians, modern-day trade practices dictate approaching the past by delving into and understanding its material and sociocultural context, the blend of beliefs, values, sociopolitical expectations, and incentives that build an individual's sense of reality, which thereby molded decisions and actions as the building blocks of events. Historians also endeavor to account for their own point of view and approach to data, filtered through the sieve of their personal and present-day perspectives. To set out *without* the intention to replicate the audiovisual and sociocultural milieu of history in a meticulous manner washes it fiction. Such an approach creates a total rather than interstitial fiction. Eschewing foreignness integrates more fiction than history strictly requires as part of the process of connecting data points into a causal chain that includes the imagining and speculating necessary to fill in all the unaccounted details and to reflect upon the motivations and meaning of those events.

In the laserdisc component of John E. O'Connor's multimodal *Image as Artifact* project, Natalie Zemon Davis narrates the opening sequence of Daniel Vigne's film *The Return of Martin Guerre* (1982) from her perspective as historical consultant and contributing screenwriter. Similar to, but predating, the practice of including director's commentary on DVDs, Davis's historian's commentary annotates the film's presentation of medieval wedding customs of 1542 in Artigat, France. The camera revels in the particularities of the marriage ceremony of Martin Guerre (Bernard-Pierre Donnadieu) and Bertrande de Rols (Nathalie Baye) as Davis explains these rituals in an engaging voice-over. Close-up shots linger on Rols and Guerre's clasped hands, the placing of the wedding ring on the thumb

and forefinger before resting it on the middle finger. The next scene depicts the settling of the dowry exchange and the signing of the contract by the bride and groom's fathers. A bedroom scene follows as the community assembles around the marriage bed to give benedictions and advice for successful and abundant procreation to the couple lying naked under the covers. In the historian's voice-over, Davis notes how strange this is for modern viewers and how vital the enactment of behaviors and customs of the past is to history on film (O'Connor 1990b). The sequence establishes the distanced setting of this mystifying tale that unfolds between husband, wife, and a welcomed matrimonial impostor.

Many moving histories draw our attention to institutional corruption that seems locked in a state of eternal return. *Free State of Jones* dramatizes the Confederate power structure resisting change through the Reconstruction era, reshaping slavery around "apprenticeship" and throwing out votes in contravention of the Fifteenth Amendment. *Let It Fall: Los Angeles 1982–1992* (2017) explores a cycle of police violence perpetrated against the Black community of South Central Los Angeles that leads to an eruption of public anguish. Histories often detail the universals of human conflicts that speak urgently to the present and the futility of doing the same thing and expecting different results. Part of the usefulness of history is to see what is universal in what initially looks different. In that, we see ourselves.

Foreign Atmosphere

Atmosphere is crucial to the expression and experience of any film, conveying ineffable qualities of mood, tone, and register. As Béla Balázs writes, film atmosphere is "the air and aroma that pervade[s] every work of art" (2010, 22). In an insightful exploration of atmosphere in moving images, Robert Spadoni explains that all elements of mise-en-scène contribute cumulatively to atmosphere: light and shadow, camera framing, performance, and even weather, along with diegetic and nondiegetic sound. These components imbue spatial and emotional feeling. He explains that atmospheres in films are "'global' entities," in two respects, because every film creates an atmosphere, and every aspect of a film contributes to it. Thus, cinematic atmospheres are not mere backdrops or settings but "totalities" (Spadoni 2020, 54, 56). Drawing on the work of German philosopher Gernot Böhme, Spadoni concludes that atmosphere creates an emotional charge to the cinematic space that connects audiences to a work and one another (56).

Atmosphere plays an even more profound role in moving histories as the source of a load of historical information, context, and insight. Atmosphere supports the message of the narration, bringing an affect-laden quality that emphasizes meaning, as in the frenetic archival montages of violence in *Let It Fall: Los Angeles 1982–1992* or in the serene stillness surrounding the last emperor of the Eastern Roman Empire as he ponders his dwindling options in *Rise of Empires: Ottoman* (2020). Further, detailed descriptions of historical atmosphere

FIG. 4.1 Constantine XI (Tommaso Basili) looks for guidance in the likeness of his namesake in *Rise of Empires: Ottoman*.

promise rigor and authenticity, creating a convincing "reality effect" while simultaneously engaging the capacity of moving images to envelop the viewer in an alternate time as another universe (Barthes 2010). Foreignness reminds viewers of their distance from the past, speaking within the narrative in the language of moving images.

Laura Marks's analysis of *haptic visuals* illustrates how moving images function to engage our "senses of touch, smell, and taste," communicating without words to "express the inexpressible" (2000, 129). She describes the interplay of the senses invoked by film, primarily through vision—light, shadow, and the close-up—and how this creates an "intersubjective" relationship between a work and its spectators, acting upon them and encouraging them to call up their own sense memories (148, 151). She illustrates the phenomena by conjuring a scene from Shani Mootoo's *Her Sweetness Lingers* (1994), in which "close-ups of magnolia flowers remind me of how they feel and how they smell, and the buzzing of insects reminds me of the heat of summer" (2000, 148). Thus, the visual and sonic details of atmosphere when transposed through moving histories interact with the audience's personal memories to create the sensual experience of time travel. The effect allows us to relate to situations with which we have no direct experience, oftentimes nothing even close. Through memory-propelled imaginative thinking, we process the chaos of the trashed homes after police raids at Thirty-Ninth and Dalton in *Let It Fall: Los Angeles 1982–1992* or the compelled surrender to strange court rituals in *Marie Antoinette* (2006) or Marguerite's experience in a suspended cage in *The Last Duel* (2021), where she watches a jousting match that will, in one fatal blow, bring her vindication or a torture-fueled public death. As we consider the emotional and sensual

FIG. 4.2 Marguerite (Jodie Comer) has a prime seat to watch the duel that will determine her fate in *The Last Duel*.

charge of atmosphere, we apprehend the remarkable power of moving histories to implant collective memories as emotional encounters deposited directly into our bodies.

In his essay "The Reality Effect," Roland Barthes analyzes "*hypotyposis*," the vivid evocation of atmosphere and detail through "notations" (2010, 141; emphasis in the original). These details are extraneous to "structure" but more than mere aesthetic accessorizing, functioning as critical support to conveying

realism (141, 145–146). Barthes explains that atmospheric details may seem an unnecessary "narrative *luxury*" with descriptions that furnish information at "the cost of narrative information" and the workings of plot, but they are essential contributions to narrative meaning (141; italics in the original). He traces the origins of this tradition of descriptive writing to the epideictic, a form of rhetoric that evolved after, and separate from, legal and political rhetoric, crafted to serve ritualistic and aesthetic functions, engineered for entertainment over persuasion (143). He notes that the modern use of verisimilitude and descriptive details imbue a "*reality effect*" that persuades through "particulars" supplying a "referential plenitude," as though representations can transcend signification, offering up the referent directly through sheer quantity (147–148; emphasis in the original). Elsewhere, Barthes notes that historians harvest and arrange not facts but signifiers (1986, 15).

What matters for Barthes is not what resonates as reality for the actual participants of history or the author's interpretation but how it sits with the audience (2010, 147). His concern is that histories convey a false sense of reality in the arrangement of a glut of seemingly irrelevant details. Particulars of atmosphere certify the author's attention to accuracy and precision in ways that spectators read as the mark of authenticity. They may, in turn, lower their guard. We may be cognitively aware that moving histories present reality through an artistic temperament while surrendering to the persuasiveness of an argument molded in concrete specifics. In some ways, foreignness creates a sense of authenticity in the way Barthes critiques. It opposes the reflexive impulse that reveals the platform and framework while exposing the narrative as a construct and its referents as symbols.

However, foreignness in moving histories strikes us in multiple ways. It delights and entertains through the sense of transporting viewers to an environment that looks and sounds different. It also creates a sense of veracity. Moving histories that show care in reproducing or evoking the sensual and psychological foreignness of the past do suggest a fidelity to the evidence. And yet, foreignness also strikes a note of reflexive verisimilitude within the frame, reminding us of the gaps between the way we make sense of the world we live in, separate from those of earlier eras. Invoking or representing the foreignness of the past no doubt increases its sense of reality. But more importantly, it offers a portal to empathetic engagement, a path by which we step outside our individual and presentist frames to consider the perspectives of those of different environments. It grants the sense of vivid access to the past while simultaneously drawing our attention to how strange and unfamiliar it is.

Other scholars of history in moving images note this layered aspect of the foreign. Leger Grindon laments the habit of historical films to value "the immediate" and habitually deny "the past its distinct and foreign character" (1994, 1). Alison Landsberg's concept of prosthetic memory highlights the value of historical works that invite audiences to intimately engage a circumstance remote from them and "become part of the archive of experience not as something

familiar, but as something foreign," and she further credits "mass culture" for its power to envelop spectators in "a relationship with the 'foreign'" (2009, 221, 228; 2004, 47). The foreignness she references is in part the mere distance between spectators and the characters with whom they identify. It is also a gulf deepened by the disparity of time, place, and experience and made more meaningful through the audience's knowledge that they empathize with real people rather than fictional emblems. Evoking the sensual, physical reality of the past alongside its cultural, psychological, intellectual, and emotional textures is critical to a moving history's historicity and its resonance as an aesthetic experience.

Flavors of Foreignness

Thinking of the past as other and exotic is an alluring aspect of any moving image depiction, whether a moving history, a historical fiction, or a mythical fantasy set within an aggregated classical or medieval tableau. Some of the most memorable moments of the historical fiction series *Mad Men* (2007–2015) were explicit invocations of cultural distance: young Sally Draper getting into trouble in the pilot episode for having a plastic bag over her head because it would mess up her father's dry cleaning, the family flapping the garbage from their picnic blanket onto the grass and walking away without any sense of transgression or shame, and stay-at-home mom Betty Draper losing her grip on reality in the face of an encroaching sense of alienation, the flattening of her identity, and a consuming emptiness that formed a season-long narrative evocation of Betty Friedan's "problem that has no name" (2013, 15–32).[1] Foreignness enriches the sensual experience of watching history by providing an enveloping context that exhibits the divergent values that govern a social reality.

Material

A past without electricity, plumbing, recorded music, guns, antibiotics, or soap is a foreign environment to most moving history watchers. These aspects of material reality inform the external environment that shapes the look, sounds, smells, options, and actions of people in the past. Audiences respond in a direct way to the expression of sensual reality. Renditions of visual and sonic atmospheres skip the processes of mental translation required to interpret the verbal language of expert or witness interviews. Archival audiovisual recordings that capture a historical mise-en-scène, and the mimetic representations of performance works, transmit a material environment to and from the senses. The divergent pathways of processing the material or sensual foreignness

[1] Stella Bruzzi interprets the same underlying meaning in Betty Draper's story arc, writing that it "feels as if Weiner et al. want to see how far they can push the parallels between Betty Draper Francis's unspecific discontent and Betty Friedan's identification of 'the problem that has no name' without citing *The Feminine Mystique* directly" (2020, 89).

of the physical environment versus the conceptual foreignness of unfamiliar laws, traditions, and expectations map onto Margrethe Bruun Vaage's explanation of empathy as either relayed through the lower-level automatic reflexes of *embodied* response or the more conscious mental effort of relating cognitively to another person that she calls *imaginative empathy* (2010). History engages a special kind of empathy, different from the hypothetical schemas of pure fiction. With histories, the receiver relates from one situated real-world identity to another. Material and cultural foreignness are the playgrounds of each kind of audience engagement, the embodied and imaginative, body and mind, creating an interdependent web of meaning.

Cultural

In the royal bedroom of *Marie Antoinette*, hands pull back the heavy drapery around the queen's bed. An attendant wakes Antoinette to tutor her on the French court's degrading daily dressing ritual that bars her from reaching for anything and demands that she stand helpless while the highest-ranking member of the court strips and dresses her garment by garment, a hierarchy she is responsible for tracking as women glide into and out of the space.

In *Free State of Jones*, the swamp offers a dark, damp hiding spot and meeting place for men who have escaped bondage. Newly free men gather among small-scale farmers who are legally bound to fight to the death to maintain an amoral system in which they do not participate. Here the men must evade detection by bloodhounds sent to shake them out as they organize against their Confederate hunters. In *Let It Fall: Los Angeles 1982–1992*, an archival montage of Los Angeles's streets depicts gang members and aggressive nighttime arrests to a rap score. An accompanying voice-over from interviewee and South Central resident Bobby Green contextualizes the images. He explains, "You have to be alert at all times in LA" (Ridley 2017). Green then recounts the death of his friend, whose mother sent him away from the city for safety only to have a gang member kill him for no reason shortly upon his return. The scene introduces the shadow story of Los Angeles as a tale of two cities—divided in resources, safety, policing, and adjudication of the law. The obsessive, overwrought, and ultimately unstable rituals of status and power in *Marie Antoinette*, the mortal danger of resisting the slavery system in *Free State of Jones*, and the recounting of ever-present menace across this two-square mile, neighborhood in *Let It Fall: Los Angeles 1982–1992* evoke the textures, values, and behaviors of a specific historical culture.

The Past as Past

Davis implores the makers of historical films to "let the past be the past" as a route to believability and in service of history's function to enable us to imagine the future (1987, 476; 2000, 136). Robert Rosenstone praises Davis for going further than anyone else in placing film within the context of "historical

discourse" but pushes back on this point, stating that historians should "let historical films be films" (2012, 189). After more than two decades of writing and considering history in moving images, he had reached a spirit of rapprochement between the expectations of academic history and the demands of story and spectacle in mass culture. In addressing Davis on this point, he argues that text-based historians also approach history from the present, suggesting that she holds films to a higher standard than written history (Rosenstone 2012, 189). Yet Davis merely implores filmmakers not to erase what is different in the past, a process of essentializing toward a staged and excessively fictionalized sense of familiarity and relatability.

Here, Rosenstone asks too little of history in moving images. With foreignness, moving histories can have it both ways. Letting the past be the past through the detailed articulation of historical context and specificity allows films to take advantage of their powerful ability to evoke lost environments of sensual feeling and intellectual ideas. In accounting for another era's material and psychic differences, moving histories exploit their experiential power to manifest the nonfiction storyworlds of Rasmus Greiner's "histospheres" (2021). Foreignness means "letting films be films" in the best way possible.

Seeing the Universal through the Specific

Rosenstone sanctions artistic license in moving image renditions of history, reasoning that "in a visual culture," the truth of the metaphors employed to understand the past may be more crucial than the particularities of the facts themselves (1995b, 148). It is worth considering how metaphorical adaptations essentialize anachronistically by papering over specific events with fictional confections. Although history's relevance is inextricably bound up in how it speaks to the concerns of the present, intentionally allowing those interests to distort the rendering of agents and events in constructing metaphorical truths is historical fiction, not history. Emphasizing material and cultural foreignness makes the universal more striking and, often, more resonant.

In *The Last Duel*, in Marguerite's version of events, she informs her husband that his longtime rival has raped her. In response, he shouts, "Can this man do nothing but evil to me?" No doubt, he expresses the thought process of a man in Normandy in the 1380s, where women's social standing and legal rights rest with their male protector. Wives were property. However, apart from being a man who sees his wife as his possession, he simultaneously voices the raw emotion of a person who feels continually challenged by the same enemy, a constant foe who has risen above him in society, taken his land, and now takes his wife for himself. Marguerite, rather than Jean, is the true victim in need of consolation. We see in her husband's harsh reaction a response that is at once very specific to its place, time, and social class but simultaneously transcends all these particulars. One need not be immersed in medieval chattel matrimony to erupt into fury and express self-interested frustration with a sentiment akin to saying,

"Again, he has taken what is mine!" It is a selfish response, but it also resounds as utterly modern, natural, and relatable to think first of the personal betrayal and disrespect of this act as an immediate reflex and impulse and secondly to feel distressed for the violated spouse. A romantic partner today might react this way in a society that grants equal rights and autonomy to all adults. The fact that he says this from his position as her supposed master draws our attention to how self-involved we can be and how constant that is.

Foreignness also serves a distancing effect. Nietzsche recommends foreignness in history as a form of friction and reflexivity. He rails against his society for being too caught up in thinking about the past. In response, he calls for the past to be made "strange" (*unheimlich*) on two grounds. First, he considers the ease of overidentification with the past to be detrimental to both the present and past. Second, since history is a representation that always risks being editorialized and fictionalized, making the past too familiar misleads (2019, 15). Foreignness in moving histories has a powerful paradoxical two-track effect. On the one hand, it evokes a critical and reflective distance. On the other, it deepens emotional absorption, seizing upon the special delight of cinema to immerse audiences in another world.

Plus ça Change, Plus C'est la Même Chose

The Last Duel shears much of the fascinating detail from the ritual of the state-sanctioned medieval duel in France as described in Eric Jager's fascinating book that serves as the film's source. According to Jager, at the outset of the duel, the royal procession enters the arena with the so-called sword of justice atop a pillow. Next, the combatants arrive on horseback, flanked by massive entourages of supporters for the inspection of weapons to guard against illegal modifications and poisons. Then comes the admonition to the crowd to remain silent and still under the threat of death. Jacques Le Gris was then knighted so he could fight as an equal. Next, the opponents knelt over an altar brought onto the field and together grasped a crucifix in their right hands while clasping each other's bare hands with the left to swear oaths to God before the battle (2020, 153–164). Ignoring the specifics of these first-person accounts of this event detailed by Jager denies us the tension and eerie atmosphere of the silent crowd and sensual close-ups of the joined bare hands of these fierce rivals, whose survival will, within moments, rest upon killing the other.

In a reverse image of the wedding ceremony in *The Return of Martin Guerre*, the grip flips from the right hands clasped to signify harmony and union to the left, symbolizing enmity. Yet the movie meticulously illustrates other medieval elements of the macabre entertainment, from the size of the crowd attending the blood match to key moments of the gripping battle and its aftermath. When it ends, peasants strip the vanquished Le Gris. A horse-drawn cart drags his naked corpse by his feet from the arena into the streets. Outside the city walls, in a busy open-air death factory for convicted criminals, the executioner, with his primary

job already fulfilled by Carrouges, hoists the naked Le Gris by a rope tied around his feet into the air before a large mass of onlookers. Although the details seem extreme and alien—combat to the death as public entertainment, the desecration of the body of a man judged guilty in losing, the faith of the crowd in some divine justice, and the delight in witnessing the condemned punished and humiliated as part of a public catharsis—the underlying impulses of mob justice are sadly not so unfamiliar. In rejecting what seems ghoulish in the rituals of the past, might we see their contemporary reverberations and reject those as well?

In Johann Gottfried Herder's grand but unfinished survey *Outlines of a Philosophy of the History of Man*, which he worked on from 1784 to 1792, he makes a point about humility that seems relevant to the contemporary viewers of moving histories, those who watch partially moored in an inherited set of values and identities. To his contemporaries, he writes a warning: "Vain therefore is the boast of so many Europeans when they set themselves above the people of all the other quarters of the Globe, in what they call arts, sciences, and cultivation, and, as the madman by the ships in the port of Piraeus, deem all the inventions of Europe their own, for no other reason, but because they were born amid the confluence of these inventions and traditions. Poor creature! Hast thou invented any of these arts? Have thy own thoughts anything to do in all the traditions thou hast sucked in" (Herder 1966, 241).

It serves the spectators and makers of moving histories to understand that technological and cultural advances are hard-fought. Institutions, social environments, and ideas develop through the conflict, toil, and struggle that make history, often at great human expense. Rather than render strong verdicts on all the characters of history, judged from a self-satisfied perch, we may behold strange acts and customs of the past as a way to peer into the human soul.

The Compact of History

Although learning and education are often considered antonyms to fun, in *Poetics*, Aristotle claims the essence of the poetic arts and imitation (*mimesis*) lies in the human love of working through problems and learning (1997, 57). In Lowenthal's catalog of the allures of history, quoted previously, he includes explaining and knowledge. Both impulses are inspired by understanding present conditions through a search for origins and in the effort to build causality models based on empiricism rather than pure, abstract deduction and conjecture.

Eric Hobsbawm argues that to "be a member of any human community is to situate oneself with regard to one's (its) past, if only by rejecting it," and this relationship to history forms "a permanent dimension of the human consciousness, an inevitable component of the institutions, values and other patterns of human society" (1997, 10; parentheses in the original). He further asserts that the abuse of history to fashion nationalizing myths and scapegoat the other is rarely fabricated atop pure falsehoods but formulated through

"anachronism" (7). These distortions, through alteration, exaggeration, and the stripping of complexity, skew history. Anachronism results from failing to apprehend historical context by grafting contemporary concerns directly onto the past to make the past conform to a specific present rather than attempting to better understand the present through a genuine inquiry into the past.

Foreignness should be specific to the context rather than a mere construction of an uncanny atmosphere. Werner Herzog's *Heart of Glass* (1976), a historical fiction about a town that relies on manufacturing ruby glass in the 1700s, indulges one of the director's many daring cinematic experiments. Herzog famously hypnotized his actors on set to deliver the past as distant and enigmatic. As a result, the film presents an array of haunting and alienating performances. The effect confers a weird and unfamiliar ambiance, an odd pace of living, and surreal interpersonal interactions. The intention of this provocation was not to contextualize the actual environment of small-town Bavaria in the eighteenth century but, as Herzog explains, to "convey an atmosphere of hallucination, of prophecy, of the visionary, of collective madness . . . an aura of mystery" (Greenberg 2012, 12). The film offers a novel and expressionistic meditation on the separation of time and our access to history through performance. And yet, the technique does not convey the audiovisual or social context of its historical time or place. It offers foreignness for its own sake. Although the result engages historiophoty as a metahistorical and reflexive gesture that expresses our distance from the past, it does not engage foreignness as a principle because it misleads as a source of particulars.

Constraining and collapsing the foreignness of the past is common in moving histories, imposing contemporary values on characters and plots, either because a screenwriter or filmmaker is unaware of specifics or in an effort to make characters and plots more relatable or appealing to audiences. In *The Better Angels of Our Nature*, cognitive psychologist Steven Pinker explores the power of story to broaden our horizons and encourage empathizing with others while stipulating that "writers know that audiences are most engaged in a story when there is a protagonist whose viewpoint they are seduced into taking" (2011, 586). His point raises a series of questions: Do audience members need to see a hero consistent with their values? Just how far do filmmakers have to go to make a character relatable? And how far will an audience go to relate?

The Myths of History

The protests of Paris 1968 were launched in large part over bad teaching and to oppose sex segregation in dormitories. Rancid meat on the ships served as the tipping point for the Potemkin mutiny. Moving histories that hide actual motivations under intellectual ideals undermine history as a tool of diachronic self-knowledge. The myth of the past as a golden age is tempting and corrosive.

One of the worst transgressions filmmakers of moving histories make in fictionalizing the past is hiding the real impetus for historical events. In this, they deny the primal, instinctive, and self-serving reasons for action or revolt, depicting brave and heroic choices made on principle by assigning to ideological conviction what might have been partially motivated by more basic concerns.

Popular histories habitually lean into myth and resist crediting the pragmatism that inspires the most epic acts of heroism or destruction. Davis makes this point in a striking fashion about *Amistad* (1997) and its denial of the emotional, visual, and cinematic exchange that spurred the revolt on the ship. As Davis recounts, what precipitated that event was a tense and visual exchange that speaks to human incentives and specific fears among the African captives about the sinister plans of their abductors with an immediacy that seems made for the movies (2000, 85). She recounts that the "immediate and frightening trigger to the revolt," according to the record and Cinqué's actual testimony (the historical person played in the film by Djimon Hounsou), was Cinqué asking the ship's cook using sign language what would happen when they docked (85). The cook responded by motioning that "their throats would be slit and they would be chopped, salted, and eaten," inciting Cinqué to find a way to release the passengers from their chains (85). Davis surmises that the decision to conceal and deny this horrific joke, one "so visually accessible and so brief a scene," was likely made to smooth away the "idiosyncratic" and "unmodern in one's heroes" (85). It denies audiences access to a vibrant historical data point and access to the complexity of human behavior and the level of threat that drives us to dispense with all hope to take risky and decisive action.

Complexity is a crucial adjunct to accuracy, speaking to the variety of human response, which is never a monolith, regardless of prevailing social pressures or beliefs. Giving voice to a range of character positions and responses complicates and heightens the learning and emotional impact of films like *Free State of Jones*. Its small-scale farmers resist the war as a threat to their own safety and security and that of their families. It is a clash of power that revolves around class. Their opinions on the institution of slavery run from indifference to opposition. In *Let It Fall: Los Angeles 1982–1992*, the participants in the beating of Reginald Deny reflect upon their actions with a range of attitudes, from contrition to defiance.

In their discussion of historical films, Ella Shohat and Robert Stam make a similar point, suggesting that historical works, audiences, and critics often go too far in excusing the excesses of the past or sculpting characters into archetypes of heroes or villains. In their analysis of Christopher Columbus films from *Christopher Columbus* (1949) to *1492: Conquest of Paradise* (1992), they detail the many omissions of events designed to make the explorer more palatable and admirable as a character, eliding Columbus's involvement in the Inquisition, the slave trade, and large-scale massacres of Indigenous peoples (1994, 63).

Reflecting on the complexity lost in the flattening of the record, Shohat and Stam note that in assessing history, we often apply a misplaced historical relativism, as though somehow, in the past, no one questioned prevailing inequity and cruelty. If this were the case, then the divergence of opinions of the twentieth and twenty-first centuries would be a unique product of modernity rather than a universal fact of human societies. Shohat and Stam explain that contemporary criticism of glossy features that glorify Columbus from start to finish does not voice an "anachronistic and unduly prosecutorial" opinion, given that the malign and violent behavior of the Europeans in the Americas did not escape consternation in Columbus's own time (69). Depicting the European discovery of the Americas as a heroic quest ignores critiques expressed then as now. Sticking to a consistent principle, they note it is no better to lionize those that oppose prevailing cruelty as being wholly good. Pointing to *The Mission* (1986), they explain that the movie overemphasizes the distinctions between "racist mercenary Colonialists and compassionate antislavery Jesuits like Father Gabriel," given that the church's objections were limited to the severity of slavery, stopping short of rejecting it as an institution altogether (69).

The Good, the Bad, and the Presentist

Complexity is compelling. In *Philosophy, Black Film, Film Noir*, Dan Flory explores Spike Lee's oeuvre through its nuanced characters. Flory explains that *Do the Right Thing* (1989) "extends the manner in which many classic *film noirs* gave audiences a foundation for identifying with and understanding socially marginalized, morally good-bad characters" (2008, 65; emphasis in the original). History and its human subjects require an extensive and detailed scope of moral ambiguity because engaging in moral assessment of real people is central to the practices of production and reception of moving histories.

In *The Antihero in American Television*, Vaage explores why morally complex protagonists are so appealing in the context of serialized fiction. In the process, she provides a persuasive argument with implications beyond that genre, relevant to all popular narratives, including history. Here and elsewhere, Vaage explicitly details the difference in audience response to fiction versus nonfiction (2017a; 2017b, 26–33). There are, no doubt, distinctions to make when applying her framework to diegetic and mimetic nonfiction. In mimesis, a layer of performance and pretense buffers our relationship to what we see, especially danger and horror. Aristotle also highlights this point, noting how differently we respond to the representation of death in art versus observing it in real life (2013, 20). Even though actors in moving history performances allegedly re-create things that happened to actual people, the fact that what we know that what we are witnessing is not real allows us to engage scenes from the fictional remove of a metaphorical interpretation. No animals were harmed. No people were harmed either. Performance sequences depicting the hanging of young teens lured from Knight's camp in *Free State of Jones* or the disappearance of

Constantine XI into a barrage of enemy soldiers in *Rise of Empires: Ottoman* swell our emotions in a way distinct from how we confront the murder of teenager Latisha Harlins through witness testimony and as displayed on CCTV footage in *Let It Fall: Los Angeles 1982–1992*. Unlike in representational death, with presentational death there is no poetic catharsis, only hollow despair.

The differences between how we engage mimetic versus diegetic nonfiction aside, Vaage's analysis of the audience's elasticity in accepting complex characters operating in moral environments foreign to their own experience offers profound insights into the possibilities for depictions of historical agents. She explains that morally ambiguous characters can be made compelling to audiences through (a) our natural desire to associate with those in power; (b) "familiarity," not in the sense of being relatable but in being well known to an audience who comes to understand their desires and loyalties; (c) opposing adversaries who are merely sketched; (d) showing "contrast characters" who are morally worse; and (e) sympathetic alignment of low-level bodily reactions to suspense, when main characters are imperiled (2017b, 46–90, 161). A further narrative reward of complex and detailed characters is the audiences' heightened visceral and cognitive engagement. Plots built around wily characters who mix positive and negative attributes raise the challenge of narrative prediction by the audience (105). There are many rewards for audiences entering the complicated worlds of customs, relationships, and moral codes that operate within boundaries distinct from their own.

Because Vaage's focus is fiction, which she explicitly distinguishes from nonfiction, the extrapolation is not that morally reprehensive historical actors or institutions of the past could or should be made palatable but that the complexity that is part of each individual can be displayed and explored rather than hidden and denied. Audiences can take on, and take enjoyment from, immersion into unfamiliar worlds with characters who resist easy identification with contemporary norms and views. Because a performance or documentary history represents the real and not the imagined, treating a real-world don, meth manufacturer, or serial killer in the manner of the antihero series is not appropriate to history. The spectators' experience of realizing that they root for the murderers and criminals at the core of shows like *The Sopranos* (1999–2007), *Breaking Bad* (2008–2013), and *Dexter* (2006–2013) only works in a fictional storyworld. It is not that histories should prod the spectator to share the goals of historical agents who hurt people; instead, what Vaage's work suggests is that audiences can handle, and will ultimately relish, more ambiguity in their protagonists and antagonists through depictions replete with complications and contradictions.

An example of a rare moving history built around a complicated antagonist is *The Act of Killing* (2012). It is a brave documentary that transgresses a taboo by deconstructing the myth of the monster. The portrait is complex, revealing the social pressures, delusions, and psychological frailty of someone who takes part in mass killings. The film does not empathize with its main character, Anwar

Congo, a death squad leader in the Indonesian genocide (1965–1968). It always keeps him at a remove and seeks to grip the impetus for his actions as it documents the toll that such barbarity exacts upon victims and perpetrators alike. Joshua Oppenheimer's character study offers up the only pieces we can extract from tragedies of this scale—the hope that through understanding the human incentives of taking part in catastrophe, we may circumvent them in the future.

Too often, histories are admonished for endeavoring to fathom the unfathomable or for portraying complexity in perpetrators and victims. As one critic framed the film, investigating this atrocity through its perpetrators makes it a "snuff movie" (Fraser 2014). But how much do we learn from mythic historical archetypes? How can we undermine or avoid horrors that we do not understand? There are many reasons to look away. It is easier to play the umpire to history than to delve into its complexities.

While *The Act of Killing* caused distress for some in its detailed portrait of a mass murderer, there is an equal impulse to present victims as wholly good in a way that diminishes them and our grasp of historical knowledge. Do we really care for victims if they must be unassailable? As another author and cultural critic has observed about public and media responses to current events argues, "If you only love someone when they're unthreatening, if you only support a group of people when you can cast them as blameless, if you'll only fight for a class of people when you can insist that they're harmless, you do not love them, you cannot support them, and will never really fight for them. Love that does not love the unlovable part of someone is not love. . . . If your response to a crime committed against someone is to minimize their negative qualities, you are inherently accepting the logic that the crime committed against them would have been justified had they not been as blameless as you've made them out to be" (deBoer 2023).

This commentary is as relevant to our interpretations of events of the past as it is to those of the present. In fact, they are deeply interconnected. When we paint historical conflicts as archetypal struggles of good and evil, when we do not allow our enemies to possess positive attributes and do not let their victims make any mistakes, we hold contemporary incidents to the same fictional standards. Those who historicize through binaries of the righteous and the damned are not engaging history but contemporary politics, and in the process, they do a damaging disservice to both. Although it is the search for insights into the present that drives us to look to the past, we must keep the present out of the past as much as possible to enable the past to inform the present.

Vaage explicitly addresses the impulse that often informs these stock characterizations and the fear of simple responses to complexity by the "bad fan" who does not meet morally ambiguous and complicated characters with a multifaceted or self-aware response (Vaage 2017b, 91, 116). Instead, they miss nuance and admire the likes of Tony Soprano, Walter White, or Dexter Morgan. Catering to immature viewers, however, by pushing characters to moral extremes to ensure

that no one misinterprets characters is not the answer. A key pitfall of popular histories is the extent to which they mistrust their audience and sand down the details of people, events, and context, creating not history but fantasy, alternate histories that likely do more harm to learning from the past than good.

Mark Carnes's edited volume *Past Imperfect: History According to the Movies* offers several illustrations of what results from eschewing foreignness and staging icons of the past as set dressings on a soundstage of the present. Such films acquiesce to the impulse to remake the past in our own image. They mash characters into ethical extremes. In part, it may be the creep of the popularity of action-hero genres as vehicles for modern myths spurring filmmakers to trade capes for codpieces. A lively takedown of *The Last of the Mohicans* (1992) by historian Richard White warns of the perils of history films that eschew accurate and complex depictions of context, liberally whisking past and present, pulling costumes over actors to wander through a contemporary universe sprinkled with period details. Though a historical fiction, his description of *The Last of the Mohicans* applies to moving histories such as *Braveheart* (1995). In an essay cataloging many misleading anachronisms and falsehoods in *Mohicans*, White complains that it presents "people just like us, except more beautiful, [who] dress up in exotic outfits and pretend, well they are just like us but more beautiful. And because they walk like us, talk like us, and share our values and prejudices, the setting, scenery, and the costumes become essential for creating the illusion that this is history" (White 1995, 82). Intentional alteration of the known facts derails the core tenets of history and nonfiction. It constitutes a failure of vigor *and* imagination. Using a free hand to reinterpret or erase the customs, worldviews, beliefs, and motivations of people and events of the past feeds misconceptions and emboldens erroneous and self-serving folklore that leads to misinterpretations of the current state of affairs.

Foreignness within the Historical Storyworld

Although foreignness in historical discourse applies principally to the distance between the makers and receivers on one side and the historical universe represented on the other, it also applies to articulating foreignness within the historical context, as so many histories include the collision of people and cultures in a shared time and place. Another missed opportunity that Davis points out about *Amistad* is that it erased another site of cinematic drama in bypassing the struggle for people to understand one another between Mende and English (2000, 87). Language barriers between peoples in the past have sometimes been mined more successfully in films, for example, in depictions of Indigenous and European contact in *Black Robe* (1991) and *The New World* (2005). Since the default language convention of mainstream moving histories for English-speaking audiences is that all the characters will speak in English, they occlude the miscommunication, fear, and wonder in exchanges between cultures. James Axtell praises *Black Robe* for its "even handed depiction of the baffling otherness

of both native and French cultures. Neither culture is morally privileged; each is presented to the viewer in its undiluted strangeness, as it was to the other in 1634" (1995, 78). In the examples of both *Black Robe* and *The New World*, by dramatizing the effort and often the failure to communicate, these films evoke many of the empirical dangers, mysteries, and enchantments of the past.

Writing about an alternative history in a manner that illuminates this aspect of intrinsic conflict, Caroline Guthrie highlights an ingenious expression of foreignness between cultures in *Inglorious Basterds* (2009), when British spy Lieutenant Archie Hicox (Michael Fassbender) tragically outs himself as such in a German bar by ordering several drinks holding up only his fingers to indicate the number, rather than using the German custom of including the thumb. She notes that five years after the film's release, Quentin Tarantino expressed frustration with the way so many films elide actual tension and drama. As an example, he specifically cites depictions of English spies in World War II movies "speaking German in English," which gives the sense that their accents were imperceptible to the Germans (Guthrie 2019, 345–346). When makers of moving histories ignore real threats and conflicts, they must concoct fictional sources of menace, strife, and narrative conflict to put in their place.

The moving histories under consideration in this book reveal different facets of foreignness. Interview-based documentaries express foreignness through language, like prose histories. Performance works, archival imagery, and reenactments embedded in most historical documentaries communicate the foreignness of atmosphere and culture through renderings of sound, light, performance, dialogue, and pacing. Few documentaries are purely interview-centered. Only documentaries that mix interviews about the past with contemporary present-tense scenes unfolding before the camera rely exclusively on descriptive, linguistic evocations of the foreignness of the past. Most history-focused documentaries take the form of compilations of archival materials or wrap archival clips or representational reenactments around an interview-based spine.

Let It Fall: Los Angeles 1982–1992 explores a famous city known to the documentary's audience through direct experience, media depictions, or both. The material and social cultures it presents are familiar. The film catalogs events that transpired within the memory of many viewers. Although recent histories like these offer fewer sources of foreignness, its archival imagery exhibits the rough textures of the analog video age and presents for the audience the media representations of the events as they looked for those who lived through them. It was a time before the social and technological paradigm shift to high-quality digital cameras and the ubiquitous cell phone. And yet, interview topics ranging from aggressive policing to racial and class-based segregation and stratification to gun culture remain eerily static. The events detailed happened decades ago. The documentary asks its viewers to question why so little has changed.

The compilation documentary *A Night at the Garden* (2017) appears as the fever dream of an alternate history in the spirit of *The Man in the High Castle*

(2015–2019). Inside the arena of an event described on the marquee as a "Pro American Rally," U.S. citizens repeatedly raise their arms in the Nazi salute, gazing toward a stage framed by a massive mural of George Washington flanked by swastikas. They listen to speeches drenched in antisemitism and call for "Gentile rule" (Curry 2017). The large, assembled crowd roars in applause in response to the violent wrestling of a Jewish protester from the stage. The chilling atmosphere of the packed auditorium of enthusiastic and patriotic American Nazis reveals an unmissable universal critique of ongoing threats of malignant nationalism, antisemitism, racism, hateful ideas, and the madness of crowds.

Free State of Jones highlights the sensual foreignness of wet moonlit swamps, accompanied by a symphony of frogs and the sparsely furnished homes of sharecroppers and small-hold farmers of the Civil War era. Their humble homesteads are open to the elements with missing slats of wooden siding and shingles. These details represent critical context for the material circumstances of the resisters to the Confederacy. The movie also chronicles the stratified society of Jones County, Mississippi, and the complex range of reactions Southerners had to the war. In choosing the history of a group of people not often told, *Free State of Jones* takes an approach foreign to other films of the Civil War subgenre. Inspired as a rejoinder to *The Birth of a Nation* (1915), it also differs from Civil War films like *Glory* (1989) and *Lincoln* (2012) in the scope of its characters, including autonomous and self-reliant women, while detailing the pressures exerted by the war effort on small-scale farmers and the poor. Its departures from evidence and fictionalizations of the history, described in the evidence chapter, include the impetus for Knight's desertion from the army and the circumstances of his ambush and murder of composite character Colonel Elias Hood; they replace more compelling details of human behavior and psychology with more generic fabrications. Davis's critique of elisions in *Amistad* applies equally here. The question in moving histories is not whether there will be fictionalizations but of what order and within which boundaries.

Historical details left out of the script leave actual events unrealized. Imagine the sequence based on the historical data, in which Knight escapes the army to confront the man who had usurped his place in his home. It would be more thrilling, tense, and accurate than the revisionist plot that revolves around Knight's return of the body of his fictional young nephew. How would Knight enter his home to chase out the interloper Bill Morgan? Would he sneak in or throw open the front door, slamming it against the wall? What would he do when he turned to his wife? Would he blame her or console her? Here is the place for targeted historical thinking and fictionalization. Such a scene, full of conflict and suspense, would illuminate a host of other aspects about the threats and politics of the era that remain untouched by the film. The issue is not with this movie but with moving histories more broadly. As the evidence chapter details, one could not ask for a filmmaker more committed to researching the historical record and accounting for depictions and departures from the record.

The point is that makers of moving histories ought to be more hesitant and circumspect about remaking and transforming the specificity of events and motivations in exchange for mythic and morally pure machinations.

John Trafton's incisive essay on the film, "*Free State of Jones* and the New Civil War Cinema," isolates one of the most moving, faithful, and artfully rendered aspects of foreignness expressed within it, through "the thousand-yard stare on Newt's face, as well as other soldiers and Knight Company members," explaining that "Knight carries the scars of battle with him throughout the film, transmitted through a shell-shocked-face known in Civil War-era parlance as 'seeing the elephant'" (2023). There is little doubt that Trafton has put his finger on a specific cultural reference enacted in the film. A prime aspect of Matthew McConaughey's performance is evinced in this recurring expression of shell shock and, for Mahershala Ali, the trauma of bondage, speaking to the attention to detail and atmospherics of the film and its deeply rendered performance of a people and an age.

Rise of Empires: Ottoman demonstrates how an allegiance to genre supersedes the effort to capture the alien material and psychological fabric of another time. The series follows the formula of other performance history programs, like *The Last Kingdom* (2015–2022) and *Vikings* (2013–2020), by pressing history into the medieval fantasy genre of a spectacle like *Game of Thrones* (2011–2019). Unlike *The Last Kingdom* and *Vikings*, historical fictions scattered with historical people and events, *Rise of Empires: Ottoman* draws its narrative from a far more detailed and reliable set of documentation about a unified event, supplementing performance sequences with expert interviews to lend critical context. Still, *Rise of Empires: Ottoman* eschews many opportunities to create a portrait that plants us in the sensual and cultural environment of its history, opting instead to enfold its audience into a genre, evoking the look and experience of fantasy films, series, and video games.

In scenes lit by daylight or firelight, Ottoman interiors envelop the viewer in opulence, warm colors, and layered tapestries, whereas an austere coldness characterizes the emperor's chamber in Constantinople. The series achieves a mixed accuracy of detail, which ranges from the transportive, sensual exoticism of period musical instruments, including the unique and enchanting reverberation of the Anatolian zurna played at the Ottoman camp, to the anachronistic kilt of John Grant, a countermining specialist who was part of Constantinople's doomed defense. A foreign mercenary, Grant's responsibility was to defend the city's walls from the Ottoman's attempts to collapse them from below. Although most sources claim he was a German named Johannes Grant, the series chooses to resurrect him as a Scot, according to a rationale forwarded by historian Steven Runciman (2012, 84). Even if Grant were a Scot, and he may have been, he would not have worn this iconic garment invented in the next century. The particulars of the series offer the global flavor of a souvenir shop.

FIG. 4.3 The "thousand-yard stare" offers a period invocation of the trauma in *Free State of Jones*.

The Janissaries, the vast ranks of highly trained soldiers enslaved as children and trained to grow into an elite Ottoman infantry, are mentioned as such in the series' narration but are otherwise depicted as universally enthusiastic in their bloodlust. In the documentary sequences, interview material hews closely to the plot rather than offering insight into details of the physical and social environment of the two clashing empires. The series tends to avoid specifics of the historical setting, sticking to the universals of the fantasy genre. Characters are types playing their assigned parts, making the complexity of real human nature scarce, while many interiors convey the look of lightly dressed sets. One key to what makes the series so compelling is how well the history fits into a fantasy and adventure plot. Nevertheless, much richness is ignored as the show overrides consideration of the details of the clash of these two distinct and distant worlds.

Set seventy years earlier, *The Last Duel* delights in evoking material and social atmosphere through its location shooting, careful replication of period technologies, and attention to the rituals and hierarchies that organized the historical agents' social reality. While it erases any legitimate skepticism about the specifics of what happened and the possibility that Marguerite may have wrongly accused her husband's rival, the film offers deft and subtle depictions of the three main characters and their own interpretations of events. *The Last Duel* proposes that the rape happened as Marguerite describes and paints those proceedings from the perspectives of each of the three main characters. The film details the pressures of maintaining a title and castle, the effort and strained obsequiousness that Jean de Carrouges (Matt Damon) must and often fails to display toward his immediate superior, Count Pierre d'Alençon (Ben Affleck). Yet many of the most intriguing aspects of the social environment revolve around

women. Marguerite's portrayal is compelling. She consistently speaks and acts as an aristocratic Norman woman of the fourteenth century. She has pride and self-respect, but not once does she question the social reality that women depend on the goodwill and cooperation of men.

One scene between Marguerite and her mother-in-law speaks directly to the sociopolitical environment for women in that time, place, and milieu. Nicole de Carrouges (Harriet Walter) scolds Marguerite for making a fuss over her assault. She tells her daughter-in-law that rapes happen, and you stay quiet about it. The elder Madame Carrouges confides that this is what she did when it happened to her. The revelation humanizes the cold and unsmiling matriarch. One wonders what else she has endured in silence. Ultimately, her complete lack of empathy for Marguerite drains much of the audience's sympathy away again. The scene speaks to a society that expects women to accept male violence as their lot. Yet the callous cruelty of the mother-in-law's words also rings as universal, a blame-the-victim hostility that lingers.

In the trial by combat between Jean de Carrouges and Jaques Le Gris that forms the film's climax, we see the tension on the faces of the supporters of Carrouges and Le Gris. They do not seem to trust in divine justice lining up behind the man whose testimony they claim to believe. This suggests a complexity of thought toward the authority of both the sovereign of France and of all creation. The film evocatively manifests fine details of atmosphere, taking audiences into drafty castles as slices of overcast blue-gray daylight streak through windows to collide with orange firelight where the inhabitants linger mostly in shadow. It is a place where women stay silent and powerful men participate in a strict social hierarchy built on acquiescence to the king and his various proxies.

Navigating Specificity

There are limits to accuracy and quantity of detail, just as there are elements of behavior in the past that may be so unrelatable and strange to modern audiences that to attempt a faithful reproduction or to furnish the requisite context would derail the entire work. Acclimatizing to the specifics of sadistic ideas and customs can be a long-term project for historians and not something easily introduced and navigated within the narrative and time constraints of mainstream moving images. All histories pick and choose their plot points and atmospherics. The question is, what is the scale of the essentializing? Moving histories that offer rich descriptive details have the power to envelop and alienate in ways that are compelling and edifying. Delivering the specifics of what is foreign about a historical time and place simultaneously deepens the entertainment and learning that moving histories offer to mass audiences and public understanding. After all, entering a portal to take on unfamiliar experiences and atmospheres is among the prime pleasures of moving image media. The last chapter leads further in this direction, considering our access to the past through a plurality of perspectives and positionalities as a method of historical truth.

5
Plurality

•••••••••••••••••••••

How does a moving history express multiperspectivity through character, interpretation, and authorship?

History offers a view of empirical reality through a jumble of subjectivities. The principle of plurality addresses the role of history as a search for origins and an inquiry into recurring patterns of human behavior. Histories may address historical contingency by offering a diversity of perspectives on events and their possible meanings, propelling a broader scope of interests that bring visibility to a greater range of historical agents. Plurality benefits history's method, the quality and stability of its truths, and the knowledge produced for the audience.

There is no such thing as a monoculture. Certainly not in the Anglosphere or the plural nations that have developed in the shadow of colonialism. Plurality concerns the wealth of divergent perspectives on-screen as appropriate to the context. For example, the moving history *Braveheart* (1995), depicting Britain in the 1200s, and the historical fiction ᐊᑕᓈ ᕐᔪᐊᑦ [*Atanarjuat: The Fast Runner*] (2001), set in Igloolik more than a thousand years ago, cannot be faulted for their lack of racial diversity but may be analyzed in terms of the voice and visibility accorded to women, nature, or a host of other perspectives within their environments. The point of plurality is not that moving histories ought to include specific identities. Instead, it asks us to consider whether a moving history represents a diversity of points of view on a topic or adds new ones to previous interpretations of similar events.

Plurality calls for intellectual flexibility and curiosity in our assessment of those who lived and acted in the past. Foreignness and plurality challenge us to grasp the values and goals that shape another person's conduct, including

those of perceived enemies or bad actors. In that process, we empower learning and the potential for progress and redress. Moving histories that build multifaceted reflections of what shapes and compels people—their worldviews, words, and actions—illuminate the human fabric. They engage historical thinking and create knowledge. Cataloging facile and binary approaches to historic goodness and badness is a mythologizing exercise of limited value to the present or future. What matters is what, why, and how. Of most interest is what is most speculative: What was inside the heads of the historical actors, and what compelled them? What were the motivations that led to specific outcomes? The goal of history is not to sort our allegiances in the present but to understand trajectories and circumstances that reveal human behavior. Without historical inquiry, empirical arguments about present-day realities, from perceiving threats to taking preventative measures, are impossible. History is a compass. As this chapter will explore, plurality serves twin goals, offering a diversity of representation and sympathy as a form of representative justice and an essential method of truth.

Judging Judgment

This is another principle springing from Natalie Zemon Davis's injunction that the best histories do the hard and complex work of understanding rather than judging (2000, 11). Avoiding judgment is one of the most crucial and difficult dictates of history. After all, what is history but an assembly of proposed facts and judgments about them? History is bound in judgments as expressed through narrative choices outlined in the principle of narration in chapter 1 and the selection of evidence explored in chapter 2. However, Davis advises that historians temper their judgment of agents and their actions through the more profound and complex process of understanding the infrastructures and incentives that manage societies and propel events. She explains that "apart from mere partisanship, judgments are involved in the choice of subject, approach, and rhetoric. Should it be told as a tragic tale? An ironic tale? Historians can recognize these moral stances and perceptual habits in themselves and acknowledge them, say, in a preface. Whatever their preference, historians are urged to describe a situation from the point of view of different actors" (11). The call to understand includes an appeal for plurality.

History has always been entwined with identity, whether religious or secular, at scales ranging from groups to regions to nations to transnational communities (Berger 2022, 2–7). Plurality acknowledges points of view previously considered peripheral to history and portrays reality as we know it, interpreted through human perspectives. Writing about the "deep relationship between historical representations and constructions of identity," Stefan Berger reminds us that the politics of a historical argument are dependent on the historian's "own positionality and (self-constructed) identity" (2022, 18). The historical pursuit

of the web of meaning is managed through a web of bias. Plurality accounts for this.

As Ella Shohat and Robert Stam explain, "Cinematic recreations of the past reshape the imagination of the present, legitimating or interrogating hegemonic memories and assumptions" (1994, 62). Put in another way, Sarah Maza writes that histories create "narratives that provide social groups—national, regional, ethnic, and other—with a collective identity, in the same way that we construct our personal identity by telling ourselves the story of our life" (2017, 6). Plurality addresses the politics of selection, inclusion, and exclusion that Leger Grindon calls a key animating force behind history (1994, 5).

Plurality Is Polyphony

What Mikhail Bakhtin writes of literature, as expressed in the work of Fyodor Dostoevsky, illuminates the concept of plurality in ways beneficial for moving histories. Bakhtin describes Dostoevsky's method as polyphony that arranges a "*plurality of independent and unmerged voices and consciousnesses*" (1973, 6; italics in the original). Bakhtin calls the technique "dialogic," as it presents "multi-voicedness" in the "interaction of several consciousnesses," expressing the contradictions and "multi-leveledness" of "the objective social world" (30). Bakhtin's insights have great historiographical value as they chart the best route toward objectivity, approximated through a conflagration of diverse subjectivities, each offering its own angle on reality and meaning.

Understanding a person's motivation, even our own, is highly speculative. We can only definitively know a person's intent in fiction. In the fictional storyworld, authors as creators have the objective scope to state unequivocally how narratives and events shape a character's thoughts and actions. Fiction makers can move through time, space, and matter, shifting from one moment to the next and from descriptions of material reality to the unveiling of thoughts and intentions within a character's consciousness. Historians often move across the same terrain but without the assurances of navigating a world of their own creation. Bakhtin could be writing a historiographical tract when he claims that "*a genuine polyphony of fully valid voices*" produces "not a multitude of characters and fates in a single objective world illuminated by a single authorial consciousness, but rather a *plurality of consciousnesses, with equal rights and each with its own world*, [that] combine but are not merged in the unity of the event" (1973, 6; emphasis in the original). Historian Robert Berkhofer reinforces this idea when he writes, "Plural viewpoints . . . do not lead to plural pasts" (1998, 190). In fact, Bakhtin explicitly suggests that the benefits of polyphony extend beyond literature, recommending it as an approach relevant to "the development of the *artistic thinking*, of humankind . . . a special *polyphonic artistic thinking*" (1973, 270; emphasis in the original). Polyphony offers a sound methodology

for negotiating historical truth and the best route to approach and approximate objectivity.

Given that history is "a site of social struggle," Berkhofer implores historians to mine and consider multiple perspectives (1998, 4–6, 71). He urges historians to relate to "otherness" by "assum[ing] degrees of difference and sameness" while navigating the space between ethnocentrism, which denies difference, and relativism, which denies knowledge (177). History speaks to and of others, seeking to grasp a range of causes, incentives, and effects that produce sociopolitical phenomena. Surveying a broader range of experiences that intersect an event is a vital historiographical practice that enhances the knowledge we draw from the past.

Plurality as a tool of historiophoty expresses polyvocality on- and off-screen through

1. the range of characters given voice and visibility within a history,
2. the dynamics of the authorial perspective, and
3. the contribution of a historical interpretation in relation to other popular renditions of similar events.

For histories to be plural, they must draw from various perspectives rather than those of a chorus of people with parallel viewpoints. Shohat and Stam's *Unthinking Eurocentrism: Multiculturalism and the Media* contributes a sound and detailed method to assess diversity in cinema. They also propose a specific version of plurality for moving images that they call "polycentric multiculturalism" (1994, 46–49, 358–359). The concept takes aim at the repeated erasures of history, as it concerns "all cultural history in relation to social power," expressing "sympathies clearly . . . to the underrepresented, the marginalized, and the oppressed" in a manner that is "celebratory," that "grants an 'epistemological advantage' to those prodded by historical circumstances into what W. E. B. Du Bois has called 'double consciousness'" (48). They devise their orientation of polyphony toward "justice" and in opposition to "monoculturalism" (48, 359). It is a call to rectify recurring biases, which results in truths repeatedly narrowed and refracted by attending to those habitually ignored. As part of their framework, they deliver an essential critique of shallow gestures of representation in the style of "corporate-managed United-Colors-of-Benetton pluralism whereby established power promotes ethnic 'flavors of the month' for commercial or ideological purposes" (47).

Shohat and Stam disavow run-of-the-mill "liberal" pluralism with the broadside that liberal values maintain hierarchies, resulting in a bad-faith polyphony that only begrudgingly allows other voices in (1994, 48). In this, they register a strenuous rebuke to the perpetual occlusion of minorities that historian Dipesh Chakrabarty points to as a "characteristic of liberal and representative democracies" (2008, 97). Their proposal for pluralization informs this principle

as it addresses the long legacy of monologic and hegemonic moving histories. They offer an important model for plurality that fills perpetual gaps in the voice and visibility offered by mainstream moving histories that have formed chasms over decades. These gaps do damage in the present by distorting the past while simultaneously severing the ties many spectators might feel to history by denying agency and erasing the representations of those they might see themselves in. Chakrabarty explains that as history engages "the stories of groups hitherto overlooked—particularly under circumstances in which the usual archives do not exist—the discipline of history renews and maintains itself. This inclusion appeals to the sense of democracy that impels the discipline ever outward from its core" (98–99). Although Shohat and Stam claim that polycentric multiculturalism "rejects a unified, fixed, essentialist concept of identities," essentializing is baked into their commitments (49).

Plurality, as a general principle, encourages the interpretation of historical agents and events from multiple points of view. It aims to compensate for natural human myopia toward a more complex picture of the social world. As Stefan Berger explains, "Historical learning" is supported by "an adherence to anti-essentialism and to greater self-reflexivity about the link between historical writing and collective identity formation" (2022, 33). Shohat and Stam address the legitimate issue of mainstream and moving histories' continual focus on hegemonic idol worship by suggesting a hegemony that plays by different rules, elevating different people into the roles of hero or good guy, as a form of equalization and justice. Polycentric multiculturalism offers a valid and worthwhile method for plurality as it elevates those who've been mistreated, violated, or ignored, past and present. However, by tying multiperspectivity as an approach to specific political commitments, it may furnish a vital corrective but not a balanced or equitable overarching principle. It swaps old biases for new ones and uses the old system in the service of different prejudices. No matter how just its concerns are, this project ultimately heads down a similarly fated and fixed path toward distorted outcomes. After all, it is only to an open, expansive, inclusive, liberal, and politically pliant plurality that polyphony works as a historiographical practice. Without liberalism, multiculturalism cannot function. Thus, trying to defenestrate liberalism in promoting a particular kind of multiculturalism is to kick away the foundation on which you are standing.

Plurality necessarily intersects identity, as it means representing diverse points of view from multiple perspectives marked in some way by difference. There is no point in replacing the narrow telescope with a kaleidoscope that merely multiplies the same point of view. An array of perspectives exposes a wider angle on the past, a cross section of values and concerns with more information and complexity. Yet the invocation of identity digs a tricky pit of quicksand that Eric Hobsbawm's foundational work of historiography, *On History*, does much to elucidate. He implores his fellow historians to exercise political agnosticism and "resist the *formation* of national, ethnic and other myths," adding that

"myth and invention are essential to the politics of identity by which groups of people today, defining themselves by ethnicity, religion or the past or present borders of states, try to find some certainty in an uncertain and shaking world" (1997, 7). Hobsbawm concedes that historical legends are formed and promoted, after all, by "educated people: schoolteachers, lay and clerical, professors (not many I hope), journalists, television and radio producers" (7–8; parentheses in the original). And filmmakers, too, no doubt. While Hobsbawm addresses historians, the urgency of his message applies to all those engaging in public and collective historicization. He advises that the historian's "responsibility . . . is, above all, to stand aside from the passions of identity politics—even if we feel them also. After all, we are human beings too" (8). As a vehicle of mass communication, moving histories require a defining code or historiophoty. Too often, they fall into mythologizing the individual, community, or nation-state. In response, all too frequently, this is met with a shrug and the resignation that, as entertainments, we can expect nothing more.

Making Plurality Move

A history that presents a variety of characters, interpretations, and topics offers more complicated and, therefore, accountable and accurate representations of truth. Reflecting on the academic practice of history, Sarah Maza explains via the example of the shift to women's history in the 1970s that what was previously considered "general history" was revealed, in fact, to be men's history (2017, 34). Ignoring people—half of humanity, in this case—distorts our view of the past. It is only through an acknowledgment of the importance of women as part of a contemporary constituency that we look for them and pull them from their hiding spots in historical records. Chakrabarty describes a similar phenomenon in "the subalternity of non-Western" histories that routinely engage European history and historians, even as that interest is rarely mutual (2008, 28). Maza explains that "every time we reframe part of the historical picture to take account of another people, the whole image changes" (2017, 44). Selecting data to construct meaning always requires excluding information to concentrate on a narrative focus and historical argument. It becomes a problem when those omissions make a repeated pattern. The universal is reached through the diverse.

Plurality of Character

Each subject position in a history reflects a different truth. Bakhtin develops his concept of polyphony into the ideal of heteroglossia, suggesting that a novel "must represent all the social and ideological voices of its era, that is, all the era's languages that have any claim to being significant; the novel must be a microcosm of heteroglossia" (1981, 411). Although a substantial remit, this seems even more imperative in a work of history, as he explains that each language in a novel

"is a point of view, a socio-ideological conceptual system of real social groups and their embodied representatives" (411). Not only does plural representation better inform us about history by offering an assemblage of truth through a collection of heterogenous perspectives, but it also draws in audiences whose identification with historical agents has long been stymied, subverted, and denied. Speaking to historical cinema, Shohat and Stam argue that since "racial multiplicity exists at the very kernel of the American historical experience, relationality, we argue, should be central for the critical and historiographic accounts of American cinema" (1994, 223). This, paired with their explicit invocation of W. E. B. Du Bois's theory of double consciousness, provides a fruitful starting point to explain why polyvocality expressed through diverse perspectives is so crucial to historiophoty.

It is exhausting and destabilizing to continually see a version of yourself, or your community, constructed from the outside and at a great and distorting distance. Du Bois describes a "veil" that separates the Black race from others and distorts the Black individual from perceiving a direct reflection of the self (1989, 4, 9). He famously and eloquently posits seeing oneself "through the eyes of others, ... measuring one's soul by the tape of a world that looks on in amused contempt and pity. One ever feels his two-ness,—an American, a Negro; two souls, two thoughts, two unreconciled strivings; two warring ideals in one dark body, whose dogged strength alone keeps it from being torn asunder" (5). Dan Flory explains that habitually taking on a double consciousness stresses the psyche in ways unfamiliar and unknown to those continually represented as the main character, protagonist, and hero of the story, an identity that affords a continual "single consciousness" (2008, 43). Seldom, if ever, seeing oneself in the role of the hero in mass-moving image narratives unmoors the spectator. To rarely, if ever, see oneself reflected in a collective history isolates and unsettles.

Stuart Hall's essay on Caribbean film and cultural identity illuminates the imperative of plurality. He advises that "instead of thinking of identity as an already accomplished historical fact, which the new cinematic discourses then represent, we should think, instead, of identity as a 'production,' which is never complete, always in process, and always constituted within, not outside, representation" (1989, 68). He explains that communal and cultural identity function in a state of "becoming," because they "come from somewhere, have histories. But, like everything which is historical, they undergo constant trans-formation. Far from being eternally fixed in some essentialized past, they are subject to the continuous 'play' of history, culture and power. Far from being grounded in a mere 'recovery' of the past, which is waiting to be found, and which, when found, will secure our sense of ourselves into eternity, identities are the names we give to the different ways we are positioned by, and position ourselves within, the narratives of the past" (Hall 1989, 70).

He also sees the damage inflicted by representations that relegate many audience members to continually view themselves as "Other" (Hall 1989, 71).

Using the example of his native Jamaica, he explains that through the lens of postcolonial theory, civil rights, Rasta, and reggae, Jamaicans may acknowledge and embrace their African heritage, which introduces new identities and with them new pasts (75). The goal of more representative and plural moving histories is not for audiences to consume only those with characters with whom they identify on ethnic or other identarian grounds; it is to chart a pathway to better and more comprehensive histories. In addition, identifying with characters very different from oneself is a core benefit of popular media in the increasingly heterogenous postcolonial societies of a globalized and networked world.

Drawing from Peter Singer's observation that over time humans have expanded the number of others with whom they identify, Steven Pinker makes the strong case that part of this is due to the growth of literacy and reading as "a technology for perspective-taking" (2011, 175). Pinker writes, "When someone else's thoughts are in your head, you are observing the world from that person's vantage point . . . you have stepped inside that person's mind and are temporarily sharing his or her attitudes and reactions" (175). He offers the caveat that although "'empathy' in the sense of adopting someone's viewpoint is not the same as 'empathy' in the sense of feeling compassion toward the person, but the first can lead to the second by a natural route" (175). Further, bell hooks explains that inhabiting foreign perspectives offers its own rewards, as films present "the perfect vehicle for the introduction of certain ritual rites of passage that come to stand for the quintessential experience of border crossing for everyone who wants to take a look at difference and the different without having to experientially engage 'the other'" (1996, 2).

While taking on alternate subject positions offers a valuable tool to build empathy for others, its usefulness diminishes significantly with repeated transference into the subjectivity of the same dominant type. Flory reflects on the effect of Spike Lee's inscriptions of White characters within a culture "trained to take as typical or normative—being white—and see it depicted from a different perspective, namely, that of being black in America, which in turn removes white viewers from their own experience and provides a detailed access to that of others," inviting them into the "double consciousness" of seeing themselves from the outside (2006, 68, 69). The editors of the book *Seeing Red* make a similar point, lamenting that "most non-Natives, filmmakers and critics alike have come by much of what they presume to know about indigenous peoples from the rich cultural assemblage of uncritical assumptions and stereotypes provided by the various popular media" (Howe, Markowitz, and Cummings 2013, ix). What these popular renditions say has effects that ripple far beyond a given work. As hooks points out, her students learn more from movies than the theories in the books she assigns. Their narrative access to "discourses of race, sex, and class" creates "a shared experience, a common starting point from which diverse audiences can dialogue about these charged issues" (1996,

2–3). She observes that not only do moving images create informed perspectives and diverse identifications, "they make culture" (9).

Cast(e) of Characters

Plurality in moving histories is hemmed by the propensity for mainstream performance narratives to produce star vehicles that focus on admirable and relatable heroes in action in the pursuit of a goal and in the face of ever-escalating obstacles. This only adds a mythologizing pressure to the preexisting propensity for mass popular histories to craft stories of heroes fighting villains. Class has long served as a marker determining who will and will not be the focal point of a moving history. This is a jarring and perpetual occlusion in moving histories. Articulating a resoundingly class-conscious and Marxist position, Colin McArthur suggests that history films seek out "great men" and singular testimonials in which the individual functions as a "central structuring category," which he attributes to "all superstructural activity in bourgeois societies" (1978, 16). That impulse creates the impression that "history is made by individual interventions of men and women acting as free agents, rather than the complex interplay of *classes, institutions* and *modes of production*" (16; emphasis in the original). As much as postmodernism and poststructuralism sought to fragment personal narratives and dethrone heroes, geniuses, and authors, they did not successfully displace the brand of hero worship that can be traced from oral storytelling to the Hebrew Bible to TMZ. Political and popular histories habitually chronicle the actions of a few powerful agents, while the masses are forgotten. But beyond the social, cultural, political, economic, and narrative incentives to focus histories on a main character flexing agency and power, centering narratives around an active, sentient individual seems natural because we experience everything in the first person and relate to others one-on-one.

The focus of popular moving images will always spotlight arresting and emotional engagement tracked through the faces, bodies, and utterances of a character. Emotionally charged personal narratives move audiences rather than more abstract ideas that engage logic (Epstein 1994). Psychology professor Paul Slovic expresses findings extremely relevant to film in his article, "'If I Look at the Mass I Will Never Act': Psychic Numbing and Genocide." He explains that "images seem to be the key to conveying affect and meaning," and in terms of "eliciting compassion, the identified individual victim, with a face and a name, has no peer" (2007, 86–87). Sociologist Matthew Hughey describes the problem this poses to history, noting that "the discourse of a postracial society is now marked by individualist explanations for the causes of, and solutions to, racial inequality. The focus on individual people thus shifts focus from historical and contemporary structural inequality to that of individual bad apples" (2014, 166).

Mainstream moving histories may span generations, but they tend to focus on individual stories in an array of close-ups rather than wide-ranging

metaphorical drone shots of societies in the so-called sweep of history. Films that present nonindividualized histories of collectives like Peter Jackson's *They Shall Not Grow Old* (2018), Marshall Curry's *A Night at the Garden* (2017), and Sergei Eisenstein's films—dubbed "historical-materialist" by David Bordwell (1985, 235)—are notable exceptions to the rule of popular moving images. Moving histories that explore social movements or protracted struggles, like *Reds* (1981), *Free State of Jones* (2016), *The Look of Silence* (2014), and *Let It Fall: Los Angeles 1982–1992* (2017), inevitably lodge national or regional conflicts within individual experiences to access and penetrate audience emotions and resonate more deeply. The wide, panning shot of the thousands of injured soldiers after the Battle of Atlanta in *Gone with the Wind* (1939) is memorable and evocative, relaying a massive scope of suffering on an epic scale. Yet it is the anguish etched into Scarlett O'Hara's body that propels the audience through the scene and, indeed, the entire narrative. Similarly, it is the anonymous woman with the cracked glasses that we conjure as the embodiment of horror shouldered by the civilians facing the czar's soldiers in *Battleship Potemkin* (1925). In *A Night at the Garden*, it is the protester Isadore Greenbaum, running to the stage only to be swarmed and physically attacked, who becomes the focal point of our sympathy and emotional engagement. The gut-wrenching grief and courageous defiance of Mamie Till-Mobley in *Till* (2022) expresses the agony and bravery experienced by so many over generations.

Building upon Hall's theories of active and differentiated reception, hooks points out that audiences are often "seduced" into dominant readings of texts regardless of any intention or effort to draw an oppositional or nuanced position from them (hooks 1996, 2–3; Hall 2021). Exclusion and stereotyping wrought by mass cultural narratives may exclude or demean on the grounds of race, sex, sexuality, class, gender, culture, physical ability, and other metrics. What could be worse for spectators than being regularly exposed to limiting and demeaning depictions of aspects of their selfhood with which they identify? Michelle H. Raheja suggests that even media misrepresentation beats erasure, pointing to early Hollywood films in which Indigenous people were featured far more often than they are today. As bigoted and blinkered as many of these portrayals were, she notes that being caricatured is preferable to being ignored (2010, xii–xxiii). Not only does a lack of visibility and identifiability isolate many spectators, but as Hall explains, cinema regulates "our relationship to the past," operating "not as a second-order mirror held up to reflect what already exists but as that form of representation which is able to constitute us as new kinds of subjects, and thereby enable us to discover who we are" (1989, 80). A shift toward a diversity of secondary and background players does not suffice.

Shohat and Stam are instructive here. They lay out a comprehensive methodology to register "patterns" that might be overlooked as "random and inchoate," warning of "the psychic devastation" of habitual stereotyping that may lead to

internalizing stigmatization (1994, 198). In the process, they articulate a path for film scholars to assess plurality in cinematic language by considering which characters a film highlights through close-ups, POV shots, narrative structure, and dialogue. For example, they explain that as spectators witness the mistreatment of a character or experience heightened suspense and concern around a person's well-being and safety, they are drawn into occupying that subject position (253). They argue it is not enough to include diverse viewpoints; we must question with whose perspective(s) a work invites us to identify. Diversity, for its own sake, is not constructive. As hooks points out, citing the work of Quentin Tarantino and Larry Clark, some White filmmakers "exploit mainstream interest in the 'other' in ways that have simply created a new style of primitivism" (1996, 7–8).

In 2005, Franklin Leonard created "The Black List," a renowned and highly influential annual aggregator of the best unproduced screenplays in Hollywood. It has since become a powerful tool that helps screenplays gain funding, many of which accumulate massive profits, critical acclaim, and awards (Popescu 2013). In an interview in 2021, Leonard articulated what is required for plurality in the film industry and the difficulty of assessing it. Concerning the diversity of authorship in films, he explains, "I have no problem with a world wherein there are writers' rooms with five White male writers ... as long as there are a bunch of writers' rooms that are all Black women ... I don't need [to see] myself represented in every piece of art, but I do want to see everybody represented by the aggregate of all of the art" (Maron 2021). Leonard's comments address the core issue of voice and visibility across a range of moving histories on a given topic. Diverse inclusion does not preclude histories dominated by a specific group, culture, or ethnicity, as in *Dunkirk* (2017) or *Judas and the Black Messiah* (2021). What matters is that, in aggregate and overall, diverse audiences see themselves and a more encompassing swathe of their fellows as part of communal and national legacies that resist the urge to compartmentalize and freeze cultures in carbonite. The complex politics of multiculturalism and polyvocality pose a complicated but essential challenge to filmmakers representing the past.

Potential friction arises when a moving history depicts populations subject to bigotry and hostility, especially if audiences misunderstand why a character acquiesces or behaves in a particular manner in response to imposed social or political constraints. This may inflict a different psychic harm than being effaced. Filmmaker John Sayles has written and spoken on this point, noting that movies need to ease viewers into the context of other times to avoid the misinterpretation of characters by registering their behavior within a contemporary context. For this reason, he explains that he allots the first twenty minutes of a history film to acclimatize spectators to the laws and mores of the time and place. Citing his film *Matewan* (1987), Sayles notes that the audience must understand that the character Few Clothes, played by James Earl Jones,

FIG. 5.1 James Earl Jones as Few Clothes in John Sayles's *Matewan*.

must defer to others at times, not out of weakness, but because, as an African American man caught up in the coal miners' strike in West Virginia in 1920, he risks death by speaking up (Foner and Sayles 1996, 26).

Representing the repression of groups of people in the past in the name of historical accuracy risks the faulty interpretation of the "bad fan," as described by Margrethe Bruun Vaage and discussed in the preceding chapter, in which some audience members choose to root for characters engaged in brutality or bad behavior (2017b, 91, 112–117). Watching subjects of historical discrimination subvert their own wills and live by their wits to manage within a society that subjugates and disenfranchises them can be challenging to watch and easy to mistake as a reflection on individual characters rather than their environment. Nonetheless, navigating the complexity posed by the foreignness of the past is vital to the knowledge produced by history. When filmmakers remake history with anachronistic values and understandings or change actions and events in the desire to make history say something that directly addresses the present, whether out of a lack of historical knowledge or for ideological reasons, they are working in the genre of historical science fiction.

The altruistic desire to incorporate diverse perspectives into histories can misrepresent the past if not properly contextualized. For example, Robert Rosenstone critiqued the documentary *The Good Fight: The Abraham Lincoln Brigade in the Spanish Civil War* (1984), based on his work on the Lincoln Brigade in the Spanish Civil War, for privileging multiplicity to the point of distortion by creating a false impression of diversity in the ranks. Rosenstone faults the filmmakers for not contextualizing their choice to seek out an unrepresentative number of African Americans and women over the White males who vastly outnumbered them in the conflict (2012, 90–91). It is not

the choice of inclusion he criticizes, only the failure to alert audiences to the unrepresentative representation because it creates a false sense of history. These authorial decisions, as well-intentioned and justified as they are, when left unarticulated wind up confusing and misrepresenting history, muddling the message and, with it, what we can learn from the past.

Polyvocality in moving histories weaves multiple data points and the perspectives of a disparate cast of characters into an aggregated sense of reality. Multiperspectivity requires someone other than a singular protagonist to become the focal point and prime mover of scenes and sequences. In the process, the audience absorbs a wider range of goals and experiences, along with alternate impressions of the historical era, toward more complex understandings. *Free State of Jones* does this at several points by excluding Knight to focus on secondary characters, such as formerly enslaved people like Rachel and Moses, in scenes in which we empathize with them, share their objectives, and fear the threats they face. *Rise of Empires: Ottoman* (2020) frequently shifts attention from Mehmed II to sympathize with the plight of his adversaries, including Giustiniani and Constantine XI, as well as those caught between them, such as Ana, a young woman enslaved by the Byzantines. *Let It Fall: Los Angeles 1982–1992* presents an ensemble of experiences of public violence in South Central Los Angeles. Director John Ridley's approach evokes a network of sympathies toward complex understandings necessary to decipher the patterns that led to the series of travesties chronicled by the film and to process their lingering effects. Of all three case studies, *Let It Fall: Los Angeles 1982–1992* goes the furthest in expressing plurality and resisting judgment of its historical participants.

To gauge plurality, one must ask a series of questions about an individual work:

> Which characters are presented in close-ups and POV shots?
> Whose inner struggles and goals are we privy to and urged to share?
> Whose perspective is highlighted?
> Is there a presentist overlay that distorts history?
> Does the text add to popular understanding of an event or era by offering an alternate or deeper interpretation of previously ignored voices?

Plurality of Interpretation as a Method of Truth

A man is murdered in the forest. There are four explanations for his death. We are led not to believe that the man was killed four times in four different ways but that humans (and their spiritual envoys) will have various—self-selective and self-serving—interpretations of the same event. Akira Kurosawa's *Rashomon* (1950) is a paragon of plurality in moving images. The unanimously anointed masterpiece of historical fiction sets a justifiably revered template for historiophoty by showing that a film can explore multiple perspectives, peeling characters like onions of complexity beyond the binaries of perpetrator

FIG. 5.2 *Rashomon*'s Masako Kanazawa (Machiko Kyô), manipulator or manipulatee? Depends on the point of view.

and victim. The film presents reality through competing interpretations while remaining compelling. In fact, it shows the ways that polyphony, in and of itself, generates drama and appeal. *Rashomon*'s spectators enter conflicting testimonies as part of an active challenge to divine the most plausible explanation of events. Each audience member refracts these stories through the influence of their own biases, identifications, and values. Spectators may watch the film and have a theory about what happened. And yet, owing to this sophisticated and triumphant artistic rendering of critical discourse, they know that they do not *know*.

The structuring of polyphony is elegantly articulated in *The Last Duel* (2021), in which we see the perspective of several events from three distinct vantage points. One of the film's many strengths is its restraint and nuance in expressing these differing viewpoints. The story swims in the sociopolitical mores of the time, exposing them for scrutiny rather than inserting a contemporary set of characters in medieval dress. The differing perspectives deftly expose the entrenched and dehumanizing sexism of the time, as well as the strict hierarchies that ensnare everyone. The movie renders the variations of interpretation with poetic subtly and metahistorical valence, offering a deep and compelling meditation on multiperspectivity and the witnessing of history. Part homage to *Rashomon*, as acknowledged by two of the film's three screenwriters, the movie explores an alleged crime from several perspectives, meditating upon our access to truth through the filtering of testimonies (Weintraub 2021). For instance, the slight variations in the memories of the assault of Marguerite by her husband's rival Jacques Le Gris prompt meaningful reflection on the part of the viewer. The sequence plays twice, from the perspective of each person involved.

Marguerite resists aggressively both times, with only modest discrepancies between the accounts. In Le Gris's version of the attack, she may appear less distressed than in her rendition, but only slightly. Even in Le Gris's telling, contemporary audiences witness a rape. In part, this may have been a choice by the filmmaking team to ensure that audiences do not perceive Le Gris as the falsely accused victim and to avoid the reading of the "bad fan" detailed by Vaage and explained in the previous chapter (2017a, 91, 112–117). However, another view of this decision reflects on the character and his culture in a fascinating way. Interpreted at face value, it is clear that in Le Gris's mind, this is something he is entitled to; thus, his conscience has no need for a guilt-induced rewriting of what happened. Adam Driver does not play Le Gris as a monster, and in another scene with Count Pierre d'Alençon (Ben Affleck), we see women seeming to enjoy a rough and ribald sexual escapade with the two men. Le Gris does not need to revise his memory of the encounter with Marguerite to ease his conscience. Instead, he can tell himself that her protestations are merely part of a courting ritual, speaking volumes to the plight of women in that society. The audience infers that he knows that her resistance might not have been feigned or performative, but he does not care. They also perceive the ways in which his assessment of her protest is emblematic of his time but also timeless.

The plurality of Scott's film buckles only momentarily—in the opening text to Marguerite's point of view. At the outset of each chapter of the film, a card appears on the screen that presents each of the three main characters' perspectives. The first character-based sequence begins with white text on a black screen that says, "The truth according to Jean de Carrouges," then "The truth according to Jacques Le Gris," and finally "The truth according to Marguerite" (Scott 2021). Not fully trusting the audience to read the film's visual language, performances, and narrative structuring of the testimony, all of which clearly support Marguerite's version of events, the opening text to her section fades out differently from the others, leaving the words "The truth" on the screen (2021). This holds for another few seconds before fading to black. The choice ensures that the spectator is not confused about what happened. And yet, the narrative elements of the film effectively communicate this position. The point-blank assertion of a metaphysical truth in the titles shows too little faith in the efficacy of the cinematic language of the film and contradicts the formidable historiographical and reflexive strengths of the work. Aside from the misstep of the point-blank assertion of the chapter title, the film masterfully explores our path to truth as sifted through individuals, providing fascinating insights into individual perspectives and the nature of perception in general.

Plurality and the representation of a diverse group of characters or historical agents arouse concern for a range of subject positions and experiences. Even more crucially for moving histories, it presents a "dialogic . . . [that] provides no support for the viewer who would objectify an entire event according to some ordinary monologic category" (Bakhtin 1973, 18). While polyphony serves

literature by putting the reader into a frame of mind that invites deeper introspection and the consideration of a broader view of the reality of a fictional storyworld, it is critical to positioning the audience into the necessary headspace for history. Exploring actual events through a compilation of viewpoints delivers more insight into the complex nature of collective conflicts that resonate as historical events. Since objective truth cannot be discerned through human consciousness, a chorus of reliable perceptions offers the best approximation. Plurality paints historical and nonfictional truth for what it is: assembled, open to a continual process of reassessment, and worth the effort.

Post-postmodern Plurality

The plurality prescribed here is decidedly not of the fractured variety of postmodern history. Instead, it advocates a metamodern one. Although a single reality and the quest for truth remain central to the mainstream moving history, plural perspectives adapt the universalizing, teleological, and often monocausal framework of the grand narrative (Lyotard 1989) toward a metamodern "grand narrative redux" that is inherently open, contingent, and polyphonic (Nelson 2023a). Plurality does not dispense with the grand narrative but reforms and rehabilitates it. Andrew Corsa argues that a scholarly reengagement with the grand narrative matters because it is the vehicle through which we process reality. Therefore, they are necessary to "address global political issues such as our environmental crisis" and to "organize communities and orient our actions," nevertheless, he supports a metamodern approach that is "provisional" and polyphonic (2018, 241).

Throughout his argument, he draws upon Arran Gare, and in particular, his essay "Narratives and the Ethics and Politics of Environmentalism: The Transformative Power of Stories," which explains the centrality of stories to the creation of our sense of meaning, history, and identity. In response to the threat of climate change, Gare calls for a "narrative of the environmentalist movement" that eschews "the oppressive tendencies of grand narratives of the past" and "the monologic epic" in favor of "a polyphonic or dialogic narrative consisting of people of diverse perspectives engaged in questioning, contesting and reformulating this narrative" (2001). For similar reasons, Corsa echoes this call for narratives that are multiperspectival, flexible, and open to revision in opposition to the "monologic epic [that] treats a variety of characters much like it treats objects—as instruments or obstructions to a single hero's success—a polyphonic narrative instead treats each person as an 'authentic reality,' and as 'another *I* with equal rights'" (2018, 261). The metamodern sensibility is like a healthy kind of love; it commits fully to truth like the beloved but holds it lightly.

Critiques of the grand narrative are not criticisms of a communication structure or style as much as they are quixotic lamentations over how our minds and memories work. Grand narratives are instinctual. They are the way we

organize our thoughts about reality, and therefore, they cannot be dispensed with—although they can be democratized and reformed. Abandoning the grand narrative will never plunge it into obscurity. It only leaves its tools to others, often those with no qualms about the persuasive skewing of actuality wrought by monologic and monocausal interpretations. Plural histories offer a method to paint a more complete picture of reality that benefits the truth value of a work while simultaneously reflecting upon the complexity of our personal relationship to the past.

Authorship and Plurality behind the Screen

Plurality includes consideration of a historical work within the context of its creation. Eleftheria Thanouli calls for "historical texts to always be embedded in [their] institutional framework[s]" (2019, 233). This is a core historiographical practice that historians must apply to their sources. In the end, historians submit to having the products of their labors submitted to the same. The second concern of plurality is to look behind the screen to ask who speaks. The creator's voice is part of Bakhtin's conceptualization of heteroglossia, which he defines as "a special type of *double-voiced discourse*" that combines the "direct intention of the character . . . and the refracted intention of the author" (1981, 324; italics in the original). Plurality in authorship attends to what Hall calls "the positions of *enunciation*," which are invariably political given that "identity is not as transparent or unproblematic as we think" (Hall 1989, 68; italics in the original). The first thing one notices when looking at the makers of moving histories is how nondiverse they are, particularly in the performance mode.

Knowing the author helps discern the commitments and worldviews that shape an argument. Hayden White highlights the "irreducible ideological component in every historical account of reality" (1975, 26), given that "ideological considerations enter into the historian's attempts to explain the historical field and to construct a verbal model of its processes in narrative" (21). An ideological worldview orients what the historian seeks, sees, and draws from the past. It frames the speculation and fictionalization that mold a historical argument. White describes the role of the historian as assembling "events in the chronicle into a hierarchy of significance by assigning events different functions as story elements," structuring them into a "beginning, middle and end" (7).

Filmmakers, like historians, approach the past from a point of view. Historians and filmmakers are no different from the rest of us. We all share the natural human instinct to look backward to find proof for our convictions and see our beliefs about the nature of reality and human behavior reinforced. Historians of the page and screen cannot but "*pre*figure" their results and interpret the data of history through their consciousnesses while conflating accuracy in detail with the convection of truth (White 1975, 30–31; emphasis in the original). This is a natural and unconscious process rather than the mark of the propagandist. In

a variation on E. H. Carr's injunction to know the historian, Marc Ferro encourages his readers "to study film and see it in relation to the world that produces it" (Carr 1961, 23; Ferro 1988, 29). In proposing his detailed ethics of critical engagement with cinema, Carl Plantinga encourages film scholars to "consider the 'imagination' of the makers, consider the array of purposes and interests of fiction, and recognize that producing politically savvy spectators is but one of the functions of fiction and of criticism" (2018, 159). This ethics is even more critical to moving histories.

As polyvocal as academic history aims to be, ultimately, as orchestrated by the single author, most are channeled through "one synoptic viewpoint" (Berkhofer 1998, 190). Berkhofer calls the singular point of view unavoidable, given that even historians who actively critique its failings lodge their criticism through it (1995, 182). Of course, the filmmaking process differs significantly from that of a history essay or monograph. Still, many of these historiographical considerations apply. While directors are frequently understood as the ultimate channelers and arbitrators of perspective in moving histories, they work in relationships with producers, screenwriters, editors, actors, and members of the art, camera, and sound departments, all of whom contribute to the expressions of meaning and voice. Davis points out that history films are the product of "collective creation," in which "processes of research, interpretation, and communication are widely dispersed" (2000, 12). And yet, most production team members do not contribute substantially to the message of the historical argument. There is a continuum in which the screenwriter or editor's control of the narrative supersedes that of the cinematographer, which in turn surpasses that of the sound recordist. As a shorthand, the authorship of a moving history often centers the director, despite the significant impact that producers, editors, and others may have in directing the interpretation. Thus, references to the authorship of moving histories in this chapter will specify the director with the understanding that this person sometimes serves as a synecdochic symbol of authorship. In most cases, some negotiation and discrepancy exist between this individual's agency and the form and meaning of a moving history.

Plurality may also function as a guiding production method. Although it is rarely engaged in the creation of English-language moving histories, it is worth mentioning plural filmmaking methods as another aspect of multiperspectival authorship. Most often, it is practiced by documentarians who reject traditional structures of authority and control. In the place of making films about subjects, they opt to create work with them. These cocreation processes grant documentary participants voice and agency throughout the filmmaking process, providing a multilayered reflection of the real. This approach undergirds ethnographic and current-event documentaries as practiced and theorized by documentarians ranging from David MacDougall and his concept of "intertextual cinema" (2003, 129–130) to Liz Miller's "collaborative storytelling" (2018),

in which filmmakers work with a community to create work together from its inception. Similar practices take place across other modes. For example, Indigenous approaches to filmmaking worldwide often craft work through cooperative structures, as exemplified by the communal filmmaking processes of Arnait Video Productions, the Women's Video Collective of Igloolik, Nunavut (Raheja 2010, 202). Other performance histories may develop through a combination of research and communal improvisation with a team of actors through a protracted rehearsal process, as exemplified by Mike Leigh's *Topsy-Turvy* (1999) and *Mr. Turner* (2014; *Guardian* 1999; Scott 2014). These approaches infuse moving images with a polyphonic spirit, enacting a process that exemplifies Shohat and Stam's polycentric multiculturalism.

Collaborative authorship also played a key role in *The Last Duel*. The film ingeniously assembled three screenwriters to author the three perspectives central to the history. Matt Damon wrote the perspective of Marguerite's husband, Jean de Carrouges, whose part he played in the movie. Ben Affleck wrote the storyline as reflected by Jacques Le Gris, and Nicole Holofcener wrote the heart of the history from Marguerite's point of view. The result of this decision redounds in the film with discernible historiographical payoffs, especially in the rendering of its female protagonist as Marguerite suffers from the patronizing patriarchal system of her society and the patrolling of punishing norms and behaviors overseen and upheld by many female collaborators nestled within it.

The Role of Multiperspectival Authorship

Laura Mulvey's "Visual Pleasure and Narrative Cinema" explains a version of "double consciousness" from the vantage point of the heterosexual female spectator. Her paradigm-shifting essay articulates the alienation of anyone who does not identify with a film's positionality expressed through the protagonist on screen. In a subsequent assessment of her own analysis, she points out that "in-built patterns of pleasure and identification seemed to impose masculinity as 'point of view'; a point of view which is also manifest in the general use of the masculine third person" that may leave a female viewer feeling excluded and isolated or "secretly, unconsciously almost, enjoying the freedom of action and control over the diegetic world that identification with a hero provides" (1981, 12). As a result, "for women (from childhood onwards) trans-sex identification is a *habit* that very easily becomes second *Nature*" (13; emphasis in the original). Her insights extend to any identity repeatedly left out of direct identification with the protagonist.

As a female spectator, for example, I have noticed that repeatedly identifying with male characters leads to associating qualities of strength, intelligence, and yearning with masculinity in ways that can alter one's sense of self and femaleness. At the same time, many popular depictions of women send potent and

FIG. 5.3 A likely speculation about Marie Antoinette's social environment and her reception at the French court that only a female director might register and dramatize in Sofia Coppola's *Marie Antoinette*.

toxic messages about their limited value or, just as troubling, elevate them when they emulate extreme masculine traits, such as the ability to mow down opponents in violent physical combat. Although significant strides have been made in broadening the spectrum of masculinity and femininity and other aspects of pluralism in moving images, the ultimate corrective is more diverse authorship. We need filmmakers who can see subject positions from the inside, who understand aspects of experience that even allies and interested others cannot. The ranks of the makers of moving histories have begun to diversify, and there is much ground to make up. Returning to my own frame of reference, what filmmakers like Sofia Coppola capture and express in a work like *Marie Antoinette* (2006) are core elements of the female experience likely faced by the dauphine, and later queen, in ways that a male director may never consider and would be less likely to care about or understand.

Analyzing the multiplicity of voices of a given history in aggregate is key. It is not the responsibility of any particular moving history to address every possible perspective. That is as impossible a goal as the hope to encapsulate all potential meanings of an event or to isolate the one metaphysical and objective rendition of what happened. We are left with the far more complicated and mammoth prospect of looking at moving histories cumulatively to consider the perspectives repeatedly expressed and those repeatedly left out. It is not necessarily productive to heap criticism on a single work for selecting some viewpoints to the exclusion of others since all histories must do this. Nor can we blame directors if they are judged to embody an overrepresented voice. All creators feel compelled to create. Maintaining a diversity of voice rests not with an individual filmmaker but with funders and, ultimately, with audiences.

Plurality of authorship does not mean patrolling who is allowed to speak for whom on a one-to-one basis, an issue that has cropped up in the public dialogue, at film festivals, and on social media (Powell 2022). Authors who take on the perspective of others are critical to artistic and historical expression and understanding. In principle, making a film centered on characters different from oneself means caring about people who are different. That is a good thing. It is useful to see one's own community or identity group reflected by a generous and conscientious author who views it from the outside. It is a problem, however, when people with one identity habitually author representations of another, crowding out authors within those communities, which is so often the case.

Beyond the work necessary to broaden the range of makers of history, Bakhtin explains the obligations of the individual creator. The polyphonic author "is not required to renounce himself or his own consciousness, but he must to an extraordinary extent broaden, deepen and rearrange this consciousness (to be sure, in a specific direction) in order to accommodate the autonomous consciousnesses of others" (1973, 68). We may consider the filmmakers and query their motivations, influences, and goals, but what is most important is what we read from the expression of their work. We may make inferences based on their positionality, especially to track the plurality of authorship of a given history. But we must do this respectfully and with a light hand. Just as we can never truly know the intentions and inner motivations of the agents of history, it is the same for the filmmaker. Although considering the source is a core aspect of the historiographical method, we must always respect the distance between the artist and the work. The artist's inner life, struggles, and moral commitments will never be fully knowable to the spectator or the critic.

Plural Variations

As addressed in the introduction, all the moving histories that receive core attention in this book engage plurality in the range of characters with whom they are concerned and express sympathy. Weaving multiple perspectives from divergent character perspectives, moving histories like *Rise of Empires: Ottoman*, *Free State of Jones*, and *Let It Fall: Los Angeles 1982–1992* succeed in inviting spectators in, and as a result, "the interaction of several consciousnesses . . . consequently makes the viewer also a participant" (Bakhtin 1973, 18).

Plural Perspectives in *Free State of Jones*

Gary Ross is a White male writer and a successful Hollywood director and producer, well known for making box office juggernauts, including *Pleasantville* (1998), *Seabiscuit* (2003), and *The Hunger Games* (2012). He is also the son of Arthur A. Ross, a screenwriter blacklisted during the chaotic overreach of the Red Scare (Allen 1998). The younger Ross turned down the opportunity to direct the second film in *The Hunger Games* franchise to pursue two years of

historical research at university libraries in preparation for making *Free State of Jones* with funding from the midsized private production company STX Entertainment (Ross 2018).

Free State of Jones centers a White male farmer, played by Matthew McConaughey, who drives the narrative and anchors most scenes. Key secondary characters include Moses, performed by Mahershala Ali, a man who escapes slavery at the beginning of the film whom Knight befriends while hiding in the woods, and Rachel, a key contributor to war-resistance efforts, Knight's love interest, and a formerly enslaved woman played by Gugu Mbatha-Raw. Through the dispersal of narrative arcs, screen time, POV, and close-up shots, plurality in *Free State of Jones* animates a chorus that voices racial and class concerns.

The film evocatively dramatizes the hypocrisy of the post–Civil War era. A powerful sequence culminates in Moses's murder by a small White supremacist mob as retribution for legally registering freedmen to vote. Subsequently, Knight leads a group of Black men through the streets of Ellisville to vote in 1875. According to the record, Knight was at the time given the position of leading a majority African American militia in Mississippi, and part of that job was to protect the freedmen's right to vote ("Report of the Select Committee" 1876). A shot of McConaughey as Knight leading a group of Black men down the street to the polling station demonstrates the peril the men faced and the bigotry of the time and place in the manner that Sayles references regarding his film *Matewan*, mentioned previously. In the next scene, after a tense standoff with racist, White election officials who try to deny the group the right to vote, we see the men duly cast their ballots. As the assembled men fill the jar with "tickets" for the Republican candidate (in those days, the more progressive option), text appears on the screen explaining that the election result was 419 votes for the Democrats and 2 for the Republicans. It is a visually powerful evocation of the fact that while the officials could not stop the men from voting, they could refuse to count their ballots. The scene reverberates, addressing plural temporalities. The audience reads it through the present, knowing it is simultaneously about the present in ways that speak to ongoing conflicts.

While some moving histories address gaps in history by depicting microhistories or untold stories, many others join a transtexual dialectic to reinterpret events repeatedly told and retold. Civil War films definitively belong to the latter category, interacting with prior narratives and engaging a comprehensive canon. Writing about *Free State of Jones* as a part of what he calls "the new Civil War cinema," John Trafton links the movie to Gilles Deleuze's claim that U.S. cinema continually revisits and re-creates "the birth of the national-civilization, whose first version was provided by Griffith" (Trafton 2023; Deleuze 2001, 148). Because of the formidable success, cinematic innovation, and painful legacy of the original *The Birth of a Nation* (1915), most subsequent Civil War films form a "layered record" attending to multiple pasts that include the time in which they are set—and 1915—as a rejoinder and corrective to Griffith (Burgoyne

2008, 76). Of course, every history interprets with a fixation on meaning that reflects upon the contemporary era.

Other films that seem particularly in dialogue with *Free State of Jones* include *Glory* (1989), about Robert Gould Shaw, a sympathetic and progressive Union colonel who led one of the United States' first African American regiments, as well as those that broaden depictions of class among Southerners in the Civil War, including *Cold Mountain* (2003) and *Ride with the Devil* (1999). *Free State of Jones* directly tackles the war and Reconstruction in the South by exposing both racism and interracial love and harmony with attention to the ways that the rich abuse the poor.

Polyvocality in *Let It Fall: Los Angeles 1982–1992*

John Ridley, the director of *Let It Fall: Los Angeles 1982–1992*, is another formidable member of the Hollywood establishment. A Black man, Ridley is the Academy Award–winning screenwriter of *12 Years a Slave* (2013), a seasoned novelist, screenwriter, producer, director, and showrunner. Lincoln Square Productions, a subsidiary of the American Broadcasting Company (ABC) based in New York City, financed the documentary. The film interrogates a decade of rising crime met by harsh police tactics, culminating in the convulsive response to the verdict in the case against four officers charged and exonerated for the beating of Rodney King.

Ridley's documentary provides a polyphonic tapestry that brings curiosity and compassion to a wide range of participants across generation, class, race, sexuality, and gender. Interviewees range from police officers to the family members and friends of people killed by gangs, vigilantes, and the police, alongside several perpetrators of violence. The documentary resists judgment, instead seeking to understand the matrix of social and institutional pressures and failures that contributed to the spiral of events. Ridley weaves a complex, compassionate, and textured portrait of what went wrong and what remains in need of fixing. The documentary accords humanity and space for expression to a range of Los Angeles residents. As one critic writes, "If there's one thing that's true across Ridley's work, it's that he tells stories with sharp humanistic logic, taking a kaleidoscopic view of systems and people and practically instructing us not to judge" (Canfield 2017).

In the same year of the release of Ridley's film, several other documentaries on the same topic were produced to mark twenty-five years since the events of 1992. *The Lost Tapes: The LA Riots* (2017) focuses on little-seen videos shot by LA police officers and contemporary audio recordings from local radio outlets, including Radio Korea and KJLH. *LA 92* (2017) also relies on archival footage and includes interviews. It pegs the beginning of this escalating conflict to unrest in the Watts district of LA in 1965.

Ridley's unceasing commitment to plurality and polyphony is the reason the film is a documentary. In an interview, he explains that producers Brian Glazer

and Ron Howard had initially approached him to write a script on the topic for a movie to be directed by Spike Lee. In the end, his complex understanding of the genesis of the violence and his subtle, balanced, and polyphonic approach to characters made the project unfeasible. As Ridley explains, he did not see things in terms of "a main protagonist or antagonist. There were people who did very, very good things, but they were not action heroes. They didn't have the typical narrative of a hero's journey. They were just at the right or wrong place at the right or wrong time." He turned in a first draft that he felt "came in very well," but questions about the budget and whether the film would make money surfaced. "You have this film with no hero, no heroic drive and, like much of my work, doesn't end on an upbeat note" (Braxton 2017).

Ridley's approach to characters and his understanding of the complexity of human behavior is the documentary's strength. His mode-jumping production trajectory, shifting from a planned performance approach to documentary, speaks to the clash between complexity and profitability, historiophoty, and popularity, especially in the case of the theatrical performance film. Documentary appears more amenable to a plurality of characters, perspectives, and interpretations, not only due to aspects of form, but in response to differing audience expectations, budgetary pressures, and market concerns. Both *Let It Fall: Los Angeles 1982–1992* and *Rise of Empires: Ottoman* embody the vibrance and resonance of histories that not only "look to the margins, but also . . . tell the story from both sides" (Maza 2017, 69).

Clash of Empires as Polyphony in *Rise of Empires: Ottoman*

The six-episode first season of the hybrid miniseries *Rise of Empires: Ottoman* was directed by Emre Şahin, a Turkish American man, and cowritten by Şahin, Kelly McPherson, and Liz Lake. Şahin's *Karga Seven Pictures*, an independent studio based in Los Angeles and Istanbul, financed the show with support from Netflix Studios and STX Entertainment. The Turkish American production was shot in Turkey, in English only, featuring an all-Turkish cast. Other moving histories about this event include a Greek documentary made for television, *1453: The Fall of Constantinople* (2007), and the Turkish film *Conquest 1453* (2012), an epic war film from the point of view of the victorious Ottomans. As a relatively unmined topic in mainstream moving history, *Rise of Empires: Ottoman* undoubtedly works from a relatively clean slate for many audience members. The plurality of this series is a distinctive aspect of *Rise of Empires: Ottoman*, spanning nations, religions, sexes, and classes. The series accomplishes the substantial feat of inviting audiences to watch in sympathy with either side, and its ambidextrous allegiances press them into respecting the opposing one. The show brings spectators into subplots driven by women, from the royal to the enslaved, and encourages them to share the hopes and fears of characters on both sides of the siege. In this way, although *Rise of Empires: Ottoman* operates within the genre of the war epic with fantasy trappings, in its dramatic

combat scenes and lionization of the bold and the brave, it may also function for some viewers as an antiwar history thanks to its polyphonic approach. It is unlikely that even spectators predisposed to root for the Ottomans throughout will relish their triumph without a care for the plight of the Eastern Romans.

Plurality beyond the Screen

Plurality in no way guarantees the quality or sincerity of a reflection of the past in moving images. An assembled chorus is as good as its parts; thus, another aspect of plurality comes into frame in the reception process as the work meets its audience. As Maza explains, "The past would surely die if we merely memorialized it, if we did not argue about it" (2017, 9). Moving histories are especially consequential as one of the last media modes not hived off by the political sorting mechanisms of partisan print, cable news, and social media's algorithms. They reach a wide range of viewers across political divides, even as this ground shrinks due to the incursions of a balkanizing media. As explored in chapter 2, adherence to an epistemology of evidence is critical to the formation of a moving history, but it is not complete until it has been processed through critical dialogue in reception. We cannot set up an infrastructure for responsible public histories, dust our hands off, and walk away. They must meet a critical viewership willing to engage their ideas and debate their contributions to public understandings of the past (Nelson 2023b).

Robert Burgoyne makes a critical observation about the influence and effect of moving histories in his appraisal of Peter Jackson's *They Shall Not Grow Old*. He explains that a new rendering of an old history "changes the past—or at least changes how we know it" (2023). He points to Mieke Bal, whose reflections on visual arts edify the reception process of moving histories. She writes that art "specifies what and how our gaze sees. Hence the work performed by later stages obliterates the older images as they were before that intervention and creates new versions of old images instead" (1999, 10). As a tool of obliteration, history's renderings ought to be deliberate, judicious, evidence-based, and self-reflexive and its meanings negotiated and discussed by an engaged and diverse audience.

Vivian Sobchack eloquently describes her engagement with historical films from her childhood. They made her feel as though she had moved through time, spurring her to explore history by other means, from artistic to scholarly works. In the process, other impressions of the past took up space alongside the cinematic imagery still dancing in her mind, creating a heteroglossia and plurality of the past, colliding and combining to evoke and incant "an absent past" with the extraordinary power to "make us *care*" (1997, 16; emphasis in the original). The art form of moving images partakes in an audiovisual world-building experience that plays upon the spectator's emotions and moral convictions with enchanting verve. Moving histories craft the ultimate shareable model of mnemotechnics, obliterating other forms of knowledge and shaping much of what

a spectator internalizes about a given past, often as an explanation for the present. The ensuing critical dialogue should aim at understanding by extending intellectual curiosity, civility, and a willingness to consider a work's core themes, historical arguments, recourse to evidence, audiovisual language, and scope of interests. Moving histories harness substantial powers, informing our sense of who we are, where we came from, and what we do about it now. Therefore, our approach to assessing moving histories is an essential aspect of this special genre's trajectory.

There is a methodology for that.

Acknowledgments

Academic books are massive undertakings, reliant on years of reading and thinking and expansive networks of encouragement. This book is no different, and I would like to thank everyone who helped me along the way. The path for this book began with a DAAD fellowship thanks to the German government. I owe this catalyst to support from Jesco Huber and the time and efforts of Martin Hagemann. Another person critical to the course of affairs leading me to write these acknowledgments is Gary Edmonds, for his point-blank, shot-in-the-arm encouragement. I am grateful to everyone in Potsdam at the Film University Babelsberg KONRAD WOLF who sustained this project, from Michael Wedel for his detailed feedback on my dissertation to my supervisor, Lothar Mikos, for championing my project from the beginning and supporting it to completion. Special thanks also to the kind and diligent administrators at the university, including Sybille Sorge and Yulia Yurtaeva-Martens. As a Canadian, I also am fortunate to have benefited from the generous support of the Social Sciences and Research Council of Canada, whose backing was essential to this work.

Thanks to all the readers who contributed to this work, beginning with Kathryn and David Elgee, who read the book in its first incarnation. Great appreciation goes to Eleftheria Thanouli and Mia E. M. Treacey for reading various chapters and for providing valuable feedback and to Joshua Yumibe for his instrumental advice on my plan for the book. Warmest thanks to Robert Burgoyne for reading several chapters at various stages and for his always insightful commentary, generous support, and wise counsel. I also extend my profound appreciation to Robert A. Rosenstone for his wisdom, mentorship, and encouragement and for connecting me to a filmmaker critical to this project. And to that filmmaker, writer, and director, Gary Ross, thank you very much for your openness in meeting with me and fielding many questions about your work and process over the past several years.

Gratitude goes to many at the University of Windsor, from the delightful and indefatigable team at the Leddy Library to the intellectual and creative force that is Nick Hector, who gave such insightful feedback on my chapters, taking on more administrative work to lighten my load while collaborating with me on so many other work projects. Thanks also to Sydney Hector for her kindness in providing such a stimulating atmosphere as a background to writing the chapter that concerns atmosphere and the exotic. Much appreciation goes to Ester Van Eek for her generous contributions to the cover, Brodie MacPhail for his inspired design work, and wordsmith Ron Leary for his editorial assistance.

Thanks to everyone at Rutgers University Press, including the copyediting and design teams, and especially to editor Nicole Solano for being such a constant and supportive shepherd of this project. Deep and enduring thanks to Jonathan Stubbs, who contributed his time and thought so generously as an external reviewer. His feedback was assured, detailed, and integral to these pages. As an enthusiastic admirer of his work, it was a pure delight to have his input on mine. Similarly, to Alison Landsberg, a foundational thinker in the field and role model in every way, I extend my gratitude to her for reading the book and providing her commentary.

I would also like to thank Robert Nelson for reading and rereading drafts of the chapters, for his commentary and encouragement, and for all the three-star work in the kitchen that allowed me to extend so many workdays. To Hagen, thanks for inspiring me with your writing, and to Ella and Clio, thank you for your indelible contributions to the cover image. Thank you for being exactly who you are (and for putting up with all my screen time while I tracked yours).

Finally, I wish to acknowledge Mr. Redford from Centennial High School, my incomparable high school teacher who infused his lessons with boundless curiosity and critical thinking. A dedicated teacher, he kindly read my poetry in the staff room and provided feedback as an extracurricular kindness. In class one day, speaking in reference to a particularly tragic chapter of international history, he said something I was not ready for at the time that has stayed with me ever since. His comment was along the lines of "Don't look at this and say look what those people did. Say, look what people did." It is the guiding principle of historical knowledge and understanding. I hope that Ray Redford and teachers like him realize how profound their impact is on developing minds by the hundreds and the endless ripple effect of their commitment and caring.

Filmography

8½. 1963. Federico Fellini
12 Years a Slave. 2013. Steve McQueen
300. 2006. Zack Snyder
1453: The Fall of Constantinople. 2007. Giorgos Louizos
1492: Conquest of Paradise. 1992. Ridley Scott
1917. 2019. Sam Mendes
Act of Killing, The. 2012. Joshua Oppenheimer
Agony and the Ecstasy of Phil Spector, The. 2008. Vikram Jayanti
American Animals. 2018. Bart Layton
Amistad. 1997. Steven Spielberg
And the Ship Sails On. 1983. Federico Fellini
Anne Boleyn. 2021. Lynsey Miller
Apocalypse Now. 1979. Francis Ford Coppola
Apocalypto. 2006. Mel Gibson
Ararat. 2002. Atom Egoyan
Argo. 2012. Ben Affleck
Assassination of Jesse James by the Coward Robert Ford, The. 2007. Andrew Dominik
Assassin's Creed. 2007–. Ubisoft
Atanarjuat: The Fast Runner [ᐊᑕᓇ ᕐ ᔪᐊᑦ]. 2001. Zacharias Kunuk
Atomic Blonde. 2017. David Leitch
Babylon Berlin. 2017–. Tom Tykwer, Achim von Borries, and Hendrik Handloegten
Barry Lyndon. 1975. Stanley Kubrick
Battleship Potemkin. 1925. Sergei Eisenstein
Ben-Hur. 1959. William Wyler
Big Short, The. 2015. Adam McKay

Birth of a Nation, The. 1915. D. W. Griffith
Black Robe. 1991. Bruce Beresford
Bonnie and Clyde. 1967. Arthur Penn
Born on the Fourth of July. 1989. Oliver Stone
Braveheart. 1995. Mel Gibson
Breaker Morant. 1980. Bruce Beresford
Breaking Bad. 2008–2013. Vince Gilligan
Celebration, The. 1998. Thomas Vinterberg
Christopher Columbus. 1949. David MacDonald
Chunking Express. 1994. Wong Kar-Wai
Citizen Kane. 1941. Orson Welles
Cold Mountain. 2003. Anthony Minghella
Conqueror, The. 1956. Dick Powell
Conquest 1453. 2012. Faruk Aksoy
Countryman and the Cinematograph, The. 1901. Robert W. Paul
Da 5 Bloods. 2020. Spike Lee
Dallas Buyers Club. 2013. Jean-Marc Vallée
Daughters of the Dust. 1991. Julie Dash
Dazed and Confused. 1993. Richard Linklater
Deadwood. 2004–2006/2019. David Milch
Death of Stalin, The. 2017. Armando Iannucci
Detroit. 2017. Kathryn Bigelow
Dexter. 2006–2013. James Manos Jr.
Do the Right Thing. 1989. Spike Lee
Downton Abbey. 2010–2015. Julian Fellowes
Driving Miss Daisy. 1989. Bruce Beresford
Dunkirk. 2017. Christopher Nolan
Favourite, The. 2018. Yorgos Lanthimos
Flags of Our Fathers. 2006. Clint Eastwood
Floating Weeds. 1959. Yasujirō Ozu
Fog of War, The: Eleven Lessons from the Life of Robert S. McNamara. 2003. Errol Morris
Fortunella. 1958. Federico Fellini
Free State of Jones. 2016. Gary Ross
Game of Thrones. 2011–2019. David Benioff and D. B. Weiss
Gentleman Jack. 2019–2022. Sally Wainwright
Get Out. 2017. Jordan Peele
Gladiator. 2000. Ridley Scott
Glory. 1989. Edward Zwick
Gone with the Wind. 1939. Victor Fleming
Good Fight, The: The Abraham Lincoln Brigade in the Spanish Civil War. 1984. Noel Buckner, Mary Dore, and Sam Sills
Good Morning, Vietnam. 1987. Barry Levinson

Gosford Park. 2001. Robert Altman
Great Escape, The. 1963. John Sturges
Great War, The. 1964. BBC
Green Book. 2018. Peter Farrelly
Grizzly Man. 2005. Werner Herzog
Halt and Catch Fire. 2014–2017. Christopher Cantwell and Christopher C. Rogers
Hamlet. 1948. Laurence Olivier. Two Cities.
Harlan County, USA. 1976. Barbara Kopple
Harriet. 2019. Kasi Lemmons
Heart of Glass. 1976. Werner Herzog
Hell on Wheels. 2011–2016. Joe and Tony Gayton
Her Sweetness Lingers. 1994. Shani Mootoo
History of Jones County, The. 2016. DVD extra
Homeland. 2011–2020. Howard Gordon and Alexa Gansa
How to Lose a Guy in 10 Days. 2003. Donald Petrie
How to Survive a Plague. 2012. David France
Hunger Games, The. 2012. Gary Ross
Ida. 2013. Paweł Pawlikowski
I'm Not There. 2007. Todd Haynes
Inglorious Basterds. 2009. Quentin Tarantino
Into the Wild. 2007. Sean Penn
Irishman, The. 2019. Martin Scorsese
JFK. 1991. Oliver Stone
Judas and the Black Messiah. 2021. Shaka King
Kanesatake: 270 Years of Resistance. 1993. Alanis Obomsawin
Knight's Tale, A. 2001. Brian Helgeland
LA 92. 2017. Daniel Lindsay and T. J. Martin
Last Duel, The. 2021. Ridley Scott
Last Kingdom, The. 2015–2022. Stephen Butchard
Last of the Mohicans, The. 1992. Michael Mann
Last Year at Marienbad. 1961. Alain Resnais
Life Is Beautiful. 1997. Roberto Benigni
Lincoln. 2012. Steven Spielberg
Look of Silence, The. 2014. Joshua Oppenheimer
Lord of the Rings: The Fellowship of the Ring. 2001. Peter Jackson
Lost Tapes, The: The LA Riots. 2017. Tom Jennings
Mad Men. 2007–2015. Matthew Weiner
Magic Mike. 2012. Steven Soderbergh
Making of The Last Duel, The. 2021. Cuba Scott
Making of They Shall Not Grow Old, The. 2018.
Man in the High Castle, The. 2015–2019. Frank Spotnitz
Marie Antoinette. 2006. Sofia Coppola

Mary Two-Axe Earley: I Am Indian Again. 2021. Courtney Montour
Masters of the Air. 2024–. John Orloff and Graham Yost
Matewan. 1987. John Sayles
McCabe & Mrs. Miller. 1971. Robert Altman
Memento. 2000. Christopher Nolan
Mighty Heart, A. 2007. Michael Winterbottom
Mission, The. 1986. Roland Joffé
Mississippi Burning. 1988. Alan Parker
MLK/FBI. 2020. Sam Pollard
Monty Python and the Holy Grail. 1975. Terry Gilliam and Terry Jones
Monty Python's Life of Brian. 1979. Terry Jones
Mr. Turner. 2014. Mike Leigh
Mudbound. 2017. Rees and Virgil Williams
Narcos. 2015–2017. Chris Bancato, Carlo Bernard, and Doug Miro
New World, The. 2005. Terrance Malick
Night at the Garden, A. 2017. Marshall Curry
Nixon. 1995. Oliver Stone
Norsemen, The. 2016–2020. Jon Iver Helgaker and Jonas Torgesen
Northman, The. 2022. Robert Eggers
O.J.: Made in America. 2016. Ezra Edelman
Oppenheimer. 2023. Christopher Nolan
Pacific, The. 2010. Bruce C. McKenna
Passion of Joan of Arc, The. 1928. Carl Theodor Dreyer
Passion of the Christ, The. 2004. Mel Gibson
Pearl Harbor. 2001. Michael Bay
Pianist, The. 2002. Roman Polanski
Planet Earth. 2006. David Attenborough
Pleasantville. 1998. Gary Ross
Prey. 2019. Matt Gallagher
Queen Cleopatra. 2023. Tina Gharavi
Raise the Red Lantern. 1991. Zhang Yimou
Rashomon. 1950. Akira Kurosawa
Rear Window. 1954. Alfred Hitchcock
Reds. 1981. Warren Beatty
Return of Martin Guerre, The. 1982. Daniel Vigne
Ride with the Devil. 1999. Ang Lee
Rise of Empires: Ottoman. 2020. Season 1. Emre Şahin
Rise of Louis XIV. 1966. Roberto Rosellini
Room with a View, A. 1985. James Ivory
Royal Affair, A. 2012. Nikolaj Arcel
Rules of the Game, The. 1939. Jean Renoir
Run Lola Run. 1998. Tom Tykwer
San Soleil. 1983. Chris Marker

Satyricon. 1969. Federico Fellini
Saving Private Ryan. 1998. Steven Spielberg
Schindler's List. 1993. Steven Spielberg
Seabiscuit. 2003. Gary Ross
Selma. 2014. Ava DuVernay and Paul Webb
Senna. 2010. Asif Kapadia
Shampoo. 1975. Hal Ashby
Sherlock. 2010–2017. Steven Moffat and Mark Gatiss
Shoah. 1985. Claude Lanzmann
Silence. 2016. Martin Scorsese
Sopranos, The. 1999–2007. David Chase
Souvenir, The. 2019. Joanna Hogg
Spartacus. 1960. Stanley Kubrick
Square, The. 2013. Jehane Noujaim
Stories We Tell. 2012. Sarah Polley
Terror, The. 2018. Max Borenstein and Alexander Woo
They Shall Not Grow Old. 2018. Peter Jackson
Thin Blue Line, The. 1988. Errol Morris
Thin Red Line, The. 1998. Terrence Malick
This Changes Everything. 2018. Avi Lewis
Till. 2022. Chinonye Chukwu
Titus. 1999. Julia Taymor
Tom Jones. 1963. Tony Richardson
Topsy-Turvy. 1999. Mike Leigh
Trainspotting. 1996. Danny Boyle
True Detective. 2014. Season 1. Nic Pizzolatto
Turn: Washington's Spies. 2014–2017. Craig Silverstein
Uncle Josh at the Moving Picture Show. 1902. Edwin S. Porter
Usual Suspects, The. 1995. Bryan Singer
Vikings. 2013–2020. Michael Hirst
VVitch, The: A New England Folktale. 2015. Robert Eggers
Walker. 1987. Alex Cox
What Happened, Miss Simone? 2015. Liz Garbus
What Time Is It There? 2001. Tsai Ming-liang
Who Will Write Our History. 2018. Roberta Grossman
Why We Fight. 1942. Frank Capra
Woman King, The. 2022. Gina Prince-Bythewood
World at War. 1974–1975. Jeremy Isaacs
Wormwood. 2017. Errol Morris
Year of Living Dangerously, The. 1982. Peter Weir
Zodiac. 2007. David Fincher

References

"The Act of Killing." n.d. Accessed January 16, 2022. http://theactofkilling.com/.

Aldgate, Anthony. 1979. *Cinema and History: British Newsreels and the Spanish Civil War*. London: Scolar Press.

Allen, Jamie. 1998. "Interview: Gary Ross Breathes His Life into 'Pleasantville.'" *CNN*, October 12, 1998. http://www.cnn.com/SHOWBIZ/Movies/9810/12/austin.ross/index.html.

Altman, Rick. 1999. *Film/Genre*. London: BFI.

American Historical Review. 1988. Vol. 93 (5). Oxford University Press. https://academic.oup.com/ahr/issue/93/5.

Anderson, John. 2013. "Shooting History: Additions Required." *New York Times*, October 17, 2013. https://www.nytimes.com/2013/10/20/movies/the-square-tries-to-keep-up-with-unrest-in-egypt.html.

Ankersmit, F. R. 1983. *Narrative Logic: A Semantic Analysis of the Historian's Language*. Martinus Nijhoff Philosophy Library, vol. 7. The Hague, Netherlands: M. Nijhoff.

———. 2012. *Meaning, Truth, and Reference in Historical Representation*. Ithaca, N.Y.: Cornell University Press.

Aristotle. 1997. *Aristotle's Poetics*. Translated by George Whalley. Montreal, Canada: McGill-Queen's University Press.

———. 2013. *Poetics*. Translated by Anthony Kenny. Oxford: Oxford University Press.

———. 2018. *The Art of Rhetoric*. Translated by Harvey Yunis and Robin Waterfield. Oxford: Oxford University Press.

Axtell, James. 1995. "Black Robe." In *Past Imperfect: History According to the Movies*, edited by Mark C. Carnes, 78–81. New York: Henry Holt.

Bakhtin, M. M. 1973. *Problems of Dostoevsky's Poetics*. Translated by R. William Rotsel. Ann Arbor, Mich.: Ardis.

———. 1981. "Discourse in the Novel." In *The Dialogic Imagination: Four Essays*, edited by Michael Holquist, 259–422. Austin: University of Texas Press.

Bal, Mieke. 1997. *Narratology: Introduction to the Theory of Narrative*. 2nd ed. Toronto: University of Toronto Press.

———. 1999. *Quoting Caravaggio: Contemporary Art, Preposterous History*. Chicago: University of Chicago Press.

Balázs, Béla. 2010. *Béla Balázs: Early Film Theory: Visible Man and the Spirit of Film*. New York: Berghahn.

Barthes, Roland. 1986. "The Discourse of History." In *The Rustle of Language*. Translated by Richard Howard. New York: Hill and Wang.

———. 2010. "The Reality Effect." In *The Rustle of Language*, 141–148. Translated by Richard Howard. Berkeley: University of California Press.

Bass, Jennifer, and Pat Kirkham. 2011. *Saul Bass: A Life in Film & Design*. London: Laurence King.

Bazin, André. 2009. *What Is Cinema?* Translated by Tim Barnard. Montreal, Canada: Caboose.

Benjamin, Walter. 2005. "The Author as Producer." In *Selected Writings, Vol. 2, Part 2, 1931–1934*, edited by Michael W. Jennings, Howard Eiland, and Gary Smith, 768–782. Translated by Rodney Livingston. Cambridge, Mass.: Belknap Press.

Bennett, Dianne. 2022. "Interview with Warren Beatty's *Reds* Historical Consultant, Robert A. Rosenstone." *2 Film Critics*, January 29, 2022. https://www.2filmcritics.com/post/warren-beatty-reds-robert-rosenstone.

Bentley, Nick. 2018. "Trailing Postmodernism: David Mitchell's *Cloud Atlas*, Zadie Smith's *NW*, and the Metamodern." *English Studies* 99 (7): 723–743. https://doi.org/10.1080/0013838X.2018.1510611.

Benz, Brad. 2007. "'Deadwood' and the English Language." *Great Plains Quarterly* 27 (4): 239–251.

Berger, Stefan. 2022. *History and Identity: How Historical Theory Shapes Historical Practice*. Cambridge: Cambridge University Press.

Berkhofer, Robert F. 1995. "A Point of View on Viewpoints in Historical Practice." In *A New Philosophy of History*, edited by F. R. Ankersmit and Hans Kellner, 174–191. Chicago: University of Chicago Press.

———. 1998. *Beyond the Great Story: History as Text and Discourse*. Cambridge, Mass.: Belknap Press.

Bordwell, David. 1985. *Narration in the Fiction Film*. Madison: University of Wisconsin Press.

Branigan, Edward. 1992. *Narrative Comprehension and Film*. Sightlines. London: Routledge.

Braxton, Greg. 2017. "'History Happened Here': Oscar Winner John Ridley Revisits the 1992 Riots in His New Documentary." *Los Angeles Times*, April 20, 2017. https://www.latimes.com/entertainment/tv/la-et-st-john-ridley-riot-documentary-20170420-story.html.

Brecht, Bertolt. 2003. *Brecht on Art and Politics*. Translated by Laura Bradley, Steve Giles, and Tom Kuhn. London: Methuen.

Brockey, Liam. 2017. "Dying for the Faith in Japan, 1597–1650." Lecture presented by Assumption University at the University of Windsor, Windsor, Ontario, Canada, March 9, 2017.

Bruner, Jerome. 1991. "The Narrative Construction of Reality." *Critical Inquiry* 18 (1): 1–21.

Bruzzi, Stella. 2020. *Approximation: Documentary, History and the Staging of Reality*. London: Routledge.

Burgoyne, Robert. 1990. "The Cinematic Narrator: The Logic and Pragmatics of Impersonal Narration." *Journal of Film and Video* 42 (1): 3–16.

———. 2008. *The Hollywood Historical Film*. Malden, Mass.: Blackwell.

———. 2010. *Film Nation: Hollywood Looks at U.S. History*. Minneapolis: University of Minnesota Press.

———. 2023. "Remediation, Trauma, and 'Preposterous History' in Documentary Film." In *The Routledge Companion to History and the Moving Image*, edited by Marnie Hughes-Warrington, Kim Nelson, and Mia E. M. Treacey, 74–82. London: Routledge.

Burke, Kenneth. 1984. *Attitudes toward History*. 3rd ed. Berkeley: University of California Press.

Burkholder, Pete, and Dana Schaffer. 2021. "History, the Past, and Public Culture: Results from a National Survey." *American Historical Association*. https://www.historians.org/history-culture-survey.

Butler, Lisa D., Cheryl Koopman, and Philip G. Zimbardo. 1995. "The Psychological Impact of Viewing the Film 'JFK': Emotions, Beliefs, and Political Behavioral Intentions." *Political Psychology* 16 (2): 237–257. https://doi.org/10.2307/3791831.

Bynum, Victoria E. 2016. *The Free State of Jones: Mississippi's Longest Civil War*. Chapel Hill: University of North Carolina Press.

Cambridge Dictionary. 2021. "Cambridge Dictionary | English Dictionary, Translations & Thesaurus." https://dictionary.cambridge.org/dictionary/english/evidence.

Canfield, David. 2017. "How John Ridley Spins Political Provocations into Essential Art." *Slate*, April 20, 2017. https://slate.com/culture/2017/04/with-guerrilla-american-crime-and-let-it-fall-john-ridley-makes-political-provocations-into-art.html.

Carnes, Mark C. 1996. Introduction to *Past Imperfect: History According to the Movies*, edited by Mark C. Carnes, 9–10. New York: Henry Holt.

Carr, Edward Hallett. 1961. *What Is History?* New York: Vintage.

Carroll, Sean M. 2019. *The Big Picture: On the Origins of Life, Meaning, and the Universe Itself*. New York: Dutton.

Certeau, Michel de. 1986. *Heterologies: Discourse on the Other*. Translated by Brian Massumi. Minneapolis: University of Minnesota Press.

———. 1992. *The Writing of History*. Translated by Tom Conley. New York: Columbia University Press.

Chakrabarty, Dipesh. 2008. *Provincializing Europe: Postcolonial Thought and Historical Difference*. Princeton, N.J.: Princeton University Press.

Chapman, James. 2001. "The World at War: Television, Documentary, History." In *The Historian, Television and Television History*, edited by Graham Roberts, Philip M. Taylor, and Nicholas Pronay, 127–144. Luton, U.K.: University of Luton Press.

Cicero, Marcus Tullius. 1968. *Rhetorica Ad Herennium*. Cambridge, Mass.: Harvard University Press.

———. 1988. *De Oratore*. Translated by Edward William Sutton. Cambridge, Mass.: Harvard University Press.

Collingwood, R. G. 1956. *Idea of History*. New York: Oxford University Press.

Comolli, J.-L. 1978. "Historical Fiction: A Body Too Much." *Screen* 19 (2): 41–54. https://doi.org/10.1093/screen/19.2.41.

Corsa, Andrew J. 2018. "Grand Narrative, Metamodernism, and Global Ethics." *Cosmos and History: The Journal of Natural and Social Philosophy* 14 (3): 241–272.

Curry, Marshall, director. 2017. *A Night at the Garden*. Documentary. https://anightatthegarden.com/.

Damasio, Antonio R. 1994. *Descartes' Error: Emotion, Reason, and the Human Brain*. New York: Putnam.

Danto, Arthur C. 1982. "Narration and Knowledge." *Philosophy and Literature* 6 (1–2): 17–32. https://doi.org/10.1353/phl.1982.0023.

Davis, Natalie Zemon. 1983. *The Return of Martin Guerre*. Cambridge, Mass.: Harvard University Press.

———. 1987. "Any Resemblance to Persons Living or Dead: Film and the Challenge of Authenticity." *Yale Review* 6 (4): 457–482.

———. 2000. *Slaves on Screen: Film and Historical Vision*. Toronto: Vintage Canada.

deBoer, Freddie. 2023. "It Only Counts When It Hurts." *Freddie deBoer* (blog), Substack newsletter. May 8, 2023. https://freddiedeboer.substack.com/p/it-only-counts-when-it-hurts?publication_id=295937&isFreemail=false.

Deleuze, Gilles. 2001. *Cinema 1: The Movement-Image*. London: Athlone.
Descartes, René, and Donald A. Cress. 1998. *Discourse on Method; and Meditations on First Philosophy*. 4th ed. Indianapolis: Hackett.
Diamond, Jared M. 1999. *Guns, Germs, and Steel: The Fates of Human Societies*. New York: Norton.
Doležel, Lubomír. 2010. *Possible Worlds of Fiction and History: The Postmodern Stage*. Baltimore: Johns Hopkins University Press.
Du Bois, W. E. B. 1989. *The Souls of Black Folk*. New York: Penguin.
Epstein, Seymour. 1994. "Integration of the Cognitive and the Psychodynamic Unconscious." *American Psychologist* 49 (8): 709–724.
Fauci, Michael, and Robert A. Rosenstone. 1988. "Letters." *Cinéaste* 16 (4): 3.
Ferro, Marc. 1988. *Cinema and History*. Detroit, Mich.: Wayne State University Press.
Flory, Dan. 2006. "Spike Lee and the Sympathetic Racist." *Journal of Aesthetics and Art Criticism* 64 (1): 67–79. https://doi.org/10.1111/j.0021-8529.2006.00230.x.
———. 2008. *Philosophy, Black Film, Film Noir*. University Park: Pennsylvania State University Press.
Fludernik, Monika. 1996. *Towards a "Natural" Narratology*. London: Routledge.
Foley, Malcolm, and Priya Satia. 2022. "Responses to 'Is History History?'" *Perspectives on History*, September 7, 2022. https://www.historians.org/publications-and-directories/perspectives-on-history/october-2022/responses-to-is-history-history.
Foner, Eric, and John Sayles. 1996. "A Conversation between Eric Foner and John Sayles." In *Past Imperfect: History According to the Movies*, edited by Mark C. Carnes, 15–17. New York: Henry Holt.
Fraser, Nick. 2014. "The Act of Killing: Don't Give an Oscar to This Snuff Movie." *Observer*, February 23, 2014. https://www.theguardian.com/commentisfree/2014/feb/23/act-of-killing-dont-give-oscar-snuff-movie-indonesia.
Free State of Jones. n.d. "Home." Accessed July 3, 2016. http://freestateofjones.info/.
Friedan, Betty. 2013. *The Feminine Mystique*. New York: W. W. Norton.
Frum, David. 2022. "The New History Wars." *Atlantic*, October 30, 2022. https://www.theatlantic.com/ideas/archive/2022/10/american-historical-association-james-sweet/671853/.
Frye, Northrop. 2020. *Anatomy of Criticism: Four Essays*. Princeton, N.J.: Princeton University Press.
Gare, Arran. 2001. "Narratives and the Ethics and Politics of Environmentalism: The Transformative Power of Stories." *Theory and Science* 2 (1): 1–10. https://theoryandscience.icaap.org/content/vol002.001/04gare.html.
Gaudreault, André. 2009. *From Plato to Lumière: Narration and Monstration in Literature and Cinema*. Translated by Tim Barnard. Toronto: University of Toronto Press.
Gearhart, Suzanne. 1984. *The Open Boundary of History and Fiction: A Critical Approach to the French Enlightenment*. Princeton, N.J.: Princeton University Press.
Genette, Gérard. 1991. *Fiction et Diction*. Paris: Editions du Seuil.
———. 1997. *Palimpsests: Literature in the Second Degree*. Lincoln: University of Nebraska Press.
Greiner, Rasmus. 2021. *Cinematic Histospheres: On the Theory and Practice of Historical Films*. Cham: Springer International. https://doi.org/10.1007/978-3-030-70590-9.
Grierson, John. 1933. "The Documentary Producer." *Cinema Quarterly* 2 (1): 7–9.
Grindon, Leger. 1994. *Shadows on the Past: Studies in the Historical Fiction Film*. Philadelphia: Temple University Press.
Gunning, Tom. 2008. "Early Cinema and the Variety of Moving Images." *American Art* 22 (2): 9–11. https://doi.org/10.1086/591163.
Guthrie, Caroline. 2019. "Narratives of Rupture: Tarantino's Counterfactual Histories and the American Historical Imaginary." *Rethinking History* 23 (3): 339–361.

Guynn, William Howard. 2006. *Writing History in Film*. New York: Routledge.
Halbwachs, Maurice. 1992. *On Collective Memory*. Edited by Lewis A. Coser. Chicago: University of Chicago Press.
Hall, Stuart. 1989. "Cultural Identity and Cinematic Representation." *Framework: The Journal of Cinema and Media* no. 36, 68–81.
———. 2021. "Encoding and Decoding in the Television Discourse." In *Writings on Media: History of the Present*, edited by Charlotte Brunsdon, 247–266. Durham: Duke University Press.
Hartley, Leslie P. 2000. *The Go-Between*. London: Penguin.
Herder, Johann Gottfried. 1966. *Outlines of a Philosophy of the History of Man*. Translated by T. Churchill. New York: Bergman.
Herlihy, David. 1988. "Am I a Camera? Other Reflections on Films and History." *American Historical Review* 93 (5): 1186–1192.
Herodotus. 1996. *The Histories*. Translated by Aubrey De Sélincourt. London: Penguin.
History vs. Hollywood. n.d. "Free State of Jones vs. the True Story of Newton Knight." HistoryvsHollywood.com. Accessed January 26, 2022. https://www.historyvshollywood.com/reelfaces/free-state-of-jones/.
Hobsbawm, E. J. 1997. *On History*. New York: New Press.
Hodges, Nick. 2015–. *History Buffs*. YouTube channel. https://www.youtube.com/channel/UCggH0Xaj8BQHIiPmOxezeWA.
hooks, bell. 1996. *Reel to Real: Race, Class, and Sex at the Movies*. New York: Routledge.
Howe, LeAnne, Harvey Markowitz, and Denise K. Cummings, eds. 2013. *Seeing Red: Hollywood's Pixeled Skins; American Indians and Film*. East Lansing: Michigan State University Press.
Hughey, Matthew W. 2014. *The White Savior Film: Content, Critics, and Consumption*. Philadelphia: Temple University Press.
Jager, Eric. 2020. *The Last Duel: A True Story of Crime, Scandal, and Trial by Combat in Medieval France*. New York: Crown.
Jameson, Fredric. 2005. *Postmodernism; or, The Cultural Logic of Late Capitalism*. Durham, N.C.: Duke University Press.
Jordanova, Ludmilla J. 2019. *History in Practice*. London: Bloomsbury Academic.
Kandel, Eric R., Yadin Dudai, and Mark R. Mayford. 2014. "The Molecular and Systems Biology of Memory." *Cell* 157 (1): 163–186. https://doi.org/10.1016/j.cell.2014.03.001.
Khorshid, Sara. 2023. "Why Netflix's 'Queen Cleopatra' Has Egypt up in Arms." *Foreign Policy* (blog). May 14, 2023. https://foreignpolicy.com/2023/05/14/egypt-netflix-queen-cleopatra-race-history-heritage-imperialism-afrocentrism/.
Kracauer, Siegfried, and Paul Oskar Kristeller. 1995. *History: The Last Things before the Last*. Princeton, N.J.: Markus Wiener.
Kuehl, Jerome. 1976. "History on the Public Screen II." In *The Historian and Film*, edited by Paul Smith, 177–185. Cambridge: Cambridge University Press.
———. 1999. "Lies about Real People." In *Why Docudrama? Fact-Fiction in Film and TV*, edited by Alan Rosenthal, 119–124. Carbondale: Southern Illinois University Press.
LaCapra, Dominick. 1996. *History & Criticism*. Ithaca, N.Y.: Cornell University Press.
Landsberg, Alison. 2004. *Prosthetic Memory: The Transformation of American Remembrance in the Age of Mass Culture*. New York: Columbia University Press.
———. 2009. "Memory, Empathy, and the Politics of Identification." *International Journal of Politics, Culture, and Society* 22 (May 26): 221–229. https://doi.org/10.1007/s10767-009-9056-x.
———. 2015. *Engaging the Past: Mass Culture and the Production of Historical Knowledge*. New York: Columbia University Press.

Lane, Anthony. 2017. "'Detroit' and 'Whose Streets?'" *New Yorker*, July 31, 2017. https://www.newyorker.com/magazine/2017/08/07/detroit-and-whose-streets.
Layton, Bart, director. 2018. American Animals. AI Film.
Limoges, Jean-Marc. 2021. "Disrupting the Illusion by Bolstering the Reality Effect in Film." In *Fictionality, Factuality, and Reflexivity across Discourses and Media*, edited by Erika Fülöp, 169–189. Translated by Johanne O'Malley. Boston: De Gruyter.
Liveley, Genevieve. 2019. *Narratology*. 1st ed. Oxford: Oxford University Press.
Lively, Sam. 2020. "Why Spike Lee Didn't De-age His *Da 5 Bloods* Stars." *MovieMaker Magazine*, June 19, 2020. https://www.moviemaker.com/why-spike-lee-didnt-de-age-his-da-5-bloods-stars/.
Lowenthal, David. 1985. *The Past Is a Foreign Country*. Cambridge: Cambridge University Press.
Lyotard, Jean Francois. 1989. *The Postmodern Condition: A Report on Knowledge*. Minneapolis: University of Minnesota Press.
MacDougall, David. 2003. "Beyond Observational Cinema." In *Principles of Visual Anthropology*, edited by Paul Hockings, 115–132. 3rd ed. Berlin: De Gruyter Mouton.
Marks, Laura U. 2000. *The Skin of the Film: Intercultural Cinema, Embodiment, and the Senses*. Durham, N.C.: Duke University Press.
Maron, Marc. 2021. "Franklin Leonard." *WTF*, September 23, 2021. Podcast. https://wtfpod.libsyn.com/webpage/category/episode-1264-franklin-leonard.
Matuszewski, Bolesław. 1995. "A New Source of History." Translated by Laura U. Marks and Diane Koszarski. *Film History* 7 (3): 322–324.
Maza, Sarah C. 2017. *Thinking about History*. Chicago: University of Chicago Press.
Mazierska, E. 2014. *European Cinema and Intertextuality: History, Memory and Politics*. Basingstoke, U.K.: Palgrave Macmillan.
McArthur, Colin. 1978. *Television and History*. London: British Film Institute.
McKee, Robert. 1997. *Story: Substance, Structure, Style, and the Principles of Screenwriting*. 1st ed. New York: Regan Books.
Menashe, Louis. 2007. "History on Film/Film on History by Robert A. Rosenstone: Russian War Films: On the Cinema Front, 1914–2005 by Denise J. Youngblood." *Cinéaste* 32 (2): 82–85.
Metz, Christian. 1974. *Language and Cinema*. The Hague, Netherlands: Mouton.
Miller, Donald L. 2019. Interview with author. University of Windsor, Windsor, Ontario, Canada.
Miller, Elizabeth. 2018. "The Shore Line: A Storybook for a Sustainable Future." *The Conversation*, January 8, 2018. http://theconversation.com/the-shore-line-a-storybook-for-a-sustainable-future-89159.
Montague, Jules. 2018. *Lost and Found: Memory, Identity, and Who We Become When We're No Longer Ourselves*. London: Sceptre.
Moses, A. Dirk. 2005. "The Public Relevance of Historical Studies: A Rejoinder to Hayden White." *History and Theory* 44 (3): 339–347. https://doi.org/10.1111/j.1468-2303.2005.00328.x.
Mulvey, Laura. 1981. "Afterthoughts on 'Visual Pleasure and Narrative Cinema' Inspired by 'Duel in the Sun' (King Vidor, 1946)." *Framework: The Journal of Cinema and Media*, no. 15/17: 12–15.
Mundhenke, Florian. 2021. "The Documentary as a Genre or Mode? A New Approach to Documentary Film Analysis through the Field of Meaning." In *Media and Genre: Dialogue in Aesthetics and Cultural Analysis*, edited by Ivo Ritzer, 283–304. Cham, Switzerland: Palgrave Macmillan. https://doi.org/10.1007/978-3-030-69866-9.
Munslow, Alun. 2010. *The Future of History*. New York: Palgrave Macmillan.

———. 2015. "Genre and History/Historying." *Rethinking History* 19 (2): 158–176. https://doi.org/10.1080/13642529.2014.973711.
National Archives. 2022. "National Archives Releases New Group of JFK Assassination Documents." December 15, 2022. https://www.archives.gov/press/press-releases/2023/nr23-14.
Nelson, Kim. 2022. "The Historian Is Present: Live Interactive Documentary as Collaborative History." *Rethinking History* 26 (3): 289–318. https://doi.org/10.1080/13642529.2022.2103618.
———. 2023a. "Live Documentary as Social Cinema and the Cinepoetics of Doubt." In *The Routledge Companion to History and the Moving Image*, edited by Marnie Hughes-Warrington, Kim Nelson, and Mia E. M. Treacey, 258–275. London: Routledge.
———. 2023b. *Picturing the Past: History Movies*. Ideas, CBC Audio documentary. March 9, 2023. https://www.cbc.ca/radio/ideas/historical-films-oscars-kim-nelson-1.6772542.
Nichols, Bill. 1991. *Representing Reality: Issues and Concepts in Documentary*. Bloomington: Indiana University Press.
———. 2008. "The Question of Evidence, the Power of Rhetoric and Documentary Film." In *Rethinking Documentary: New Perspectives, New Practices*, edited by Thomas Austin and Wilma de Jong, 29–38. Maidenhead, U.K.: Open University Press.
———. 2016. *Speaking Truths with Film: Evidence, Ethics, Politics in Documentary*. Oakland: University of California Press.
———. 2017. *Introduction to Documentary*. 3rd ed. Bloomington: Indiana University Press.
Nietzsche, Friedrich Wilhelm. 2019 [1874]. *The Use and Abuse of History*. Translated by Adrian Collins. Mineola, N.Y.: Dover.
"A Night at the Garden." n.d. Accessed October 9, 2021. https://anightatthegarden.com/.
Novick, Peter. 1988. *That Noble Dream: The "Objectivity Question" and the American Historical Profession*. Cambridge: Cambridge University Press.
NPR. 2016. "'The Witch' Achieves Puritan American Horror without the Gore." *Weekend Edition*. National Public Radio. https://www.npr.org/2016/03/06/469383396/-the-witch-achieves-puritan-american-horror-without-the-gore.
O'Connor, John E. 1988. "History in Images/Images in History: Reflections on the Importance of Film and Television Study for an Understanding of the Past." *American Historical Review* 93 (5): 1200–1209. https://doi.org/10.2307/1873535.
———. 1990a. "Case Study: The Plow That Broke the Plains." In *Image as Artifact: The Historical Analysis of Film and Television*, edited by John E. O'Connor and American Historical Association, 284–301. Malabar, Fla: R. E. Krieger.
———. 1990b. *Image as Artifact: The Historical Analysis of Film and Television*. Laserdisc. Malabar, Fla: R. E. Krieger.
O'Connor, John E., and American Historical Association, eds. 1990. *Image as Artifact: The Historical Analysis of Film and Television (Companion to Video)*. Malabar, Fla: R. E. Krieger.
Okediji, Moyosore B. 1999. "Returnee Recollections: Transatlantic Transformations." In *Transatlantic Dialogue: Contemporary Art In and Out of Africa*, edited by Michael D. Harris, 32–51. Chapel Hill, N.C.: Ackland Art Museum, University of North Carolina at Chapel Hill.
Oppenheimer, Joshua, and Michael Uwemedimo. 2007. "History and Historionics: Vision Machine's Digital Poetics." In *Fluid Screens, Expanded Cinema*, edited by Janine Marchessault and Susan Lord, 177–191. Toronto: University of Toronto Press.
Peters, John Durham. 2015. *The Marvelous Clouds: Toward a Philosophy of Elemental Media*. Chicago: University of Chicago Press.
Pinker, Steven. 2011. *The Better Angels of Our Nature: Why Violence Has Declined*. New York: Viking.
Plantinga, Carl R. 2009. *Moving Viewers: American Film and the Spectator's Experience*. Berkeley: University of California Press.

———. 2010. *Rhetoric and Representation in Nonfiction Film*. Grand Rapids, Mich.: Chapbook Press.

———. 2018. *Screen Stories: Emotion and the Ethics of Engagement*. New York: Oxford University Press.

Plato. 1945. *The Republic of Plato*. Translated by Francis MacDonald Cornford. London: Oxford University Press.

Popescu, Adam. 2013. "Franklin Leonard, the Man behind the Black List." *LA Weekly*, July 3, 2013. https://www.laweekly.com/franklin-leonard-the-man-behind-the-black-list/.

Powell, Michael. 2022. "Sundance Liked Her Documentary on Terrorism, Until Muslim Critics Didn't." *New York Times*, September 25, 2022, sec. U.S.

Price, Brian. 2020. *Classical Storytelling and Contemporary Screenwriting: Aristotle and the Modern Scriptwriter*. London: Routledge.

Raheja, Michelle H. 2010. *Reservation Reelism: Redfacing, Visual Sovereignty, and Representations of Native Americans in Film*. Lincoln: University of Nebraska Press.

Rancière, Jacques. 2013. "Is History a Form of Fiction?" In *The Politics of Aesthetics: The Distribution of the Sensible*, edited by Gabriel Rockhill, 31–38. London: Bloomsbury.

Renov, Michael. 1993. Introduction to *Theorizing Documentary*, 1–11. 1st ed. New York: Routledge.

"Report of the Select Committee to Inquire into the Mississippi Election of 1875." 1876. Washington, D.C.: Government Printing Office. http://freestateofjones.info/.

Rhines, Jesse Algeron. 1996. *Black Film, White Money*. New Brunswick, N.J.: Rutgers University Press.

Ricœur, Paul. 1980. "Narrative Time." *Critical Inquiry* 7 (1): 169–190.

———. 2004. *Memory, History, Forgetting*. Translated by Kathleen Blamey and David Pellauer. Chicago: University of Chicago Press.

———. 2009. *Time and Narrative*. Vol. 1. Translated by Kathleen McLaughlin and David Pellauer. Chicago: University of Chicago Press.

Ridley, John, director. *Let It Fall: Los Angeles 1982–1992*. Lincoln Square Productions.

"Rise of Empires: Ottoman." n.d. STX Television. Accessed January 16, 2022. https://www.riseofempiresottoman.com/.

Roads, Christopher H. 1966. "Film as Historical Evidence." *Journal of the Society of Archivists* 3 (4): 183–191. https://doi.org/10.1080/00379816509513842.

Rosen, Philip. 2001. *Change Mummified: Cinema, Historicity, Theory*. Minneapolis: University of Minnesota Press.

Rosenberg, Alexander. 2018. *How History Gets Things Wrong: The Neuroscience of Our Addiction to Stories*. Cambridge, Mass.: MIT Press.

Rosenstone, Robert A. 1982. "Reds as History." *Reviews in American History* 10 (3): 297–310. https://doi.org/10.2307/2702489.

———. 1988. "History in Images/History in Words: Reflections on the Possibility of Really Putting History onto Film." *American Historical Review* 93 (5): 1173–1185.

———. 1989. "History, Memory, Documentary: A Critique of *The Good Fight*." *Cinéaste* 17 (1): 12–15.

———. 1995a. *Revisioning History: Film and the Construction of a New Past*. Princeton, N.J.: Princeton University Press.

———. 1995b. *Visions of the Past: The Challenge of Film to Our Idea of History*. Cambridge, Mass.: Harvard University Press.

———. 2006a. *History on Film / Film on History*. 1st ed. Harlow, U.K.: Longman/Pearson.

———. 2006b. "Reel History: In Defense of Hollywood." *Journal of Interdisciplinary History* 37 (1): 159–160. https://doi.org/10.1162/jinh.2006.37.1.159.

———. 2012. *History on Film / Film on History*. 2nd ed. London: Routledge.

———. 2023. Email correspondence with author.
Rosenstone, Robert A., and Kim Nelson. 2023. "Afterword: History with Images: A Conversation with Robert A. Rosenstone." In *The Routledge Companion to History and the Moving Image*, edited by Marnie Hughes-Warrington, Kim Nelson, and Mia E. M. Treacey, 330–343. London: Routledge.
Rosenthal, Alan, Jerome Kuehl, Raye Farr, and Susan McConachy. 1978. "'The World at War' the Making of a Historical Documentary." *Cinéaste* 9 (2): 6–25.
Ross, Gary, director. 2016. *Free State of Jones*. STX Entertainment.
———. 2018. Interview with author. Los Angeles, Calif.
———. 2022. Email correspondence with author.
Ruby, Jay. 1977. "The Image Mirrored: Reflexivity and the Documentary Film." *Journal of the University Film Association* 29 (4): 3–11.
———. 2000. *Picturing Culture: Explorations of Film & Anthropology*. Chicago: University of Chicago Press.
Runciman, Steven. 2012. *The Fall of Constantinople 1453*. Cambridge: Cambridge University Press.
Ryan, Marie-Laure. 2010. "Possible-Worlds Theory." In *Routledge Encyclopedia of Narrative Theory*, edited by David Herman, Manfred Jahn, and Marie-Laure Ryan. London: Routledge.
Şahin, Emre, director. 2020. *Rise of Empires: Ottoman*. Netflix.
Schuessler, Jennifer. 2016. "A Confederate Dissident, in a Film with Footnotes." *New York Times*, June 15, 2016. https://www.nytimes.com/2016/06/16/movies/free-state-of-jones-a-film-with-footnotes.html.
Scott, A. O. 2014. "The Painter Was a Piece of Work, Too." *New York Times*, December 18, 2014. https://www.nytimes.com/2014/12/19/movies/mr-turner-about-the-life-of-the-artist-j-m-w-turner.html.
Scott, Ridley, director. 2021. *The Last Duel*. 20th Century Studios.
Seitz, Matt Zoller. 2017. "Errol Morris on *Wormwood*, Fake News, and Why He Hates the Word 'Reenactment.'" *Vulture*, December 15, 2017. https://www.vulture.com/2017/12/errol-morris-wormwood-interview.html.
Selk, Avi. 2017. "You Can Thank Oliver Stone's Sensationalized 1991 Movie for the JFK Document Release." *Washington Post*, October 21, 2017. https://www.washingtonpost.com/news/retropolis/wp/2017/10/21/you-can-thank-oliver-stones-sensationalized-1991-movie-for-the-jfk-document-release/.
Shohat, Ella, and Robert Stam. 1994. *Unthinking Eurocentrism: Multiculturalism and the Media*. London: Routledge.
Sklar, Robert. 1997. "Historical Films: Scofflaws and the Historian-Cop." *Reviews in American History* 25 (2): 346–350. https://doi.org/10.1353/rah.1997.0058.
Skoller, Jeffrey. 2005. *Shadows, Specters, Shards: Making History in Avant-Garde Film*. Minneapolis: University of Minnesota Press.
Slingerland, Edward G. 2008. *What Science Offers the Humanities: Integrating Body and Culture*. Cambridge: Cambridge University Press.
Slovic, Paul. 2007. "Psychic Numbing and Genocide." *American Psychological Association*, November 2007. https://doi.org/10.1037/e718332007-003.
Smyth, J. E. 2006. *Reconstructing American Historical Cinema: From Cimarron to Citizen Kane*. Lexington: University Press of Kentucky.
Sobchack, Vivian. 1997. "The Insistent Fringe: Moving Images and Historical Consciousness." *History and Theory* 36 (4): 4–20.

Sorkin, Aaron. n.d. "Rules of Story." *Aaron Sorkin Teaches Screenwriting*. MasterClass. Accessed September 13, 2021. https://www.masterclass.com/classes/aaron-sorkin-teaches-screenwriting/chapters/rules-of-story.

Sorlin, Pierre. 1980. *The Film in History: Restaging the Past*. Totowa, N.J.: Barnes & Noble Books.

Spadoni, Robert. 2020. "What Is Film Atmosphere?" *Quarterly Review of Film and Video* 37 (1): 48–75. https://doi.org/10.1080/10509208.2019.1606558.

Staiger, Janet. 2000. *Perverse Spectators: The Practices of Film Reception*. New York: New York University Press.

———. 2004. "The Future of the Past." *Cinema Journal* 44 (1): 126–129.

Stam, Robert. 1985. *Reflexivity in Film and Literature: From Don Quixote to Jean-Luc Godard*. Ann Arbor, Mich.: UMI Research Press.

Stern, Fritz. 1973. *The Varieties of History: From Voltaire to the Present*. New York: Vintage.

Stone, Oliver. 2000. "Stone on Stone's Image (As Presented by Some Historians)." In *Oliver Stone's USA: Film, History, and Controversy*, edited by Robert Brent Toplin, 40–65. Lawrence: University Press of Kansas.

Stone, Oliver, and Zachary Sklar. 1992. *JFK: The Book of the Film*. New York: Applause Books.

Stubbs, Jonathan. 2013. *Historical Film: A Critical Introduction*. New York: Bloomsbury Academic.

Sweet, James H. 2022. "Is History History? Identity Politics and Teleologies of the Present." August 17, 2022. https://www.historians.org/publications-and-directories/perspectives-on-history/september-2022/is-history-history-identity-politics-and-teleologies-of-the-present.

Thanouli, Eleftheria. 2009. *Post-Classical Cinema: An International Poetics of Film Narration*. London: Wallflower Press.

———. 2019. *History and Film: A Tale of Two Disciplines*. New York: Bloomsbury Academic.

Theodorakopoulos, Elena. 2010. *Ancient Rome at the Cinema: Story and Spectacle in Hollywood and Rome*. Exeter, U.K.: Bristol Phoenix.

Tierno, Michael. 2002. *Aristotle's Poetics for Screenwriters: Storytelling Secrets from the Greatest Mind in Western Civilization*. 1st ed. New York: Hyperion.

Todorov, Tzvetan. 1990. *Genres in Discourse*. Translated by Catherine Porter. Cambridge: Cambridge University Press.

Townsend, Camilla. 2019. *Fifth Sun: A New History of the Aztecs*. New York: Oxford University Press.

Trafton, John. 2023. "Free State of Jones and the New Civil War Cinema." In *The Routledge Companion to History and the Moving Image*, edited by Marnie Hughes-Warrington, Kim Nelson, and Mia E. M. Treacey, 225–239. London: Routledge.

Treacey, Mia E. M. 2016. *Reframing the Past: History, Film and Television*. London: Routledge.

Umanath, Sharda, Andrew C. Butler, and Elizabeth J. Marsh. 2012. "Positive and Negative Effects of Monitoring Popular Films for Historical Inaccuracies: Learning History from Popular Films." *Applied Cognitive Psychology* 26 (4): 556–567. https://doi.org/10.1002/acp.2827.

Vaage, Margrethe Bruun. 2010. "Fiction Film and the Varieties of Empathic Engagement: Fiction Film and the Varieties of Empathic Engagement." *Midwest Studies in Philosophy* 34 (1): 158–179. https://doi.org/10.1111/j.1475-4975.2010.00200.x.

———. 2017a. *The Antihero in American Television*. London: Routledge.

———. 2017b. "From the Corner to the Wire: On Nonfiction, Fiction, and Truth." *Journal of Literary Theory* 11 (2): 255–271.

Vermeulen, Timotheus, and Robin van den Akker. 2015. "Utopia, Sort of: A Case Study in Metamodernism." *Studia Neophilologica* 87 (sup1): 55–67. https://doi.org/10.1080/00393274.2014.981964.

Voltaire. 1966. *Philosophy of History*. New York: Citadel Press.

Walker, Michael. 2014. "How Matthew McConaughey's Crazy Ads Gave Lincoln Some Much-Needed Buzz." *Hollywood Reporter*, October 19, 2014. https://rb.gy/w1r8v1.

Watt, Donald. 1976. "History on the Public Screen I." In *The Historian and Film*, edited by Paul Smith, 169–176. Cambridge: Cambridge University Press.

Waugh, Thomas. 1990. "'Acting to Play Oneself': Notes on Performance in Documentary." In *Making Visible the Invisible: An Anthology of Original Essays on Film Acting*, edited by Carole Zucker, 64–91. Metuchen, N.J.: Scarecrow Press.

Weimann, Robert. 2000. "Introduction: Conjunctures and Concepts." In *Author's Pen and Actor's Voice: Playing and Writing in Shakespeare's Theatre*. Edited by Helen Higbee and William N. West, 1–17. Cambridge: Cambridge University Press.

Weintraub, Steve. 2021. "Matt Damon and Nicole Holofcener on 'The Last Duel' and Using the 'Rashomon' Storytelling Device." *Collider*, October 13, 2021. https://collider.com/matt-damon-the-last-duel-interview-nicole-holofcener/.

Westwell, Guy. 2007. "Critical Approaches to the History Film—a Field in Search of a Methodology." *Rethinking History* 11 (4): 577–588. https://doi.org/10.1080/13642520701652129.

White, Hayden V. 1966. "The Burden of History." *History and Theory* 5 (2): 111–134. https://doi.org/10.2307/2504510.

———. 1975. *Metahistory: The Historical Imagination in Nineteenth-Century Europe*. Baltimore: Johns Hopkins University Press.

———. 1988. "Historiography and Historiophoty." *American Historical Review* 93 (5): 1193–1199. https://doi.org/10.2307/1873534.

———. 1990. *The Content of the Form: Narrative Discourse and Historical Representation*. Baltimore: Johns Hopkins University Press.

———. 1996. "The Modernist Event." In *The Persistence of History: Cinema, Television, and the Modern Event*, edited by Vivian Carol Sobchack, 17–38. New York: Routledge.

———. 1999. "Afterword." In *Beyond the Cultural Turn: New Directions in the Study of Society and Culture*, edited by Victoria E. Bonnell and Lynn Hunt, 315–324. Berkeley: University of California Press.

———. 2008. "Letters." *Cinéaste* 33 (3): 83.

———. 2017. "E-Mail to Robert L. Nelson." October 25, 2017.

White, Richard. 1995. "The Last of the Mohicans." In *Past Imperfect: History According to the Movies*, edited by Mark C. Carnes, 82–85. New York: Henry Holt.

Yates, Frances A. 1972. *The Art of Memory*. London: Routledge & Kegan Paul.

Yee, Vivian. 2023. "Whose Queen? Netflix and Egypt Spar over an African Cleopatra." *New York Times*, May 10, 2023. https://www.nytimes.com/2023/05/10/world/middleeast/cleopatra-netflix-race-egypt.html.

Zacks, Jeffrey M. 2015. *Flicker: Your Brain on Movies*. Oxford: Oxford University Press.

Index

Page numbers followed by *f* and *t* refer to figures and tables, respectively.

Act of Killing, The: archeological performance, 86, 125; characterization, 52–53, 159–160; companion website, 93, 94, 94*f*, 96; genre, 57; metamodernism, 142; rhetoric, 41
affect, 14–15; characterization, 40; classic poetics, 47; memory, 123; metamodernism, 114; music, 42, 68–70, 139; reception, 143; reflexivity, 107, 111; scale, 175; visual, 139
Affleck, Ben, 165, 181, 185
Agony and the Ecstasy of Phil Spector, The, 89–90, 136
Akker, Robin van den, 113–114
Aldgate, Anthony, 75
Ali, Mahershala, 98, 141, 164, 188
All Quiet on the Western Front, 80
Altman, Rick, 73
American Animals, 32*t*, 127–128, 128*f*, 137
American Historical Association, 25–26, 81, 103
American Historical Review, forum issue, 4, 79, 81, 89
Amistad, 121, 157, 161, 163
Ankersmit, Frank, 8, 109
Anne Boleyn, 121
Apocalypse Now, 135
Apocalypto, 126
Ararat, 118
Argo, 117*t*, 128, 132–133

Aristotle: character, 60; emplotment, 52; history versus *poiesis*, 36, 72; learning, 155; mimesis, 23, 60, 75, 155, 158; plot, 36, 60; *Poetics*, 36, 47, 52, 60; *poiesis*, 65, 155; rhetoric, 41, 52; visual poetics, 65
art direction, 15, 77, 84, 89, 117*t*, 120–121
art films, 16, 16*t*, 18–19, 27–28, 108; aesthetics, 112–113, 138–139
Assassination of Jesse James by the Coward Robert Ford, The, 57
Assassin's Creed, 67
Atanarjuat: The Fast Runner [ᐊᑕᓈᕐᔪᐊᑦ], 30, 32*t*, 167
atmosphere, 79, 143, 144, 147–151, 154, 156, 163, 165–166
Atomic Blonde, 28
Attenborough, David, 135
audience. *See* spectatorship
authenticity: academic history and, 84; archival material and, 87, 133, 139–140; documentary claims to, 84; marketing of, 36; period detail, 147–150; polyphony as route to, 182; realism and, 17–18, 108; reality effect, 147–150; "token" representations and, 29
authorship, 33; collaborative, 183–185; diverse, 177, 185–187; of history and nonfiction, 43–46, 119
avant-garde film, 16*t*, 18–19, 27–28
Axtell, James, 161–162

213

Babylon Berlin, 30, 32t
Bakhtin, Mikhail: heteroglossia, 172–173, 183; polyphonic authorship, 187; polyphony, 169, 181
Bal, Mieke, 44–45, 191
Balázs, Béla, 147
Barry Lyndon, 135
Barthes, Roland, 51, 148, 149–150
Bass, Saul, and Elaine, 134
Battleship Potemkin, 176
Bazin, André, 17
Beatty, Warren, 57–58, 124, 133
Ben-Hur, 126
Benjamin, Walter, 114–115
Bentley, Nick, 114
Berger, Stefan, 168, 171
Berkhofer, Robert: historiography, 9, 33; plurality, 33, 169, 170, 184; reflexivity, 108, 115–116
Bigelow, Kathryn, 100, 140
Big Short, The, 117t, 125
Birth of a Nation, The, 66, 163, 188
Black Robe, 161–162
Boal, Mark, 100
Bordwell, David, 18, 40, 45, 113, 176
Branigan, Edward, 31, 40
Braveheart, 31, 52–53, 161, 167
Breaking Bad, 159, 160
Brecht, Bertholt, 5, 114–115, 126, 146
Britell, Nicholas, 68, 141
Brockey, Liam, 81
Broomfield, Nick, 136
Bruner, Jerome, 107
Bruzzi, Stella, 103, 105, 133, 151n1
Burgoyne, Robert: dual focus, 28; focalization, 44; layered record, 126, 134, 188–189, 191; narration, 44, 136; quotation, 26; subtypes of the historical film, 57
Burke, Kenneth, 53–54
Burkholder, Peter, 25–26
Butler, Andrew C., 73

Canfield, David, 189
Capra, Frank, 135
Carnes, Mark, 36, 161
Carr, E. H., 183–184
Carroll, Sean M., 109, 110
casting, 61, 117t, 121–123
Celebration, The, 130
Certeau, Michel de, 6

Cervantes, Miguel de, 112
Chakrabarty, Dipesh, 170–171, 172
characterization: affect, 40, 119, 136, 178; complexity, 35, 85, 158–161, 163–164, 165–166; composite, 97–100; diegetic versus mimetic, 2–3, 21, 23, 28, 30, 42, 87, 90–91, 97–100, 103, 190; emplotment, 52–54; historiophoty, 7, 19, 39, 61, 130–131; identification, 19, 33, 159–161, 174, 176–177, 185–187, 190–191; narration, 44, 52–53; narrative argument and, 58, 60–61, 62–64; plurality, 35–36, 130–131, 169–171, 172–182; presentism, 177–178; range of, 35t; reflexivity, 122, 125–126, 136; truth and, 90–91, 99–100, 103, 130–131, 179–183, 190
Cheese and the Worms, The, 30
Christopher Columbus, 157
Cinéaste, 12, 79
cinematography, 67–68, 77, 118–119, 117t, 120f, 128–129, 131, 139, 176
Citizenfour, 32t
Citizen Kane, 5, 129
Civil War genre, 163, 164, 188–189
Cold Mountain, 189
collage, 23, 26, 61, 108, 128
Collingwood, R. G., historiography, 7, 8, 11, 19, 31, 35, 39, 41; truth, 11
Come and See, 80
comedy, 46t, 52, 53–54, 130
Comer, Jodie, 130
Comolli, Jean-Louis, 20, 123, 127
companion works, 82, 90, 91–92; documentaries, 100–102; websites, 93, 94f, 95, 96–100
Conqueror, The, 121
Conquest 1453, 190
Coppola, Sofia, 186
Cornford, Francis, 23–24
Corsa, Andrew, 182
costume film, 16t, 28, 54, 57
Countryman and the Cinematograph, The, 112, 113f
credits, 83–84, 90–91
critical thinking, 39, 50–51, 81, 83, 184, 191, 192; plurality, 173, 182, 187; reception, 51–52, 180, 191; reflexivity, 33, 107–108, 109, 111, 130, 132
criticism, ethical, 103, 184
Cummings, Denise K., 174
Curry, Marshall, 65–66, 86, 93–94, 106, 176

Da 5 Bloods, 32*t*, 117*t*, 122–123
Damon, Matt, 130, 165, 185
Danto, Arthur, 7
Darwin, Charles, 39, 54
Daughters of the Dust, 33
Davis, Natalie Zemon, 3, 30, 35; authorship, 184; documentary, 3, 5, 82, 90, 146; evidence, 33, 71, 73, 82, 89, 90, 97, 98, 99–100; fictionalizing history, 33, 73, 152–153; foreignness, 33, 143, 146–147, 152–153, 157, 161, 163; historiophoty, 4–6, 168; methodologies for historical filmmaking, 4–6; plurality, 33, 168, 184; reflexivity, 115, 131
Deadwood, 32*t*, 117*t*, 126
Death of Stalin, The, 53, 54, 117*t*, 130
deBoer, Freddie, 160
Deleuze, Gilles, 188
Derrida, Jacques, 146
Descartes, René, 145–146
Detroit: archival insertions, 45, 87, 117, 139–140; companion documentary, 100; companion website, 95–96; frame within a frame, 120, 121*f*; mode shifting, 45
Dexter, 159, 160
Diamond, Jared, 39
diegesis (narration mode): classical, 23–24, 60, 158; documentary, 22, 23–24, 40, 85–86; evidence, 85–86; historiophoty, 26, 87; mimesis and, 85–86, 87, 133, 158–159; narration, 23–24, 40, 43, 44; performance nature of, 22–24, 43, 85–86, 133; reflexivity, 116, 118–126, 117*f*
diegetic (film storyworld), 68, 147, 185
digital media: citation and, 93–101, 105–106; history, 76; production effects and technology, 29, 85, 89, 122–123; threat of, 104, 105–106; transmedia, 93–106
documentary, 3, 4, 16*t*, 18–24, 27, 29–30, 32*t*, 35*t*; collage, 23, 26; compilation, 16*f*, 23, 61, 83, 85–86, 89, 162; diegesis, 22, 23–24; evidence, 83–84; expository mode, 27; method, 26; modes of, 27–28; narration, 42, 43, 44; observational mode, 27, 29–30; participatory mode, 27; performance model, 21, 22; performative mode, 27; poetic mode, 27; presentational, 21–23; quotation, 26; reenactment, 19, 23; reflexive mode, 27; spectatorship, 45
Doležel, Lubomír, 25, 26, 43
Dostoevsky, Fyodor, 169

double consciousness, 170, 173, 174, 185
Downton Abbey, 29, 32*t*, 54
Driver, Adam, 130, 181
Driving Miss Daisy, 54
Du Bois, W. E. B., 170, 173
Dunkirk, 54, 177
Dunst, Kirsten, 131

editing: authorship, 84; continuity, 44, 107, 115; digital, 50, 85–86, 89, 105–106; documentary, 23, 29–30, 50, 61, 67–68, 76, 85–86, 101; historiophoty, 77, 82; narrative structuring and, 62, 67, 76, 84, 101, 117; noncontinuity editing, 117*t*, 128, 136–139; reflexive, 115, 117, 126, 128, 136–139
Eggers, Robert, 126
Egoyan, Atom, 118
Eisenstein, Sergei, 10, 176
emotion: atmosphere and, 147–149; audience, 92, 100, 109, 114, 176, 191–192; ethical criticism and, 103; evidence, 85, 92; foreignness, 153–154; historiophoty, 2, 3, 14–15, 45, 92, 111, 151; memory and, 111; music, 68–70, 141–142; plurality, 63, 157; reflexivity, 114–115, 138; rhetoric and, 41, 45, 103, 158–159, 175, 176
empathy: characterization and, 35–36, 135–136, 166, 179; identification and, 150–151, 174; imaginative empathy, 152; visual poetics of, 139
emplotment, 55*t*; comedy, 52; historiography, 73; narration, 46*t*, 51, 52–56, 55*t*, 68; reflexivity, 108, 117*t*, 130; romance, 52; satire, 52, 54, 129–130; tragedy, 52
epic theater, 114–115
Epstein, Seymour, 175
evidence: citation and footnoting, 83, 89–92, 93, 96–97, 100, 105; companion documentaries, 100–101; companion websites, 93–97; companion works, 91–92; credits, 90–91; definition, 72–75; diegetic, 68, 85–86; discussion and dialogue, 102–105; documentary, 65, 84–88; extratextual citation, 91–105; factuality, 77–78; historiophoty, 1, 3, 5, 12, 15, 35, 37; hybrid, 87–89; imagistic, 12; lack of, 31; methodology, 5, 7, 83–84, 101–102; mimetic representation, 97–100; narration, 41, 47, 52, 76–77; principle of, 6, 7, 32–33, 71–106; reenactment of, 86–87; within the text, 84–89

experimental film, 16, 18–19, 27–28. *See also* art films

Favourite, The, 89
Fellini, Federico, 5, 135
female point of view, 131, 132*f*, 148, 165–166, 180–181, 186, 186*f*
Ferro, Marc, 10, 184
Fielding, Henry, 112
flashbacks, 56, 65, 122, 137–138
Floating Weeds, 119
Flory, Dan, 158, 173, 174
Fludernik, Monika, 15
Fog of War, The: Eleven Lessons from the Life of Robert S. McNamara, 45, 90, 138
Foley, Malcolm, 104
Foner, Eric, 36
Fortunella, 51
Foucault, Michel, 146
1492: Conquest of Paradise, 157
frame within a frame, 112, 113*f*, 116, 118–120, 117*t*, 120*f*, 121*f*
Fraser, Nick, 160
Free State of Jones, 32*t*, 35, 46, 165*f*; archival content and titles, 87, 90–91; authenticity in, 163, 164; characterization, 53, 61–62, 99*f*; companion documentary, 100–101; companion website, 96–100, 104–105, 106; emplotment, 53, 54–56, 55*t*; evidence, 106; fictionalization in, 97–98, 163–164; foreignness, 144, 152; ideology in, 57; multiperspectivity, 35, 157, 179, 187–189; music, 68–69; narration, 47–48; reflexivity, 117*t*, 137–138, 141, 142; story and plot, 47–48; subtype and genre, 57; theme, 58, 60, 147; visuals, 66–67
Frye, Northrup, 17–18, 39, 41, 52, 53

Game of Thrones, 28, 50, 63, 64, 67, 164
Gare, Arran, 182
Gaudreault, André, 23, 45
Gearhart, Suzanne, 51, 74
Genette, Gérard, 3, 43
Gentleman Jack, 54
Get Out, 124
Gibson, Mel, 126
Ginzburg, Carlo, 30
Gladiator, 63, 67, 125
Glazer, Brian, 189–190
Glory, 99, 163, 189

Go-Between, The, 144
Gone with the Wind, 176
Good Fight, The: The Abraham Lincoln Brigade in the Spanish Civil War, 178–179
Good Morning, Vietnam, 117*t*, 139
Gosford Park, 28
Great Escape, The, 31
Great War, The (BBC series), 75, 78
Green Book, 54
Greiner, Rasmus, 10, 14–15, 20, 153
Grierson, John, 3
Griffith, D. W., 66, 188
Grindon, Leger, 150, 169
Gunning, Tom, 24
Guthrie, Caroline, 162
Guynn, William, 99, 116, 120

Halbwachs, Maurice, 110
Hall, Stuart: audience and reception, 176; cultural identity, 173–174; voice and authorship, 183
Halt and Catch Fire, 29
Hamilton, 121
Hamlet, 88, 118
Harlan County, USA, 29
Hartley, Leslie P., 145
Heart of Glass, 156
Hell on Wheels, 29
Herder, Johann Gottfried, 155
Herlihy, David, 89
Herodotus, 112
Herzog, Werner, 136, 156
heteroglossia, 172, 183, 191
historians: appraisal of historical films by, 3, 4–6, 10, 33, 36–37, 40, 75–84, 92, 103–104, 146–147, 152–153; evidence, 33, 71–82, 87–88, 89, 92, 93, 101, 103–104, 105; historiography, 74–75, 84, 150, 168–172, 183–183; historiophoty, 13–14, 36–37, 50–52, 75–84, 103, 105; interviews with, 65, 87–88, 93, 100–101; methodologies of, 6–9, 24, 60, 71, 72–73, 83–84, 89, 92, 103–104, 105, 146–147, 150, 166, 168–172, 183–184; narration practices, 19–20, 43–44, 50–51, 60, 65, 169; plurality, 168–172, 183–184; reflexivity, 109–110, 113
historical consultants, 80–81
historical film: definition, 2–3; public discourse, 25–26, 75, 103, 187, 191; screened

history, 8, 10; soft power, 2, 25–26, 79, 111; as subfield, 8
historicity, 16, 18, 19, 20, 28, 37
historiography: bias, 171–172, 183–184; definition, 6–7, 9–10; fiction and, 25, 73–75; films and, 4–5, 8–10, 75–85; historiophoty, relationship to, 36–37; methodologies, 25, 71–72, 115–116; narrative theory, 50–54, 74
historiology, 9
historiophoty, 1–15, 20–26, 31–34, 53; affect, 14–15; alienation techniques, 116–142; cross-disciplinarity, 1, 8, 10, 37; definition, 1–4, 6, 12–13, 14–15; documentary, 85–86; estrangement, 145–146; filmmakers and, 36, 61, 88–100, 177–178, 183–185, 186–191; five principles of, 1–2, 4–6, 9, 31–34; historiography, relationship to, 36–37, 40, 71–73, 75–106, 115–116, 143–144, 168–169, 170–172; hybrid films, 87–89; influence of, 14–15; moving histories, 16–18, 20–24, 28–33; narrative strategies, 45–70, 73–74, 179–183; performance films, 86–87; polyphony, 169–172; pronunciation, 12–13; representational scope, 172–179
history, academic. *See* historians; historiography
History Buffs, 103, 106
History of Jones County, The, 100–101
History vs. Hollywood, 103
histospheres, 14–15, 153
Hitchcock, Alfred, 119
Hobsbawm, Eric, 74, 75, 146, 155–156, 171–172
Hodges, Nick, 103, 106
Holofcener, Nicole, 185
hooks, bell, 174–175, 176, 177
Howard, Ron, 189–190
Howe, LeAnne, 174
Hughey, Matthew, 175
Hunger Games, The, 187
hybrid histories, 16*t*, 19, 35–36, 35*t*; definition, 23, 24, 32*t*; methodologies, 87–89, 95, 125, 126–128; narration, 46*f*; polyphony, 190–191; progenitors, 24

Ida, 117*t*, 129, 129*f*
identity, 1, 87; audience, 152, 173–174, 182–183, 185–187; authorship and, 183–187; collective, 87, 102; diverse representation and, 171, 173–174; history and, 168–169, 171–172; memory and, 109–110; moving histories and, 14–15, 40, 102, 151; performance modes, relationship to, 21–23, 42; public history, 10
imagery: affect and, 1, 15, 85–86, 107, 109, 111, 135–136, 138, 139, 175, 191–192; archival, 85, 88, 101, 133, 139–140; authenticity, 45, 139–141; diegetic and mimetic, 23, 42, 87, 117; digital, 50, 122–123; haptic, 148–150; historiography, 108–109, 111; historiophoty, 12–13, 109; marketing, 58; memory, 109–111; metaphorical, 99, 118–119; narration, 46*f*, 47, 65–68; reenacted, 85; reflexive, 18–19, 46, 125, 128, 131, 134–135, 136, 138–139; scale, 76, 176
I'm Not There, 122
Inglorious Basterds, 31, 162
Into the Wild, 30
Irishman, The, 122–123
Isham, Mark, 69

Jackson, Peter, 26, 101–102, 106, 136, 176, 191
Jager, Eric, 130, 154
Jameson, Frederic, 12, 77
Jayanti, Vikram, 136
JFK, 57, 91–92, 136, 139–140
Jones, James Earl, 177–178, 178*f*
Jordanova, Ludmilla, 72, 83, 100, 106
Judas and the Black Messiah, 32*t*, 124, 177

Kanesatake: 270 Years of Resistance, 29, 32*t*
King, Allan, 27
King, Rodney, 48–49
Knight's Tale, A, 120, 142
Kracauer, Siegfried, 17, 20, 72
Kubrick, Stanley, 134
Kuehl, Jerry, 78–80, 89
Kurosawa, Akira, 130, 179–180

LA 92, 189
LaCapra, Dominick, 41
Lake, Liz, 190
Landsberg, Alison: foreignness, 151; historiophoty, 3; mass history, 40, 151; prosthetic memory, 150–151; public history and identity, 2; reflexivity, 107, 123
Lane, Anthony, 139–140
language, 117*t*, 125–126; communication barriers, 157–162; polyphony and, 172–173

218 • Index

Last Duel, The, 30; affect and emotional engagement, 41–42, 148–149, 149f; authorship, 185; companion works, 100, 102; gender roles, 165–166, 180–181; polyphony, 130, 180–181; reflexivity, 117t, 137; social and material atmosphere, 153–155, 165–166, 180–181; truth claims, 181
Last Kingdom, The, 164
Last of the Mohicans, The, 161
Layton, Bart, 127–128
Lee, Spike, 122–123, 158, 174, 190
Leigh, Mike, 185
Leonard, Franklin, 177
Let It Fall: Los Angeles 1982–1992, 23, 32, 32t, 35t, 40, 46, 46n1, 46t, 92, 142, 147, 176; affect, 148, 159, 176; archival material, 67, 85, 136, 138, 152, 159; atmosphere, 148, 152, 162; characterization, 61, 62–63, 131; diegesis, 85; emplotment, 53, 54–56, 55t; evidence, 85, 93; foreignness, 147, 148, 152, 157, 159, 162; ideology, 56–57; mimesis, 53; multiperspectivity and plurality, 48, 53, 61, 62–63, 131, 157, 179, 187, 189–190; music, 69; narration, 46t, 48, 53, 54, 56; reflexivity, 131, 136, 138, 142; story and plot, 48–49; subtype and genre, 57; theme, 58–59, 60; truth, 131; visuals, 67, 136
Letters from Iwo Jima, 80
liberalism, 35, 46t, 56–57, 60, 170–171
Life Is Beautiful, 54
Limoges, Jean-Marc, 108, 130
Lincoln, 105, 163
Lively, Genevieve, 47
Look of Silence, The, 176
Lord of the Rings: The Fellowship of the Ring, 26
Lost Tapes, The: The LA Riots, 189
Lowenthal, David, 7, 109, 114, 145, 155
Lyotard, Jean Francois, 182

MacDougall, David, 184
Mad Men, 2, 30, 32t, 54, 151
Making of The Last Duel, The, 102
Making of They Shall Not Grow Old, The, 101–102, 136
Man in the High Castle, The, 31, 162–163
Marey, Étienne-Jules, 14f
Marie Antoinette: atmosphere, 148, 152; authorship, 186; empathy, 131, 186f; female perspective, 131, 132f, 186, 186f; reflexivity, 117t, 131, 142

Markowitz, Harvey, 174
Marks, Laura, 148
Marsh, Elizabeth J., 73
Mary Two-Axe Earley: I Am Indian Again, 26, 32t
Masters of the Air, 33
Matewan, 177–178, 178f, 188
Maza, Sarah, 83, 84, 169, 172, 190, 191
Mazierska, Eva, 146
Mbatha-Raw, Gugu, 188
McArthur, Colin, 175
McCabe & Mrs. Miller, 124
McConaughey, Matthew, 48, 96, 121, 124, 164, 188
McKee, Robert, 60, 75
McPherson, Kelly, 190
McQueen, Steve, 139
Memento, 110
memory, 1, 2, 7, 109–111; cognition and, 25, 85, 109–110, 137; collective, 26, 40, 79–80, 110, 111, 134, 150–151, 162, 175; historiography, 4, 7, 10, 110–111; historiophoty, 85, 86, 122–123, 131, 133, 137, 148–149, 180–181; mnemotechnics, 111, 191; prosthetic, 150–151; reflexivity, 123–124; slander, 131
Menashe, Louis, 12, 13
metamodernism, 113–114, 127, 142, 182–183
Metz, Christian, 117
microhistory, 30, 128, 188
Mighty Heart, A, 121
Miller, Donald L., 33
Miller, Liz, 184
mimesis: characterization, 52–53, 60; classical definition, 23–24, 60, 158; diegesis versus, 23–25, 42–43, 75, 86, 133, 158–159; evidentiary practices, 75, 86–87; historical mode, 24–25, 26, 40, 42, 43; historiophoty, 16f, 26, 120, 158; learning and, 75, 155; narration, 15, 22, 44–45, 52–53, 60–61, 115–116; performance mode, 23–24, 86–89, 133; spectatorship, 44–45, 85–86, 151–152, 155
MLK/FBI, 23
Montague, Jules, 109
Monty Python and the Holy Grail, 54, 130
Monty Python's Life of Brian, 54, 130
Moore, Michael, 136
Morris, Errol, 60; credits, 90; hybrid history, 88–89; performance, 21; reenactment, 26, 88–89, 136–137; reflexivity, 136, 137; truth, 83; use of music, 68

Moses, Dirk, 50–51
moving histories: academic history, 60–61, 78–84, 89–90, 152–153, 172; definition, 1–4, 16, 16*t*, 32*t*; diegetic performance, 23; flattening of history and, 156–157, 162, 163–164, 175–176; genre of, 73, 75, 77–78; historiophoty, 4–6, 10–11, 16–17, 40–45, 46*t*, 71, 99, 105–106, 107–108, 144–145, 168–170, 172; histospheres, 14–15; influence of, 40–41, 51; makers of, 36, 183–187; mimesis and diegesis, 23–24; mimetic performance, 23; modes of history in, 16*t*, 19–33, 32*t*; mummification, 16–17; presentational performance, 21–23; proto forms, 25; public history, 40–41; realism, 16–18; reenactment, 20–23, 27; representational performance, 21–23; revivification, 17; spectator experience, 65, 102–103, 107–109, 115, 166; storyworld, historical, 25–26; truth status, 36–37, 42–44, 139–140
Mr. Turner, 185
Mudbound, 28
multiculturalism: challenge of, 170, 177; depictions of, 56; metamodernism and, 113; methodology, 33; polycentric multiculturalism, 170–171, 185
multiperspectivity, 167–168, 171, 179, 182, 184, 185–187
Mulvey, Laura, 185
mummification, 16–17
Mundhenke, Florian, 44
Munslow, Alun, 113
music, 42, 46*t*, 68–70, 117*t*, 141–142

Narcos, 31
narration, 46*t*; author, 43–46; characterization, 52–53, 60–65; classic poetics, 47–48; diegetic, 22, 23–24, 40; emplotment, 46*t*, 51, 52–56, 55*f*; focalization, 3, 43–45, 84, 113; foreignness, 147; historiophoty, 31–32, 32*t*, 38–40; ideology, 46*t*, 56–57; metamodern, 113–114, 142, 182–183; methods, 45–46; mimesis, 22, 23–24, 40; music, 68–70; poetics, 42–70, 46*t*; principle of, 6, 31–32, 38–70; reflexivity, 113–114; rhetoric, 41–42, 52, 115–116, 149–150; satire, 46*t*, 52, 54; story and plot, 47–50; storyworlds, 15, 25–26, 30–31, 43, 118–119, 125, 139–140, 161–162, 169–170, 181–182;

subtypes and genres, 57–58; theme, 58–60; visuals, 65–68; voiceover, 23
Nash, Julie, 33–34
Nelson, Kim, 1, 182, 191
New World, The, 56, 161–162
Nichols, Bill, 12, 20–21, 27, 45–46, 72, 84
Nietzsche, Friederich, 17, 56, 145, 154
Night at the Garden, A, 65–66, 66*f*; archival footage, 76; citation, 93–95, 95*f*, 96; collective history and scale, 176; companion website, 93–96; compilation documentary, 86, 89; editing, 76, 86; evidence, 86, 89; foreignness, 162–163; narrative intervention, 76, 86; plurality, 176; quotation, 65
1917, 26, 30
Nixon, 92
Nolan, Christopher, 110
Norsemen, The, 130
Northman, The, 130
Novick, Peter, 9, 39

objectivity: focalization and, 43–45, 135–136; historiography, 83; historiophoty, 85; methodologies of, 85, 113–115, 131, 135, 169–170, 182; truth and, 43–45
O'Connor, John E., 81–82, 90, 146
O.J.: Made in America, 18
Okediji, Moyosore B., 113
Oppenheimer, 26
Oppenheimer, Joshua, 86, 106, 160
Ozu, Yasujirō, 119

paratext, 20, 35, 44, 58, 73, 87, 89–91, 93–105, 115, 117*t*, 131
Passion of Joan of Arc, The, 117*t*, 120, 129, 131
Passion of the Christ, The, 126
Paul, R. W., 112, 113*f*
Pearl Harbor, 56
Peele, Jordan, 124
performance histories: archival material, 45, 86–87, 99–100, 117, 117*t*, 132–133, 137–138, 139–140; conventions, 87, 140–141; definition, 16*t*, 19, 20–23, 26, 28–29, 30–31, 32*t*; evidence, 83–84, 91–93, 95–101, 102; fiction, 25–26, 75; focalization, 44–45, 135–136; mimesis, 22, 23–24, 26; narration, 42; reenactment and paraphrase, 26, 83–84, 115; representational performance, 21–23, 24, 45, 56, 61, 123–124
Persepolis, 132

personal history documentary, 16t, 29–31, 32t
Peters, John Durham, 2, 16, 32, 116
Pianist, The, 119, 120f
Pinker, Steven, 156, 174
Planet Earth, 135
Plantinga, Carl: documentary films, 43, 45; emotion, 14; ethical criticism, 103, 184; experimental films, 18; plot, 48; spectatorship, 14, 15; truth, 43
Plato, 11, 23–24
plurality, 35–36; authorship, collaborative, 183–185; authorship, diverse, 177, 185–187; characters, 172–179; collective history, 110; female perspectives, 172, 185–186; interpretation, 179–182; metamodern narrative, 182–183; polyphony, 169–172; polyvocality, 170, 173, 175–179, 189–190; principle of, 6, 33–34, 82, 167–192; racial representation, 172–175; reception process, 191–192; tempered judgment, 168–169
poiesis, 25, 41, 47, 60, 65, 72
point of view (POV) shot, 119, 120f, 127, 177, 179, 188
Polley, Sarah, 30
polyphony, 169–173, 179–182, 189–191
polyvocality. *See* polyphony
popular history. *See* public history
Porter, Edwin S., 112
possible worlds theory, 25, 26
postclassical cinema, 112–113, 114, 120–121, 127, 132
postmodern(ism), 11, 31, 39, 73–74, 110, 113–114, 115, 122, 146, 175, 182–183
Powell, Michael, 187
power relations, 3, 33–34, 115, 123; archive and, 11, 39; historiography and, 183–184; representation of, 56–57, 67, 134, 147, 152, 157, 159, 165–166, 170, 173, 179, 180; satire as critique of, 54
presentism, 35, 103–104, 143, 145–146, 150, 155–156, 159, 160, 161, 177–179, 180
Prey, 30, 32t
public consciousness, 10, 25–26, 51, 86, 103, 115–156, 116; collective memory, 110; double consciousness, 170, 173–174, 185; estrangement, 111; exclusions from, 169, 173–177, 186; individual versus collective histories, 175–176; methodologies of, 112, 114–115, 150–151, 166, 172; pacifism and, 79; plurality and, 182

public history: authorship, 37; collective memory, 1; dialogue and reception of, 103, 160, 187; digital age, 10; estrangement and foreignness, 166; genealogy and progenitors to, 6–7; historical enactment of, 24; historiophoty of, 13, 37, 172; impact and influence of, 2, 10, 25–26, 75, 78–79, 111; methodologies of, 37, 106, 123, 166, 172; modes of, 18–19, 27; moving images and, 3, 41–42, 112; relationship to academic history, 5, 37; responsibility of, 2, 104, 106, 172, 191

Queen Cleopatra, 122
quotation, 26, 116; documentary method, 24, 26, 65

Raheja, Michelle H., 176, 185
Raise the Red Lantern, 30
Rancière, Jacques, 20
Ranke, Leopold von, 9
Rashomon, 5, 130, 136, 179–180, 180f
realism, 2–3, 16–19, 27–28, 29, 30; historiophoty, 73–74, 80, 85–86, 108, 113–114, 115–116, 119, 120, 123–124, 140; reality effect, 149–150; reflexivity, 117, 118, 119, 125–126, 137–138, 141
reality effect, 149–150
Rear Window, 119
reception. *See* spectatorship
Reds, 45, 57–58, 117t, 124, 133, 176
reenactment: *Act of Killing, The*, 86; *American Animals*, 137; audio, 101; documentary, 19–20, 23, 27, 45, 101, 108, 138; genre of, 19–20, 27; historiophoty, 77, 84–85; history as, 19–20; hybrid histories, 45, 87–89, 125, 137; mimetic, 24, 26, 45, 75; observational, 45; performance histories, 26, 45, 75, 137; representational, 24, 27, 121–122, 126, 137; *Rise of Empires: Ottoman*, 87; *They Shall Not Grow Old*, 101; *Wormwood*, 88–89, 125, 128, 136
reflexivity, 117f; alienation, 109, 125, 126, 140; archival material, 139–140; art direction, 120–121; audiovisual expressionism, 138–139; casting, 121–125; cinematography, 128–129; diegetic, 118–126; emplotment, 130; estrangement, 118, 122; frame within a frame, 118–120; functions of, 116–117; language, 125–126; memory and, 109–111;

metamodernism, 113–114; mode shifting, 126–128, 132–133; music, 141–142; noncontinuity editing, 136–137; nondiegetic sound, 126–142; nonlinearity, 137–138; plural viewpoints, 130–131; point of view (POV) shot, 119–120; principle of, 6, 33, 107–141; prologues and epilogues, 131; role of, 107–108, 110; screen within a screen, 128; techniques of, 117–142, 117t; theatrical antecedent, 114–115; time shifting, 134–135; titles, 140–141; total, 130; voice-over, 135–136

Renov, Michael, 42, 43

representational performance, 21–24, 45, 56, 61, 64, 125, 126, 159. *See also* mimesis

Return of Martin Guerre, The, 30, 146–147

Ricœur, Paul, 41, 73, 77, 108–109, 110, 114

Ride with the Devil, 189

Ridley, John, 35, 48, 49, 59, 67; polyvocality, 179, 189–190

Rise of Empires: Ottoman: characterization, 35–36, 35t, 60, 61, 63–65, 64f, 124–125; companion website, 95; emplotment, 53, 54–56, 55t; evidence, 87–89; foreignness, 147, 148f, 164–165; hybrid history, 23, 32t, 46; ideology, 57; music, 69–70; polyphony, 179, 187, 190–191; reflexivity, 117t, 126–127, 138; representational performance, 158–159; story and plot, 48, 50; subtype and genre, 57; theme, 59–60; visuals, 67–68

Roads, Christopher, 75–76, 78, 81

Rome, 18

Room with a View, A, 54

Rosen, Philip, 3, 8, 17, 18, 37

Rosenberg, Alex, 38–39

Rosenstone, Robert: affect, 115, 155; AHR forum issue, 4, 65, 109; documentary, 3, 45, 84, 85, 178–179; emplotment, 57–58; fictionalization of history, 99, 153; historiophoty, 2, 3, 4, 8, 12, 14, 23, 79, 102, 115, 152–153; interviewees and representation, 178–179; public history, 109, 115, 153; representation, 178–179; spectatorship, 109, 115; visuals, 65, 84, 109, 153

Ross, Arthur A., 187

Ross, Gary: Aristotle, 47; citations and website, 96–98, 97f, 99f, 100, 104–105, 106; narrative argument, 61, 62, 66–67; plurality, 187–188

Royal Affair, A, 32t, 117t, 138

Ruby, Jay, 114, 116

Runciman, Steven, 164

Ryan, Marie-Laure, 25

Şahin, Emre, 190

Sarraounia, 80

satire, 46t, 52, 54, 125, 130, 139

Satyricon, 117t, 134–135

Saving Private Ryan, 56, 80

Sayles, John, 36, 177–178, 188

Schaffer, Dana, 25–26

Schindler's List, 129

Scorsese, Martin, 81, 122

Scott, Cuba, 102

Scott, Ridley, 102, 130, 181

screen within a screen, 117t, 120, 128

Selma, 31, 124

Senna, 26, 89

Shakespeare, 118, 124–125, 126

Shoah, 2

Shohat, Ella: historical relativism, 157–158; identity, 169; liberalism, 170; plurality, 170–171, 173, 176–177, 185; polycentric multiculturalism, 170–171; racial representation, 173, 176–177

Silence, 81

Singer, Peter, 174

Sklar, Robert, 77

Skoller, Jeffrey, 19

Slovic, Paul, 175

Smith, Paul, 78

Smyth, J. E., 84, 87

Sobchack, Vivian, 4, 8, 12, 51, 73, 191

Sopranos, The, 159, 160

Sorkin, Aaron, 47

Sorlin, Pierre, 36, 77, 84

Souvenir, The, 30

Spadoni, Robert, 147

Spartacus, 117t, 125, 126, 134

spectatorship, 20, 33–34, 119; absorption, 14–15, 44, 70, 107, 109, 158–159, 176; active, 77–78, 103; affect, 4, 14–15, 44, 68, 92, 103, 131, 136, 138, 148; assumptions and expectations, 20, 28–29, 45, 51, 73; bad fan, 159, 178, 181; critical context, 1–2, 20, 22, 28, 39, 44, 51, 58, 73, 76–77, 83, 86, 90, 93, 99, 103, 105, 107, 111, 117, 123, 132–133, 144, 150–151, 155, 159, 181, 184, 187, 191; depictions of, 119; digital, 93;

spectatorship (*continued*)
diverse representation and, 170–171, 173, 176–177, 180, 184, 185, 191–192; documentary, 45; evidence, 73, 76, 79, 82, 86, 90, 92, 99, 103, 105; experiential history, 2, 4, 17, 25, 40, 44, 47, 61, 65, 70, 92, 94, 117, 136, 138, 150–151; foreignness, 148, 150–151, 159; historiophoty, 1, 10, 82, 83, 116; identification, 33–34, 54–56, 61, 92, 148, 159, 172–175, 176–177, 180, 185–186, 187, 190–191; interpretation and dialogue, 116, 191; mimesis, 23, 44, 158–159; narration, 40, 44–45, 58, 158; persuasion and, 44, 191–192; reflexivity and alienation effects, 107, 111, 114, 117, 118, 123, 126, 131, 133, 134–135, 138, 141–142; visual culture, 65, 79–80, 93, 109, 123

Square, The, 29

Staiger, Janet, 11, 36–37

Stam, Robert: historical relativism, 157–158; identity, 169; liberalism, 170; music, 141; plurality, 170–171, 173, 176–177, 185; polycentric multiculturalism, 170–171, 185; racial representation, 173, 176–177; reflexivity, 108, 112

Stone, Oliver, 72–73, 91–92, 139–140

Stories We Tell, 30, 32*t*, 140

storyworld: documentary, 43; fictional, 159, 169, 181–182; foreignness, 153, 161–166; historical, 15, 25–26, 30–31, 181–182; performance histories, 169; reflexivity, 116, 117, 118–120, 123, 125, 128, 132, 134, 135, 140–141, 144

Stubbs, Jonathan, 9–10, 75, 92, 131

Sweet, James H., 103, 104

sympathy, 34–35, 64, 166, 168, 176, 187–191; *Free State of Jones*, 66; *Let It Fall: Los Angeles 1982–1992*, 179; plurality, 168, 170, 176, 187; *Rise of Empires: Ottoman*, 54, 64, 88, 179, 190

Tarantino, Quentin, 162, 177

Taylor, A. J. P., 78, 80

Terror, The, 18

Thanouli, Elftheria, documentary, 43; historiophoty, 3, 13, 17, 51–52, 183; narration, 51–52; postclassical cinema, 112–113, 114

Theodorakopoulos, Elena, 134

They Shall Not Grow Old: citation and companion works, 93, 100, 101–102; evidence, 85–86; historiography, 191; moving history, 32*t*; plurality, 176; as quotation, 26, 191; reflexivity, 136

Thin Blue Line, The, 26, 45, 88–89, 136, 138

Thin Red Line, The, 135

This Changes Everything, 56

300, 63

Till, 2, 176

titles, 117*t*, 140–141

Titus, 120–121

Todorov, Tzvetan, 40

Tom Jones, 112, 125, 135

Topsy-Turvy, 185

Trafton, John, 164, 188

Trainspotting, 113

Treacey, Mia E. M., 8, 10

truth: bias and, 39, 44, 83, 109, 168–169; claims, 14, 18–19, 27–28, 36, 83, 90, 130, 181; documentary, 27–28, 41–43, 76, 83–85, 88–89; evidentiary links, 72, 83; failure, 105; fictional, 19–20, 25–26, 41–43, 153; focalization and, 113, 135–136; historiography, 11–12, 14, 17–20, 41, 72, 83–84, 90, 130, 183–184; historiophoty and, 5, 9, 10, 14–15, 36–37, 41–44, 72, 77–78, 83, 88–90, 99–100, 103, 105, 113–114, 127–128, 179–183; identity, 1, 167–169; metamodern, 127; methodologies of, 14, 21–23, 76, 83, 88–90, 103, 105, 113–114, 119, 127–128, 130–131, 133, 142, 169–171, 172–173, 179–183; realism and, 17–19; valuation of, 25, 103

Turn: Washington's Spies, 125

12 Years a Slave, 53, 139, 189

Umanath, Sharda, 73

Uncle Josh at the Moving Picture Show, 112

universalism: foreignness and, 144, 153–155, 174; historical relativism and, 158; historiography, 147; historiophoty, 163, 166; plurality, 172; principle of, 20, 41, 72

Uwemedimo, Michael, 86

Vaage, Margrethe Bruun, 152, 158, 159, 160; the bad fan, 178, 181; token and types in historical film, 28, 29, 30, 48, 54, 57

Vermeulen, Timotheus, 113–114

Vikings, 31, 32*t*, 89, 125, 164

voice-over, 135–136

Voltaire, 112

VVitch, The: A New England Folktale, 117*t*, 126

Walker, 117*t*, 120
Walkowitz, Daniel, 82, 90
Walter, Harriet, 166
Watt, Donald, 78, 80–81, 82, 89, 103
Waugh, Thomas, 21, 22, 43
Westwell, Guy, 13
What Happened, Miss Simone?, 30
What Time Is It There?, 130
White, Hayden, 50–52; "The Burden of History," 1, 51, 91; citation, 89; historical truth, 36; historiophoty, 1, 4, 8, 9, 10, 11–13, 34, 51, 73–74, 79; ideology, 51, 56, 183; *Metahistory*, 13, 51; modes of emplotment, 51, 52, 130; narrative, 20, 36, 50–53, 56, 76–77, 183; on realism, 73–74
White, Richard, 161
Why We Fight, 135
Williams, Gary, 58–59, 59*f*

Wiseman, Frederick, 27
Witch, The: A New England Folktale. See *VVitch, The: A New England Folktale*
Woman King, The, 103–104
World at War, 79
Wormwood: characterization, 53, 60, 61; citation, 90, 91*f*; foreignness, 144; hybrid history, 23, 26, 88–89, 126–127; moving histories, 32*t*, 41; performance, presentational and representational, 21, 60, 61, 125; reflexivity, 117*t*, 125, 126–127, 128, 136, 142

Year of Living Dangerously, The, 122
Youngblood, Denise, 12

Zacks, Jeffrey, 2, 15, 25
Zodiac, 57

About the Author

KIM NELSON is the director of the Humanities Research Group and an associate professor of Cinema Arts in the School of Creative Arts at the University of Windsor in Canada. A filmmaker whose work has been screened internationally at film festivals and by broadcasters, she is the co-editor of *The Routledge Companion to History and the Moving Image* (2023).